# Sources for the History of En

Offering insights on the wide range of sources that are available from across the globe and throughout history for the study of the history of emotions, this book provides students with a handbook for beginning their own research within the field.

Divided into three parts, *Sources for the History of Emotions* begins by giving key starting points into the ethical, methodological and theoretical issues in the field. Part II shows how emotions historians have proved imaginative in their discovering and use of varied materials, considering such sources as rituals, relics and religious rhetoric, prescriptive literature, medicine, science and psychology, and fiction, while Part III offers introductions to some of the big or emerging topics in the field, including embodied emotions, comparative emotions, and intersectionality and emotion. Written by key scholars of emotions history, the book shows readers the ways in which different sources can be used to extract information about the history of emotions, highlighting the kind of data available and how it can be used in a field for which there is no convenient archive of sources.

The focused discussion of sources offered in this book, which not only builds on existing research, but encourages further efforts, makes it ideal reading and a key resource for all students of emotions history.

**Katie Barclay** is Deputy-Director of the ARC Centre of Excellence in the History of Emotions and Associate Professor in History at the University of Adelaide, Australia. She writes on the history of emotions, family and gender, and with Andrew Lynch and Giovanni Taratino edits *Emotions: History, Culture, Society.*

**Sharon Crozier-De Rosa** is Associate Professor in History at the University of Wollongong, Australia. She writes on the history of emotions, gender, militancy and transnationalism, and her books include *Shame and the Anti-Feminist Backlash* and *Remembering Women's Activism*. She is Deputy Editor of *Women's History Review*.

**Peter N. Stearns** is University Professor of History at George Mason University, USA. He has written widely on the history of emotions, with books including *American Cool* and *Shame: A Brief History*. He regularly teaches an undergraduate course on emotions history, and has collaborated with a number of students on research projects in the field.

# Routledge Guides to Using Historical Sources

How does the historian approach primary sources? How do interpretations differ? How can such sources be used to write history?

The Routledge Guides to Using Historical Sources series introduces students to different sources and illustrates how historians use them. Titles in the series offer a broad spectrum of primary sources and, using specific examples, examine the historical context of these sources and the different approaches that can be used to interpret them.

**History and Material Culture**
A Student's Guide to Approaching Alternative Sources, 2nd Edition
*Edited by Karen Harvey*

**Reading Russian Sources**
A Student's Guide to Text and Visual Sources from Russian History
*Edited by George Gilbert*

**History and Economic Life**
A Student's Guide to Approaching Economic and Social History Sources
*Edited by Georg Christ and Philipp R. Roessner*

**Approaching Historical Sources in their Contexts**
Space, Time and Performance
*Edited by Sarah Barber and Corinna M. Peniston-Bird*

**Reading Primary Sources**
The Interpretation of Texts from Nineteenth and Twentieth Century History, 2nd edition
*Edited by Miriam Dobson and Benjamin Ziemann*

**Sources for the History of Emotions**
A Guide
*Edited by Katie Barclay, Sharon Crozier-De Rosa and Peter N. Stearns*

For more information about this series, please visit: www.routledge.com/ Europa-Regional-Perspectives/book-series/ERP

# Sources for the History of Emotions

A Guide

**Edited by**
**Katie Barclay, Sharon Crozier-De Rosa**
**and Peter N. Stearns**

Routledge
Taylor & Francis Group

LONDON AND NEW YORK

First published 2021
by Routledge
2 Park Square, Milton Park, Abingdon, Oxon OX14 4RN

and by Routledge
52 Vanderbilt Avenue, New York, NY 10017

*Routledge is an imprint of the Taylor & Francis Group, an informa business*

*British Library Cataloguing-in-Publication Data*
A catalogue record for this book is available from the British Library

*Library of Congress Cataloging-in-Publication Data*
Names: Barclay, Katie, editor. | Crozier-De Rosa, Sharon, editor. | Stearns,
Peter N., editor.
Title: Sources for the history of emotions : a guide / edited by Katie Barclay,
Sharon Crozier-De Rosa, Peter N. Stearns.
Description: Milton Park, Abingdon, Oxon ; New York,
NY : Routledge, 2020. |
Series: Routledge guides to using historical sources | Includes bibliographical
references and index.
Identifiers: LCCN 2020005626 (print) | LCCN 2020005627 (ebook) |
ISBN 9780367261436 (hardback) | ISBN 9780367261450 (paperback) |
ISBN 9780429291685 (ebook)
Subjects: LCSH: Emotions--History--Sources.
Classification: LCC BF531 .S64 2020 (print) | LCC BF531 (ebook) |
DDC 152.4--dc23
LC record available at https://lccn.loc.gov/2020005626
LC ebook record available at https://lccn.loc.gov/2020005627

ISBN: 978-0-367-26143-6 (hbk)
ISBN: 978-0-367-26145-0 (pbk)
ISBN: 978-0-429-29168-5 (ebk)

Typeset in Times New Roman
by Taylor & Francis Books

# Contents

# Figures

# Contributors

**Katie Barclay** is Deputy Director of the ARC Centre of Excellence for the History of Emotions and Associate Professor in History, University of Adelaide, Australia. She is the author of *Love, Intimacy and Power: Marriage and Patriarchy in Scotland, 1650–1850* (2011), *Men on Trial: Performing Emotion, Embodiment, and Identity in Ireland, 1800–1845* (2019), and numerous articles on emotion, gender and family life. She is the editor, with Andrew Lynch and Giovanni Tarantino, of the journal *Emotions: History, Culture, Society.*

**Xavier Biron-Ouellet** obtained his PhD at Université du Québec à Montréal, Canada, and École des Hautes Études en Sciences Sociales (Paris), and is presently a post-doctoral fellow at Università Ca'Foscari in Venice, Italy. His thesis concerns the fourteenth-century Italian preacher Simone Fidati da Cascia and how he uses emotions to encourage spiritual reform in the urban context of Florence.

**Rob Boddice** is *Wissenschaftlicher Mitarbeiter* in the Department of History and Cultural Studies, Freie Universität Berlin, Adjunct Professor in the Department of Social Studies of Medicine, McGill University, and will take up a post of University Researcher at the Finnish National Academy Centre of Excellence for the History of Experiences at Tampere University in 2020. He is the author of six books, including *The Science of Sympathy* (2016), *The History of Emotions* (2018) and *A History of Feelings* (2019). He is a Fellow of the Royal Historical Society.

**Marcelo J. Borges** is Professor of History and the Boyd Lee Spahr Chair in the History of the Americas at Dickinson College, USA, where he teaches Latin American history and migration history. He has been a research fellow at the Netherlands Institute for Advanced Studies in the Humanities and Social Sciences and the Nantes Institute of Advanced Studies. He is the author of *Chains of Gold: Portuguese Migration to Argentina in Transatlantic Perspective* (2009) and co-editor of *Migrant Letters: Emotional Language, Mobile Identities, and Writing Practices in Historical Perspective* (with Sonia Cancian, 2018) and *Emotional Landscapes: Love, Gender, and Migration* (with Sonia Cancian and Linda Reeder, forthcoming 2021). His

current research focuses on personal letters, identity, and emotional connections among migrants from southern Europe to the Americas and their families.

**Catharine Coleborne** is a Professor and the current Head of School of Humanities and Social Science, Faculty of Education and Arts, University of Newcastle (NSW), Australia. She is the author of four books including *Insanity, Identity and Empire: Colonial Institutional Confinement in Australia and New Zealand, 1870–1910* (2015). She is currently part of two Australian Research Council funded projects, one focused on psychiatric records and convict lives, and the other on the development of Australian community psychiatry.

**Sharon Crozier-De Rosa** is Associate Professor in History at the University of Wollongong, Australia. Her research is situated at the intersections of emotions, gender, imperial/colonial and violence histories. It is transnational in scope, spanning Ireland, Britain, Australia and the USA. She is the author of *Shame and the Anti-Feminist Backlash: Britain, Ireland and Australia, 1890–1920* (2018) and co-author of *Remembering Women's Activism* (with Vera Mackie, 2019). Her current project on the emotional and material dimensions of women's efforts to preserve and archive their own memory has been awarded a National Library of Australia Fellowship (2020). She is the Deputy Editor of *Women's History Review*.

**Louise D'Arcens** is Professor in the Department of English at Macquarie University, Australia, and Director of the Macquarie node of the ARC Centre for the History of Emotions. Her publications include *Comic Medievalism: Laughing at the Middle Ages* (2014), *Old Songs in the Timeless Land: Medievalism in Australian Literature 1840–1910* (2011), and the co/edited volumes *The Cambridge Companion to Medievalism* (2016) and *International Medievalism and Popular Culture* (2014). She is currently writing *World Medievalism: The Middle Ages in Global Textual Cultures* (2020). Her work in emotions history has included recently co-editing the journal issues 'Emotions, History and Philosophy', *Screening the Past* (2016) and 'Feeling for the Premodern', *Exemplaria* (2018).

**Thomas Dodman** is Assistant Professor of French History at Columbia University, USA. He is the author of *What Nostalgia Was: War, Empire, and the Time of a Deadly Emotion* (2018) and has co-edited *Une Histoire de la Guerre, du XIXe siècle à nos jours* (2018). He has worked at *Emotion Review* and currently co-edits the journal *Sensibilités*.

**Luke Fernandez** is Assistant Professor in the School of Computing at Weber State University, USA. He is co-author with Susan J. Matt of *Bored, Lonely, Angry, Stupid: Changing Feelings about Technology from the Telegraph to Twitter* (2019). His writing has appeared in the *Washington Post, Slate, Lapham's Quarterly* and the *Chronicle of Higher Education*.

**Alan Maddox** is Program Leader in Musicology at the Sydney Conservatorium of Music, University of Sydney, Australia. Initially trained as a singer, his research interests focus on Italian Baroque vocal music, Australian colonial music, music and intellectual history, and music and the history of emotions. He is University of Sydney Node Leader of the Australian Research Council's Centre of Excellence for the History of Emotions, a member of the University's Medieval and Early Modern Centre, consultant musicologist to the Australian Brandenburg Orchestra, and was until recently a member of the National Committee of the Musicological Society of Australia.

**Susan J. Matt** is Presidential Distinguished Professor of History at Weber State University, USA. She is co-author with Luke Fernandez of *Bored, Lonely, Angry, Stupid: Changing Feelings about Technology, from the Telegraph to Twitter* (2019), and author of *Homesickness: An American History* (2011) and *Keeping Up with the Joneses: Envy in American Consumer Society, 1890–1930* (2003). With Peter J. Stearns, she co-edited *Doing Emotions History* (2013).

**Sarah Hand Meacham** is an Associate Professor of History at Virginia Commonwealth University in Richmond, Virginia, USA. She earned her BA at Smith College, her MA in American History at Vanderbilt University and her PhD in American History at the University of Virginia. She is the author of *Every Home a Distillery: Alcohol, Technology, and Gender in the Early Chesapeake* (2009). She has also published articles on colonial art, pets and girlhood. Currently, she is writing a book about why colonists invented the idea that Americans ought to be cheerful and the burdens that this emotion labour has created, as well as publishing an article on the history of smiling in early American portraiture.

**Piroska Nagy** is Professor of Medieval History at the Université du Québec à Montréal, Canada. Her current research explores the relation between collective religious emotions, events and change in the Middle Ages and medieval affective anthropology, especially embodied religious emotions, experience and charismas. She is author of *Le don des larmes au Moyen Age: Un instrument spirituel en quête d'institution, Ve–XIIIe siècle* (2000) and co-author, with Damien Boquet, of *Medieval Sensibilities: A History of Emotions in the Middle Ages* (2018); among her recent publications is co-editing, with Naama Cohen-Hanegbi, *Pleasure in the Middle Ages* (2018).

**Mark Neuendorf** is a Visiting Research Fellow in the History department at the University of Adelaide, Australia. His research examines the intersection of emotions and psychiatry, with a focus on legislative and humanitarian reform movements within psychiatric medicine. His research has been published in *Medical History*, and a monograph, *Emotions and the Making of Psychiatric Reform in Britain, 1770–1820*, is forthcoming.

**Joseph Ben Prestel** is Assistant Professor (*wissenschaftlicher Mitarbeiter*) of History at Freie Universität Berlin, Germany. His teaching and research focus on the histories of Europe and the Middle East in the modern era, global history, and urban history. He is the author of *Emotional Cities: Debates on Urban Change in Berlin and Cairo, 1860–1910* (2017).

**Sarah Randles** is an Honorary Research Fellow in the School of Historical and Philosophical Studies at the University of Melbourne, Australia, an Adjunct Researcher in the School of Humanities at the University of Tasmania, and a former Postdoctoral Fellow with the Australian Research Council Centre of Excellence for the History of Emotions. Her research focuses on medieval and early modern material culture and emotions and she is the co-editor, with Stephanie Downes and Sally Holloway, of *Feeling Things: Objects and Emotions through History* (2018).

**Alecia Simmonds** is a Lecturer in Law at the University of Technology Sydney and a Lecturer in Australian Cultural History and Pacific World History at New York University-Sydney, Australia. She has published on the relationship between intimacy, imperialism and law, and gender and emotions in a range of scholarly journals. Her current project examines the legal regulation of love through the lens of breach of promise of marriage cases from 1806 to 1975 (forthcoming 2021). Her books include *Transnationalism and Nationalism in Australian History* (2017) and *Wild Man: A True Story of a Police Killing Mental Illness and the Law* (2015) which won the 2016 Davitt Award for best crime non-fiction.

**Peter N. Stearns** is Professor of History at George Mason University, USA. He has written widely on the history of emotions, with books on grief, fear, anger, jealousy and most recently shame (*Shame: A Brief History*, 2018). His edited volume *Death in Modern World History* will appear later in 2020, published by Routledge. He currently co-chairs the new North American Chapter on the History of Emotion. He has taught a course in the field for several years, and has sponsored several successful undergraduate research projects.

**Anne-Gaëlle Weber** is a PhD candidate in Medieval History at UQÀM (Montréal), Canada. Her research focuses on the relations between identity and emotions within Carolingian missionary hagiography during the eighth to ninth centuries and how they are instruments of integration into the Carolingian Empire.

# Part I

# Introducing the history of emotions

# 1 Introduction

## A guide to sources for the history of emotions

*Katie Barclay, Sharon Crozier-De Rosa and Peter N. Stearns*

Historical research on emotion has been gaining ground steadily over the past three decades, becoming a significant subfield in the discipline and tackling a growing range of topics. Major scholarly centres have emerged in a number of places, including Britain, Germany and Australia, sponsoring a variety of publications and conferences. In recent years, historians of emotion have begun to apply their interests to teaching as well as research. Both undergraduate and graduate students now have many opportunities to do work in the field, not only in formal classes but through their own research projects as well.

An increasingly visible research field and the growing involvement of students create an obvious opportunity to discuss the kinds of sources available for historical work on emotion – and this is the purpose of this collection. Historians of emotion have been using a number of types of evidence, and many of the categories are fairly accessible – another reason to provide some guidance in finding and utilising the building blocks for further historical work.

Primary sources are essential for all types of historical research. History is, at base, an empirical discipline, and historians get their facts from materials created in past periods – written records most obviously, but also artistic materials, artefacts, and for contemporary history oral and digital archives as well. With rare exceptions, these primary sources were not produced with any eye towards an audience in the future – and certainly not an audience composed of twenty-first-century historians and history students. (What historians call secondary sources, in contrast – books and articles by scholars in the field – do have this kind of audience in mind, and therefore, at least in principle, are much easier to interpret.) Thus primary sources may involve police reports – for example, on the history of crime or protest; or parish registers, where births and deaths are recoded; or personal diaries and letters; or statements by political parties; or – the list here is a long one. In the essays that follow, a wide variety of types of sources are covered, correctly suggesting that emotions history requires a considerable range of evidence.

Utilising primary sources offers two challenges: the first, self-evident, is finding them in the first place, which can sometimes be difficult. But the second challenge centres on figuring out what they mean, given the fact that they were usually created for specific purposes in the past and so their

meaning is shaped by that context, reflecting the concerns and interests of the author. Deriving meaning from primary sources is one of the most enjoyable tasks for a study of history, but it is not always an easy assignment.

Emotions history is no different from any other field of history in needing primary sources, but it may involve some unusually difficult interpretive issues. For, at base, historians of emotion are trying to figure out what people *felt* in the past, and this is a really ambitious goal. People often have trouble figuring out what others are feeling right now, in the present; multiply this complexity by adding in the dimension of the past, and it is clear that the emotions history field can require some really complicated assessments of available evidence.

Historians of emotion make several basic arguments, as they work to define what their new field is all about. First, and most obviously, they contend that we will get a much richer picture of the past if we include emotional experience. People are, after all, not simply rational actors, though rationality should not be ignored. Reflecting shifting ideas about cognition, emotion is now recognised as a central part of decision-making, which makes a study of emotion relevant for almost every area of life. When people form families or deal with children, or when they take to the streets in protest, or indeed when they go to war, they are responding to emotional spurs at least in part. Indeed, emotions history began to take shape when family historians, for example, realised that understanding past family patterns was not simply a matter of birth and marriage rates, but had to include a set of emotional interactions.[1] Other historians likewise now realise that understanding past protest movements is probably impossible if anger is not given serious attention. Once emotion gains attention, it clearly plays a role in all sorts of other historical topics, from the study of art and theatre in the past, to an understanding of disease and healing, even to the rise of sports and impassioned spectatorship in modern societies.

But arguing for the importance of emotion in dealing with the past is only step one. Most emotions historians go on to offer a more challenging contention; emotional combinations in the past are usually not the same, or at least not quite the same, as emotions in the present. It would be a mistake, for example, to look back on a group of people in the seventeenth century and expect them to have the same ideas about happiness that we do today.[2] Or that they would be disgusted by the same things that disgust us.[3]

Sometimes word use makes it particularly easy to identify emotional differences between past and present. The word nostalgia, for example, was introduced only at the end of the seventeenth century, and for quite a while it designated a serious mental disorder, requiring medical attention. It settled into its current meaning only toward the end of the nineteenth century. Another case: 'shamefast' was a fairly common word in English into the nineteenth century, usually designating people (particularly young women) who were very sensitive to the need to avoid any shameful behaviour. But in the nineteenth century the term began to fade away, and it is not used at all

today. Experiences of nostalgia or shame in the past were clearly somewhat different from patterns in contemporary society, which adds a major challenge to the effort to understand emotions, and the impact of emotions, in earlier times.[4]

And this means, finally, that many emotions historians are also deeply interested in the process of change, when emotions or emotional standards take on new dimensions. Dealing with change brings historians into questions of causation (why did nostalgia become a new kind of problem in the late seventeenth century?) and impact (how did this new 'problem' influence the lives of those living then?). Some emotions historians are eager to apply the analysis of change to the emergence of contemporary emotional patterns, in trying to figure out how and why they differ from patterns in the recent past.

Efforts to analyse past emotion and emotional change involve one other basic challenge that has direct bearing on the kinds of sources emotions historians use and the ways they try to interpret these sources. Ultimately, most emotions historians are eager to get as close as they can to the actual emotional experience of people in the past, trying to figure out what they felt and how their feelings affected their outlook and behaviours. But emotions historians also deal with the cultural standards that societies or groups generate about emotion, for these often are significant in their own right. In the 1920s, for example, lots of American parents were urged to pay greater attention to signs of jealousy among their young children – a new term, sibling rivalry, was introduced to designate what was now regarded as a serious problem.[5] The cultural evaluation of jealousy, in other words, was changing. Almost certainly, this involved some change in the experience of jealousy itself – getting at emotional experiences being the ultimate target for emotions history. But the new standard was important in its own right, affecting what parents worried about and how young people interpreted jealousy in their own lives. Both emotion and emotional culture – or what some sociologists call 'feeling rules' – are significant candidates for historical research.

'Emotion' is not an easy word to define.[6] Emotion clearly can involve some instinctive reactions, which in turn call forth chemical responses in the body: fear and anger obviously involve physiological changes including jolts of adrenaline and more rapid heartbeats. But emotion – and this is crucial for historians – also involves cognitive or mental appraisals, which quickly add to the physiological response. Should I be afraid in this situation? What will other people think of me? What will I think of myself? Emotions, in other words, are partly *culturally constructed*, and this is where historical factors can be fundamental. Some emotions, like shame or guilt, have an intrinsic social component as well – they involve a real or imagined audience – which adds another potential historical dimension.

Emotions research has been gaining ground in recent decades in a number of disciplines, partly because of new opportunities to study the brain but partly also because of new awareness of the importance of emotion in social interactions. The rise of the history of emotion is thus part of a wider,

ultimately interdisciplinary surge, and many emotions historians interact directly with psychologists and sociologists who share similar interests. But emotions historians also deal with colleagues in other humanities areas, from philosophy to art, some of which contribute to the effort to find relevant historical sources. Figuring out the relationship between various other disciplines and the specifically historical analysis of emotion, and uncovering a wealth of sources as we do so, is an interesting and essential aspect of the field.

## Research in the history of emotions

The first call for historical work on emotion came from a French historian in the middle of the twentieth century.[7] Obviously, many historians had already been working on topics related to emotion, but the notion of explicit attention was new – part of an effort to expand historical research to provide greater understanding of daily life and the experience of ordinary people. Serious work on emotions history, however, emerged only in the 1980s and 1990s, as historians began to devote more attention to topics like the family or the nature of popular beliefs and values.[8] Since that time, work on the history of emotions has accelerated steadily.[9] Major academic centres have formed in Australia, Germany and Britain, but scholars in many other countries are actively involved. And while the field is still defined primarily by research efforts, it increasingly spills over into teaching as well.

Over the past three decades work on the history of emotion has been applied to a wide variety of chronological periods – which is what one would expect from a healthy and expanding scholarly interest. A number of historians have worked on emotions in classical societies (both Greece and Rome and Confucian China).[10] A large group of medievalists now study emotion, obviously particularly in relationship to the impact of Christianity (like Xavier Biron-Ouellet, Piroska Nagy and Anne-Gaëlle Weber in this volume).[11] A number of really important contributions to emotions history have come from scholars working on the early modern period – Renaissance to eighteenth century.[12] And a variety of studies have addressed emotional issues in the nineteenth and twentieth centuries and into the early twenty-first.[13]

Geography has been less fully addressed than chronology, in what is still a fairly new field. A disproportionate amount of emotions history has applied to developments in Europe and 'settler societies' like Australia and the United States. Interest is growing among scholars dealing with other regions – particularly China and Japan, but increasingly South Asia and Latin America as well.[14] Work on the Middle East and Islam is less fully developed, and the same applies to Africa.[15] Some of this geographical unevenness shows up in this book, where essays on the whole offer fuller references to Western cases than to other regions, though issues of linguistic fluency are also involved since sources require often subtle capacities in language. The geography problem is widely recognised in emotions history, and a number of scholars are now working to provide better balance and even to venture some comparative work (Joseph Ben Prestel's Chapter 14 in this collection helps us to realise the potential in this area).[16]

Social class and race/ethnicity offer other important challenges, and these also directly affect identification of relevant historical sources (and we discuss this in greater detail in Chapter 15 'Intersectional Identities'). Evidence about emotional standards and experiences is more abundant for middle and upper classes than for other groups; and the same point applies to evidence about changes over time. These were the groups most likely to generate letters or diaries, which often directly comment on emotion. These were the groups that provided the most obvious audience for authors offering advice on issues like how to raise children or how to display good manners. Here too, emotions historians are actively aware of this challenge, and increasingly use sources that provide evidence about working-class or immigrant experience, or the experiences of racial minorities.[17] The interesting issue of the emotional life of rural populations is also gaining some attention – for, obviously, urban sources are usually more abundant.[18] An important approach in emotions history has emphasised the variety of 'emotional communities' that exist in any complex society, and this directly addresses some of the differences in emotional standards and experiences at any point in time. But there is no question that social divisions are vital factors in emotions history – factors that are not easy to address fully, but that directly involve the search for relevant historical sources.

Gender is also a vital component in emotions history, but it is less clearly problematic than other social divisions simply because many groups and societies are quite articulate about what they claim are differences in emotions and emotional goals for men and for women. Emotional distinctions are often fundamental to work in gender history overall, and this is also an important arena for the exploration of emotional change.[19] Past claims often invite careful analysis – emotions have often been used to support gender hierarchies – but the category itself is usually explicit at least on the surface. While many of the chapters in this volume consider gender a significant issue for emotions historians, Chapter 15 'Intersectional Identities' addresses it directly.

As the history of emotions has gained increasing visibility, it has drawn scholars working on a vast array of specific topics. There is important work on relationships between emotions history and the history of health and medicine (which Rob Boddice draws on in his chapter). Art history and the history of theatre attract growing attention (see chapters by Sarah Hand Meacham and Alan Maddox). Emotions and technology is becoming an interesting subfield (and Susan Matt's and Luke Fernandez's chapter comments on this). And there are many other examples of topical expansions. These widening connections testify to the vitality of the field, and they add important findings and, often, additional kinds of source materials; several of the essays in this volume reflect these kinds of contributions. Ultimately, however, it is also important to remember that the history of emotion does have a common core of interests, in the nature of emotional life in the past and in the ways that life has changed.

## The key question

Chronology, geographical range, social and cultural divisions, the variety of topical connections – these are all important themes in the history of emotion, and they are gaining increasing attention in the field today. The central issue in emotions history is, however, quite straightforward: what is the relationship between the standards a society or group asserts about various emotions, and the nature of emotional experience for individuals and groups? And – let's be honest – it is an issue that is difficult fully to resolve, simply because of the difficulty of knowing, at any point in time, exactly what emotional experience is. It is always hard, in any historical field, to claim to know what the past was like, but emotions history presents this challenge in a particularly stark fashion.

New methodologies and theories are helping to elucidate these challenges (Thomas Dodman's Chapter 2 outlines some of these). As well as concepts like 'emotional communities' and 'emotional regimes', which explain how emotional standards shape group behaviour and which are explained more fully in Chapter 3, the idea that emotions are 'practised' or 'performed' is increasingly popular, as can be seen across this volume.[20] Both practice and performance theories, from slightly different perspectives, suggest that emotional experiences are a form of socialisation, a training that becomes so natural for the individual that they don't think about it.[21] These ideas are popular as they explain how 'culture' – the lessons we are taught about how to feel in response to certain situations and the social valuation of that feeling (whether it is good or bad) – becomes an embodied experience for individuals and groups. Moreover, they are suggestive that there is an important relationship between emotional standards and individual experience, which means that as historians we might have greater confidence that the emotions we discover in sources have some relationship to personal experience, at least for the group if not for every individual in a society.

This core issue of the relationship between sources and personal experience certainly supports the effort to develop a wide variety of sources, to provide evidence about what emotional values have been in the past and how these values have applied to the ways people reported on their emotions and emotional behaviours. Figuring out not just what sources are available and what features each type of source displays, but how sources can be combined to provide a more complex picture of the emotional experiences and standards of the past, lies at the heart of good work on emotions history. Here is the foundation for heightened understanding.

Directly or indirectly, historians have explored an impressive range of emotions, at least in some times and places. But the vitality of the field also responds to the many opportunities that remain, particularly as we gain greater awareness of the kinds of sources that can be brought to bear. One historian has recently pointed out that we don't have a lot of work on joy as yet.[22] Loneliness – a vital contemporary topic – is just beginning to gain some

revealing historical attention.[23] There are only a few studies on the history of gratitude.[24] And even more familiar domains – like fear – inevitably invite further attention, because of their complexity and importance.[25] There is lots to do, for history students as well as professionals in the field.

And it is vital to remember that, done well, emotions history serves two purposes. It genuinely expands what we know about the past: the basic claim that we cannot fully understand earlier societies without including emotions has been amply demonstrated. But it also can expand what we know about emotion itself – what shame or loneliness involve, and how current issues have emerged from the past – making historical work a vital component of emotions research more generally. As we realise how many contemporary issues have emotional components, from the anger of voters to changes in marriage rates, the importance of using the past to improve emotional understanding will continue to support this growing field.

## Enabling future research

This book is organised into three sections: the first introduces readers to some key considerations when 'doing' the history of emotions; the second surveys a range of source materials, exploring how they can be used by historians of emotions; and a final section addresses some emerging themes in the field, introducing readers to new research and new approaches that are being developed. The goal of the volume is to provide students and those new to the field with key skills in conducting empirical research in this area and to offer some insight into important developments in the practice of emotions history.

Beginning with this chapter, Part I introduces students to the field of the history of emotions and offers a brief survey of the coverage of the current scholarship in the field. The history of emotions – perhaps because it deals with a historical phenomenon that is so ephemeral and abstract – has more than most fields of history deployed a range of theories and methodologies to help us interpret our source material. Thomas Dodman in Chapter 2 provides a survey of the main approaches, highlighting how they can be applied to sources to enrich our analysis of the material. Katie Barclay concludes this part with a discussion of the practice and ethics of the history of emotions. Like any field, the history of emotions is underpinned by a set of guiding rules, principles and assumptions that shape our work. This chapter highlights some of these, such as the importance of interdisciplinarity to our field and our engagement with the biological and psychological sciences, before turning to the importance of ethical research practice within the field. This chapter finally concludes by discussing the feelings of the historian, asking what difference our emotions make to our research.

Part II consists of ten chapters that each approaches a key source material used by historians of emotion in their scholarship. The sources covered range from those that provide access to emotional standards (and occasionally deviance from them), such as religion, prescriptive literature, fiction, popular

culture and visual arts (in chapters by Piroska Nagy and others, Peter N. Stearns, Louise D'Arcens and Sarah Hand Meacham) – standards that evolved over time – to others that, if still representational, perhaps provide better access to how individuals have interpreted and applied those standards in their own lives. These include legal and institutional records, medical records and 'narratives of self', that is letters, diaries and other similar accounts of personal experience (see contributions by Alecia Simmonds, Catharine Coleborne, Rob Boddice and Marcelo J. Borges). This division is of course somewhat artificial. Fictional sources, for example, often draw closely on the personal experience of the author or those they have researched; the efficacy of a good novel, for example, typically relied on the capacity of the writer to capture in words experiences that felt universal to their readers – to give voice to feeling.[26] Similarly personal writings, from the medical case file to the letter, acted to shape the experience of emotion for the individual and for their readers. As the authors of these chapters point out, no source provides unmediated access to people's inner experiences, but they do provide opportunities to understand how those people articulated their emotions and how they managed them in relation to wider norms and power relationships.

An important form of historical source in a chapter by Sarah Randles, and also engaged with in a chapter on rituals and relics, are material culture sources – the physical traces that humans leave behind them and which are marked by their use in both ritual contexts and everyday life. If written sources appear more straightforward in giving access to emotion words and accounts of personal emotional experience, material sources offer an important reminder that our personal experiences are shaped by material structures and deployed through the use of physical items, such as when we give gifts as a mark of love. Material culture sources open up alternatives to understanding emotion from those that focus just on language or verbal expression, acknowledging the dimensions of emotional experience that go unspoken.

The visual and performing arts offer similar benefits, providing insight into physical gesture and appearance (how emotions are displayed on the body) and in allowing us, if not without important limits, to also imagine how a body might have expressed emotion through responding to a piece of music or performing a dance. Listening to music, playing historic instruments or dancing with our own bodies – especially trying to replicate the manner, style and practices of past societies – can give us an alternative research tool to reading text, while recognising (just like when we read) that we can never quite replicate the experience of those we study. Chapters on these topics remind us that the experience of emotion is shaped not just by ideas but through our senses and movements of the body, and that it can be useful to explore sources that help us access that part of human experience. Across Part II, readers are provided with a broad range of access points into historical sources for emotions research, but, of course, such a survey can never be comprehensive and so students and scholars are encouraged to be imaginative in their approach to finding relevant sources and to reading their material carefully to uncover emotional insights.[27]

The final part of the volume provides an introduction to some key topics and points of discussion in the field. Joseph Ben Prestel offers a discussion of how to do comparative work in the history of emotions, where emotions are compared across different cultures, periods or nations. For a field where the question of the 'naturalness' of emotion and biological determinism still lingers, such comparative research can provide important insights into similarities and differences in emotional experience. It can prompt us to consider ways in which we can have conversations across borders within our field. Katie Barclay and Sharon Crozier-De Rosa offer a similar methodological discussion in their chapter on intersectional identities. The experience of emotions was shaped not just by history and culture, but by the significant social divisions that mark most times and places. Accessing the experience of emotion requires historians to take account of how social positioning provided limitations and opportunities for emotional experience and how individuals negotiated emotional norms in response to wider social structures.

The final three chapters explore important emerging topics in the field of the history of emotions, which are opening up new ways of thinking about the relationship between the body, emotion, environment and society. Sharon Crozier-De Rosa offers a survey of the history of protest, a site long associated with emotion yet where emotion was considered problematic as it conflicted with norms for 'rational' political exchange. Histories of protest however are not just interesting for the insight they offer into political change, but because they require us to consider how the emotions of the individual intersects with those of the group, even to the question of whether emotion can become contagious. Debates in this area have allowed scholars to move beyond discussions of emotional standards and individual experience to emotion as something performed and experienced by groups.

If a history of emotional protest extends the individual to the group, then Susan J. Matt's and Luke Fernandez's discussion of emotion and technology asks how technology intertwines with the individual in the production of emotion. This is a question of relevance to all historical sources, which are all a form of 'technology' through which emotion is expressed, but Matt and Fernandez also remind us how technologies can place limits on emotional experience or open up opportunities for new types of emotion. Technologies, associated with particular historic periods, are therefore a critical component of how we 'do' emotions. Our body might be considered a technology, or at least an organism that technology can enhance and extend. Mark Neuendorf's contribution turns to the body and embodiment as a key site of current analysis by historians, a source material in its own right. Here he highlights how the idea of uniformity of the body – a stable entity over time – is actually itself a topic of contest and debate that has bearing for how we understand emotion to work. Neuendorf also highlights how a scholarship of emotions is intersecting with research on the history of the senses, material culture and the self. Both of these chapters highlight how new researchers in the field might deploy insights from their discussions to analysis of their material to enable richer and more nuanced insights of how emotions are produced within particular historical contexts.

As Peter N. Stearns highlights in his Epilogue, the history of emotions is coming to maturity, yet it is still a field with plenty of gaps – especially when considered in a global context – that provide opportunities for original research for scholars at all levels. This volume offers a starting point to using sources for research in emotions history, but it is certainly not an end point. Turning an 'emotions eye' to other types of sources will no doubt enable new insights, perspectives and emotional experiences to emerge. New methodologies may open up new ways of analysing well-trodden sources, and new research findings will enliven ongoing debate in the field. This volume hopes to enable a new generation of researchers to produce this research.

**Notes**

1  For example, Hans Medick and David Warren Sabean, ed., *Interest and Emotions: Essays on the Study of Family and Kinship* (Cambridge: Cambridge University Press, 1984).
2  For a history of happiness, see Darrin M. McMahon, *Happiness: A History* (New York: Atlantic Monthly Press, 2006).
3  Winfried Menninghaus, *Disgust: Theory and History of a Strong Sensation*, transl. Howard Eiland and Joel Golb (New York: State University of New York Press, 2003).
4  For a historical survey of nostalgia, see Malcolm Chase and Christopher Shaw, eds, *The Imagined Past: History and Nostalgia* (New York: Manchester University Press. 1989), and Thomas Dodman, *What Nostalgia Was: War, Empire, and the Time of a Deadly Emotion* (Chicago: University of Chicago Press, 2018). For shame, see Peter N. Stearns, *Shame: A Brief History* (Urbana: University of Illinois Press, 2018).
5  Peter N. Stearns, *Jealousy: The Evolution of an Emotion in American History* (New York: New York University Press, 1989).
6  Jan Plamper, *The History of Emotions: An Introduction* (Oxford: Oxford University Press, 2012).
7  Lucien Febvre, 'Sensibility and History: How to Reconstitute the Emotional Life of the Past', in *A New Kind of History: From the Writings of Lucien Febvre*, ed. Peter Burke (New York: Harper & Row, [1941] 1973).
8  There are too many works to list here. However, see, for example, the work of Peter Stearns and others including: Peter N. Stearns and Carol Z. Stearns, 'Emotionology: Clarifying the History of Emotions and Emotional Standards', *The American Historical Review* 90, no. 4 (1985): 813–36; Carol Z. Stearns and Peter N. Stearns, *Anger: The Struggle for Emotional Control in America's History* (Chicago: University of Chicago Press, 1986); Stearns, *Jealousy*; Peter N. Stearns, *American Cool: Constructing a Twentieth-Century Emotional Style* (New York: New York University Press, 1994); and Peter N. Stearns and Jan Lewis, eds, *An Emotional History of the United States* (New York: New York University Press, 1998).
9  Individuals and groups of researchers working in this field have begun to collate bibliographies. See, for example, Jan Plamper's 'Bibliography' in *The History of Emotions*; and an online Bibliography that continues to be updated on the website of the Society for the History of Emotions (Australia): http://www.historyofemotions.org.au/publications-resources/, accessed 10 November 2019.
10  For example, Angelos Chaniotis, ed., *Unveiling Emotions: Sources and Methods for the Study of Emotions in the Greek World* (Stuttgart: Franz Steiner Verlag, 2012); Laurel Fulkerson, *No Regrets: Remorse in Classical Antiquity* (Oxford: Oxford

University Press, 2013); and William V. Harris, *Restraining Rage: The Ideology of Anger Control in Classical Antiquity* (Cambridge, MA: Harvard University Press, 2001).

11 See also, for example, the work of Barbara Rosenwein including: Barbara H. Rosenwein, ed., *Anger's Past: The Social Uses of an Emotion in the Middle Ages* (Ithaca: Cornell University Press, 1998); Barbara H. Rosenwein, *Emotional Communities in the Early Middle Ages* (Ithaca: Cornell University Press, 2006); and, Barbara H. Rosenwein, 'Thinking Historically about Medieval Emotions', *History Compass* 8, no. 8 (2010): 828–42.

12 These include research on topics as diverse as family and war. See, for example: Nicole Eustace, *Passion is the Gale: Emotions, Power, and the Coming of the American Revolution* (Chapel Hill: University of North Carolina Press, 2008); and Katie Barclay, *Love, Intimacy and Power: Marriage and Patriarchy in Scotland, 1650–1850* (Manchester: Manchester University Press, 2011).

13 Again there are far too many to list here. But see, for example, modern literature on the workings of shame and associated emotions through modernity, including: Deborah Cohen, *Family Secrets: Shame and Privacy in Modern Britain* (Oxford: Oxford University Press, 2013); Judith Rowbotham, Marianna Muravyeva and David Nash, eds, *Shame, Blame and Culpability: Crime and Violence in the Modern State* (Abingdon: Routledge, 2013); Stearns, *Shame* (2018); and Sharon Crozier-De Rosa, *Shame and the Anti-Feminist Backlash: Britain, Ireland and Australia, 1890–1920* (New York: Routledge, 2018). For a wide-ranging survey of emotions (including shame) in their nineteenth-century contexts, see Margrit Pernau et al., *Civilizing Emotions: Concepts in Nineteenth Century Asia and Europe* (Oxford: Oxford University Press, 2015).

14 See works from diverse regions including: Rebecca Earle, 'Letters and Love in Colonial Spanish America', *Americas* 62, no. 1 (2005): 17–46; Paolo Santangelo, *Sentimental Education in Chinese History: An Interdisciplinary Textual Research in Ming and Qing Sources* (Leiden: Brill, 2003); Monika Freier, 'Cultivating Emotions: The Gita Press and its Agenda of Social and Spiritual Reform', *South Asian History and Culture* 3, no. 3 (2012): 397–413; and, William Reddy, *The Making of Romantic Love: Longing and Sexuality in Europe, South Asia & Japan, 900–1200* (Chicago: Chicago University Press, 2012). For a recent collection of articles on emotions in urban South Asia, see *Journal of the Royal Asiatic Society* 27, no. 4 (2017), especially introductory essay, Elizabeth Chatterjee, Sneha Krishnan and Megan Eaton Robb, 'Feeling Modern: The History of Emotions in Urban South Asia': 539–57

15 For research on Africa, for example, see Kathryn M. de Luna, 'Affect in Ancient Africa: Historical Linguistics and the Challenge of "Emotions Talk"', in *Encoding Emotions in African Languages*, ed. Gian Claudio Batic (Munich: Lincom Europa, 2011): 1–11; and Kathryn M. de Luna, 'Affect and Society in Precolonial Africa', *International Journal of African Historical Studies* 46, no. 1 (2013): 123–5. For work on Islam, see, for example, Margrit Pernau, 'Male Anger and Female Malice: Emotions in Indo-Muslim Advice Literature', *History Compass* 10, no. 2 (2012): 119–28.

16 For example: Paolo Santangelo, 'Evaluation of Emotions in European and Chinese Traditions: Differences and Analogies', *Monumenta Serica* 53 (2005): 401–27; and Joseph Ben Prestel, *Emotional Cities: Debates on Urban Change in Berlin and Cairo, 1860–1910* (Oxford: Oxford University Press, 2017)

17 This work is emerging. See, for example: Thomas C. Buchanan, 'Class Sentiments: Putting the Emotion Back in Working-Class History', *Journal of Social History* 48, no. 1 (2014): 72–87. See also the 'Intersectional Identities' chapter in this volume.

18  See, for example, emerging research into emotions and farming and drought in rural Australia: Rebecca Jones, 'Uncertainty and the Emotional Landscape of Drought', *International Review of Environmental History* 4, no. 2 (2018): 13–26.
19  Many of the contributors to this volume work explicitly on the relationship between gender and emotion. For example, see Katie Barclay, *Men on Trial: Performing Emotion, Embodiment and Identity in Ireland, 1800–1845* (Manchester: Manchester University Press, 2019) and Crozier-De Rosa, *Shame and the Anti-Feminist Backlash*.
20  For 'emotional communities', see Rosenwein, *Emotional Communities in the Early Middle Ages* (2006). For 'emotional regimes', see William M. Reddy, *The Navigation of Feeling: A Framework for the History of Emotions* (Cambridge: Cambridge University Press, 2001). To understand emotions as a 'practice', see Monique Scheer, 'Are Emotions a Kind of Practice (and is That What Makes Them Have a History)? A Bourdieuian Approach to Understanding Emotion', *History & Theory* 51, no. 2 (2012): 193–220.
21  For a longer discussion of these theories see: Katie Barclay, *The History of Emotions: A Student Guide to Methods and Sources* (Basingstoke: Palgrave Macmillan, 2020).
22  Darrin McMahon, 'Finding Joy in the History of Emotions', in *Doing Emotions History*, ed. Susan J. Matt and Peter N. Stearns (Urbana: University of Illinois Press, 2014), 103–19.
23  Fay Bound Alberti, 'This "Modern Epidemic": Loneliness as an Emotion Cluster and a Neglected Subject in the History of Emotions', *Emotions Review* 10, no. 3 (2018): 242–54.
24  For example, work has been carried out on the history of gratitude within religious cultures: Stephen C. Berkwitz, 'History and Gratitude in Theravāda Buddhism', *Journal of the American Academy of Religion* 71, no. 3 (2003): 579–604.
25  Some groundbreaking work on the history of fear includes: Joanna Bourke, *Fear: A Cultural History* (Berkeley: Shoemaker & Hoard, 2006); and Peter N. Stearns, *American Fear: The Causes and Consequences of High Anxiety* (New York: Routledge, 2006).
26  For an example of how popular novels can be used to access the emotions of the past, see Sharon Crozier-De Rosa, 'Popular Fiction and the "Emotional Turn": The Case of Women in Late Victorian Britain', *History Compass* 8, no. 12 (2010): 1340–51.
27  Another useful volume that provides insights into sources is Susan Broomhall, ed., *Early Modern Emotions: An Introduction* (London: Routledge, 2016).

# 2 Theories and methods in the history of emotions

*Thomas Dodman*[1]

Like other emergent fields of scholarship, the history of emotions has its heroic tale of becoming and cast of leading characters. The story typically goes something like this. In the beginning, there were solitary pioneers who, ahead of their time, laid the field's foundations. Among these were the Dutch cultural historian Johan Huizinga, for his classic portrait of the 'violent tenor of medieval life'; the German sociologist Norbert Elias, whose monumental study *The Civilizing Process* (first published in 1939 but only rediscovered in the 1970s) provided a grand narrative for the regulation of emotions in the modern era; and the French historian Lucien Febvre, founder of the *Annales*, who in 1941 famously wrote: 'Sensibility and history – a new subject: I know of no book that deals with it.'[2] Febvre's call for a historical psychology made few converts at the time but fed into *histoire des mentalités*, or the attempt to grasp the 'mental equipment' ('*outillage mental*') and collective psychology of a given epoch. As the great medievalist Jacques Le Goff candidly confessed, *mentalités* was an ambiguous concept that seduced first and foremost because of its lack of precision.[3] For a while, the study of affective life strictly speaking remained the work of mavericks such as Alain Corbin, whose history of the senses blossomed into its own at the margins of the *Annales* school.[4] Like all coming-of-age stories, that of the history of emotions has its structural impediments (a discipline by and large allergic to the topic) and false dawns (like psychohistory, briefly in vogue in the 1970s but since become bogeyman to warn historians against dabbling with psychoanalysis).[5] Maturation only arrived at the turn of the twenty-first century and is generally associated with the efforts of three American scholars – Peter Stearns, William Reddy, Barbara Rosenwein – and the key concepts they forged: 'emotionology', 'emotives' and 'emotional communities'. By the early 2000s, publications, conferences, research centres, book series and journals dedicated to the history of emotions were mushrooming across the globe. A decade later, with the field institutionalised and begrudgingly accepted by a growing number of historians, it was already time to take stock and think about what lay ahead.[6]

This narrative of sorts can be retold as an account of the conditions of possibility (or of 'emergence') for a new field of scholarship, and of the interdisciplinary crossover that enabled it. Huizinga, Elias and Febvre wrote in the midst of the two world wars and the rise of Nazism, a dark backdrop

that helps explain their interest in 'contagious' emotions such as fear, anger and hate. To understand these, Febvre pleaded with his colleagues to familiarise themselves with the work of psychologists and anthropologists on 'collective' and 'primitive' emotions. To those who dismissed this as 'empty talk', he retorted that 'such empty talk [...] will tomorrow have finally made our universe into a stinking pit of corpses'.[7] Febvre's sense of urgency echoes in contemporary portrayals of our (renewed) 'age of anger' and populist politics of resentment and nostalgia. Arguably, it was a widespread sense of anxiety – in the wake of the 11 September 2001 attacks among other things – that acted as catalyst to what has been dubbed the 'affective turn' of the 2000s across the humanities and social sciences.[8] As Jan Plamper has argued, this turn was driven by the bio-revolution that elevated the life sciences on a pedestal (and the neoliberal capitalism that financed it).[9] These developments may well have contributed to a crisis in the humanities, but talk of the body and the brain was music to the ears of many cultural historians tired of postmodern uncertainties and linguistic reductionisms. The history of emotions came of age in this neo-empiricist moment. Few sought (or at least claimed) to write history 'as it really *felt*', but they insisted on viewing emotions as historical objects that left identifiable traces and clues. Of course, emotions were *not* historical sources just like any other: by their very nature they were evanescent and posed a set of epistemological (and, indeed, ontological) questions requiring theoretical work. The conceptual and methodological scaffoldings for the field would come from interdisciplinary poaching among disciplines with more long-standing investments in the topic.

## Defining the field

Historians of emotions rarely have the ambition to define what emotions are – a task that has mobilised and befuddled philosophers, psychologists and anthropologists for millennia. The psychological study of emotions has for a long time been wedded to the idea of their biological, evolutionary, and thus universal nature. This tradition typically points back to Charles Darwin's research in the mid-nineteenth century and attempts to capture the expression of emotions on photographs and drawings.[10] Although Darwin's findings were ambiguous (and lent themselves to quite different readings), the research protocol was appropriated in the 1960s by Paul Ekman, who used facial recognition experiments to 'prove' the existence of 'basic emotions' across all cultures (how many there are has varied over the years, ranging between six and a dozen). Ekman's model suffered from glaring problems in both its methods and extrapolations, but nonetheless reached paradigmatic status among psychologists, policy makers and the wider public.[11]

Behind the idea of 'basic emotions' lay the notion of 'affect', first defined by another psychologist, Silvan S. Tomkins, as an evolutionary motivation mechanism that pre-existed emotions and that operated beneath the threshold of consciousness (it reacted autonomically to stimuli).[12] Affect theory was, in some ways, a reworking of another classic late nineteenth-century theory of

emotions – the so-called James–Lang theory, initially formulated by William James – which postulated the primacy of bodily physiological arousal over cognitive processes (in short: we do not cry because we feel sad, but feel sad because made to cry).[13] Tomkins and his followers also reacted against the ideas of cognitive psychologists, who rejected 'stimulus-response' models in favour of 'appraisal' ones. Emotions, cognitivists contended, were the result of perception and appraisal, and thus most often (though not necessarily) of a cognitive operation. The evaluative element of appraisal models harked back to Aristotelian thinking about emotions as deliberative rhetorical categories; it also pointed forward to attempts to overcome the well-entrenched reason/emotion divide with notions of 'cogmotion' or 'affective intelligence'.[14] By the 1990s, the emergence of neuroscience promised to swipe the slate clean as functional magnetic resonance imaging provided a window of sorts into the brain (or at least onto neuronal activity as measured by oxygen content in blood vessels within the brain). Affective neuroscientists accorded prime importance to emotions, understood as bodily reactions to stimuli that play into our decision-making processes. To prove this, they zeroed in on the workings of the amygdala, somatic markers in the prefrontal cortex, or mirror neurons in the premotor cortex, prompting a 'neural' frenzy across and beyond academia.[15]

For obvious reasons, historians have by and large kept their distance from these psychological efforts to portray universal human responses. To put it simply, unchanging, basic emotions hard-wired by evolutionary processes go against the very idea of a *history* of emotions. Unlike literary scholars, historians have also resisted the sirens of affect theory, whether because of its anti-intentionalism or propensity to theoretical jargon.[16] The turn to biology and neuroscience, on the other hand, has elicited more excitement, opening for some the prospect of a 'neurohistory' (or the factoring of neurochemical processes into our accounts of historical experience).[17] It has also provoked much pushback, as most historians stick to tried and tested social constructivist positions. Drawing from ethnographic research in non-Western cultures, cultural anthropologists have long argued that facial expressions are not universal but culturally specific. At the height of the linguistic turn, they went so far as to claim that raw feelings themselves were socially constructed. As Catherine Lutz famously put it, 'emotional experience is not precultural but pre-*eminently* cultural'.[18] Sociologists, for their part, have worked on the many ways in which emotions mediate power relations in society: in the 'emotional labour' required of flight attendants and other service sector employees to bring their feelings in line with professional expectations; the regulation of emotions under capitalism; or the power of affect to mobilise collective action behind social causes.[19] For all these social scientists, it goes without saying that emotions are not simply organic processes contained within the envelope of an individual body; they are both products and constituents of social relations within a determinate historical context.

The gap between universalist and social constructivist understandings of emotions frames the first of several theoretical tensions confronting any history of emotions: that between emotion and reason (or nature and nurture). Since long before C.P. Snow lamented the separation of 'two cultures' (sciences and humanities), 'Western' societies have tended to oppose emotions and reason, relegating the former to the innate and the primitive, that is beyond (or rather, beneath) the scope of the study of culture and society.[20] For a long time, historians happily followed suit, implicitly endorsing the view of human beings as rational choice actors. Tellingly, even Huizinga and Febvre understood emotions to be irrational, childish expressions of uncivilised behaviour. It took another kind of maverick in Raymond Williams to propose, in the mid-1970s, the notion of 'structures of feeling' as a way of grasping 'not feeling against thought, but thought as felt and feeling as thought'.[21] A decade later, an aging Norbert Elias placed emotions at the heart of a unitary and resolutely processual science of Man in permanent becoming. He hypothesised that the human species constituted an evolutionary breakthrough insofar as it was biologically predisposed to (and dependent for its survival on) socialised learning. Adapting Aristotle, Elias provocatively suggested that it was emotions (rather than speech) that showed how 'human being are by nature constituted for … life in society'.[22] The reason/emotion rift has also come under attack in rhetoric and philosophy, most eloquently in Martha Nussbaum's neo-stoic argument for viewing emotions as cognitive operations central to personal flourishing and ethical judgement.[23] It is increasingly questioned in the life sciences as well, whether among psychologists interested in the social construction of 'situated' emotions, social neuroscientists working on brain plasticity, or epigenesists intent on showing how changing environmental factors can determine gene expression, without actually altering the DNA sequence itself (for example with the intergenerational transmission of trauma).[24]

There are two other tensions, related and derived from this basic issue, that agitate the sleep of historians of emotions: the relationship between the inner experience and outer expression of emotion, and that between the individual and the collective. Unlike ethnographers or neuroscientists, historians cannot embed themselves in a community or scan the brain of a patient to get at some sort of raw emotional data. They rely on semiotic mediations of various kinds, but primarily the language used to express feelings. Hence the importance of close reading, interpreting silences, and translation from one context to another (a particularly thorny problem when it comes to exploring emotions before they even 'existed' as such, or were thought of as 'emotions').[25] From these traces historians can try to work their way back to an actual subjective experience of emotion or forward to what these expressions reveal (for example about reigning codes of conduct in a given time and place). These metaphors of movement are a useful heuristic, but they are equally deceptive, insofar as one of the key challenges of the field has been to overcome the problematic distinction between a (natural) bodily emotion and its (cultural) manifestation and reception. As we will now see, historians of emotions

have used theories of practice and performativity to overcome this divide, thinking the individual as socialised and the experience/expression of emotion as inseparable facets of an ongoing process of making meaning.

## New concepts

In 1985, Peter N. Stearns and Carol Zisowitz Stearns provided the history of emotions with a new analytical category – 'emotionology' – and its first programmatic statement since Febvre's call to arms half a century earlier.[26] Bracketing the subjective experience of emotions, emotionology focused on grasping the rules and standards that governed emotional life at a given time and in a given society or social group. It fitted squarely within the Elias paradigm of encroaching emotional restraint in modernity, and drew from Arlie Hochschild's concept of 'emotion work' to understand how institutions such as schools or the family both reflected and reinforced emotional norms.[27] Stearns and Stearns viewed mapping out the 'emotionological context' and its gradual variations as a prerequisite to understanding how people could make sense of their emotional lives and what motivated them to act in a certain way. They deployed this programme of research in a series of influential studies on anger, jealousy and 'being cool' (dubbed an emotional 'style') among others, typically amassing voluminous evidence from advice literature among other sources and then measuring its impact in ego documents.[28] Slightly ahead of its time and at odds with the recentring of the profession on the self, emotionology failed to anchor the field as such but left a durable imprint on the way in which historians have come to appreciate the social and political 'managing' of emotions.

Viewing emotions through a social lens was also central to the study of 'emotional communities', the programme of study launched by Barbara Rosenwein in an equally influential article published in 2002.[29] A medievalist, Rosenwein rejected two central planks to the modernist 'grand narrative' of emotions as it had developed over the course of the twentieth century: the image of the Middle Ages as a kind of childish or primitive society, serving as a foil to the modern civilising process; and a hydraulic model of emotions as irrational outbursts distinct from reason that underpinned this narrative. Taking her distances from emotionology and what she perceived as overly political analyses of emotional norms, she instead sought to capture the nuances and sophistication of medieval emotional life, paying attention to complex emotional vocabularies used by historical actors to express shared feelings. These forged 'emotional communities', loosely defined as 'groups in which people adhere to the same norms of emotional expression and value – or devalue – the same or related emotions'.[30] Crucially, multiple emotional communities coexisted and overlapped at any given moment, allowing people to move between them, forge news ties, re-purpose emotions in new environments and, ultimately, precipitate historical change.[31]

Rosenwein emphasised the fluidity of 'emotional communities' in part to distinguish the notion from that of 'emotional regimes' advanced a few years earlier by William Reddy as part of his attempt to provide the history of emotions with a comprehensive conceptual and methodological framework. Reddy sought to move beyond the limitations of both social constructivism and psychological universalism, and bridge the divide between inner feelings and outer expression. To do so, he turned to speech act theory and adapted the distinction drawn by John L. Austin between constative and performative utterances.[32] Emotional gestures (for example crying) or statements such as 'I love you', Reddy argued, are not merely descriptive; they are also performative and self-reflexive, in that they *affect* both the interlocutor *and* the speaker, intensifying, moderating or displacing their feelings as the case may be (they have, in other words, 'self-exploratory' and 'self-altering' effects). Reddy called these emotional statements 'emotives'. He further defined 'emotional regimes' as the set of emotional norms that emotives and other inculcated practices prescribed in a given political regime. It could be relatively loose, allowing for more 'emotional freedom', or strict, causing much 'emotional suffering' to those unable to align their emotions with expected standards. In such cases, people might seek 'emotional refuge' in spaces that escaped the reigning emotional prescriptions.[33]

Reddy's conceptual scaffold for the history of emotions is the most sophisticated proposed to date and comes, tellingly, from a historian equally at ease in a department of anthropology and discussing cognitive psychology or neuroscientific research. It bridges the nature/nurture and individual/social divides, placing emotions firmly within a relational network. In doing so, it upends the distinction between 'authentic' inner experience and 'staged' outer expression, dissolving the two into an ongoing and unstable process of emotional navigation. In *The Navigation of Feeling*, Reddy sought to apply this groundwork to offer a novel understanding of the French Revolution and its aftermath. Throughout this period, people learnt how to 'navigate' changing emotional regimes and challenge those that caused them too much suffering. Without convincing in all its claims, this book can be said to have shown how the history of emotions could both identify a new object of study and exploit it to account for historical change.

## New directions

Reddy's seminal work has acted as a catalyst for further theorisation in the field, in particular with regard to emotional 'practices', 'translations' and 'encounters' in a decentred, global context. In an important article from 2012, Monique Scheer brings into dialogue Extended Mind Theory (EMT) and Pierre Bourdieu's theory of practice to define 'emotional practices' that are both of the mind and of the body.[34] They are embodied not merely because of physiological processes, but because of the inculcation of durable dispositions that are then reproduced as a form of habit. The body is kneaded with multiple,

at times contradictory social structures and emotions arise from this incorporated bodily knowledge.[35] Scheer distinguishes among four kinds of emotional practices: ones that mobilise or generate feeling; that name or re-purpose emotions; that communicate feelings to others; and that regulate emotions (where norms are not just limits to emotional expression, but the social conditions of subjectivity itself). Compared to Reddy, Scheer places emphasis on physical gestures and the physicality that transpires from discourse. The study of emotional practices offers interesting perspectives to historians working with limited written sources (such as pre-modern topics) and on the reproduction of emotional dispositions (such as violent habits acquired in a colonial context and reproduced elsewhere).[36] By looking to material culture, it opens up possible dialogues with New Materialists who insist on taking seriously the materiality of objects – for example how these become 'sticky' and implicate people in relations of affect and power.[37] Arguably, emotional practices also point to renewed engagement with psychoanalysis – not with the reductionist explanations offered by psychobiography, but rather with psychoanalysis's attentiveness to the multiple temporalities of our affective life and how it exceeds the conscious self (for instance in fantasies or automatic gestures).[38]

The notion of 'emotional practices' has recently been expanded by Margrit Pernau to account for 'emotional translations' – that is for the affective dimension to the constant operations of translation that we engage in in our daily interaction with the world. Like Scheer, Pernau is interested not only in language, but also in translations mediated by the body, the senses and multimedia experiences.[39] She takes cue from recent developments in translation studies towards an understanding of translation as an unstable act that creates equivalents between languages (rather than 'find' pre-existing equivalents). She also pays renewed attention to anthropological studies of cultural and emotional difference to promote the study of 'emotional encounters', or the attempt to expand the study of emotional concepts and practices to a transnational framework better attuned to the current global orientations of the profession.

The history of emotions has thus far been a largely European and North Atlantic affair (duly reflected in this article), but its (de)provincialising moment beckons on the horizon. Reddy has recently adapted his theoretical framework to develop a comparative analysis of love and sexuality in Europe and Asia in the eleventh and twelfth centuries.[40] Pernau and others have started exploring the specificities of 'feeling communities' in South Asian history and reassessing moments of 'emotional encounter' both within imperial networks and between non-Western regions.[41] The extent to which emotions can be factored into 'connected histories' and in 'equal parts' – that is, with symmetric documentative 'dignity' – is an open question that forces historians not only to expand their linguistic and interdisciplinary competence, but revisit assumptions about what sources are at their disposal.[42] Ego documents such as letters and diaries may well do for Europeans in the modern era; they will not necessarily in a time and place where emotions are

22    *Thomas Dodman*

viewed as fundamentally social rather than individual acts. As the field moves away from Western norms and logocentrism, non-Western perspectives on emotion are likely to alter its methodological protocols as well.

## Notes

1 I wish to thank the volume editors and members of the Weill Cornell psycho-analysis working group, particularly Dagmar Herzog and Jonas Knatz, for helpful feedback on an earlier draft.
2 Johan Huizinga, *The Autumn of the Middle Ages* (Chicago: University of Chicago Press, [1921] 1997); Norbert Elias, *The Civilizing Process: Sociogenetic and Psychogenetic Investigations* (Oxford: Blackwell, [1939] 2010); and Lucien Febvre, 'Sensibility and History: How to Reconstitute the Emotional Life of the Past', in *A New Kind of History: From the Writings of Lucien Febvre*, ed. Peter Burke (New York: Harper & Row, [1941] 1973), quote at 12.
3 Jacques Le Goff, 'Les mentalités. Une histoire ambiguë', in *Faire de l'histoire, vol 3: Nouveaux objets*, ed. Jacques Le Goff and Pierre Nora (Paris: Gallimard, 1974), 79.
4 For an overview of Corbin's oeuvre, see Sima Godfrey, 'Alain Corbin: Making Sense of French History', *French Historical Studies* 25, no. 2 (Spring 2002): 381–98. See also Alain Corbin, Jean-Jacques Courtine and Georges Vigarello, *Histoire des émotions*, 3 vols (Paris: Editions du Seuil, 2016–17).
5 Psychohistory's principal figures were Peter Gay, Lloyd de Mause and Peter Loewenberg. The (partly) stereotypical image of psychohistory is that it sought to reduce all historical actors' motivations to unresolved childhood psychological conflicts.
6 For some introductions to the field that grapple extensively with its theoretical and methodological challenges, see Jan Plamper, *The History of Emotions: An Introduction* (Oxford: Oxford University Press, 2012); Susan Matt and Peter N. Stearns, eds, *Doing Emotions History* (Urbana: University of Illinois Press, 2013); Barbara Rosenwein and Riccardo Cristiani, *What Is the History of Emotions?* (Cambridge: Polity, 2018); and Rob Boddice, *The History of Emotions* (Manchester: Manchester University Press, 2018).
7 Febvre, 'Sensibility', 26.
8 Patricia T. Clough and Jean Hally, eds, *The Affective Turn: Theorizing the Social* (Durham: Duke University Press, 2007). The first signs of an 'emotional turn' could already be detected in the 1980s, particularly in the work of cultural anthropologists. See Catherine Lutz and Geoffrey M. White, 'The Anthropology of Emotions', *Annual Review of Anthropology* 15 (1986): 405–36.
9 Plamper, *History of Emotions*, 59–63, 240, and *passim*.
10 Charles Darwin, *The Expression of the Emotions in Man and Animals*, 3rd edn, ed. by Paul Ekman (Oxford: Oxford University Press, [1872] 1998).
11 For the original formulation see Paul Ekman and Wallace V. Friesen, 'Constants across Cultures in the Face and Emotion', *Journal of Personality and Social Psychology* 17, no. 2 (1971): 124–29; and for a list of further readings and successful derivative products, <www.paulekman.com>. For one of several devastating critiques of Ekman's methodology and extrapolations, see James A. Russell, 'Is there Universal Recognition of Emotion from Facial Expression? A Review of the Cross-Cultural Studies', *Psychological Bulletin* 115, no. 1 (1994): 102–41. Daniel M. Gross argues for a different take on Darwin's pioneering work in *Uncomfortable Situations: Emotion between Science and the Humanities* (Chicago: University of Chicago Press, 2017), 28–51.

12 Silvan S. Tomkins, 'Affect Theory', in *Approaches to Emotion*, ed. by Klaus R. Scherer and Paul Ekman (Hillsdale, NJ: L. Eribaum Associates, 1984), 163–95.
13 William James, 'What is an Emotion?' *Mind* 9 (1884): 188–205.
14 For initial statements and recent surveys of appraisal theory, see Magda B. Arnold, *Emotion and Personality, vol. 1: Psychological Aspects* (New York: Columbia University Press, 1960); and Agnes Moors, Phoebe C. Ellsworth, Klaus R. Scherer and Nico H. Frijda, 'Appraisal Theories of Emotion: State of the Art and Future Development', *Emotion Review* 5, no. 2 (2013): 119–24. 'Cogmotion' comes from Douglas Barnett and Hilary H. Ratner, 'The Organization and Integration of Cognition and Emotion in Development', *Journal of Experimental Child Psychology* 67, no. 3 (1997): 303–16.
15 Keeping abreast of research in affective neuroscience is difficult such is its sheer output. For two recent syntheses, see Tim Dalgleish, Barnaby D. Dunn and Dean Mobbs, 'Affective Neuroscience: Past, Present, and Future', *Emotion Review* 1, no. 4 (2009): 355–68; and Ralph Adolphs and David J. Anderson, *The Neuroscience of Emotion: A New Synthesis* (Princeton: Princeton University Press, 2019). Some influential popularisations are: Antonio Damasio, *Descartes' Error: Emotion, Reason, and the Human Brain* (New York: Putnam, 1994); Joseph E. LeDoux, *The Emotional Brain: The Mysterious Underpinnings of Emotional Life* (New York: Simon & Schuster, 1996); Jaak Panskepp, *Affective Neuroscience: The Foundations of Human and Animal Emotions* (Oxford: Oxford University Press, 1998); and Marco Iacoboni, *Mirroring People: The New Science of How Connect with Others* (New York: Farrar, Strauss, and Giroux, 2008). For a sweeping critical assessment of neuroscience and of the 'neural-turn', see Fernando Vidal and Francisco Ortega, *Being Brains: Making the Cerebral Subject* (New York: Fordham University Press, 2017).
16 A useful introduction to affect theory is Melissa Gregg and Gregory J. Seigworth, eds, *The Affect Theory Reader* (Durham: Duke University Press, 2010). For a trenchant critique of affect theory, affective neuroscience and basic emotions, see Ruth Leys, *The Ascent of Affect: Genealogy and Critique* (Chicago: University of Chicago Press, 2017).
17 Daniel Lord Smail, *On Deep History and the Brain* (Berkeley: University of California Press, 2008); Lynn Hunt, *Inventing Human Rights* (New York: Norton, 2008); and Rob Boddice, 'Neurohistory', in *Debating New Approaches to History*, ed. by Marek Tamm and Peter Burke (London: Bloomsbury Academic, 2019), 301–12. See also the roundtable 'History meets Biology' in *The American Historical Review* 115, no. 5 (2014); and critical assessments by William Reddy, 'Neuroscience and the Fallacies of Functionalism', *History and Theory* 49, no. 3 (2010): 412–25; and Ethan Kleinberg, 'Just the Facts: The Fantasy of a Historical Science', *History of the Present* 6, no. 1 (2016): 87–103.
18 Catherine A. Lutz, *Unnatural Emotions: Everyday Sentiments on a Micronesian Atoll and their Challenge to Western Theory* (Chicago: University of Chicago Press, 1988), 5. See also Lila Abu-Lughod, *Veiled Sentiments: Honor and Poetry in a Bedouin Society* (Berkeley: University of California Press, 1986).
19 Arlie Russell Hochschild, *The Managed Heart: Commercialization of Human Feeling* (Berkeley: University of California Press, 1983); Eva Illouz, *Cold Intimacies: The Making of Emotional Capitalism* (Cambridge: Polity, 2007); Jeff Goodwin, James M; Jasper and Francesca Polletta, eds, *Passionate Politics: Emotions and Social Movements* (Chicago: University of Chicago Press, 2001); Deborah Gould, *Moving Politics: Emotion and ACT UP's Fight against AIDS* (Chicago: University of Chicago Press, 2009)
20 C. P. Snow, *The Two Cultures and the Scientific Revolution* (New York: Cambridge University Press, 1961).

21  Raymond Williams, *Marxism and Literature* (Oxford: Oxford University Press, 1977), 132.
22  Norbert Elias, 'On Human Beings and their Emotions: A Process-Sociological Essay', *Theory, Culture and Society* 4 (1987), quote at 361.
23  Martha C. Nussbaum, *Upheavals of Thought: The Intelligence of Emotions* (Cambridge: Cambridge University Press, 2001); and Daniel M. Gross, *The Secret History of Emotion: From Aristotle's 'Rhetoric' to Modern Brain Science* (Chicago: University of Chicago Press, 2006).
24  On psychological constructionism, see Lisa Feldman Barrett and James A. Russell, eds, *The Psychological Construction of Emotion* (New York: Guilford, 2015); and Maria Gendron and Lisa Feldman Barrett, 'Emotion Perception as Conceptual Synchrony', *Emotion Review* 10, no. 2 (2018): 101–10. Epigenesists explore chemical processes that alter gene expression (such as DNA methylation) both in laboratory experiments and try to extrapolate from real-life case studies as well, for example in the intergenerational effects of malnutrition of trauma on given populations. For a useful introduction to current research, see Margaret Lock and Gisli Palsson, *Can Science Resolve the Nature/Nurture Debate?* (Cambridge: Polity, 2016).
25  For works that tackle the historicity of emotion categories head on, see Thomas Dixon, *From Passions to Emotions: The Creation of a Secular Psychological Category* (Cambridge: Cambridge University Press, 2003); Ute Frevert, *Emotions in History: Lost and Found* (Budapest: Central European University Press, 2011); and Thomas Dodman, *What Nostalgia War: War, Empire, and the Time of a Deadly Emotion* (Chicago: University of Chicago Press, 2018).
26  Peter N. Stearns and Carol Z. Stearns, 'Emotionology: Clarifying the History of Emotions and Emotional Standards', *The American Historical Review* 90, no. 4 (1985): 813–36.
27  Arlie Hochschild, *Managed Heart*; and 'Emotion Work, Feeling Rules, and Social Structure', *American Journal of Sociology* 85, no. 3 (1979): 551–75.
28  Carol Z. Stearns and Peter N. Stearns, *Anger: The Struggle for Emotional Control in America's History* (Chicago: University of Chicago Press, 1986); Peter N. Stearns, *Jealousy: The Evolution of an Emotion in American History* (New York: New York University Press, 1989); and *American Cool: Constructing a Twentieth-Century Emotional Style* (New York: New York University Press, 1994).
29  Barbara H. Rosenwein, 'Worrying about Emotions in History', *The American Historical Review* 107, no. 2 (2002): 821–45. See also her 'Problems and Methods in the History of Emotions', *Passions in Context: Journal of the History and Philosophy of the Emotions* 1, no. 1 (2010), https://www.passionsincontext.de/index.php/?id=557.
30  Barbara H. Rosenwein, *Emotional Communities in the Early Middle Ages* (Ithaca: Cornell University Press, 2006), 2. The concept owes to Benedict Anderson' notion of national 'imagined communities'. Benedict Anderson, *Imagined Communities: Reflections on the Origins and Spread of Nationalism* (London: Verso, 1983).
31  Barbara H. Rosenwein, *Generations of Feeling: A History of Emotions (600–1700)* (Cambridge: Cambridge University Press, 2015).
32  J. L. Austin, *How to do Things with Words*, 2nd edn (Cambridge, MA: Harvard University Press, 1975).
33  Reddy first articulated his theory in 'Against Constructivism: The Historical Ethnography of Emotions', *Current Anthropology* 38, no. 3 (1997): 327–51; developed it fully in his landmark study *The Navigation of Feeling: A Framework for the History of Emotions* (Cambridge: Cambridge University Press, 2001), esp. 96–137; and has offered partial revisions since, for instance in *The Making of Romantic Love: Longing and Sexuality in Europe, South Asia & Japan, 900–1200 BC* (Chicago: University of Chicago Press, 2012).

34 Monique Scheer, 'Are Emotions a Kind of Practice (And Is that What Makes Them Have a History)? A Bourdieuian Approach to Understanding Emotions', *History and Theory* 51, no. 2 (2012): 193–220.

35 In his later works Bourdieu increasingly came to acknowledge the importance of psychology and emotions in understanding people's 'cleft' (or 'divided') habitus. See Pierre Bourdieu, *Pascalian Meditations* (Palo Alto: Stanford University Press, 2000).

36 On Ancient emotions, see Angelos Chaniotis, ed., *Unveiling Emotions: Sources and Methods for the Study of Emotions in the Greek World* (Stuttgart: Franz Steiner Verlag, 2012). On intimacy in colonial power relations, see Anne Laura Stoler, *Carnal Knowledge and Imperial Power: Race and the Intimate in Colonial Rule* (Berkeley: University of California Press, 2002). The relation between colonial and domestic violence in German history has been explored, among others, by Isabel V. Hull, *Absolute Destruction: Military Culture and the Practices of War in Imperial Germany* (Ithaca: Cornell University Press, 2005); and Geoff Eley and Bradley Naranch, eds, *German Colonialism in a Global Age* (Durham: Duke University Press, 2014).

37 See, for example, Sarah Ahmed, *The Cultural Politics of Emotion* (Edinburgh: Edinburgh University Press, 2004) and, for a useful guide, Katie Barclay, 'New Materialism and the New History of Emotions', *Emotions: History, Culture, Society* 1, no. 1 (2017): 161–83.

38 For more open-ended attempts to incorporate psychoanalysis into historical research attentive to emotional life, see Lyndal Roper, *Oedipus and the Devil: Witchcraft, Religion and Sexuality in Early Modern Europe* (London: Routledge, 1994); Michael Roper, *The Secret Battle: Emotional Survival in the Great War* (Manchester: Manchester University Press, 2009); and Joan W. Scott, 'The Incommensurability of History and Psychoanalysis', *History and Theory* 51, no. 1 (2012): 63–83.

39 Margrit Pernau and Imke Rajamani, 'Emotional Translations: Conceptual History Beyond Language', *History and Theory* 55, no. 1 (2016): 46–65. For a different take on emotion translation that recognises the existence of a culturally universal metalanguage, see Anna Wierzbicka, 'Language and Metalanguage: Key Issues in Emotion Research', *Emotion Review* 1, no. 3 (2009): 3–14.

40 Reddy, *Romantic Love.*

41 Margrit Pernau, guest editor, Special Issue on Feeling Communities in *The Indian Economic & Social History Review* 54, no. 1 (2017); and Benno Gammerl, Philippe Nielsen and Margrit Pernau, eds, *Encounters with Emotions: Negotiating Cultural Differences since Early Modernity* (New York: Berghahn, 2019). A classic and hotly debated instance of such emotional encounter would be that between Hawaiians and Captain Cook in the late eighteenth century. See Gananath Obeyesekere, *The Apotheosis of Captain Cook: European Mythmaking in the Pacific* (Princeton: Princeton University Press, 1992); and Marshall Sahlins, *How 'Natives' Think: About Captain Cook, for Example* (Chicago: University of Chicago Press, 1995).

42 On connected histories and history 'in equal parts', see in particular Sanjay Subrahmanyam, *Explorations in Connected History*, vol. 1: *From the Tagus to the Ganges*, and vol. 2: *Mughals and Franks* (Oxford: Oxford University Press, 2012); and Romain Bertrand, *L'Histoire à parts égales: Récits d'une rencontre Orient-Occident (XVIe–XVIIe siècle)* (Paris: Éditions du Seuil, 2011).

# 3 The practice and ethics of the history of emotions

*Katie Barclay*

The history of emotions explores how people expressed, experienced (felt) and practised emotions in their daily lives. To access this, historians draw on a wide range of source material, explored in this volume, and historical methodologies, approaches designed to help interpret source material with greater sophistication and nuance (see especially Chapter 2). Like all forms of knowledge-making, writing a history of emotions raises a range of ethical dilemmas, practical problems and implications for the present. Producing rigorous and ethical histories requires historians to reflect on these issues when producing research. This chapter offers an introduction to some of the key questions that arise for emotions historians as we conduct research. This chapter particularly explores problems that arise for historians working in an interdisciplinary field and one which focuses on the body; it then highlights some ethical considerations of a topic that at least in the twentieth century was imagined as 'private'; and finally it explores the emotions of the historian, suggesting that our feelings too might matter for the histories that we write.

From at least the eighteenth century, historians in the West have argued about the practice of history, and particularly the role of emotion within it. Whilst some of the more famous forefathers of the discipline argued for the importance of analysing the past with rationality and objectivity, others sought to make the case for empathetic engagements with historical subjects, as critical to nuanced readings and interpretation.[1] For most of the nineteenth and much of the twentieth century, that history should be an objective profession was the dominant approach in the discipline, yet one that was often used to exclude certain types of scholar – objectivity was not thought to be possible for women, the working class, people of colour or other minorities, either due to ideas about their innate 'emotionality' or as they were thought to have vested interests that middle-class, largely white, men did not.[2]

More recently, particularly following the post-structuralist turn in the 1990s, whether 'objective' history either is possible or desirable has increasingly been questioned. This is not to reject disciplinary norms around rigour, analysis or the nature of evidence, but to ask whether a rejection of emotion is possible for analysis and also how we might harness alternative approaches to source material in interpretation. Moving forward from strict objectivity,

historians have sought to reflect on the multiple and diverse subjectivities involved in the production of historical sources and contemporary histories, and to incorporate such perspectives in their analytical approach. To do this, we have looked beyond the traditional tools of the field to anthropology, sociology and other disciplines where the researcher–subject relationship has been more often foregrounded. If early work in this area sought to find space for the 'subject' – the person and how they shaped sources and scholarship – the 'emotional subject' is now of increased interest, as we seek to recognise how emotion shapes our engagements with the past.

Critiques of objectivity have been critical in shaping our relationship with source material. One of the important benefits has been to open up the range of sources available to historians for analysis. Historically, records produced by institutions and bureaucracies, or as part of administrative processes, were viewed as less 'biased' than others. Those produced by individuals for their own purposes – letters, diaries, autobiographies – and later oral histories caused anxieties for scholars seeking to remove emotion from the profession. Historians had to develop mechanisms for extracting 'truth' from the personal, from the subjective perspective of the person who made the source. More recently, the concept of 'bias' has both reduced in use – we no longer use the term – and expanded in its analytical purchase. Historians now recognise that almost all sources are produced by humans, or at least made relevant to history through human attention, and so understanding who made them, who kept them and why is critical to understanding how to interpret them. This is also true of institutional records, which are not 'neutral' but reflect the concerns and interests of organisations and the people who work for them. Indeed, as an increasing scholarship on institutional, legal and similar organisational records now shows, emotions and personal interests are found in all types of material. We might need a variety of methods for interpreting different types of sources, but the underlying principle that all sources reflect various forms of subjectivity is now a central principle of historical research. This chapter places the subjectivities of the historian as central to the practice of the history of emotion, looking at our relationships with other disciplines as the first line where they are made and shaped, before exploring how our relationality – with other scholars and with the past – thus requires us to engage in ethical practices. Finally, this chapter looks at our own subjectivities, and how the emotions of the historian can be used in historical research.

## Interdisciplinary bodies

If historians are emotional subjects, then some of our most important relationships are with other scholars in the field and in the academy more widely. The history of emotions is an interdisciplinary project that both brings together scholars who study the past from a range of disciplines, where historians borrow from an array of fields to answer questions we consider important, and where non-historians borrow from us to help them interpret their material.

Interdisciplinarity is the combining of two or more academic disciplines into one activity. It sounds straightforward, perhaps especially for historians who think of boundaries less in terms of methodology than chronology.[3] A historical boundary is between the medieval and the early modern or nineteenth and twentieth centuries, not something that places a barrier between a sociologist and psychologist. This might seem a strange thing to say – how can an academic discipline not know its own edge? But historians have long been magpies in exploring the broad diversity of the past. Methodologies and approaches from other fields are selected as they seem relevant to research and enable answers to questions. This process of methodological selection creates its own boundaries within the field, so that history now includes economic, social, political, gender historians and so forth with their own rules.[4] Yet if methodological choices allow historians to fight freely and at length, few methods are excluded from the field as inappropriate if a historian can make them work for their questions.

The 'discipline' of history – the thing that unites the field – is a commitment to viewing events, phenomena, people in context. 'Context' is a word that does a lot of work in history; it is not just to acknowledge that somebody living in the nineteenth century might live within different material, cultural, ideological conditions from one today. Rather, it places that context as critical to analysis – approaches that distract from embeddedness in time and place are not history (or, at least, makes many historians quite uncomfortable).[5] Increasingly an emphasis on context extends to even relatively stable structures like the body, where emphasis is now placed on the plasticity of the human form and its production through environment.[6] If some of the early 'historians' – David Hume, Karl Marx, Norbert Elias – offered large-scale theories of human development, of progress, that were remarkably influential in the sciences, their evidentiary basis was weak, even non-existent, and later historians rejected such 'meta-narratives' in favour of phenomenological approaches, where the different parts of a system cannot be understood outside of that system.[7] To understand emotion, we need to understand not only the class, gender and race of the individual experiencing it, but where they were (at work or home?), what they were doing, who with and how their understanding of the world was shaped by ideas, values, culture, technology and so forth. Indeed, some historians now go further, rejecting scientific methodologies that break systems down into parts in the first place.[8] They highlight 'intersectionalities' where different components of a system take on entirely new features and functions in combination; it might be important to some that a cake was once flour, egg and sugar, but the value of this information for understanding the phenomenon of cake only goes so far. This has also led some groups of historians towards the 'micro', to stories of individuals, events and moments, as narratives of larger groups are found to be unsatisfactory for both explaining change and continuity, and in their potential for inclusion and democratic history-making.[9] 'Big data' approaches can in some senses also be included within this framework in their rejection of representing groups, in favour of universal capture of information.

The 'new' history of emotion, as I am styling the field in the last twenty years, is framed through this context. On the one hand, scholars of emotion are comfortable with using methodologies and ideas from other fields if it helps further the analysis of emotion in particular times and places; on the other, context is ever more critical to analysis. The methodologies historians of emotion have been turning to in the search for new approaches to past materials have been increasingly diverse. Attending to bodies and science and increasingly also materialities, like landscape or physical environments, historians of emotion are more engaged with the biological and psychological sciences than many other branches of history.[10] William Reddy, for example, uses findings from psychology and especially neuroscience to enable a re-reading of descriptions of love as 'speech acts' that shape embodied feeling. This allows him to move beyond claims that sources 'represent' emotion to insights about what long-dead people might actually have felt.[11] This can place historians of emotion at odds with historical disciplinary norms for rigour. A particular site of tension here is around 'universal' explanations. With some notable exceptions, historians shy away from 'universal' answers – those that sit above different times and places and offer solutions than can be applied to a wide array of contexts. In contrast, psychology and biology tend to focus on the body and the mind as having essential structures that remain stable across very large swathes of time (thousands of years); to access those structures they often wish to strip away the dimensions that change with culture and context. Reddy's claims to understanding historic feeling rely on the belief that historic bodies are not dissimilar to our own. How, then, do historians use and apply such findings?

One of the obvious challenges is that the lab-based approaches used by many psychologists and biological scientists are often quite distant from the contexts that we place so much emphasis on. Historians of emotion cannot replicate the method – dead people cannot be placed in an MRI or subjected to an interview – and historians worry about how data produced in scientific settings can be translated into 'real world' contexts. Historians are also not scientists, so not always trained to assess 'good' science from 'bad', and we are aware that ideas change rapidly in these disciplines, making it challenging to 'keep up' with their findings. As a result, historian's relationship with the science can be somewhat half-hearted; how do we know whose findings to use in our work?

One of the results of this is that the application of new methods from these fields in history can be on different terms that those anticipated by the originating field. Many historians tend to use methods from other fields analogically – these are good ideas to think with – not strict rules for conducting research. They apply them by using them as a lens for teasing out different types of information from source material, to enable new types of questions to be asked. We are also often happy to deploy and combine multiple methods or theories in our work, something that some other disciplines discourage. Only a few, like Reddy, have wholeheartedly embraced particular scientific ideas or theories as compelling explanatory models, sometimes acknowledging their work as a product of its own historical moment.[12]

More important for historians are the rules that attend to source production – how was a source made, by who, and what difference does that make to how it should be interpreted? Increasingly, historians also emphasis sources as 'objects', so that a letter, for example, is not just read for what it contains but analysed for how its production, circulation and use informs how it should be understood. One of the impacts of this methodology for historians of emotion is that emotion is no longer just contained within the body, but analysed as a product of interactions between humans, the material world and language. As Diana Barnes notes for the early modern letter, exploring its materiality – the type of paper, inkblots and marks of produced by a reader – should be used alongside the content to understand how they made, or were meant to make, the recipient feel.[13] Approaches drawn from psychological and biological sciences that give insight into how bodies work are then relegated to only one strand of a more complex conversation that seeks to integrate the different components that contribute to emotional experience and its impacts.

The history of emotions is a discipline whose methods and approach are continually evolving, a conversation happening between historians but also with many others beyond the field. It is an approach that adds value to other disciplines in denaturalising the body and emotion – highlighting how things we assume are universal are actually different across time and place – and, like other humanities subjects, in evidencing the important role of culture and language to shaping ideas, values, priorities and meaning. History offers insights into how bodies and emotions have changed and how we might in turn change things in the future. If historians do not always agree on the best approach to excavating historic emotions, our diversity and the intellectual generosity that the field has built upon has made it a rich environment for research. As a quickly evolving field, there is plenty of room for new approaches and methods as we develop. Critical to any approach is a consideration of ethical practice.

## Private feelings

As a historian of the love letter, one of the most frequent questions that I am asked is whether it is ethical to invade the private communications of the dead. For a historian of the eighteenth century, there is an irony to this question. The eighteenth-century love letter was rarely private, often mediated through a third party (a sister or mother) or designed to be read aloud to a family group. This was not because eighteenth-century letters were 'dry' or lacked passion. Quite the contrary, the European culture of sensibility ensured that flowery prose and dramatic declamations of love were often the order of the day – at least for men.[14] In contrast, many of the people I have studied were concerned to keep their finances private. As members of a social elite, during an age of booming consumerism, many felt pressured to spend, dress and display goods that reflected their social status, but not always their bank balances. By the end of the century, many were bankrupt.[15] Conspicuous consumption relied on keeping their incomes confidential, partly to

ensure their credit did not reduce but also as status and wealth were expected to co-exist.[16] Despite this, I have never been asked whether making the accounts of those I study public is a breach of ethics; it is not a question that appears to be routinely asked of economic historians.

Emotions, particularly those related to family and love relations, are particularly associated with the 'private' sphere in the contemporary West.[17] This produces certain ethical considerations when working with material that provides access into such relationships, whether that is the archival materials – letters, diaries, account books – that survive or oral histories and interviews with people involved. Writing histories that include the living or their near relatives, those that might have known them personally, is always fraught. The historian has to particularly consider the implications of what they research and write not only in terms of its contribution to historical debates, but the impacts on those who survive. Will making this information public cause embarrassment, physical or emotional harm, damage character or reputation, or lead to legal liability, for those under discussion or, occasionally, the historian? These considerations are not particularly distinct to the history of emotions. Until recently for many born in the twentieth century, and for many even now, certain types of personal information have been considered not suitable for public consumption; discussion of family life, emotions, and relationships outside of a close circle of family and friends was considered embarrassing and inappropriate.[18] Attitudes to this are rapidly changing, but such considerations cannot be ignored by contemporary scholars who wish to write ethical histories.

As both the eighteenth-century culture of sensibility and the twentieth century's stoic reserve might suggest, whether emotion was considered to be 'private' or 'public' or something else entirely ranges enormously across time periods and geographic space. Historical contexts – including the one we live in – inform how we approach such information and the ethical implications that arise. Whose ethics apply to the histories that we write? Should we use our own sense of what is private and public and apply them to eras for whom such ideas had little relevance? Should we seek to behave ethically in the terms of those we study, using their values to determine how we engage with the materials that survive for the historian? The latter raises some particular problems, firstly because we do not always know what our subjects might have thought about their information. Even if our subjects may have preferred that some of their less flattering behaviours went unknown to their contemporaries, the possibility of historical fame or a commitment to historical scholarship may have made them less worried about their reputation several hundred years later. Indeed, as the owners of their life stories, many may have enjoyed being remembered and having their voices contribute to posterity. Today, many groups that have experienced critical wrongs (like racism or genocide) value having their stories made public, recognising that having one's story in the public sphere is the first step in redress and reconciliation.[19]

Secondly, and perhaps more importantly, historical knowledge has its own ethical commitments. Many historians are motivated by providing histories for groups that do not have them, recognising that a past is significant in the formation of identity and the capacity to act in the public sphere. LGBT histories, histories of domestic violence, of rape, not only provide important information about what happened in the past, but allow people today to make sense of their experiences, to shape identities and to make political claims to human rights or legislative change.[20] For women's historians, histories of the home, the 'private' sphere, have been vital in ensuring that women's experiences form part of public record, that women have a past, and that interventions in the 'private' to enable greater equality and to reduce harm have been possible. Histories of emotion have similar ethical functions, in enabling people to better understand how experiences that feel deeply personal and individual can be implicated in larger systems of power.[21] Through denaturalising emotion, people are enabled to rethink the role of emotion in personal, social, economic and political life, and to enable change for the better.

Like any history-making, then, historians of emotions do need to attend to the ethics of their practices, but in doing so, rather than attending to 'taboos' that change over time and place, it is perhaps more useful to ask about harms and impacts. History is written for the present. While it is respectful and helpful to approach our subjects with empathy and a willingness to engage with them on their own terms, the knowledges we produce should give greater consideration to the impacts on people now. Will our histories harm individuals or groups? What is the nature of that harm, and is it outweighed by the benefits it might bring to others? What are the 'pay-offs' of the research for social inclusion, justice, rights, health or wellbeing? Are there ways to mitigate harms, such as anonymising material, and how should we balance these against both individual rights to own their stories and the rights of communities to know their past?

Ethics in research is never straightforward. If scholars provide useful guidelines based on best practice principles and in response to historic harms or problems, the best approach is to use such guidelines alongside sincere and meaningful reflections on the material being used and the impacts of the histories to be produced.[22] Ethics are ever-evolving to respond to historical conditions and the good historian is responsive to the world they live in and the impacts of their work on others. They also attend to their own feelings as part of historical practice.

## Felt judgements

Historians of emotion are increasingly concerned with our own emotional encounters with the dead, the historical sources that convey them through time and the material conditions in which they lived. If historians of emotions argue, as we do, that emotions are not just reactions and responses to historical events, but things that act on the world, shaping historical conditions and

processes of change, then the emotions of the historian must do something too. But what? And if they do, does it really matter? How should we approach our relationships with the dead?

An older commitment to objectivity looked in askance at such feeling, both an irrational but also modern imposition on a past that we should come to without agenda (as if emotions have agendas that rationality does not). More recently, a focus on multiple subjectivities has sought to locate the historian in the making of their histories – to recognise history as a human process shaped by its author in a relation with their subject – but even here emotions have been underplayed, perhaps present and to be controlled, but not necessarily an emotional tool, something that matters. Emotions seem to have troubled historians more than other fields. Anthropologists, having early on written themselves into their ethnographies, have spent more time on the relation between observer and observed, and with less existential angst.[23] Perhaps that is because they are less likely to be separated by time and distance, more aware that their observation is actually a relationship with living humans that respond to them and their interventions in place.

The line between 'them' and 'us' is perhaps more necessary for a discipline whose value has often been located in the disjuncture between past and present, where what history has to offer has more often been located in change – the past as a foreign country – than continuity.[24] Thus, historians have been sensitive to teleological thinking, to imposing current values on past societies, to applying lessons from history to the present. This is an anxiety, along with our emotional attachments to historical sources, that has underpinned the continuing commitment to empiricism in history and occasionally a lacklustre embrace of theory. Applying 'modern' methodologies to historic sources has often been associated with favouring contemporary interpretations over historic people's own beliefs and attitudes. Yet, not only are many methodologies produced because of our study of historical people – William Reddy's concept of the 'emotional regime' was developed through his study of the French Revolution – but imagining that there is a 'pure' encounter between the historian and source material is naïve.[25] Rather, we all bring something of ourselves and society to our interpretation of the past. New methodologies are designed to enable more sophisticated readings of historic material and to help clarify the boundaries between 'them' and 'us'.

Given this, and that the impact of emotions on the world is our concern, how our own emotions shape our encounters with source material is now of increasing interest. In a recent article about my relationship with an unlikeable Scottish banker Gilbert Innes of Stowe, I suggest one of the utilities of attending to the emotion of the historian was its capacity to allow us to tease out the various subjectivities of historical subjects in relation to each other, and also to ourselves, an approach that centred the relationality of past and present but also the boundaries between.[26] Empathy is often considered critical to historical research, as explaining the behaviour of our research subjects requires understanding their motivations, concerns and cares. Yet,

not only can empathy sometimes be hard, but it risks centring the experience of one historical subject over that of others and of our commitment to writing ethical histories for the present. I really disliked Gilbert Innes, because his sexual exploitation of a large number of women left them socially disadvantaged and often excluded from society, while his own reputation – and economic success – went largely untouched. One of the reasons for this dislike, however, was not just my own 'modern' feminist response to a man in a patriarchal society, but that my source materials were the writings of distressed women who had been wronged by Innes. My dislike was a response to their distress. Learning to use my emotional response to help me interpret my source material was useful in providing a deeper understanding of the behaviour and emotional dynamics of a man that I wished to understand. But it also enabled me to do this without losing sight of those he hurt. As a historian writing history for the present, it thus allowed greater analytical purchase of this story for a history that should contribute to greater gender equity and social justice today. Like the 'felt judgements' discussed by philosophers of emotion, historians can use their feeling for its evaluative and interpretive capacities, and to unpack the various subjectivities deployed in the production of history.[27]

Conversely, an exploration of our own emotion can be used to trouble such claims. Lines designed to articulate boundaries between 'us' and 'them' are challenged by emotions scholarship that deploys methods that focus attention on our embodiment, whether the tactility of emotional objects held in the hand, in encounters with landscape that highlight the affective dimensions of space, or in our relationships with subjects both living and dead. A desire for firm boundaries between humans reinforces a particular model of selfhood that imagines that it is separate from 'the other'. Some philosophers instead suggest we should be open to how we impact on each other, how relationality and engagement shapes who and what we are. This is not the least the case for historical subjects who shape us through the traces they have left of themselves.[28] As history practices move from a simple engagement with text to affective responses to objects, landscapes and people – things that deploy bodies and emotion in the process of interpretation – boundaries become increasingly amorphous. This is not to collapse past people into present feeling but it is to recognise that a focus on emotion – both of what we study and ourselves – refuses certain types of separation that the discipline has tended to hold dear. To explore the past through the body, and not just the word, requires an attendance to knowledge-making as an embodied process, suggestive of porousness and openness, as much as edges and separation.

If this is a challenge to the historian, it is one that the field is increasingly situated to respond to. From a scholarship of affect, which explores feeling before it is given shape by language, to new materialism and object ontologies that seek to recognise the agency of the material world, to explorations of emotions as social and cultural practices that move and circulate, emotions scholarship offers an analytical lens for the intangible processes, the intimacies, that bind people together.[29] The challenge for the historian is to apply

these analyses to our own practices and relationships with those we study. It is to reflect on the historical source as an emotional object, where its affective meanings form part of the explanation for its survival and its capacity to produce history; to acknowledge emotion as a social and cultural practice of historians and thus to consider how the circulation of historian's emotions enable certain types of historical economies – of what becomes important, what is taboo, who matters, what methodologies are robust, and so forth. It is to ask how a refiguring of objectivity and subjectivity through an emotional lens might offer an opportunity for a more democratic history, where the histories produced by other types of historical knowledge-makers, from those we interview to the general public, are not discounted because of their attachments, their naïve nostalgias, but recognised as part of the emotional web that is history making.[30] It is to recognise that if nostalgia shapes how some parts of the public interpret the past our feeling too does similar work.

## Conclusion

Making history is an ethical practice that involves a variety of relationships. The relationships formed by historians of emotions are perhaps especially broad due to our willingness to engage with scholars in an especially wide array of disciplines, including in the sciences whose universalism has often been challenging to those who emphasise the significance of time and place. Interdisciplinarity is central to the field, requiring not only knowledge and understanding of our own approaches but those outside. This necessitates a form of intellectual generosity, a willingness to open ourselves to other ideas and approaches. Like any practice that involves relationships with others, the writing of the history of emotions thus requires attending to ethics. What harm might our histories cause and what benefits does it bring? Thinking about our relationships to our historical subjects can form an important dimension of our ethical reflections, but should not overlay commitments to those in contemporary society, who may be harmed or helped by our research. This is not to ignore our emotional attachments to those we study, recognising that the practice of history is emotional and that emotions play an important dynamic in human activities. Rather, the historian needs to attend to how our emotional relationships with the dead, with the living and with historical sources might shape the histories produced, and explore what emotion is doing for emotions history.

## Notes

1 Mary Spongberg, *Women Writers and the Nation's Past, 1790–1860: Empathetic Histories* (London: Bloomsbury, 2018).
2 Keith Jenkins, *On 'What is History'? From Carr and Elton to Rorty and White* (London: Routledge, 1995); Georg G. Iggers, *Historiography in the Twentieth Century: From Scientific Objectivity to the Postmodern Challenge* (Middletown: Wesleyan University Press, 2005).

3  Allen F. Repko, *Interdisciplinary Research: Process and Theory* (Los Angeles: Sage, 2008); Lisa R. Lattuca, *Creating Interdisciplinarity: Interdisciplinary Research and Teaching among College and University Faculty* (Nashville: Vanderbilt University Press, 2001).

4  Anna Green and Kathleen Troup, eds, *The Houses of History: A Critical Reader in Twentieth-Century History and Theory* (Manchester: Manchester University Press, 1999).

5  Andrew Shryock and Daniel Lord Smail, *Deep History: the Architecture of Past and Present* (Berkeley: University of California Press, 2011).

6  Kathleen Canning, 'The Body as Method? Reflections on the Place of the Body in Gender History', *Gender & History* 11 (1999): 499–513.

7  Douglas Low, *In Defense of Phenomenology: Merleau-Ponty's Philosophy* (New Brunswick: Transaction, 2016).

8  Katie Barclay, 'New Materialism and the New History of the Emotions', *Emotions: History, Culture, Society* 1, no. 1 (2017): 161–83.

9  Brodie Waddell, 'What is Microhistory Now?', Many Headed Monster, https://manyheadedmonster.wordpress.com/2017/06/20/what-is-microhistory-now/#more-5403, accessed 3 August 2019.

10  William Reddy, *The Making of Romantic Love: Longing and Sexuality in Europe, South Asia & Japan, 900–1200* (Chicago: Chicago University Press, 2012); Barbara H. Rosenwein, *Generations of Feeling: A History of Emotions, 600–1700* (Cambridge: Cambridge University Press, 2016); Jan Plamper, *The History of Emotions: an Introduction* (Oxford: Oxford University Press, 2012).

11  Reddy, *The Making of Romantic Love.*

12  Reddy, *The Making of Romantic Love*; Rosenwein, *Generations of Feeling.*

13  Diana G. Barnes, 'Emotional Debris in Early Modern Letters', in *Feeling Things: Objects and Emotions through History*, ed. Stephenie Downes, Sally Holloway and Sarah Randles (Oxford: Oxford University Press, 2018), 114–32.

14  Katie Barclay, *Love, Intimacy and Power: Marriage and Patriarchy in Scotland, 1650–1850* (Manchester: Manchester University Press, 2011); Nicole Eustace, '"The Cornerstone of a Copious Work": Love and Power in Eighteenth-Century Courtship', *Journal of Social History* 34 (2001): 518–45.

15  Stana Nenadic, *Lairds and Luxury: the Highland Gentry in Eighteenth-Century Scotland* (East Linton: John Donald, 2007).

16  Margot Finn, *The Character of Credit: Personal Debt in English Culture, 1740–1914* (Cambridge: Cambridge University Press, 2003).

17  Sylvia Walby, 'From Public to Private Patriarchy: the Periodisation of British History', *Women's Studies International Forum* 13, no. 1/2 (1990): 91–104.

18  Deborah Cohen, *Family Secrets: Shame and Privacy in Modern Britain* (Oxford: Oxford University Press, 2013).

19  Anna Haebich, 'Forgetting Indigenous Histories: Cases from the History of Australia's Stolen Generations', *Journal of Social History* 44, no. 4 (2011): 1033–46; Shurlee Swain and Nell Musgrove, 'We are the Stories We Tell About Ourselves: Child Welfare Records and the Construction of Identity among Australians who, as Children, Experienced Out-of-Home "Care"', *Archives and Manuscripts* 40, no. 1 (2012): 4–14.

20  Stefan Berger, Heiko Feldner and Kevin Passmore, eds, *Writing History: Theory & Practice* (London: Arnold, 2003).

21  William Reddy, *The Navigation of Feeling: a Framework for the History of Emotions* (Cambridge: Cambridge University Press, 2001).

22  David Carr, Thomas Robert Flynn and Rudolf A. Makkreel, eds, *The Ethics of History* (Evanston: Northwestern University Press, 2004); Martin Hammersley and Anna Traianou, *Ethics in Qualitative Research: Controversies and Contexts* (Los Angeles: Sage, 2012).

23 See, for example, Ruth Behar, *The Vulnerable Observer: Anthropology That Breaks Your Heart* (Boston: Beacon Press, 1996).
24 David Lowenthal, *The Past Is a Foreign Country* (Cambridge: Cambridge University Press, 1985).
25 Reddy, *The Navigation of Feeling*.
26 Barclay, 'Falling in Love'.
27 John Jervis, *Sympathetic Sentiments: Affect, Emotion and Spectacle in the Modern World* (London: Bloomsbury, 2015).
28 Downes, Holloway and Randles, *Feeling Things*; Katie Barclay, 'Falling in Love with the Dead', *Rethinking History* 22, no. 4 (2019): 459–73.
29 Ruth Leys, 'The Turn to Affect: a Critique', *Critical Inquiry* 37, no. 3 (2011): 434–72; Barclay, 'New Materialism'; Sara Ahmed, 'Affective Economies', *Social Text* 22, no. 2 (2004): 117–39.
30 Julia Bennett, 'Narrating Family Histories: Negotiating Identity and Belonging through Tropes of Nostalgia and Authenticity', *Current Sociology* 66, no. 3 (2018): 449–65.

# Part II

# Sources for the history of emotions

# 4 Rituals, relics and religious rhetoric

*Piroska Nagy, Xavier Biron-Ouellet and Anne-Gaëlle Weber[1]*

Among the sources available to students of emotions, religious sources are of particular interest since they allow us to grasp how culture shapes the intimate feelings of individuals' connection with supernatural forces. In most religions, spiritual relationships, linking together the visible and invisible, the profane and the sacred, involve emotions like awe, love, fear or fascination, expressed both individually and collectively. In order to fully comprehend the emotional aspect of religious sources, historians need a diversified methodological toolbox. Above all, they must adopt an anthropological approach, and consider the vision of man alongside society's structures and main cultural practices. Being medievalists, our 'anthropological field' is Latin Christendom. We will thus refer to Western Christian religion and culture throughout this chapter. As many of our sources have their equivalent in other religions, the historical method advocated here can also be applied in other cultural contexts.

Affectivity and emotions are central to Christian anthropology. As we read in the New Testament, God is love; Christ sacrificed himself and suffered his passion out of love for humankind. Christianity is therefore a highly affective religion, in which the faithful draw closer to the divine by experiencing certain feelings inspired by the Holy Scriptures and other sacred texts.[2] Leaving aside the moral and theological discussion of how humans must behave in community, an anthropological approach to religious discourse expressed by textual, iconographic or monumental sources, reveals the role played by emotions in a Christian culture and society. Forming a common thread that wove together the different cultures present in medieval Europe, Christianity and the Church defined the shape of Western civilisation. Mindful that a *longue durée* perspective is required to understand the global dynamics of history, historical anthropologist and medievalist Jacques Le Goff argues for a long Middle Ages (300–1800), with the purpose of shedding light on the deep cultural structures of Western history.[3] This extension of the medieval era, which traditionally ranges from 500 to 1500, reflects the fact that Christian religious thought determined the organisational and mental structures of Western societies from Late Antiquity to the Industrial Revolution. For this reason, in order to understand and interpret religious sources, as well as to make sense of their affective content in the *longue durée*, the student of emotions needs a global understanding of Western Christian culture.

Paradoxically, language acts both as a gateway and a barrier to the use of Christian religious sources and to the study of emotions of the past in general. A term similar to the one we use today does not necessarily have the same meaning: false cognates are numerous. For instance, *'esmotion'* in late medieval French designates social unrest – something very different from our understanding of emotion as an individual and psychological phenomenon.[4] Another example is the English word 'passion': although passion might be a translation of the Latin term *passio*, its meaning is closer to the Greek *pathos*. For Christian authors, the Latin term *passio* derives from the verb *patior*, which means 'to suffer', so that a *passio* refers either to the sufferings endured by Christ and the martyrs – or to sinful carnal impulse that Christians 'suffer' as a consequence of the Fall. The modern idea of passion as an uncontrolled emotion combines this Christian idea of *passio* as a carnal impulse with the Greek idea of *pathos* as a spiritual 'accident of the soul'. We could also mention medieval *caritas*, the most virtuous form of Christian love, far from today's 'charity' events and shops! A critical approach to Christian texts of all kinds therefore involves a contextualised semantic analysis to make sure that our understanding of the words is not distorted by their contemporary meaning.

This chapter is divided into two main sections, dealing with two different means of accessing historical Christianity. The first part is methodological, and discusses the ways and means by which religious authors and texts use emotion words and the emotionality of their readers in order to shape the faithful's moral and emotional behaviour. The second part is dedicated to lived religion, focusing on the sources that may help us to grasp the affective behaviour of people during rituals and the devotion to relics.

## Spiritual text as an affective path

The first step towards a general comprehension of a religious anthropology, which determines the place and role of emotions within a society, can be made by reading the religion's foundational texts and major authors.[5] In the case of Western Christian religion, Augustine of Hippo (d. 430) provides a good entry point for understanding how emotions were understood within Western Christian culture. He is considered a major author not only because of the breadth of his thoughts on Christianity, but also because his texts were read and reflected upon throughout the Middle Ages, making his theology an authoritative reference in any kind of intellectual discussion during this period. In his main work *The City of God*, Augustine set out the anthropological foundation of the Christian man.[6] According to him, Adam and Eve's fault caused the fall of humankind, who were henceforth subjected to passions. In order to hope for salvation, the faithful has to gain control over these uncontrolled movements of the soul, and direct them towards God, who is love. For Augustine, every emotion is also a movement of the will: it is the wilful intention and orientation of such movements that makes them either virtuous, leading to salvation, or vicious, leading to damnation. Moral vices

and virtues are therefore strongly linked with emotions, as they are at the root of the intention and orientation of feelings. The faithful have to scrutinise the direction of their emotions through *discretio* (discernment), a moral faculty that distinguishes what is good from what is bad in order to inform the *ratio* (reason) of the moral quality of a thought, before the will makes a decision. *Discretio* can be trained with spiritual exercises that generally rely on texts. Different versions of these ideas are also present in the classics of monastic literature; they were repeated and rethought from century to century. This was for instance the case of Gregory the Great (d. 604) and Bernard of Clairvaux (d. 1153), two eminent figures of Western monasticism and among the most read authors for generations of medieval as well as early modern monks and nuns, shaping their gestures and morals.[7]

As the Scriptures transmit the only traces of Christ's revelation, the main Christian spiritual exercise is meditative reading, that is reflecting on the moral meaning of events in relation to the evangelical teaching of Christ. Medieval societies had only limited literacy; the ability to read was a privilege, even a monopoly of elites, mostly of monks and clerics. However, the moral and affective content of sacred and spiritual texts was transmitted through diverse channels, from public sermons to the churches' iconographic programmes, as well as by spiritual mentoring and correspondence.

The way emotions were expressed by oral, textual or visual means is guided by rhetoric, as an art seeking to instruct, to please and to *move* the soul; rhetorical composition guides the mind during the 'reading' of a text, a speech or an image.[8] In this perspective, Augustine writes that the way of Christ (*via Christi*) is a pathway not made of physical places, but of affects.[9] The path to salvation is an affective process, and the 'straight path' is found by doing a meditative reading of the Holy Scriptures, or through pastoral care. Since the moral value of an emotion is given by its moral orientation – towards virtue or vice – attention must be paid to the narrative context in which an emotion word is employed. When reading sermons, narrative sources like chronicles and hagiography, or even literary works, the historian of emotions has to observe the intentions and sequences of emotions in order to understand the moral meaning given to specific emotion words. For instance, anger is one of the Christian vices; yet, when felt towards one's sin, for virtuous reasons, and first of all by love of God, it will be considered good and will cause joy, whereas anger elicited by jealousy or hate is considered bad, 'mundane', and will cause pain and perdition. In a Christian context where the salvation of the soul is a priority, the moral value of an emotion is all that matters, and this value is given by the orientation of the emotional movement. Exemplary and entertaining stories called *exempla*, widely used in Christian preaching and literary texts, were considered more efficient than theoretical explanations because they gave vivid examples of good and bad moral behaviour.[10] These kinds of stories are also present in other traditions, for instance Muslim or Buddhist spiritual literature. Reflecting on models of correct and incorrect emotional conduct, whether they were sacred or profane, was the very activity through which

medieval people readied themselves psychologically to feel morally good emotions: love of God and compassion, fear of God, shame of sins, contrition and humility. Experiencing these kinds of emotions was part of their moral education, helping the soul reach salvation.

Sacred and spiritual texts also played a crucial role by giving reading and memory a pre-eminent function in the shaping of the Christian self. As studied by Brian Stock, Augustine operated a shift between the classical and Christian application of rhetoric.[11] While classical ethical debates were typically held in public, Christians instead interiorised these discussions by focusing on a text, transforming it into an interior and silent debate – a *soliloquium*, an inner dialogue with oneself.[12] This spiritual exercise based on texts was crucial to the shaping of Christian emotional self. Based on reading or the listening of spiritual teachings, and even on the visual contemplation of religious iconography that evoke events, figures and stories of the Bible, this kind of spiritual practice involves both body and soul, forming a total experiential immersion within the biblical narrative. As John Cassian (d. 435), a father of Western monasticism and one of the most-read authors of monks and nuns through the Middle Ages instructs, one has to *experience* the Scriptures in order to feel the same affect of the heart (*affectus cordis*) as [the one described or suggested by] the text, thus becoming like its author or participant and anticipating its very meaning rather than following it.[13]

A common image to express the mnemonic effect of this participative and contemplative approach is the imprint of a moral message on the subject's soul, like a seal in wax. The more often this spiritual exercise is repeated, the better virtues are memorised and inscribed in the heart. This exercise creates and implements a moral, spiritual and affective movement and path to follow. Let us take the example of the most common devotional figure, Jesus Christ on the cross. When looking at an iconographic or textual representation of this figure, the spiritually advanced member of the faithful holds an interior discourse about Christ's passion. In the early Middle Ages, one would evoke the exemplarity of His path; in the second half of the medieval millennium, one would seek to identify oneself with the Saviour. Guided by authoritative texts, images and sermons, one relives the whole sequence as one's own affective and spiritual progression: from the pain of Christ when he is nailed on the cross, through the sadness of Mary at his feet, to the joy of redemption and the love manifested by Christ's sacrifice. By mentally engaging the faithful in the experience of sequenced emotions associated with Christ's passion, this spiritual exercise aims at strengthening the salvific virtues and emotions represented by the sacred figure: the humility of crucifixion, the faith of Mary, the love (*caritas*) of sacrifice and the hope of redemption. This meditative tradition, elaborated in the Middle Ages, has been kept alive into our own time, as is shown for instance by the success of Ignatius of Loyola's *Spiritual Exercises*, and by the frequent re-editions of a corpus made of meditative texts attributed to Augustine, Anselm of Canterbury, and Bernard of Clairvaux in the sixteenth to eighteenth centuries.[14] Apart from contextual evolutions, this type of emotional work was also cultivated in the Protestant world in a very similar way.[15] Other religions have their

own approach to accomplishing this kind of emotional work. In Buddhism, one particular way of generating religious emotions such as devotion or compassion is by means of mantra recitation, that is, the concentrated repetition of a short formula imbued not only with a philosophical but also with an emotional meaning.[16]

Most medieval texts, from exegetical sermons to meditative prayers, from historical and hagiographical narratives to spiritual treatises, have a moral and affective educational meaning that needs to be assimilated through a slow, patient and contemplative process of reading or listening. This spiritual education gives a moral orientation to the soul's emotional movement toward salvation. All this applies specifically to Christian culture, from 300 to 1800, but the same anthropological pattern can be found in other religious traditions too; therefore, the same method can be used to analyse other religions or cultures. Reading the sacred texts and the major authors provides an understanding of how they conceived emotional life in relation to their vision of humankind. Paying close attention to semantics helps to avoid anachronistic interpretations, and linking the sources to their context of production, consumption and circulation allows us to understand the transmission and transformations of the meanings attributed to the emotions they express. Reconstructing the historical anthropology of a given culture is thus a fruitful way to appreciate the role attributed to emotions and affective processes in religious practices.

## Emotional practices of lived religion

Combined with the rhetorical and textual understanding of the Biblical tradition, the lived, experiential dimension of religion is essential when studying emotions in religious sources.[17] Although they are shaped by textual culture, religious emotions can also be considered in their relationship with material supports, like charms, epitaphs, iconography, manuscripts[18] and, above all, relics.[19] In a work concerned with contemporary devotion, sociologists Ole Riis and Linda Woodhead emphasise the triangular relationship between the individual, the community, and the objects that mediate devotion and generate both individual and collective emotions.[20] There are several types of sources which allow to work on the emotions associated with lived religion: iconographic, [21] architectural[22] and, of course, textual.[23] After a period of strong historiographical interest in ritual and the performative dimension of religious acts, recent scholarship has paid much attention to the materiality of medieval sources, delivering important information about their circulation and effective uses. In the case of relics, it informs us about the emotions sought for or felt during the material contact linking the faithful to the saint. For instance, parts of holy statues became shiny by being frequently touched. The study of relics as affective objects includes various aspects such as their material production, practical use, and the sharing of and control over the emotions elicited in their presence, located at the heart of a sacred and ritualised space.[24] While some relics' inventories date back to the medieval period, recent catalogues prepared by archaeologists and historians, sometimes for exhibitions, are of great value.[25]

## Relics

The word 'relic' comes from the Latin word *relinquare* (to leave behind, to abandon). Relics therefore represent what a holy man or woman has left behind: their terrestrial remains, bodily parts or objects that were in contact with the saint (e.g. the cape, *capa* of Saint Martin whose veneration in a consecrated place is at the semantic root of the word 'chapel').[26] Perceived as tangible traces of divine presence on earth, relics are used, even today, as means of communication with the sacred, a communication that can be performative and public, or intimate. Deeply ingrained within Christian culture since the fourth and fifth centuries, the cult of relics raises the question of the emotions embedded within religious practices: holy remains play a number of important roles in the process of spiritual and affective conversion to God.[27] Though it could be assimilated to idolatry, the worship of relics was considered in the Middle Ages as the most widespread way to engage with the divine.[28] Present under the altar of every Christian church, relics are instrumental in the success of prayer and liturgy. They could also serve political aims, since medieval oaths were sworn upon them, thereby taking the saint and God as witnesses, and linking the legitimacy of a dynasty to the patronage of a specific saint. This patronage could also be publicly challenged or put on trial.[29] On an individual level, they maintained the emotional economy of the special relationship between the saint and the faithful, whether the faithful prayed on a regular basis or for a specific reason.

From the eleventh century onwards, the cult of relics enjoyed a growing success, strongly related to a shift in the representation of Christ from the image of a divine and majestic judge to the humble figure of the God-man incarnate.[30] This major change, making clear what Jacques Le Goff calls the 'descent of values from heaven to earth', explains why the embodied imitation of the earthly path of Christ underwent a spectacular increase in popularity during the second half of the medieval millennium. In this perspective, sensory contact with relics – visual and tactile above all – came to the forefront of devotional practices.[31] Miracles, the ultimate expression of its effectiveness, were understood as proof of the saint's actual ability to intervene in the name of God. They attested in a tangible way the contact between nature and the supernatural, generating changes to the real world and strong emotions of devotion and exaltation. Even in today's Catholic and orthodox cultures, people make their requests directly to the saint represented by the relics. Thus, the faithful engage their body in the process of veneration when moving through a pilgrimage or a procession, or when prostrating in front of the relic.

Pilgrimage is a very important performative phenomenon since its aim is to experience a direct, physical contact with the relic that can be touched or kissed, creating a sensorial link, and involving an important affective commitment. Leaving their ordinary lives, the faithful often travel long distances to reach shrines; today, people walk to Compostela from France or Italy, travel to Lourdes and to Jerusalem. A careful staging, including architecture

and iconography, supports the path to the relics.[32] At the end of the pere-grination, the sacred space where the encounter usually happens (monumental basilicas, simple churches or chapels, the tomb or statue of a saint) is a site of intense physical interaction with the supernatural. At the shrine, the faithful experience a strong relationship with the saint through the sensorial and spiritual experience of this mystical encounter.[33] Sacred architecture – from a monumental sanctuary to the modest family altar – is designed to generate religious emotions, either by an intimate staging, or by evoking the majesty of God. For instance, the interactions of light need to be considered in the sta-ging of the sacred as symbolising the divine virtue that the believer must internalise.[34] The emotional effect depends on the intensity of the light, from exaltation when it is bright, to appeasement when it is dark; or on the awe inspired by the miraculous beauty of light shining through the stained glass windows of Gothic churches. Iconographic and stage elements of shrines thus serve as spiritual guides for the moving soul, orienting devotion towards God and virtue. As we have seen, these staged emotional responses are formed by the Scriptures and other major Christian texts including hagiography,[35] which instruct the faithful on the ways to live a good life, and to accomplish devo-tional practices through the example of saints.[36]

## Rituals

A great variety of experiences related to the sacred take place during pro-cesses or events qualified as rituals by social scientists. Relics and all the material present at the holy place are central in these moments, which have to produce specific feelings, both individual and communal. The term 'ritual', widely used and discussed since the 1980s, at least in social sciences and his-tory, has been at the heart of a polemic between those who deem it useful as an analytical tool, and those who doubt its utility and rather see the biases and dangers of the notion.[37] The main difficulty, for any historian interested in emotions and gestures during religious rituals, is our access to them, which is always mediated by texts. They are either normative texts describing how a given ritual should take place and what kind of emotion it should produce; or narrative ones, offering particular interpretations of the ritual as well as of the gestures and feelings performed in it. These interpretations, always linked to singular circumstances, might greatly differ from what the actors involved actually felt.[38]

Indeed, clerics performing religious rituals at shrines could usually rely upon written guidelines like liturgical texts, transmitted from one generation to the next, which codified the whole process: the right order of words, ges-tures and feelings. Liturgical texts determine how a mass, a baptism, a wed-ding or a church consecration should be held at a given place and time, in order to produce the expected effect. This effect involves a transformation that relates to the spiritual and affective world, but also to the 'real' world. We observe this interference between the spiritual and the material world in

an array of rituals; it is necessary so that transubstantiation takes place; so that one gets baptised and enters the Christian community; so that two people get married and may live together publicly; so that a community may start celebrating in its newly built church.

In the twelfth century, when the theology of sacraments – i.e. the major rituals of the Catholic Church establishing contact between the natural and supernatural worlds – was codified, the role of emotions during the ritual of penance was explicitly evoked and discussed. While his thought was much contested, the argument presented by Peter Abelard (d. 1142) won this debate.[39] Abelard considered that repentance, meaning the real regret of sins called contrition, plays an instrumental role in making the penitential process efficient. Following Abelard, Peter Lombard, whose *Book of Sentences* (c. 1150–8) became the standard textbook of theology of the West in the coming centuries, defined penance as a virtue including both weeping and hatred towards one's sins.[40] Does this mean that every penitent actually felt sad while doing penance? It means at least that the Church promoted this feeling, and its expression through tears was required before receiving the absolution from the priest.

Frequently undertaken as a penitential act, pilgrimage was probably the model for the description of 'liminal state' by Arnold van Gennep in his famous study *Rites of Passage*: penitential pilgrimage entailed sadness of separation from one's familiar world, fear of dangers and insecurity on the path that could enhance the feelings expected from a true penitent.[41] In the same way, from the twelfth century onwards, the Church promoted the *affectus coniugalis*, conjugal love, in the framework of the new sacrament of marriage. This was a new kind of heterosexual love, which was neither chaste nor impossible.[42] In a much less explicit fashion, the liturgy of the Mass provides joy and love, especially around the key gestures of consecration and communion, which represent and include Jesus in the ecclesial community and in the heart of every participant, both being re-vivified. A thorough study of liturgical texts, of their changes and interpretations through different centuries and geographic areas, may yield interesting conclusions about the ways emotions were elaborated and taught to the faithful by the practice of sacraments and other frequent liturgical ceremonies. Many other, less consensual rituals have been identified and analysed by historians, like the humiliation of saints, the thefts of relics and Benedictine maledictions; the list is not exhaustive.[43]

Clear codification of emotions in the framework of Christian rituals determined education of feelings for centuries. Yet, the actual meaning of a ritual, performed for specific and contextual reasons, can be strongly defined by the social, religious and political conditions that brought the actors to act as they did. Historians of emotions must be aware that most frequently contemporaries produced detailed descriptions of rituals when something gave the ritual a specific meaning or when something went wrong, thus perverting the well-known and expected meaning or effect of the ritual act. Such occasions have a high degree of performativity. While the expected religious effect may or may not occur in these cases, specific social and political effects are

nonetheless produced: they determine, and are determined by, the feelings of participants. This was the case, for instance, with the celebration of Christmas by Francis of Assisi in the little town of Greccio in 1223.[44] According to his first biographer, Thomas of Celano, in order to celebrate the Nativity of Jesus in Greccio with great solemnity and fidelity, Francis, a simple deacon, decided to reconstruct the scene of Bethlehem, using a real crib and real animals.[45] The mass was then celebrated over the crib, used for the occasion as an altar – all this may have taken place outdoors, in a natural cave.[46] In this staging, Francis simultaneously drew on a lively tradition and transgressed elements of that same tradition: by constructing the first 'living' representation of Nativity of Christian history;[47] by abandoning the great urban churches for a place that symbolised, in his words, the richness of poverty; and by precisely staging a series of material details that recalled the biblical scene so that during the celebration, a miracle occurred and an extraordinary collective joy was experienced by all those who were present.

## Conclusion

Pilgrimages, ordinary liturgy and extraordinary rituals all have a strong performative dimension, making the participants enter direct, sensorial and collective contact with the sacred, through the ordered experience of an emotional and spiritual process that enhances the effects of such contacts. Once the methodological difficulties pertaining to the study of lived religion are acknowledged, one can focus on the ways in which emotions are evoked in a given source concerning rituals. Is the text written to prescribe or codify a ritual and its ideal execution – or is it written to record and commemorate an event during which the ritual took place? In the latter case, there are good reasons to investigate the context that produced both the ritual and the written record. Why, in fact, did this specific pilgrimage or ritual take place and why was it described? Why and how do emotions play a role in the ritual or its narration? As discussed at the beginning of this chapter, one has to work with textuality, and the rhetoric process implemented by the texts, to answer these questions. The rhetoric of a text which, most of the time, evokes or describes feelings – good or bad, salvific or leading to damnation – obeys the intentions of the author, and fulfils educative aims. The anthropological approach helps us understand the medieval visions and practices of emotion; reading historical sources from the perspective of their past users is the first condition for acquiring such an understanding.

## Notes

1 Our gratitude goes to colleagues and friends whose remarks helped us improve or refine our work: Katie Barclay, Lochin Brouillard, Daniel Ross, Julia Steinzel, Peter Stearns.
2 Damien Boquet and Piroska Nagy, *Medieval Sensibilities: a History of Emotions in the Middle Ages*, trans. Robert Shaw (Cambridge: Polity Press, 2018).

3  Jacques Le Goff, *Must We Divide History Into Periods?*, trans. Malcolm DeBevoise (New York: Columbia University Press, 2017).

4  Nicole Hochner, 'Le corps social à l'origine de l'invention du mot "émotion"', *L'Atelier du Centre de recherches historiques* 16 (2016), http://journals.openedition.org/acrh/7357; Thomas Dixon, *From Passions to Emotions: The Creation of a Secular Psychological Category* (Cambridge: Cambridge University Press, 2003).

5  For a general survey, see Simo Knuuttila, *Emotions in Ancient and Medieval Philosophy* (Oxford: Oxford University Press, 2004).

6  See the books 9 and 14 of Augustinus, *De civitate Dei*, ed. Bernhard Dombard and Alfons Kalb (Turnhout: Brepols, 1955). On Augustine, see Carla Casagrande and Silvana Vecchio, *Passioni dell'anima. Teorie e usi degli affetti nella cultura medievale* (Florence: SISMEL Edizioni del Galluzzo, 2015).

7  On Gregory, see Carole Straw, *Gregory the Great: The Perfection in Imperfection* (Berkeley: University of California Press, 1988); and on Bernard, see M.B. Pranger, *Bernard of Clairvaux and the Shape of Monastic Thought: Broken Dreams* (Leiden: Brill, 1994).

8  Mary Carruthers, *The Craft of Thought: Meditation, Rhetoric, and the Making of Images 400–1200* (Cambridge: Cambridge University Press, 1998), 72–82.

9  Augustinus, *De doctrina chistiana*, 1.17.16, ed. Josef Martin and Klaus Daur (Turnhout: Brepols, 1962).

10  Jacques Berlioz et Marie-Anne Polo de Beaulieu (eds), *Les exempla médiévaux: nouvelles perspectives* (Paris: Honoré Champion, 1998); Larry Scanlon, *Narrative, Authority, and Power: the Medieval Exemplum and the Chaucerian Tradition* (Cambridge: Cambridge University Press, 1994); John D. Lyons, *Exemplum: the Rhetoric of Example in Early Modern France and Italy* (Princeton: Princeton University Press, 1989).

11  Brian Stock, *Augustine the Reader: Meditation, Self-Knowledge and the Ethics of Interpretation* (Cambridge: Harvard University Press, 1996); and more recently Brian Stock, *The Integrated Self: Augustine, the Bible, and Ancient Thought* (Philadelphia: University of Pennsylvania Press, 2017).

12  Brian Stock, *Augustine's Inner Dialogue: The Philosophical Soliloquy in Late Antiquity* (Cambridge: Cambridge University Press, 2010).

13  Cassianus, *Collationes XXIII*, X.11, ed. Michael Petschenig (Vienna: CSEL 13, 1886).

14  Cédric Giraud, *Spiritualité et histoire des textes entre Moyen Âge et époque moderne. Genèse et fortune d'un corpus pseudépigraphe de méditations* (Paris: Institut d'Études Augustiniennes, 2016).

15  Susan C. Karant-Nunn, *The Reformation of Feeling: Shaping the Religious Emotions in Early Modern Germany* (Oxford: Oxford University Press, 2010).

16  Patrul Rinpoche, *Heart Treasure of the Enlightened One* (Boulder: Shambhala Publications, 2003, 58); Julia Stenzel, *The Buddhist Roots of Secular Compassion Training* (PhD dissertation, McGill University, 2019), 74.

17  Stephen E. Gregg and Lynne Scholefield, *Engaging with Living Religion: A Guide to Fieldwork in the Study of Religion* (London: Routledge, 2015); Victor W. Turner and Edward M. Bruner, eds, *The Anthropology of Experience*, with an Epilogue by Clifford Geertz (Urbana-Chicago: University of Illinois Press, 1986); David D. Hall, ed., *Lived Religion in America. Toward a History of Practice* (New Jersey: Princeton University Press, 1998).

18  See *Transmission des Textes: Catalogues (CATA)*, Brepols, published by Loes Diercken, http://www.brepols.net/Pages/BrowseBySeries.aspx?TreeSeries=CATA

19  Mark A. Hall, 'The Cult of Saints in Medieval Perth: Everyday Ritual and the Materiality of Belief', *Journal of Material Culture* 16, no. 1 (2011): 80–104; John Kieschnick, 'Material Culture', in *The Oxford Handbook of Religion and Emotion*, ed. John Corrigan (Oxford: Oxford University Press, 2008), 223–36 (228).

20 Ole Riis and Linda Woodhead, *A Sociology of Religious Emotion* (Oxford: Oxford University Press, 2010).
21 Jérôme Baschet, *L'iconographie médiévale* (Paris: Gallimard, 2008); see especially Chapters 17 and 18 in Colum Hourihane, ed., *The Routledge Companion to Medieval Iconography* (London: Routledge, 2017).
22 Banister Fletcher, *A History of Architecture on the Comparative Method* (London: Batsford, 1905); Yves Christe et al., *Art in the Christian World 300–1500: A Handbook of Styles and Forms* (London: Faber and Faber, 1982); Nicola Coldstream, *Medieval Architecture* (Oxford: Oxford Press, 2002); Dominique Iogna-Prat, *La Maison Dieu: Une histoire monumentale de l'Église au Moyen Âge (v. 800–v. 1200)* (Paris: Seuil, 2006).
23 For instance, numerous sources are edited in *Monumenta Germaniae Historica*, http://www.mgh.de/bibliothek/bibliothek-allgemeines/ or in the *Corpus Christianorum (CC)*, Brepols, published by Tim Denecker, Luc Jocqué, Bart Janssens, http://www.brepols.net/Pages/BrowseBySeries.aspx?TreeSeries=CC
24 Stephanie Downes, Sally Holloway and Sarah Randles, eds, *Feeling Things: Objects and Emotions Through History* (Oxford: Oxford University Press, 2018). See also Caroline W. Bynum, *Christian Materiality: An Essay on Religion in Late Medieval Europe* (New York: Zone Books, 2011); Luigi Canetti, *Frammenti d'eternità: Corpi e reliquie tra Antichità e Medioevo* (Rome: Viella, 2002).
25 Timothy Husband and Julien Chapuis, *The Treasury of Basel Cathedral* (New York: The Metropolitan Museum of Art, 2001); Henk Van Os, *The Way to Heaven. Relics Veneration in the Middle Ages* (Baarn: de Prom, 2000); Hans-Joachim Kracht and Jacob Torsy, *Reliquiarium Coloniense* (Siegburg: Schmitt, 2003).
26 Arnold Angenendt, *Heilige und Reliquien: die Geschichte ihres Kultes vom frühen Christentum bis zur Gegenwart* (München: C. H. Beck, 1994).
27 Peter Brown, *Society and the Holy in Late Antiquity* (Berkeley: University of California Press, 1989), 222–50.
28 Caroline W. Bynum, *The Resurrection of The Body in Western Christianity, 200–1336* (New York: Columbia University Press, 1995), 91.
29 Patrick Geary, 'L'humiliation des saints', *Annales ESC* 34, no. 1 (1979): 27–42; Lester K. Little, *Benedictine Maledictions. Liturgical Cursing in Romanesque France* (Ithaca: Cornell University Press, 1993).
30 Émile Mâle, 'L'Art français de la fin du Moyen Âge – L'apparition du pathétique', *Revue des deux mondes* 29 (1905): 656–81; Caroline W. Bynum, *Jesus as Mother: Studies in the Spirituality of the High Middle Ages* (Berkeley: University of California Press, 1982); Lauren Mancia, *Emotional Monasticism: Affective Piety in the Eleventh-Century Monastery of John of Fécamp* (Manchester: Manchester University Press, 2019).
31 For an intercultural approach, see Tōkyō Daigaku, Jinbun Shakaikei Kenkyūka, *The Interrelationship of Relics and Images in Christian and Buddhist Culture* (Tokyo: Global COE Program DALS, Graduate School of Humanities and Sociology, University of Tokyo, 2009).
32 Meg Boulton, Jane Hawkes, Heidi Stoner, eds, *Place and Space in the Medieval World* (New York: Routledge, 2017).
33 Victor W. Turner and Edith L.B. Turner, *Image and Pilgrimage in Christian Culture* (New York: Columbia University Press, 1978); Kathryn Blair Moore, *The Architecture of the Christian Holy Land: Reception from Late Antiquity through the Renaissance* (Cambridge: Cambridge University Press, 2017).
34 Jean Bachelot et al., *Le symbolisme de la lumière au Moyen Âge: de la spéculation à la réalité: actes du colloque européen des 5 et 6 juillet 2003* (Chartres: AACMEC, 2004).
35 Jan Willem Drijvers, 'Travel and Pilgrimage Literature', in *A Companion to Late Antique Literature*, ed. Scott C. McGill and Edward Jay Watts (Malden: Blackwell, 2018), 359–72.

# 5 Prescriptive literature

*Peter N. Stearns*

Prescriptive materials constitute one of the easiest entrées into emotions history, at least for the last two centuries, and they have been widely used in studying a whole range of emotional standards.[1] At the same time, prescriptive literature has some inherent limitations and may at times tempt researchers into overgeneralisation – so some warnings must accompany any enthusiasm for this type of source.

Prescriptive literature quite simply involves materials designed to tell people how to behave, how to react to others, and in some cases what kinds of emotions are appropriate or inappropriate. While all societies have emotion rules, explicitly prescriptive materials became increasingly common from the seventeenth century onward, with a further surge from about 1800 onward, in part because of steady improvements in printing and also in literacy.[2] They are not entirely different, however, from religious materials that can be studied in earlier periods that also sought to set standards for various aspects of emotional behaviour. And religion has continued to be a source of prescriptive statements in the past two centuries. Philosophy can also enter in. Thus the Confucian tradition sponsored a long series of prescriptive materials, which scholars have widely used to get at past emotional standards in China; for example, Ban Zhao's book on women, written in the Han dynasty and republished frequently into the later nineteenth century, is full of direct admonitions about how men and women should comport themselves emotionally. Recent studies of shame and other emotions topics in Chinese history have relied heavily on Confucian and neo-Confucian materials. In another important case, philosophers and medical writers in classical Greece, in their advice on moderation and other subjects, directly worked to promote certain emotional values.[3]

But prescriptive literature most commonly refers to the kinds of advice materials that began to appear first with the Protestant Reformation, and then as a result of industrialisation, urbanisation and modern state activity. With urbanisation, for example, more people were cut off from advice from traditional community sources and were thus open to guidance from a growing number of writers who believed they had special knowledge to impart. The huge spread of literacy in the modern world, along with the rise of a growing number of popularising authors eager to offer advice and sell their works, makes recent prescriptive materials a particularly rich resource.

Prescriptive materials most obviously show up as books or pamphlets about family relations. In the United States, for example, a series of writers, both male and female, began to issue this kind of advice literature from the 1820s onward, including famous offerings like Catharine Sedgwick's *Home*. These materials featured guidance about emotional behaviour in marriage and especially the kinds of emotional approach and goals that were essential to good parenting (particularly, mothering). Fairly soon, periodicals began to join the parade – particularly, magazines aimed at women, like Godey's *Ladies Book* or, from the 1870s, the durable *Ladies Home Journal*. But men's magazines offered advice as well – for example, as part of a new genre of men's periodical in the 1920s, *Esquire* pointedly argued against the kind of romantic love goals that had been popular in the prior century, urging a more controlled emotional approach at least for 'Real Men'. Certain kinds of fiction also sought to offer emotional instruction,[4] linking the prescriptive category to literature as a historical source. Various political groups have offered emotional advice; labour movements appealed to righteous anger, feminist movements (particularly in 'second stage' feminism from the 1950s onward) worked hard to modify domestic emotional habits to encourage more assertive women.

Self-help books also emerged as a general advice category, becoming increasingly popular from the 1920s onward but with earlier precedents. Benjamin Franklin's *Poor Richard's Almanack*, dating back to the later eighteenth century, often preached emotional habits appropriate to promote personal success. Most recently positive psychology has generated a range of prescriptive materials designed to encourage individual happiness or at least well-being. Interpreting the emotional signals embedded in self-help books is an interesting opportunity, particularly for the modern period.[5]

Prescriptive materials also include manners books, a genre that, in the West, goes back to the Renaissance and in East Asian society has an even longer history.[6] Historians have used manners books widely for information about rituals designed to control and channel emotion (for example, how to behave in dealing with the grief of others, or how to moderate anger). Manners books become somewhat less useful in the twentieth century, as greater informality becomes popular, but this shift itself allows assessment of new kinds of emotional guidance.

Governments began to issue prescriptive materials in the modern centuries as well, and these materials become a crucial way of tracing what kinds of emotions various political regimes sought to encourage or discourage. Most modern revolutionary regimes have sought to shape popular emotions in certain respects; Mao Zedong in China, for example, worked explicitly against Confucian habits of deference, urging that popular anger was an appropriate response to injustice as well as a potential support for his revolutionary effort.[7] Governments more generally turned to prescriptive efforts particularly from the later nineteenth century onward. They often supported a highly emotional nationalism that they thought would serve to bolster the political system; in Japan, from the 1880s, this included specific injunctions about

devotedly worshipping the emperor. In a slightly different vein, governments also began to issue pamphlets to guide families, particularly in raising children. Early materials often focused on physical health, but they soon branched out into emotional categories as well – on the grounds that parents needed to be guided by expert advice, against traditional habits that might prove bad for their offspring. The United States publication *Infant Care*, issued by the Children Bureau initially in 1914 and frequently republished, has been the most popular American government publication of all time. Japanese materials, intended among other things to define the emotional importance of the 'wise mother' in family life, were urged on parents from the early twentieth century onward.

Shading off from explicit government efforts, modern schools also offered emotional prescriptions – this is in fact a category that deserves more attention from emotions historians. Schools preached emotional nationalism. They sought to define gender standards – a century ago most school systems offered specific domestic training for girls (called 'home economics' in the United States) that included advice about deference and emotional control along with cooking tips. In more recent decades, explicit character training efforts, including programmes designed to improve emotional self-esteem, have become common.[8]

The modern workplace has also provided a framework for prescriptive materials aimed at calibrating emotional behaviour. Work settings have always had emotional content – as when parents sought to train their children, or masters sought to maximise obedience from apprentices. But more formal prescriptive materials became increasingly necessary under industrialisation, when the size of the enterprise expanded and rules supplemented personal guidance. Particularly from the early twentieth century onward, industrial psychologists and others recommended all sorts of emotional behaviours. Sales personnel and secretaries were urged to present a smiling countenance, even in the face of angry customers. Foremen were hauled in for retraining sessions to teach them how to control their anger and deflect angry workers. Both customer service and protest avoidance sponsored a steady stream of prescriptive efforts.[9]

Initial prescriptive literature in the nineteenth century, at least in the West, was heavily shaped by a religiously linked kind of moralism – not fiercely religious, but based on presumed moral standards. In the United States, mainstream Protestantism inspired the most widely popular efforts. Even at this point, however, medical practitioners, eager to gain wider popularity and increasingly claiming a research base, issued materials that had bearing on emotion – for example, in recommendations about sexuality. In the twentieth and twenty-first centuries, the prescriptive field has been increasingly – though not exclusively – dominated by popularisers disseminating or claiming to disseminate research findings, from medicine but also from psychology and psychiatry. These kinds of experts played an increasing role in defining government publications and also, as we have seen, workplace prescriptions.

## Finding the materials

Relatively few prescriptive works are very famous; they hover well below the levels of great literature. A few authors gained unusual attention, like the paediatrician Benjamin Spock whose childrearing book went through multiple editions after 1946.[10] But prescriptive authors generally sought a wide audience, so while the category requires some research it is usually quite accessible.

Furthermore, some prescriptive categories have been studied for other reasons. Family advice literature, for example, has been probed as part of women's history – which makes identifying key works easier.[11] Where periodicals enter the picture, again it is often possible to identify particularly important works, if only because of their subscription levels and durability; in the childrearing field *Parents Magazine* (founded 1926) falls in this category. Not surprisingly some topics invited such a flood of prescriptive enthusiasm that finding materials is far less a problem than trying to figure out which works are particularly representative or influential. Happily, while there are of course some disagreements from one author to the next, a good bit of prescriptive material in a given time period overlaps and repeats on the issue of emotional goals and standards – and this consistency in turn reflects the common standards involved.[12]

In certain categories – nineteenth-century childrearing literature, for instance – many works are available online, which not only facilitates access but allows quick sorting for relevant passages through the use of key words. And, for many languages, Google has developed an Ngram search mechanism that allows students to chart patterns of word frequency, in some cases from the sixteenth century to the present day. The books that have been digitised are not just prescriptive materials – they also include literature and scientific research – but the overall corpus is at least suggestive of prescriptive interests, and again the system can help guide enquiry.[13]

Overall, the prescriptive genre is far more accessible than some other sources for emotions history. There are some challenges depending on category, and certainly a need for care in determining representativeness. But in many cases the issues prove manageable.

## Some samples

Prescriptive materials, no matter what their specific form, seek to convey and generalise emotional standards accepted, or sought, either in society as a whole or within a major group or organisation. They work, in other words, to translate wider cultural values – group harmony, individual success, the desirability of happiness – into more explicit emotional formulas, including efforts aimed at the socialisation of children. As such, prescriptive standards automatically have real importance in indicating widely shared, or at least widely propagated, emotional goals. Some more specific examples will convey the potential value but also the range of prescriptive materials more directly – without claiming any comprehensive survey.

British or American family manuals written during the first two-thirds of the nineteenth century convey a pretty clear picture of emotional standards.[14] The family is to be filled with love – beginning with a loving wife and mother. Good women have, by nature, emotional qualities that set the framework for a successful family, capable of avoiding disruptive emotions like anger. Parents are urged not only to surround children with affection, but to be sure not to use anger and also fear in discipline – for these emotions would only disrupt childish innocence. Emotional goals for boys and girls did differ. While girls should be trained to keep their tempers in check, boys should be urged to restrain anger within the family but keep the capacity for the outside world – as a spur to fighting injustice or sustaining business competition. 'Channelling' was the key for boys, and sports (including boxing) were seen as a great way to help boys keep the emotional spirit alive but move it out of the family environment. For married couples themselves, the theme of anger control was maintained by frequent references to the disruption of the 'first quarrel' and the need to handle it carefully, within a loving framework.[15] Family and childrearing literature continue to be a vital prescriptive source to our own day, reflecting crucial changes such as a growing acceptance of envy and a growing commitment to children's happiness.[16]

A second example: by the later nineteenth century, school teachers in the United States and elsewhere in the Western world were increasingly urged not to shame students as a means of discipline. Shaming would simply make children feel bad and resentful, damaging their 'self-esteem' (a term first used as early as the 1850s). Rather, teachers should rely on more positive incentives, like praise, as their primary motivation. And indeed, though gradually, some traditional shaming practices – like the dunce cap – went out of fashion.[17]

And from the workplace, in a final example: spurred by industrial psychologists but also a growing concern about labour protest, corporations and personnel trainers began to urge greater control over anger on the job by the 1920s. This was the framework in which many foremen were sent for formal retraining, to teach them to handle emotions more carefully: 'Control your emotions, control your remarks.' For certain kinds of workers – secretaries, sales personnel – not just anger control but positive efforts to relate to customers and colleagues became essential. 'The secretary should never forget that in order to please people, he needs to exert himself.' A major effort was directed at training successful salesmen, under the guidance of Dale Carnegie, whose prescriptions emphasised the importance of smiling and people-pleasing regardless of the provocation.[18]

## Basic advantages

Using prescriptive materials to get at emotions history offers three fundamental strengths. First, and this follows from the fact that the materials usually reflect wider cultural values, assessing recommendations for spouses,

parents, workers, teachers helps to explore the nature of emotional experience in past time and to link emotional standards to other topics. Even the individual who finds it difficult fully to measure up to recommendations may be affected, like the women who recorded in their diaries, in the 1870s, how hard they tried to keep their tempers when dealing with husbands or children given the prescriptive belief that a 'lady' should not get angry. Prescriptions on emotion relate closely to wider subjects like gender, or consumerism, or management structure; thus a new kind of advice given to factory foremen from the 1920s onward, that they become friendlier with their workers, highlighted a significant change in beliefs about emotions and job hierarchies. Prescriptions can even tie into broader topics like war and violence: changes in prescriptive approaches to the need for courage, for instance, relate closely to the ways that military organisations seek to handle fear.[19]

Second, though this needs more attention: prescriptive materials can facilitate comparisons between one society and the next. The kinds of recommendations about cheerfulness drummed into American sales personnel in the early twentieth century were definitely *not* being given to similar personnel in the Soviet Union, who were regarded more as workers, whose grievances deserved attention, than as customer-pleasers.[20] Or another example: in the 1920s, a number of authors called attention to the growing interest in romantic love among many Japanese couples. Several prominent young people openly broke with their parents in insisting they had to follow their hearts in choosing a mate. This occasioned wide debate in the prescriptive literature about the role of love that can be compared to corresponding materials in Europe and the United States.[21] Again, examples of ambitious comparisons in emotions history are still rare, but prescriptive materials form an obvious starting point.

Third and most important: prescriptive materials facilitate the identification of change in emotions history – which in turn is one of the fundamental contributions emotions history makes in general. Most of the examples offered above signal change. Parents had not been urged to avoid fear in discipline until the 1820s – the use of bogeymen to scare children into compliance had a long tradition.[22] Employers had not worried about manipulating worker emotions, at least to the same degree, before the later nineteenth century. Prescriptions change – as these examples suggest – and this forms a vital entry into the exploration of emotional change more generally.

Sometimes, change shows up in new words used in the prescriptive literature, or a decline of old words; this is a vital contribution of these materials to emotions history more generally.[23] The eighteenth century saw the introduction of a new word, 'tantrum', to describe fits of anger, linking these displays with childishness. The idea of boredom began to be introduced at the same time, another emotional state that had not had a word before. Materials in the nineteenth century referred to 'sulky' children – another new word – suggesting a similarly new need to designate youth who were not disobedient exactly, but who were not adequately cheerful. Or another new word, 'soulmate', introduced

in the early nineteenth century to exemplify new goals in romantic courtship and love; the term would become even more popular in the later twentieth century, when it was associated with online dating services.[24] Or a final example: the word 'shamefast' was a widely used term in the English language to highlight people who were appropriately careful to control their behaviours so as not to risk shaming. But as shame was reconsidered, shamefast dropped out of common usage altogether during the nineteenth century, as prescriptive writers began to urge that shaming be avoided.

Often, change can be charted through tracking the frequency of word use through Google Ngrams or other data bases (such as the *New York Times* index). Shame came under attack from the later eighteenth century onward in the Western world, as a now-undesirable and demeaning emotion: and sure enough, the frequency of use of the word shame declined fairly steadily until very recent decades. Gratitude enjoyed great attention in the nineteenth century but then has declined massively in relative frequency until very recently.

Finally change, as measured in the prescriptive materials, can be dramatic. In the late nineteenth century, on both sides of the Atlantic, prescriptive literature played up the importance of grief. Family manuals urged people to realise that grief was a vital part of loving family life, sad to be sure but, if handled right, a tribute to beloved relatives. Etiquette books offered elaborate rules on how to deal with families that were in the mourning process. Fast-forward fifty years, to the 1920s. Family and personal advice now urged that grief was largely a nuisance, that children should be kept away from grief situations that were simply too unpleasant for them, and that individuals who could not shake off grief quickly needed psychological help. Manners books began to insist that grieving people risked being annoying to others – they needed to get a grip. The 'emotion rules' around grief had changed dramatically.[25]

## Challenges and risks

The advantages of prescriptive materials – relative accessibility, often-explicit clarity, links to other phenomena, and above all their service as indicators of change – are very real. But the same type of source has several problems – manageable, but requiring careful attention.

### *Where further analysis is required*

Authors of prescriptive materials may not be entirely aware of how their emphases relate to past standards. They may be innovating without being fully conscious of the fact. When family manuals in the 1820s urged parents not to use fear in disciplining they children, the authors suggested a vague perception that past approaches were different, but they did not spell out the change or deal with the reasons they thought a new type of emotional discipline was vital.

Or take another example: in the 1920s, prescriptive advice for parents began to emphasise the problem of sibling rivalry. Authors claimed that, when a new baby was brought home, a toddler-aged sibling would usually be so jealous that the baby itself might be in danger – and the toddler himself, if not managed properly, might grow up with an impaired emotional style, incapable of forming meaningful relationships. This had not been an explicit topic in the nineteenth century. But the new self-styled experts did not discuss their concerns as innovations; they were preaching change, but they did not evaluate or define the process involved.[26] This means, obviously, that in many cases the emotions historian has to make his or her own determination of change, by looking at roughly comparable prescriptive materials over time and figuring out at what points, and in what ways, significant innovations are occurring. The sources do not do the job themselves.

Sometimes, on the other hand, the need for explicit analysis may be turned on its head. Particularly in the twentieth century, when so much prescriptive literature issued from psychologists and other experts, specific signals seemed to change almost every decade or two. One group of authorities would seek to unseat the previous generation, claiming dramatic new insights. Thus, famously, childrearing advice in the decades between the world wars, influenced by behaviourist psychology, tended to be rather strict, and then it was relaxed a bit by more permissive experts, including the famous Dr Spock, in the later 1940s. There were, admittedly, some real changes involved. But a closer look at many of the emotional implications of the advice patterns over a half century suggests that some of the shifts were more apparent than real. Again, the emotions historian has to make, and document, his or her own decision about when significant change is involved.[27]

A second analytical challenge slides off from the first: prescriptive materials rarely directly suggest what *causes* change. The issues here can be fascinating, and they are obviously important not only in explaining what was going on but in linking emotional changes to other developments in society. The extent of the challenge can vary. The reasons for the new emphasis on controlling anger and encouraging cheerfulness in the workplace, in the early twentieth century, are not hard to find. The economy was changing, concerns about labour protest were mounting, a new type of expert – the industrial psychologist – was now helping to shape a new approach. Here, explaining the change, while important, is not rocket science.

Explanations for some other shifts are harder to come by. Figuring out why prescriptive materials newly filled with warnings about sibling rivalry is actually not an easy task. It probably relates to changes in the birth rate – fewer children meant more direct competition for parents' attention, and other shifts in the wider family and social structure. But the interpretive challenge is real and, again, the sources themselves do not do the job. It is important not only to figure out why prescriptive writers offered new advice, but also why there was a receptive audience: change involves both groups. The points are clear, and the challenge is usually really interesting: prescriptive materials help

pinpoint change, but defining the change requires explicit analytical effort and, then, explaining the causes of change and audience impact necessitate a further step as well.

### What the sources do not do

All this, in turn, leads to the next set of issues, where warning signs are essential. Prescriptive materials, suggesting what emotional responses should and should not be, are not, themselves, evidence of emotional experience. There is a danger that researchers, excited about their discoveries and eager to identify key changes in emotional patterns in the past, over-claim their results. Thus, merely because prescriptive materials urged new levels of anger control in the family, particularly on the part of mothers, does not mean that domestic anger diminished. All we can know, from the sources themselves, is that there was a new kind of interest in this type of restraint, by the early nineteenth century, and we can speculate about why. Without other evidence, we cannot claim to be sure of the connections between advice and reality.

Sometimes, prescriptive materials themselves can help in resolving this issue. Warnings about using fear in discipline, for example, emerging in the 1820s in the United States and parts of Western Europe, continued to be repeated in parenting advice for a full century – suggesting that experts were concerned that their audience was not following through. But then the advice dropped off, which may possibly suggest that enough parents already internalised this particular warning that experts could turn to other issues.

It is also often possible to evaluate prescriptive materials in terms of probable audience. Thus a few authors gained real fame, and even others wrote works that went through multiple editions – a useful though not infallible index of significance. In the self-help genre, works by Dale Carnegie or Norman Vincent Peale stand out for their sales records and authorial fame during the middle decades of the twentieth century. Prescriptive periodicals can be directly checked for sales levels: *Parents' Magazine* at its peak had over 2 million subscribers.[28] Sales records of other works are often available from the eighteenth century onward. Data of this sort at least suggest influence and interaction with real emotions, though of course it is impossible to say exactly why people bought a certain book or magazine or how much they internalised the emotional advice that was urged on them.

Sometimes, as well, particularly by the twentieth century, additional evidence links to the prescriptive materials. In the case of advice about sibling rivalry, by the 1930s polls of parents revealed that a large number listed this problem as a real and pressing concern. Whether they were responding to the advice or for other reasons, actual reactions were connecting to the new prescriptive emphasis.

Always, however, it is important to be cautious in equating prescriptive statements with emotional reality. This point may be particularly important in dealing with the attractions of Google Ngrams and similar quantitative techniques. Ngrams show patterns of relative frequency in word use, nothing more. They do not prove that, when word use goes down, an emotion is becoming less important.

They merely set up a problem for further enquiry. Thus the Ngrams for the United States and Britain clearly show that gratitude dropped pretty steadily, in relative reference frequency, during the later nineteenth and through the twentieth centuries. Was the actual experience of gratitude changing similarly? Only other kinds of research can allow an answer to that difficult question (and the enquiry is actually under way). Indeed, the obvious initial next step, when responding to these very superficial quantitative clues, is to look more deeply into prescriptive materials directly, to see if what parents, or teachers, were being told about gratitude was in fact changing in ways that mesh with the reference patterns.[29]

And there is a second warning, at least as important. Prescriptive materials, or at least the most obvious ones, come from dominant sectors of a culture. In modern Western history, that has usually meant the middle and upper-middle classes (the decline of the role of aristocrats in setting emotional standards is an interesting topic in itself). Workers and peasants often had little access to the materials and even less interest in them.

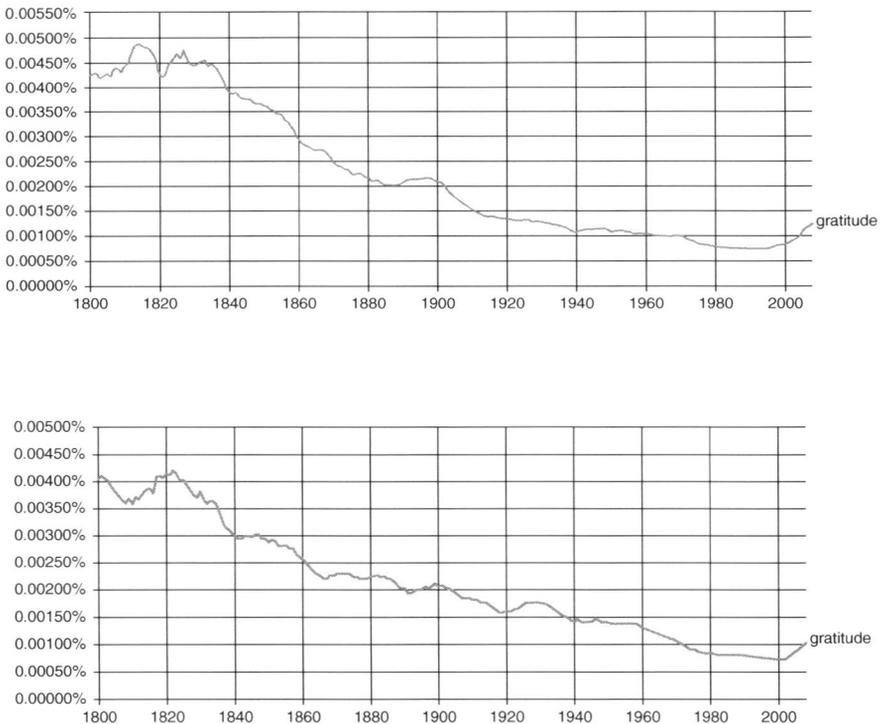

*Figure 5.1* The two Google Books Ngram Viewer graphs represent the frequency of 'gratitude' in American English (top) and British English (bottom) from 1800 to 2008

The social bias of prescriptive sources is a constant challenge. Of course, subordinate groups may have issued their own prescriptions. In the United States it is possible to trace Catholic or evangelical Protestant prescriptions and compare them with 'mainstream' (largely white middle-class Protestant) advice. But we must never assume that prescriptive advice applies equally, across the social spectrum.[30]

Even here, with appropriate caution, there may be connections. Lower classes may ultimately pick up, or be pressed to pick up, on some middle-class signals – this is one reason to pay more attention to prescriptive emotional guidelines in the schools, as mass education gained ground. Some key institutions, dominated by the middle classes, may respond to prescriptive signals in ways that affect other groups: thus new jealousy standards, reflected in the concerns about sibling rivalry, also reached into courts of law, making jealousy excuses for crimes of passion less tenable – for all social groups.

But the main points should be clear. Prescriptive materials offer a real, often fairly accessible, window into emotional standards in the past, and to key patterns of change. They invite further analysis that will help pin down connections to broader social and cultural patterns and to delineate change. They also require care and discipline, to avoid inaccurate leaps beyond what the evidence demonstrates. Most obviously, they invite combination with other types of sources, to help with the challenging problem of linking dominant advice to the actual emotional experience of key social groups. The links are often quite real, and prescriptive materials often also help make sense of other kinds of sources, for example in the area of law or personal testimony. The source is particularly intriguing not only because of its availability but also because of the additional steps its analysis requires.

## Notes

1 Jean Delumeau, *Sin and Fear: The Emergence of the Western Guilt Culture, 13th–18th Centuries* (London: Palgrave Macmillan, 1990); Susan Matt, *Keeping Up with the Joneses: Envy in American Consumer Society, 1890–1930* (Philadelphia: University of Pennsylvania Press, 2002); Peter N. Stearns, *American Cool: Constructing a Twentieth-Century Emotional Style* (New York: New York University Press, 1994).
2 Anna Bryson, *From Courtesy to Civility: Changing Codes of Conduct in Early Modern England* (Oxford: Oxford University Press, 1998); Merridee Bailey, 'In Service and at Home: Didactic Texts for Children and Young People, c. 1400–1600', *Parergon* 24, no. 2 (2007): 23–46.
3 Norman Kutcher, 'The Skein of Chinese Emotions History', in *Doing Emotions History*, ed. Susan Matt and Peter N. Stearns (Urbana: University of Illinois Press, 2014), 57–73; David Konstan, *The Emotions of the Ancient Greeks: Studies in Aristotle and Classical Literature* (Toronto: University of Toronto Press, 2007); Peter N. Stearns, *Shame: A Brief History* (Urbana: University of Illinois Press, 2017). For example, it has been estimated that well over a third of all Confucian writings deal fairly directly with emotional standards, most particularly the importance of shame. See also Ping-chen Hsiung, *A Tender Voyage: Children and Childhood in Late Imperial China* (Stanford: Stanford University Press, 2005).

Promising work on Russia has also widely utilised prescriptive materials: see Mark Steinberg and Valeria Sobol, eds, *Interpreting Emotions in Russia and Eastern Europe* (Dekalb: Northern Illinois University Press, 2011).

4  Peter Keating, *The Haunted Study: A Social History of the English Novel, 1875–1914* (London: Secker & Warburg, 1989).

5  Micki McGee, *Self-Help, Inc.: Makeover Culture in American Life* (New York: Oxford University Press, 2005); Daniel Horowitz, *Happier? The History of a Cultural Movement that Aspired to Transform America* (New York: Oxford University Press, 2018).

6  Norbert Elias, *The Civilizing Process: The History of Manners* (New York: Wiley, 2000). This study, based on manners books and arguing that Western society became increasingly capable of self-control from the Renaissance onward, has occasioned considerable controversy, in part because of the power but also limitations of the prescriptive materials it relies upon. See John F. Kasson, *Rudeness and Civility: Manners in Nineteenth-Century Urban America* (New York: Hill & Wang, 1991); Cas Wouters, *Informalization: Manners and Emotions Since 1890* (Thousand Oaks: SAGE Publications, 2007); Cas Wouters, *Sex and Manners: Female Emancipation in the West, 1890–2000* (Thousand Oaks: SAGE Publications, 2004).

7  William M. Reddy, *The Navigation of Feeling: A Framework for the History of Emotions* (New York: Cambridge University Press, 2001); Peter N. Stearns with Olivia A. O'Neill and Jack Censer, *Cultural Change in Modern World History: Cases, Causes and Consequences* (New York: Bloomsbury Academic, 2019), 82–87; Nicole Eustace, *Passion Is the Gale: Emotion, Power, and the Coming of the American Revolution* (Chapel Hill: Omohundro Institute and University of North Carolina Press, 2011).

8  Ute Frevert, Pascal Eitler, Stephanie Olsen, Uffa Jensen, Margrit Pernau, Daniel Bruckenhaus, Magdalena Beljan, Benno Gammerl and Anja Laukotter, *Learning How to Feel: Children's Literature and the History of Emotional Socialization, 1870–1970* (Oxford: Oxford University Press, 2014).

9  Susan Porter Benson, *Counter Cultures: Saleswomen, Mangers, and Customers in American Department Stores, 1890–1940* (Urbana: University of Illinois Press, 1988); Arlie Russell Hochschild, *Managed Heart: Commercialization of Human Feeling* (Berkeley: University of California Press, 1983).

10  Michael Zuckerman, 'Dr. Spock: The Confidence Man', in *The Family in History*, ed. Charles E. Rosenberg (Philadelphia: University of Pennsylvania Press, 1975), 179–207.

11  Nancy F. Cott, *History of Women in the United States: Historical Articles on Women's Lives and Activities* (New York: K.G. Saur, 1992).

12  In looking for prescriptive materials one can of course consult some of the available works in emotions history directly that have used these materials without exhausting the possible topics. There are other good guides, like Ann Hulbert, *Raising America: Experts, Parents, and a Century of Advice About Children* (New York: Knopf, 2003) or Christina Hardyment, *Perfect Parents: Baby-Care Advice Past and Present* (New York: Oxford University Press, 1995) – that help not only find titles, but decide which were the most representative or influential. Marriage manuals have also been widely probed for more general purposes, which offers an entry to materials of interest to the emotions historian: see, for example, Stephanie Coontz, *Marriage, A History: From Obedience to Intimacy or How Love Conquered Marriage* (New York: Viking, 2005). Prescriptive literature in the workplace has been less systematically studies, but there were some good guides for certain periods, like Loren Bartiz, *The Servants of Power: A History of the Use of Social Science in American Industry* (Middletown: Wesleyan University Press, 1960). For government publications, a research can consult relevant agencies, like the famous Children's Bureau in the United States. As suggested already, prescriptive literature

in the schools has been less examined from the standpoint of emotions history, but there are some guides to specific character-building programmes – for example, on the recent social and emotional learning (SEL) programme, www.Casel.org,www. responsiveclassroom.org.

13 The Google Books Ngram Viewer is an online search engine that graphs the frequencies of particular words appearing in Google Books. For a critique of the tool, see Barah Zhang, 'The Pitfalls of Using Google Ngram to Study Language,' *Wired*, 12 October 2015, https://www.wired.com/2015/10/pitfalls-of-studying-language-with-google-ngram/ (accessed 6 August 2018).

14 Two famous examples are Catharine Sedgwick and Catherine Beecher.

15 Steven Mintz, *Huck's Raft: A History of American Childhood* (Cambridge, MA: Belknap Press of Harvard University Press, 2004); Stearns, *American Cool.*

16 Matt, *Keeping Up with the Joneses.*

17 Peter N. Stearns and Clio Stearns, 'American Schools and the Uses of Shame: An Ambiguous History', *History of Education* 46, no. 1 (2017): 58–75.

18 Edward Kilduff, *The Private Secretary* (New York, 1915), 50, 57; see also later editions to 1935; see also Margery W. Davies, *Woman's Place Is at the Typewriter: Office Work and Office Workers, 1870–1930* (Philadelphia, 1982), 95. The routinisation of claims of emotional control as part of professional competence in industrial psychology can be traced through standard textbooks (Hepner, *Human Relations*) and journals. Dale Carnegie, *How to Win Friends and Influence People* (New York: Pocket Books, 1998).

19 William Ian Miller, *The Mystery of Courage* (Cambridge: Harvard University Press, 2000).

20 Marjorie L. Hilton, 'Retailing the Revolution: The State Department Store (GUM) and Soviet Society in the 1920s', *Journal of Social History* 37, no. 4 (2004): 939–64.

21 Mark Jones, 'The Year of the Runaway Love: Emotion and Opportunity in 1921 Japan', conference paper presented at the international conference on emotions history at George Mason University, 1–2 June 2018.

22 Prescriptive materials are vital, for example, in interpreting what the rise of modest birthday celebrations meant for the people involved in the nineteenth century. Peter N. Stearns, Dante Burrichter, and Vyta Baselice, 'Debating the Birthday: Innovation and Resistance in Celebrating Children', *Journal of the History of Childhood and Youth*, forthcoming.

23 James M. Wilce, *Language and Emotion* (New York: Cambridge University Press, 2009).

24 Peter Toohey, *Boredom: A Lively History* (New Haven: Yale University Press, 2011).

25 Peter N. Stearns, *Revolutions in Sorrow: The American Experience of Death in Global Perspective* (New York: Routledge, 2007).

26 Peter N. Stearns, *Jealousy: The Evolution of an Emotion in American History* (New York: New York University Press, 1989).

27 Hulbert, *Raising America.*

28 Thus John Gregory, *A Father's Legacy to His Daughter* (1774) was a top eighteenth-century seller; when published in the US it was purchased by 20,000 people (21 per cent of the population), one of the top three sells in the whole period.

29 Peter N. Stearns and Ruthann Clay, 'Don't Forget to Say "Thank You": Toward a Modern History of Gratitude', *Journal of Social History* (March 2019) https://doi.org/10.1093/jsh/shy120

30 Tim Kelly and Joseph Kelly, 'American Catholics and the Discourse of Fear', in *An Emotional History of the United States*, eds Peter N. Stearns and Jan Lewis (New York: New York University Press, 1998), 259–282; Philip J. Greven, Jr., *Spare the Child: The Religious Roots of Punishment and the Psychological Impact of Physical Abuse* (New York: Kopf Doubleday Publishing, 2010).

# 6    Medicine, science and psychology

*Rob Boddice*

Historians of emotion have found scientific, medical and psychological sources relating to the emotions among the principal avenues of enquiry in exploring and unpacking knowledge about the affective life of humans and animals in the past, from ancient times to modernity. This chapter explores the extraordinary richness of these sources, which provide the most fundamental information about how passions, affects and emotions have been formally defined, as well as probing the challenges such sources often present. The further back in time we go, the more difficult it becomes to access either vernacular epistemologies or the experience of patients. Nonetheless, scientific and medical knowledge is 'in the world'. In analysing the wide variety of sources available, it can be shown how knowledge claims might be interrogated to find their measurable impact on lived experience more broadly.

The stakes of uncovering such past knowledge about affective experience are becoming increasingly high. As social neuroscientists provide substantial evidence for their claim that the development of emotion concepts directly colours the experience of emotions in the plastic, developing brain, so it becomes essential to know the sources of emotion concepts in the first place.[1] Since emotion concepts are not 'natural' or 'objective' (though they may seem that way), we must explore how they are made, according to dynamics of power and authority in the process of knowledge production. Communities of doctors, scientists and those who claimed to know the nature of the soul have held the principal positions in supplying the concepts that laypeople have used to conceive of their affective experiences. Those communities can therefore be understood to be partly responsible for how past 'emotions' felt. The caveat is that, prior to about 1850, those feelings did not usually concern 'emotions' at all, but other conceptual categories entirely. Sources relating to the production, maintenance and collapse of those categories that defined, prescribed and delimited affective experience – sources that largely fall within the compass of *Wissenschaftsgeschichte*, or the history of knowledge – therefore hold one of the keys to unlocking the historicity of what it felt like to be there, then.

# Scope

The history of medicine is particularly privileged within the history of emotions because so much medical knowledge about 'emotions' has been preserved from antiquity onwards. The history of science quickly takes us into natural philosophy the further back we go, but also presents a wealth of data from around the world. The history of psychology, properly considered, begins only in the nineteenth century, at the same moment that the worlds of medicine and science became specialised and professionalised, with psychology forming one such branch. Here I take a somewhat broader view, including sources from different periods that were chiefly concerned with the nature and function of the soul, with special reference to the passions. Still, modern psychology's rise to prominence as *the* custodian of emotion knowledge in the late twentieth century marks it out for special interest, especially as it has had the tendency of throwing a veil over the history of emotions in its claims of universality, auto-maticity, and non-cognitive bases for human emotions. In the light of recent disruptions of some of these fundamental orthodoxies, the sources in play here reveal as much about how the politics of academic primacy effect the erasure of alternatives as they inform about the construction of new knowledge. The sources also implicitly document how orthodoxies resist critical inroads. Given the extraordinary depth and breadth of the available sources in this domain, I will focus here on representative examples. The notes here provide a rudimentary guide to finding and accessing the rarer of these sources, with links to digitised originals where available. Readily available modern editions are cited in the standard format.

# Ancient sources

Can Aristotle (384–322 BCE) be described as an emotion scientist? Hardly. But Aristotle's ideas about morals and virtues and the passions of the soul certainly fall within the broader category of the history of knowledge. In this respect, Aristotle's contribution to the understanding of 'emotions' over two millennia cannot be overstated. Among today's positive psychologists and doyens of 'happiness studies', Aristotle is still much in vogue.[2]

While Aristotle's ideas about passions are spread throughout his oeuvre, his principal contributions lie in *De anima* and the *Nicomachean Ethics*, for it is here that we learn about the soul or the animating life force, as well as the soul's passionate dispositions, the ways in which passions are practised either as virtuous or vicious behaviour, the importance of temperance, and the blueprint for the good, or happy, or, perhaps better yet, the *good spirited* life in *eudaemonia*. The problem for historians who want to use Aristotle lies in the inadequacy of modern translations, which were not meant to serve historians of emotion. The same applies to almost all renderings of Greek and Latin into English, where specific and situated conceptual knowledge about *feelings*, construed in its broadest sense, have been reduced and re-cast as 'emotions'.[3]

This is perhaps unsurprising, representing the general reception of a biologically reductionist notion of human emotion that has been dominant in the West since the 1960s and 1970s. Yet it is extremely unhelpful for those of us with a specific interest in how affective life was both understood and practised in the past. Returning to the Greek sources, one cannot fail to be struck by the distance between Aristotelian *pathe* and so-called 'basic emotions'.

This presents an enormous challenge for many, for whom the sources are *all Greek*, but it seems to me an essential component of source criticism to reject any a priori assumptions that translations of ancient works are faithful to the original's contextualised concepts and epistemologies.[4] Fortunately, there is a good secondary corpus to support work on Greek and Latin works that have been foundational for what we might now think of as 'emotion knowledge'.[5]

If Aristotle dominates Western thought on the passions and their social and political implications, Galen dominates equally in medical terms. Galen (130–210 CE) in turn was working in the Hippocratic tradition (Hippocrates, 460–370 BCE), such that both merit serious attention, with the same critical caveats as for work on Aristotle.[6] Galenic medicine endured until well into the nineteenth century, and one might fruitfully follow the ways in which Galen was translated and applied in a great variety of historical periods and places. Insofar as the focus here is 'emotion', we again must proceed with caution, for there are no emotions in Galen's works. But Galen fills in the bodily background to the passions, rooting 'temperament' (from the Latin *tempere*, 'to mix') in the specific admixture of bodily humours. These liquids – blood, yellow bile, phlegm and black bile – were physical presences that had to be balanced in each individual, affected by climate, diet, race, sex, activity, and so on. The simple fact that from these physical substances we have derived affective characteristics – the sanguine, the bilious, the phlegmatic and the melancholic – ought to impel us to understand what these categories originally meant and how they came to change. Most interesting of all, perhaps, is melancholy, which became a major philosophical, artistic and medical concern, and which in modernity lost all connection to black bile and became a disposition of the brain as a forerunner to modern 'depression'.

The Galenic corpus, written in Greek, was handily translated into Latin (but preserving the Greek) by Karl Gottlob Kühn in the 1820s, which already permits study of the slipperiness of concepts when wrought into other languages.[7] The historical value of such a source lies largely in the way it reveals past sensations and past feelings as embodied experiences with physical causes. In *A History of Feelings*, I particularly highlighted the significance of this as it pertained to bleeding as a cure for affective dysfunctions and diseases. Galen prescribed bloodletting for those who carry on with 'a sense of heaviness' (*gravatur tenditurve* in Latin translation, something like 'weighed down tension'; *barunomenois* in Greek, something like 'being weighed down' or physically, literally 'depressed'). Here a physical problem with a physical cause is given a physical solution, but the signs of the problem are sensory and affective: 'a sense of heaviness … mental sluggishness and a dulling of

consciousness'. The sign of the cure is *feeling* better.[8] This rationale, of the entanglement of felt experience and bodily dis/order, dominated Western medical thinking for a millennium and a half.

The need to look beyond the West is becoming critically urgent within the history of emotions, not least in order to understand how encounters between competing or incompatible epistemologies and medical practices have played out. A growing body of work on ancient China, for example, has demonstrated the fundamental intertwinement of the sensory, the 'emotional' and the cognitive, and the distinct historico-cultural development and framing of Chinese sensory-emotional concepts.[9] A key source here is the *Huangdi neijing*, a canon of medical treatises. Angelika C. Messner states that 'the whole canon reflects the *development* of concepts which obviously were inseparable from the creation of authority within the field of medicine and of the field of medicine itself within society'. Its formulations are traced as far back as 400 BCE, up to the second century CE. [10]

## Medieval and early modern sources

Medieval sources of note concern the translation and practical adaptation of much older texts, which is not to say that these sources were not also conceptually innovative.[11] Here I draw in particular on the useful synthesis of Simo Knuuttila, who highlights the following: the translation into Latin of 'Alī ibn al-'Abbās al-Maǧūsī's Arabic medical encyclopedia (c. 980), first by Constantine the African in c. 1080 (the *Pantegni*) and later by Stephen of Antioch in 1127 (the *Regalis dispositio*); and *Liber de Anima* or *Sextus de naturalibus*, the Latin translation of Avicenna's *Shifā'* (*Book of Healing*) from the twelfth century, which in turn helped frame the reception of Aristotle's *De anima* as it was rendered in Latin between the mid-twelfth and mid-thirteenth centuries.[12]

The Aristotelian domination of 'psychology' was matched only by Galenic ideas of the physical basis of human sensory and affective experience. Knuuttila highlights a Galenic medical classificatory system that reckoned with the speed and directionality of 'vital spirits', and which was reproduced from the eleventh to the seventeenth centuries by the likes of John of la Rochelle (*Summa de anima*, 1235), Maino de Maineri (*Regimen sanitatis*, c. 1336), and Jacob Wecker (*Medicinae utriusque syntaxes*, 1576).[13]

Maintaining a strict demarcation here between 'scientific' or medical sources and theological or philosophical texts is difficult if not impossible, especially since the central concern here is the production of *knowledge*. Thomas Aquinas (1225–1274), for example, cannot be overlooked for his theological contextualisation and applications of Aristotelian thought (*Summa Theologica*, c. 1265–1274).[14] Fundamental divergences in the ways in which sensory and affective life were both conceived and functioned can be read across competing canonical works, such as Albertus Magnus' (c. 1193–1280) *De homine* and *De bono*, Bonaventure's (1221–1274) *Commentaria in quatuor libros Sententiarum* and the third book of Duns Scotus' (1266–1308) *Ordinatio*

on the passions of Christ.[15] If these might be said to constitute the typical medieval canon, other figures left voluminous sources that demonstrate both the intellectual latitude available even within orthodox theological lines and the vicissitudes of practical medical experience. Most important here are the works of Hildegard von Bingen (1098–1179), who wrote both visionary treatises with esoteric conceptualisations of sensory and passionate functions, and practices and practical medical texts on the causes, treatments and cures of diseases. These are complemented by an extensive body of extant letters in Latin that demonstrate the practical negotiation of contemporary 'emotion' knowledge in everyday life.[16]

The challenge of all these sources is linguistic, for while there are translations of practically everything, those translations may be antithetical to historicist intentions. The other principal challenge is the distance of most of these sources from lived experience (Hildegard is the exception). Direct engagement with the original language is essential. Into the early modern period, this imperative remains, even where Anglophone scholars are engaging with texts originally written in English. The 'false friend' lurks in 'emotion' concepts that look or sound familiar to presentist understandings. Key here is Robert Burton's (1577–1640) *Anatomy of Melancholy* (1621, but revised and expanded five times up to 1651).[17] Not only do the many editions make for fascinating comparative work in their own right, but Burton's melancholy is wonderfully situated in many worlds, from medical to artistic. The book amounts to a whole treatise on early modern emotions. Read in the context of its reception, it is a good starting point for understanding situated emotion concepts and the vicissitudes of their experience.[18]

Descartes is perhaps an obvious figure to mention here, since his work appeared in both French and Latin (making for interesting comparison) and has since been frequently translated into English and many other languages. His work is best known for its denial of an immortal soul to non-human animals, meaning not only that they did not reason, but also that they did not feel. The original source, the *Discours de la methode*, continues to reward study.[19] It is a blueprint for the scientific use of animals in research, predicated on the absence of feeling. But there is more here besides: Descartes' famous line *cogito ergo sum* pertains specifically to soul's movement with which it apprehends the world. Here *cogito* is better understood as a contraction of *con agito* – with movement – and is fully explored in Descartes' *L'Homme*.[20] Here, the passions of the soul were indicative of humanity's divine nature.[21] Everything depended on movement, for the soul gained an awareness of the body's movements, and its own movements were projected outwards to form expressions of itself. These, literally, were *e-motions* (*e* = 'outward' and *motion* = 'movement'). Descartes' fame is often couched in the separation of mind and body, in a dualism that proved enormously influential in medical and psychological sciences over more than three centuries. But it is in the fundamental connectivity between the mechanical movement of the body and physical movement of the soul, the placement of the latter inside the former, secreted in the pineal gland in the brain, that

we find the roots of automaticity of expression and human emotional exception-alism. As ever, it is worth reading sources in context. Often overlooked is Descartes' contemporary Marin Cureau de la Chambre (1594–1669), whose innovations in a proto-science of emotions remained couched in Aristotelian thinking. He has even been claimed as the true pioneer of neuropsychology.[22] And these formal, canonical works are further complemented by evidence of daily practice in the form of medical case notes, midwifery manuals and an extra-ordinary range of anatomical models that embodied passionate expressions of ecstasy and agony at the same moment as they rendered the human frame inert and unravelled for the medical student's gaze, culminating in Susini's *Venerina* in 1782, currently displayed in the Palazzo Poggi, Bologna.[23]

## Enlightenment and modernity

For all that Descartes' shadow looms over scientific and psychological notions of passions and, later, emotions, well into the nineteenth century, it did not go unchallenged. Baruch Spinoza (1632–1677) provides the essential reading against Descartes, his *Ethics* supplying its own chain of thought on the nature of the self, of passion and *affectus*, that would influence thinkers in political, philosophical and scientific spheres down to the present, from Thomas Paine (1737–1809) to Gilles Deleuze (1925–1995) to Antonio Damasio (1944–).[24] Spinoza's importance lies in the rejection of Cartesian dualism and in the completely innovative construction of new conceptions of the passions and their relationship with reason. The *Ethics* is a biopsychological treatise as much as a philosophical one, for it attempts to define and explain functions of the soul in its relation to God/nature.

Despite Spinoza's influence, the Enlightenment period witnesses a pro-liferation of new theories and concepts for the passions. Given their later influence on a science of emotions, it seems reasonable to include the princi-pal works by Adam Smith (1723–1790), David Hume (1711–1776), Edmund Burke (1729–1797), Francis Hutcheson (1694–1746) and the third Earl of Shaftesbury (1671–1713) under the head of *Wissenschaftsgeschichte*, even though they have chiefly been explored as part of the histories of philosophy, morality and society.[25] Indeed, Smith in particular might be considered the father of social psychology, his *Theory of Moral Sentiments* being essential background for Alexander Bain (1818–1903), Herbert Spencer (1820–1903) and Charles Darwin (1809–1882).

The latter thinkers would have to wrestle with Smith's ambiguous moralism and somehow also handle the long shadow of Descartes over the science of emotions, which lasted well into the nineteenth century. Charles Bell, for exam-ple, combined his skills in anatomy and art to produce a work that illustrated why the face looked the way it did when undergoing certain passions or pains, and why it could look no other way, in a treatise ostensibly to help painters achieve verisimilitude in rendering emotional expressions. Bell, a surgeon and anatomist, understood the passions of the soul to have been put there by

intelligent design, but he also firmly believed that the expression of those passions was divinely delimited, universal and automatic in humans.[26] The source is invaluable as a record of how discrete passions were supposed to look.

Early canonical sources for the history of psychology as a discrete scientific discipline remain essential reading if we are to understand the scientification of vernacular emotion categories. Of particular note are works by Bain, William James (1842–1910) and Wilhelm Wundt (1832–1920).[27] What shines through the published works is the situation of early psychology within broader physiological concerns. For comparative psychology, the compendious but often forgotten volumes of George John Romanes (1848–1894) demonstrate a clear intellectual and personal link between the study of animal emotions and Charles Darwin's theories of evolution.[28]

Darwin's own work became canonical in the everyday understanding of the evolution of civilised emotions in late Victorian and Edwardian societies. But it is his *Descent of Man* that provides the key reading here, not the red herring work of *The Expression of Emotions in Man and Animals*, about which more below.[29] Behind the scenes, readily available repositories of correspondence that cluster around Darwin illuminate not only the epistolary development of a new science, but also science's political salience. New emotion concepts not only justified innovative research on the brain and the body, but also defined that work as a novel form of affective practice, as well as providing an effective defence of potentially unpalatable methods (especially concerning vivisection). Here scientists and medical researchers left traces of their understanding of science as an emotional practice, fit for men of a certain emotional bearing, in compendious sources produced by committees of parliamentary inquiry (in the United Kingdom), or as extensive remonstrances against lay oversight of medical research in legislatures (in the United States).[30] They speak to the imprint left by a science of emotions on the emotions of scientists themselves. In Conwy Lloyd Morgan's (1852–1936) *Introduction to Comparative Psychology*, we find the reason for Romanes' obscurity.[31] Morgan, Romanes' mentee, promoted a startlingly different approach to interpreting animal emotions: behaviourism. This cynical view breathed new life into the animal machine.

In all of these works we find the attempt to pin down working definitions of the category 'emotion' and programmatic strategies for operationalizing further research. That they are comparatively incongruous and led to divergent strands of investigation does not alter the fundamental point that each provided a set of conceptual orthodoxies for increasingly insulated disciplinary atmospheres and techniques. The rise in laboratory science and of disciplinary psychology were both of significant moment for the world of medicine, as much for research as for clinical practice.

Famously, new conceptions of emotion and emotional dysfunction, representing a coalescence of Darwinian and proto-psychoanalytical ideas, had a large impact on the treatment of the insane. From the hysterical men and women under the care of Charcot (1825–1893) at the Salpêtrière, to the

patients under the care of James Crichton-Browne (1840–1938) at the West Riding Lunatic Asylum, the influence of laboratory science and psychological ideas was directly *applied* in the spirit of patient health and scientific curiosity. Both institutions, and others like them, leave us with extensive archival traces of clinical insight, patient encounter and medical photography.[32] The asylum represents the arena par excellence where scientific ideas about how emotions functioned and dysfunctioned, according to novel emotion concepts, were practically operationalised. What has become clear is the extent to which patients (especially Charcot's patients) quickly understood and internalised what was expected of them from the point of view of physical practices of emotional dysfunction. Patient and doctor converged according to the idea of emotional instability, and we might wonder if this had the effect, at least for some patients, of ameliorating symptoms as a result of the clinical satisfaction of the doctor. Strategies of emotional coaching, emotional staging (especially in demonstrative lectures, clinical rounds and photographic endeavours) and emotional dissonance (the failure of patients to feel or behave according to new clinical standards) are all fair game for the historian through the sources left to us, which often include writings by patients themselves.[33]

A major innovation that impacted on medical-scientific affective practices and the emotional experiences of human patients and experimental animals was the advent of anaesthesia (in the form of ether and chloroform, first demonstrated in 1846, but widely employed only later, with the first textbook on the subject being published in 1914).[34] Sources here pertain to distinct ethical and experiential arguments, sometimes personal, sometimes political. Anaesthesia was central to medical-scientific arguments – before legislative bodies, in the press, and through pressure groups established to protect research – about the preservation of tender emotions, sympathy and compassion among the medical and surgical class, for it allowed them to operate without causing pain. At the same time, it allowed them to shift those tender emotions beyond the immediate scene, towards calculations of diminished suffering at a societal level. In the process, there were countless discussions of the capacity of animals to suffer in the experimental environment. Meanwhile anaesthesia, where it was available and applied, transformed the patient experience of surgery, diminishing pain and its attendant, fear.[35] Visual sources capture the complexity in this shift in the emotional register, or drama, of the operating theatre, with Thomas Eakins' *Gross Clinic* (1875) standing out in this regard.

If disciplinary preoccupations were the cause of divergence in ideas about what emotions were and how they went wrong, the First World War marks a major point of disruption and instability. In a recent exemplary study, Todd Meyers and Stephanos Geroulanos demonstrate the astonishing breadth of medical source material available in demonstrating the disintegration of concepts of experience, sense, emotion, pain and shock wrought by a surfeit of disintegrating human bodies and minds from the battlefield. Medical treatises, laboratory procedures, field procedures, patient encounters and case notes are all entangled in a competing mess of theories, with the boundaries of

'medicine' being blurred by inroads from physiology, anthropology and psycho-analysis. Laying out this array of sources, the authors show that fixed ideas of how humans *worked*, emotionally, experientially, sensually, became uncertain, plural, mysterious.[36] At the same time, the catastrophes of the war shattered many of the conceits that underlay theories of the emotional evolution of civilised society, making the emotional and moral content of Darwin's *Descent* something of a dead letter. In many ways it had already been replaced, or perhaps *usurped* is better, by the new sciences of biometry and eugenics, which housed an acutely racist and classist *scientism* within reportedly objective procedures. Here, the collected works of Francis Galton (1822–1911), compiled by his disciple Karl Pearson (1857–1936) and published between 1914 and 1930, make for rich reading concerning the abstraction and intentionalism of social emotions. Pearson's own attempts, in popular pamphlets, to popularise his creed of social nationalism through a cor-ruption of Darwinian sympathy are equally compelling.[37] For these reasons, it is essential to read medical and scientific sources against each other, mapping the rapidly changing intellectual and conceptual ground regarding emotions.

## Post-war physiological and psychological orthodoxies

I referred above to Darwin's *Expression of Emotion* as a red herring. In its own time, this work was overshadowed by Darwin's more famous tomes. *Expression* was about what animal and human faces *looked* like. It had little to do with emotion itself. Yet *Expression* became interesting again as a key intertext in the history of twentieth-century psychology. Despite its rather loose credentials as a key work in emotions history, it was given enormous retrospective stature by latter-day psychologists who craved an authoritative-sounding intellectual gen-ealogy for their own theories. Ruth Leys' recent book *The Ascent of Affect* has demonstrated clearly the extent to which Sylvan Tomkins, Paul Ekman and others appropriated Darwin's *Expression* – Ekman went so far as to annotate a new edition, claiming to have inherited this particular Darwinian mantle – in order to ground affect theory, basic emotions, automaticity, emotional universals and non-cognitive emotions on seemingly solid foundations. Leys, among others, has demonstrated the extent to which this strategy was based on assumption, fallacy, mis-reading and wishful thinking, but the sources produced by affect theorists and emotion reductionists from the 1960s through the 1980s (and per-haps even down to the present) – mainly academic articles in psychology jour-nals – become key texts for reaching a critical understanding of how a new emotion-science orthodoxy was established and policed.[38]

Perhaps this perspective is key. Emotion scientists in the present still fre-quently proceed on the basis that 'emotion' exists as a discrete and objective phenomenon, to be found and explained, through methodologies interwoven with untroubled notions of objectivity, fact finding and neutral reporting. The rise of a new wave of emotion-detecting or emotion-defining machines has reinforced such naivety with mechanical awe. But we have seen all this before, and historians, anthropologists and sociologists have long since developed a

healthy scepticism of scientific neutrality and have developed reliable tools for exposing and exploring its affective ideological practices.[39] Post-war anthropological sources, moreover, based on ethnographic research all over the world, emphasise the cultural situatedness of 'emotion' and sit in stark contrast to the universalist tendencies in other scientific disciplines.[40] Sources in contemporary psychology are fair game, especially as psychology itself fragments along its own intellectual and theoretical fault lines.[41] Here, the perspective and methods that historians bring to bear upon emotion sources realise their political potential, in turn illuminating the political work of emotions history on more remote sources. For by challenging how we come to know what emotions are, how they work and who they serve in our own societies, we expose their fundamental mutability and the concomitant contingencies of lived experience. Contemporary psychology assumes its place among other narratives of emotions history and the critical source-criticism of historical evidence becomes a vital method in the future of emotions research, within the discipline of history certainly, but also beyond it.

## Conclusion

This can only be a sketch: a loose landscape of source material across more than two thousand years of history. Yet it ought to illuminate the most important aspect of doing emotions history in the fields of medicine, science and psychology: power structures behind knowledge production literally *make* the terms by which people emote, live by feeling and conceive of their own experiences. The obvious observation that these terms change over time introduces a further political dynamic: the how and why of knowledge and experiential transformation. We must always keep in mind the processes of translation, resistance and contestation that occur when people practise through or against constructed concepts as they live their lives. These processes are also constructive, and in turn influence knowledge production, but the precise ways in which this takes place are opaque and often the weak point of the historical record. Still, 'emotions' change over time. Now, the empirical observations of social neuroscientists echo William James: the only universal law is the law of variability.[42] This variability is recorded in the canonical medical and scientific sources, across the historical record. The how of that change is partly embedded in their details, partly recoverable from sources in other fields (political, cultural, institutional) and partly lost between the lines.

## Notes

Funded by the European Union's Horizon 2020 research and innovation programme under the Marie Sklodowska-Curie grant agreement No. 742470.

1  For a precis of emotional bioconstruction and the role of concepts, see Lisa Feldman Barrett, *How Emotions Are Made: The Secret Life of the Brain* (New York: Houghton Mifflin Harcourt, 2017)

2 For a summary of happiness studies, see Rob Boddice, *A History of Feelings* (London: Reaktion, 2019), 169–87.
3 Even an excellent recent guide to the way such theories were applied in medieval times falls into this mistake. Simo Knuuttila, 'Medieval Theories of the Emotions', *Stanford Encyclopedia of Philosophy*, plato.stanford.edu, accessed 27 June 2019.
4 In my own research I have found the Perseus Digital Library extremely helpful, allowing for detailed readings of Greek and Latin texts with an excellent 'word study tool', 'vocabulary tools' and parallel translations. See Perseus Digital Library, www.perseus.tufts.edu, accessed 26 July 2019. I use this in tandem with the Loeb Classical Library (Cambridge: Harvard University Press), which pairs original Greek or Latin text with English translations on facing pages. For those dependent on translations, always read more than one.
5 Exemplary starting points are David Konstan, *The Emotions of the Ancient Greeks: Studies in Aristotle and Classical Literature* (Toronto: University of Toronto Press, 2006) and Robert A. Kaster, *Emotion, Restraint, and Community in Ancient Rome* (Oxford: Oxford University Press, 2005).
6 Hippocrates' works can be read in Greek on the Perseus Digital Library.
7 Karl Gottlob Kühn, *Claudii Galeni opera omni* (Leipzig: Cnoblochii, 1826). Mostly available digitally via archive.org: https://archive.org/search.php?query=claudii%20galeni%20opera%20omnia, accessed 2 July 2019.
8 Boddice, *History of Feelings*, 57–8.
9 See the impressive corpus of Paolo Santangelo, Sapienza University, Rome.
10 An extensively annotated translation is available in English. Paul U. Unschuld and Hermann Tessenow, *Huang Di Nei Jing Su Wen: An Annotated Translation of Huang Di's Inner Classic*, 2 volumes (Berkeley: University of California Press); Angelika C. Messner, 'Emotions, Body, and Bodily Sensations within an Early Field of Expertise Knowledge in China', in *From Skin to Heart: Perceptions of Emotions and Bodily Sensations in Traditional Chinese Culture*, ed. Paolo Santangelo (Wiesbaden: Harrassowitz Verlag, 2006), 41–63 (41).
11 For an extensive summary, Barbara Rosenwein, *Generations of Feeling: A History of Emotions, 600–1700* (Cambridge: Cambridge University Press, 2015).
12 Knuuttila, 'Medieval Theories'; the original Arabic text is called *Kitāb Kāmil al-ṣinā'ah al-ṭibbīyah: al-ma'rūf bi-al-Malaki* and is known in English as *The Complete Art of Medicine*. The manuscript is in the Harvey Cushing/John Hay Whitney Medical Library, Yale University. A high-resolution digital copy of the *Pantegni* is available from the National Library of the Netherlands: https://galerij.kb.nl/kb.html#/en/liberpantegni/page/0/zoom/3/lat/75.69393145698817/lng/49.74609374999999, accessed 1 July 2019; the *Regalis Dispositio* is digitally available from Harvey Cushing/John Hay Whitney Medical Library, Yale University, http://findit.library.yale.edu/catalog/digcoll:189669, accessed 1 July 2019; Avicenna's *Kitāb al-Šifāẚ* is available digitally from the University of Toronto via archive.org: https://archive.org/details/kitabalshifafiki00unse, accessed 1 July 2019.
13 The *Summa di Anima* is available from the Bodleian Library, Oxford, MS. Canon. Misc. 338; the *Regimen sanitatis* was published in printed versions in Paris in various editions in the late fifteenth and early sixteenth centuries, held by the Bibliothèque nationale de France; the *Medicinae utriusque syntaxes* is available in high-resolution digital format via the Bayerische Staatsbibliothek https://reader.digitale-sammlungen.de/de/fs1/object/display/bsb11200141_00005.html, accessed 1 July 2019.
14 Harvard University Library's copy of *Summa Theologica*, 8 volumes (L. Vivès: Paris, 1856–60), is digitally available at archive.org https://archive.org/details/summatheologica04nicogoog/page/n9, accessed 1 July 2019.
15 Albertus Magnus, *De bono*, in *Opera omnia: Ad fidem codicum manuscriptorum edenda apparatu critico notis prolegomenis indicibus instruenda*, vol. 28, ed. H. Kühle et al. (Münster: Aschendorff, 1951); Albertus Magnus, *De homine*, in *Opera*

*omnia*, vol. 27, ed. H. Anzulewicz and J.R. Söder; Bonaventure, *Commentaria in quatuor libros Sententiarum*, in *Opera omnia* I–IV (Quaracchi: Collegium S. Bonaventurae, 1882–1902); John Duns Scotus, *Ordinatio. Liber Tertius* in *Opera omnia* (Vatican City: Polyglottis, 2006, 2007), vols 9 and 10.

16 Hildegard von Bingen, *Physica: Liber subtilitatum diversarum naturarum creaturarum* [1150–58], 2 volumes (Berlin: De Gruyter, 2010); *Causae et Curae* [before 1179] (Basel: Hildegard-Gesellschaft, 1980). For the letters see L. Van Acker, ed., *Hildegardis Bingensis Epistolarium, pars prima* (Turnhout: Brepols, 1991), *pars secunda* (Turnhout: Brepols, 1993), and, with M. Klaes-Hachmoller, *pars tertia* (Turnhout: Brepols, 2001).

17 Robert Burton, *The Anatomy of Melancholy* (Oxford: Henry Cripps, 1638) is available online at google books: https://books.google.ca/books?id=cPgveWnCdRcC&printsec=frontcover&redir_esc=y#v=onepage&q&f=false, accessed 1 July 2019.

18 For the contradictory entanglement of medical concepts of passion with the way those concepts were lived and practiced, with special reference to melancholy, see Erin Sullivan, *Beyond Melancholy: Sadness and Selfhood in Renaissance England* (Oxford: Oxford University Press, 2016).

19 René Descartes, *Discours de la methode pour bien conduire sa raison, & chercher la verité dans les sciences* (Leiden: Ian Maire, 1637), digital version available at the Bibliothèque nationale de France: https://gallica.bnf.fr/ark:/12148/btv1b86069594/f5.image#, accessed 1 July 2019.

20 Boddice, *History of Feelings*, 88–97; René Descartes, *L'homme* (2nd edition, Paris: Theodore Girard, 1677): digital version available at the Bibliothèque nationale de France: https://gallica.bnf.fr/ark:/12148/bpt6k942459?rk=21459;2, accessed 1 July 2019.

21 See also, René Descartes, *Les Passions de L'ame* (Paris: Henry Le Gras, 1649): digital version available at the Bibliothèque nationale de France: https://gallica.bnf.fr/ark:/12148/btv1b8601505n/f3.image, accessed 1 July 2019.

22 Marin Cureau de La Chambre, *Les characteres des passions*, 4 vols (Paris: Jacques D'Allin, 1642): digital version available at the Bibliothèque nationale de France: https://gallica.bnf.fr/ark:/12148/bpt6k1510396k.r=marin%20cureau%20de%20la%20chambre?rk=42918;4, accessed 1 July 2019. O. Walusinski, 'Marin Cureau de La Chambre (1594–1669), a 17th-century pioneer in neuropsychology', *Revue Neurologique* 174 (2018): 680–88.

23 For the classic use of the former, see Harvey Graham, *Eternal Eve: The History of Gynecology and Obstetrics* (New York: Doubleday, 1951); for the usefulness of the Anatomical Venus see Joanna Ebenstein, *The Anatomical Venus: Wax, God, Death & The Ecstatic* (London: Thames & Hudson, 2016).

24 A major source for the study of Spinoza, with parallel English or French translation, is R.W. Meijer's website: http://users.telenet.be/rwmeijer/spinoza/works.htm. Benedict de Spinoza, *Ethica*, 1677.

25 Adam Smith, *Theory of Moral Sentiments* (London: Penguin, 2009); Edmund Burke, *A Philosophical Enquiry into the Origin of our Ideas of the Sublime and Beautiful*, in *Pre-Revolutionary Writings* (Cambridge: Cambridge University Press, 1993); David Hume, *A Treatise of Human Nature*, (Oxford: Clarendon Press, 1975); Francis Hutcheson, *Essay on the Nature and Conduct of the Passions with Illustrations on the Moral Sense* (Indianapolis: Liberty Fund, 2002); Anthony Ashley-Cooper, Earl of Shaftesbury, *Characteristics of Men, Manners, Opinions, Times*, ed. Lawrence E. Klein (Cambridge: Cambridge University Press, 1999).

26 Charles Bell, *Essays on the Anatomy of Expression in Painting* (London: Longman, Hurst, Rees and Orme, 1806).

27 Alexander Bain, *Emotions and the Will* (London: John W. Parker and Son, 1859); William James, *The Principles of Psychology*, 2 vols (New York: Henry Holt and Co, 1890); Wilhelm Wundt, *Grundzüge der physiologischen Psychologie* (Leipzig: Engelmann, 1874)

28  George John Romanes, *Animal Intelligence*, 3rd ed. (London: Kegan Paul, Trench, 1882); George John Romanes, *Mental Evolution in Animals* (London: Kegan Paul, Trench, 1883); George John Romanes, *Mental Evolution in Man* (London: Kegan Paul, Trench, 1888).
29  Charles Darwin, *The Descent of Man, and Selection in Relation to Sex* (London: John Murray, 1871); Charles Darwin, *The Expression of the Emotions in Man and Animals* (London: John Murray, 1872).
30  The primary sources are too numerous to mention here, but see Rob Boddice, *The Science of Sympathy: Morality, Evolution, and Victorian Civilization* (Urbana-Champaign: University of Illinois Press, 2016) and Rob Boddice, *Humane Professions: The Defence of Experimental Medicine, 1876–1914* (Cambridge: Cambridge University Press, forthcoming) for full details and analysis.
31  C. Lloyd Morgan, *An Introduction to Comparative Psychology*, 2nd ed. (London: Walter Scott, 1903).
32  See, for example, J. Crichton Browne, *The West Riding Lunatic Asylum Medical Reports* (London: J & A Churchill, 1871); J.-M. Charcot and Paul Richer, *Les démoniaques dans l'art* (Paris: Adrien Delahaye and Émile Lecrosnier, 1887).
33  For example, Sander L. Gilman, 'The Image of the Hysteric', in *Hysteria beyond Freud*, ed. by Sander L. Gilman, Helen King, Roy Porter, G.S. Rousseau, and Elaine Showalter (Berkeley: University of California Press, 1993): 345–452; Mark Micale, *Hysterical Men: The Hidden History of Male Nervous Illness* (Cambridge, MA: Harvard University Press, 2008).
34  James Tayloe Gwathmey, *Anesthesia* (New York and London: D. Appleton, 1914).
35  For a precis of primary sources and the accompanying secondary literature, See Boddice, *History of Feelings*, 144–63; Boddice, *Science of Sympathy*, 65–71, 86–92; Stephanie J. Snow, *Blessed Days of Anaesthesia: How Anaesthetics Changed the World* (Oxford: Oxford University Press, 2008).
36  Stefanos Geroulanos and Todd Meyers, *The Human Body in the Age of Catastrophe: Brittleness, Integration, Science, and the Great War* (Chicago: University of Chicago Press, 2018).
37  Karl Pearson, *The Life, Letters and Labours of Francis Galton*, 4 volumes (Cambridge: Cambridge University Press, 1914–30); a representative example of Pearson's own work is his *Social Problems: Their Treatment, Past, Present, and Future* (London: Dulau, 1912).
38  Ruth Leys, *The Ascent of Affect: Genealogy and Critique* (Chicago: Chicago University Press, 2017); Charles Darwin, *The Expression of the Emotions in Man and Animals*, ed. Paul Ekman (Oxford: Oxford University Press, 2009). The foundations of the 'basic emotions' model are legion, and Leys documents most of them, but I mention here three of the most important: Sylvan Tomkins, *Affect Imagery Consciousness*, 4 vols (New York: Springer, 1962–3, 1991–2); Paul Ekman and Wallace Friesen, 'Constants across Cultures in the Face and Emotion', *Journal of Personality and Social Psychology* 17 (1971): 124–9; Paul Ekman and Wallace Friesen, *Pictures of Facial Affect* (Palo Alto: Consulting Psychologists Press, 1976).
39  Lorraine Daston and Peter Galison, *Objectivity* (New York: Zone Books, 2007) – an exemplary history of emotions and science in its own right, but also the blueprint for disrupting contemporary scientific claims of neutrality.
40  For a thorough review of these sources, see Jan Plamper, *The History of Emotions: An Introduction* (Oxford: Oxford University Press, 2015), 75–146.
41  The schism was opened by Alan Fridlund, *Human Facial Expression: An Evolutionary View* (San Diego: Academic Press, 1994); the gap was widened by Feldman Barrett, *How Emotions Are Made*.
42  This is the nub of Feldman Barrett's science. James said that 'emotions of different individuals may vary indefinitely', *Principles of Psychology*, vol. 2, 454.

# 7  Legal records

*Alecia Simmonds*

Looking for the passions of the past in the archives of law may seem, at first blush, counter-intuitive. What could law – that grand monument to universality and reason – tell us about the minutiae of individual emotions? Why search for proof of sentiment or feeling in an institution so steadfastly committed to its expulsion? After all, law in positivist thought is public, disembodied and general with its source of authority in the sovereign, the very opposite of emotion – as popularly conceived – with its clandestine languages, exquisitely personal manifestations, ephemeral traces and tendency towards the rebellious. Where law governs, emotion is ungovernable, disruptive of bodies and body politics.

Of course, these are crude dichotomies. When we think a little bit deeper about law, we start to see emotion everywhere, from the collective fears and anxieties expressed in a criminal code, to the loves and losses debated in family law, to the rowdy public gallery of a courtroom or the 'affective austerity' of a judge.[1] And when we turn our minds to emotion, we begin to see its profoundly juridical character: the reciprocal duties and obligations of friendship, the punishments dispensed by lovers or the emotional 'rules' or 'regimes' that historians of the emotions exhort us to study.[2] Far from being the conceptual antipodes imagined in popular discourse, law and emotions have long been engaged in an intimate frisson, and this makes legal archives a natural home for historians of emotions.

Historians who have examined legal records have noted their usefulness for recovering the voices of the poor, the inarticulate and the marginalised, albeit in a form constrained by legal procedure.[3] Legal testimony does not come to us as an authentic whispering across the centuries, but sounds more like a jumble of voices, a collaborative, slightly fictive enterprise undertaken by litigants, court clerks, lawyers and scribes.[4] For historians of the emotions, this brings into question the capacity for legal records to give us access to 'real' feelings, rather than those scripted by legal actors with an eye to legal success.[5] These debates over legal and government 'sources' as 'springs' for the truth of the past have recently extended, as Ann Laura Stoler has argued, to a study of state archives as a source in themselves.[6] We need to attend not only to archival content, she argues, but to archival form and process: 'prose style,

repetitive refrain, the arts of persuasion, affective strains that shape "rational" response'.[7] Thinking about legal archives ethnographically, as material culture, has also led historians to write about these records as sites of affective encounters between scholars and the papery relics of the past.[8] Legal archives do not simply tell of past emotions, they generate emotions among those of us privileged enough to touch them, to hear their pleadings, to examine the blotched, tremulous ink of a litigant caught in webs of power, unable to hold the pen still. In short, a legal case file may reveal the emotional norms that the state sought to enforce, the cultural repertoire of sentimental narratives used by legal actors, the purported emotions of litigants, and the shifting archival practices that channelled affects and emotions into bureaucratic forms. Finally, they may make you laugh, sob or shudder, and this encounter with the past will be generative of historical knowledge.

In this chapter I want to extend upon these historiographical insights in a number of ways. Firstly, the debate around the possibility of accessing 'real' emotions in legal records rather than those simply scripted for court under-estimates how heterogeneous and messy legal case files can be; it negates the sheer volume of original materials – from love letters to store receipts to lists of the items of a trousseau, medical reports, photographs, novels or lockets of hair – that may spill out of a yellowing folder and that were never intended for the court, nor for you. Secondly, legal records are not simply the 'rational' ordering of unruly emotions, but are themselves, at different periods and in different places, saturated in affect. Legal records belie the historiographical cliché of a prying, rational state subjecting its citizens to affective order and bureaucratic control. And finally, law can take us beyond the relationship between Western states and citizens, because there is no reason to confine legal records to Eur-opean forms. Like emotion, law is a permeable language that can be spoken across cultures, and legal archives can be found beyond courts.[9] Decolonising the history of the emotions means expanding our definition of law and legal records to encompass evidence such as bark petitions, gifts between sovereigns as well as non-European legal categories. As such, this chapter will begin with official legal archives and end on the beach of a Pacific island, with a treaty forged between two sovereigns through an exchange of pigs, guns and letters of friendship. Just as legal archives were crucial for social historians to gain access to the lives of the inarticulate poor, so too can they be at the forefront of decentred histories of the emotions written across time, place and cultures.

## Civil and criminal sources

### *Secondary sources*

Let us begin by imagining that we are historians interested in the history of love in an Anglophone country. We have read all the secondary literature on our topic and marvelled at the growth of romantic love in the Western world from the seventeenth to the nineteenth centuries, when it became sanctified as the ideal foundation of marriage.[10] We have noted the importance that historians place on

leisure, love letters and literature in this process, and have begun to question whether this history is somewhat biased towards the middle classes. What if a person's illiteracy or poor education made them incapable of writing giddy, frolicsome love letters? What if their work as a domestic servant allowed them no time to take moody strolls across ocean cliff-tops during a storm with their lover? Could the poor afford romantic love? It would be no use looking in the family papers of state archives to answer this question because diaries and letters were usually left by those with an eye to posterity, people of wealth and status. Similarly, literature, romance novels or government reports will have been almost exclusively written by the middle classes. One of the best sources for cross-class analysis, as social and cultural historians have taught us, will be legal records.

Having identified law as your source-base you will now need to find legal actions or suits relevant to romantic love. Your secondary reading has revealed that courting couples could be found in a range of civil and criminal actions including abduction, seduction, breach of promise of marriage, maintenance, sodomy and a variety of sexual assault offences. You may choose to examine all of these actions within a certain time and place, or just one or two actions over a long sweep of time. Either way, the discrete categories that the law presents to you will in practice bleed into each other and you should follow the source into all the domains of law that it may take you.[11] A case of marital cruelty in the divorce courts may appear earlier as desertion in the civil courts or assault in the criminal courts. Looking at law as a fabric, rather than just one thread, will reveal how emotions were subject to different standards of proof depending on the jurisdiction (the criminal law preferred bodily traces of sexual violence whereas civil actions were possible without this) and it will reveal the legal avenues available to litigants who used, and were not just subject to, the law.[12]

## *Legal treatises*

Once you have settled upon an action you will need to know the legal elements required to satisfy the claim, the established defences against the claim and the remedies offered, such as imprisonment in criminal offences or financial damages in civil actions. This will help you to understand how emotional content has been fitted to suit legal purposes and why particular lines of questioning are being pursued or why certain forms of evidence of emotion were adduced. Legal treatises had their high point in eighteenth- and nineteenth-century England when jurists such as Matthew Hale and William Blackstone sought to codify and systematise the very messy body of common law that had developed over the centuries. To this extent, treatises will be of less use for early-modern or medieval scholars, although you might find it useful to consult Littleton's *Tenures*, the key (and possibly, only) treatise in this period.[13] If your library subscribes to databases such as *The Making of Modern Law* you can access them there or you should be able to get them in hard copy from your library or a library attached to a Supreme or High

Court. In the example of nineteenth-century breach of promise of marriage, a legal treatise, such as Blackstone's *Commentaries on the Laws of England* or *Chitty on Contract*, would be the most obvious place to go for this information.[14] Here you would read that the plaintiff needed first to prove that there was a promise of marriage, and that this did not need to be in writing but could be established through evidence such as the exchange of letters, lockets of hair or gifts, walking out together, advertising a wedding date, community gossip or a trousseau. Do not stop your research with the first definition you find. Legal treatises were updated on average every ten years, which makes them an invaluable source for tracking how vernacular romantic practices became enshrined in law and how courtship practices shifted over time. An engagement ring, for example, has little place as evidence of a promise of marriage in nineteenth-century treatises but by the early twentieth century it was the primary form of proof.[15] When read alongside legal cases, treatises thus demonstrate the everyday life of law, its rhetoric of stability and its more malleable reality. Changes in treatises happened because people thought that a particular practice should have legal significance and they argued this in court. Over time, these successful arguments hardened into precedent until they were codified in legal treatises, reminding us that law developed from the ground up as much as it was imposed from the top down. Finally, do not assume that the legal elements outlined in a treatise will be followed in court. Judicial discretion, the inapplicability of certain metropolitan laws to the colonies and, in some instances, ignorance of the law on the part of its practitioners allowed for wide variation in practice.

*Newspapers*

Having now identified your action and its legal elements, your next step is to go to the newspapers to find the cases. In some countries, many newspapers are digitised so it may be simply a matter of searching for your action; alternatively you can search through police gazettes or microfilm of newspapers in state and national libraries. The first newspapers, or broadsheets as they were once called, began to appear in Anglophone countries in the 1600s[16] and principles of open justice meant that in most Western countries courts were generally available to the public. Descriptions of thronging crowds or rowdy public galleries show that law was a popular form of entertainment from the medieval period through to the mid-twentieth century. The press exploited this appetite and often provided verbatim transcripts of proceedings including pleadings by attorneys, oral statements by witnesses and litigants, directions by judges to the jury, questions by the jury to the judge, attorneys' reaction to the judge's or jury's decision, audience reactions throughout the trial and opinion commentary. In many Anglophone countries such as Australia, New Zealand, the United Kingdom and Ireland, press reports were the only official legal records until the late nineteenth century and therefore tend to be more reliable than archival records or official law reports for this period.[17] And unlike law reports, which were limited to

significant cases in which a principle of law was being debated, the press covered cases from the lowest to the highest courts. Newspapers are thus an essential source for legal histories of the emotions, both quantitatively, as a corrective to archival records, and for the kind of qualitative information they offer. Somatic evidence offered in newspaper records, such as fainting litigants, weeping attorneys or austere judges can reveal how emotional norms were given corporeal expression and how the body was understood to authenticate inner feelings, including which emotions were crucial to legal success.[18] They also raise questions that can start to undermine the cliché about law's timeless privileging of reason and restraint. When did it become important for the judge to perform objectivity and how did they do this? How did the laughter of the gallery work to undermine the seriousness of the plaintiff's harm? In what ways did the plaintiff make her suffering intelligible to the court? Was the plaintiff or defendant punished because of their failure to emote or because of over-emoting? And how do these affective performances translate to social media today, a primarily textual medium that also functions as a court of public opinion?

There are, however, drawbacks in using newspapers and gazettes. Editors may have had a preference for high-profile cases, scandalous proceedings, or famous litigants and attorneys, or they may focus their coverage on the major cities rather than regional areas.[19] You will also notice that there is no one true record reported in newspapers. Newspaper reports were generally the work of court reporters who were not legally trained and did not have access to court documents. As a result, they could get the complaints or facts wrong, they may spell the names of litigants incorrectly and those with a literary bent will provide novelistic details with fictional flourishes often contradicting crucial details found in other press reports. Rather than being frustrated by these discrepancies, historians of the emotions can use inconsistencies or possible fabrications to delve deeper into *why* the author might have done this, what romantic plot-lines, what telling details were necessary for a particular sentimental narrative to seem convincing? How were journalists involved in the creation and circulation of stories through which people made meaning of, and assessed their emotions as well as those of other people? And how did these change over time? Rather than imagining journalists as faithful transmitters of the truth, we would be better seeing them as one of many collaborators in the affective production of legal narratives.

### Civil and criminal court records

Newspaper reports will provide you with the public face of the hearing, whereas legal archives will give you access to all the behind-the-scenes action including witness statements, affidavits, writs, summonses, deposition papers and letters of pardon. Legal archives are usually found at a state or national repository that will be called something like the State Records Office or the State Archives, or they might be attached to a court, such as the Supreme Court or the Coroner's Court. Archives in Western nations came to be systematised in the nineteenth century

and, for positivist historians, carried with them the promise of objective, empirical proof. But don't be fooled. This official, state version of events is not always more accurate than that of newspapers. Historians of the medieval and early-modern period who used civil and criminal records to reconstruct the mentalities of non-elites, such as Carlo Ginzburg, Natalie Zemon Davis and Laura Gowing, inspired discussion about the peculiar narrative qualities of these records.[20] First, there is the narratological claim that all transcription involves a degree of fiction. Phenomena does not present itself to perception in the form of a narrative with a beginning, middle and an end, which means that literary traces of past emotion will always be an imperfect record of actual feeling. People make meaning of emotions, it is argued, through emplotting them on a story found within the existing repertoire of culturally acceptable narratives.[21] Confessionals, affidavits or letters of pardon may appear like life stories; in fact we are reading words that have crafted events or feelings into narrative form in order to be legally and socially intelligible.[22] Secondly, although the evidence may read like it is coming from the lips of the lower orders, it almost certainly is not. Legal testimony was written by third-party clerks who may have omitted certain details, altered phrasing and determined the kind of story through questions or requests that were not recorded.[23] Then there is the explicit notarial sequences and legal formulae, which affect what information will be included and how it will be structured. In criminal cases, there is further distortion engendered by the fact that we are dealing with litigants' or witnesses' 'enforced narratives' recounted after exceptional events (such as murder) under threat of punishment.[24] When we open a criminal file what we often find is a record of a vulnerable person captured mid-fall within the sticky webs of state power, who offers a fragmentary, mediated account of an extraordinary episode in their life, which now comes to us through the vocabulary of elites. Testimony from the criminal courts is, in Muir and Ruggiero's words, 'polluted with authority'.[25] It would be difficult to extrapolate from this proof of real feeling.

Legal records must thus be approached with prudence, yet it is important not to generalise. These debates mostly emerged out of historians dealing with medieval or early modern criminal records and are less applicable to civil court records, which, as William Reddy has argued, are less prone to distortion.[26] Cases, like debt or contract, were often part of the weave and weft of everyday life, and the narratives of plaintiffs (if not defendants) were wilfully given. In nineteenth- and twentieth-century Anglophone countries, civil and criminal case files also appear more heterogeneous than medieval records, as archival practices developed with the growth of the modern state. In a civil case file, you may find the petition or writ stating the grievance; a summons; affidavits by the litigants and witnesses; interrogatories (questions and answers by the plaintiff and defendant); bills of cost; orders by the court directing who is to pay for the costs; a praecipe, which is an order to the clerks of the court to produce a writ containing the formal decree made by the justice, including a summary of the decision; evidence submitted in support of the plaintiff or

defendant, including receipts, photographs, love letters, medical statements or tickets from trains; and correspondence between the judge and the litigants, particularly in cases involving alimony or negotiations over child custody. Criminal records, like civil records, also vary greatly depending upon the seriousness of the crime. But in general you would be likely to find indictments (records outlining formal criminal charges); warrants for arrests; depositions, which may include testimony from witnesses or litigants; exhibits; petitions; confessions; correspondence; additional police statements; medical evaluations; psychiatric case histories; letters of character; affidavits signed by the client or friends and family; accounts of trial proceedings (transcribed directly, or you may find them printed in publications such as *The Proceedings of the Old Bailey*) and court orders. Thus, life stories recounted in affidavits or depositions could be contrasted with evidence produced with no legal audience in mind such as medical records, letters or diaries. Further, extra-legal forms of evidence are often inscribed with the judge's underlining and marginalia which, when read alongside the judge's notebooks (sometimes available in archives), will reveal the forms of popular emotional expression that were intelligible to law and could be converted into legal rights.

Legal records from a coronial court are also likely to be more conceptually and materially expansive than a criminal or civil trial, by virtue of the different rules of evidence governing the procedure. Where the purpose of hearings in an adversarial system is to abolish ambiguity and to decide upon one correct narrative, with one clear victim and perpetrator, a coronial inquest is structured according to the rules of evidence governing an inquisitorial system where the primary purpose is not to win the case, but to discover the truth. The rules of evidence are more relaxed in inquests into deaths and priority is given to allowing witnesses to tell their own stories without interruption, or cross-examination, as would occur in an adversarial context. Coronial inquests also contain rich medical files which may reveal how establishing motivation – which typically involves questions of emotion – were subject to contested knowledges, and how different forms of expertise competed for jurisdiction over emotion.[27] It is thus important not to catastrophise when discussing the supposedly distorting effects of legal records. The evidentiary content of a case file as well as the structure of legal narratives will vary in accordance with archival practices, whether it is a civil or criminal trial, and whether it is an adversarial or inquisitorial hearing.

When treated with necessary caution, civil and criminal case files can yield rich material on the inner lives of people in the past as well as evidence of changes in emotional standards over time. Extra-legal forms of evidence such as diaries and letters can give you access to moments of spontaneous feeling unscripted by legal formula while misunderstanding or conflict between litigants, witnesses and jurists can reveal collisions between popular feelings and social norms. These tensions also often reveal different emotional standards across class, evident most clearly when litigants fail to understand a barrister's line of questioning or jurors ignore the judge's instructions and find a clearly guilty party innocent (female unchastity or infanticide are obvious examples

here). Letters submitted into evidence outlining the breakdown of a relationship, be it commercial or intimate, can also reveal informal community mechanisms developed to regulate emotional behaviour. By the time a case reaches court, the parties have usually already been subject to a series of informal trials conducted at street level or in houses by neighbours and kin along with threats of communal sanctions.[28] Letters and testimony can reveal the emotional norms that members of the community believe to have been transgressed and the role of emotions such as shame, humiliation or guilt, in enforcing social norms. In the space of one case file, we can see litigants move through a range of different emotional communities each with their own feeling rules and the fact of the litigant's transgression (presumably the reason why they have ended up in court) alongside the community's reaction to them can give us direct access to the social and affective norms governing these communities.[29]

## Archives

### *Affective encounters in the archives*

So far, we have discussed archival research as an extractive enterprise, one where we sift through the legal records contained in the papery catacombs of state records offices for knowledge of emotions and emotional standards in the past. But what if we were to take these archives as a source for the history of the emotions? What if we were to treat the archive ethnographically? This is an approach that has been recently advocated by historians such as Ann Laura Stoler, Carolyn Steedman and Arlette Farge, inspired partly by Michel Foucault's historically minded interventions into epistemology in the 1960s.[30] Rather than seeing archives as containing the truth about the past we should regard them as 'the system that establishes statements as events and things', he argued.[31] Archives authenticate historical knowledge, consolidate and solidify state power and determine, through exclusionary record-keeping practices, who and what will be remembered or forgotten.

Like law, archives – with their indexes, taxonomies, stylised grammar of citation and their promise of objective, impartial, empiricist history – seem like state memorials to the supremacy of reason. Indeed, we might read them as an example of sociologist Max Weber's rationally minded, scientific, bureaucratic state whose success is measured by its excision of all non-calculable emotional elements from official business.[32] In Weber's words 'bureaucratic domination' is characterised by 'a spirit of formalistic impersonality "*sine ira el studio*" without hatred or passion, and hence without affection or enthusiasm'.[33] Yet legal records reveal the state's persistent interest in the intimate and emotional lives of subjects, as well as showing that legal record keeping was not the positivist dream of impersonality that Weber imagined.[34] Observing how the form and content of the legal case files that we summon changes over time also allows us to trace the emotional life of bureaucracy, the way in which the emotional standards of state record keeping changed over time.

For example (and continuing with breach of promise of marriage as our case study), the judgment papers of the first Supreme Court Breach of Promise action in Australia in 1823 come bound in pink ribbon and are brimful of different-sized scraps of paper and seemingly proliferating styles of inky cursive announcing pleadings, summonses, a transcript of the trial, the original love letters from the litigants and the bill of costs (which fits on one page).[35] It is a cacophony of voices, literary and legal registers and a rag-bag of sepia-toned papers with none of the numbered formalities we see later in the century and all the suspense of a good drama. In place of a writ, we have the following statement of claim by the barrister: 'the said defendant contriving and fraudulently intending craftily and subtly to deceive and injure the said plaintiff' did go on to break his promise.[36] The affective registers found within the judgment papers exceed bureaucratic calculability; they are perhaps best associated with a form of charismatic authority based on, in Weber's words, 'an emotional form of communal relationship'.[37] Of interest to the historian of the emotions is how these archival remains change throughout the century, as law becomes professionalised and as new forms of bureaucratic governance minister to a developing industrial capitalist system. Adjectives are replaced by imperatives and hand-written scraps of varying sized paper are colonised by official, typed, standardised forms. Bills of cost grow longer and more ponderous with each decade as lawyers seek to show off their expertise and to make their labour calculable as law develops into a technocratic machine. 'Engaged three hours at night perusing Belgian and Swedish laws of divorce' explained one barrister in his bill of costs.[38] By the early twentieth century, judgment papers are thin and impersonal, delivered on pale-institutional blue paper creased into a rectangle. In certain jurisdictions, the materiality of the archive diminishes as forms of proof such as love letters or receipts for rings are recorded in itemised lists rather than preserved in the file. Modern bureaucratic record keeping did not need to preserve things, letters or voices. Its rationality, stability and calculability was founded on formal impersonal writing. As love and law began to self-circumscribe, to declare a learned incompetency in the realm of the other, law and its archival remains became disenchanted; emotion was banished from the record.

## Decolonising archives

Thinking about legal records ethnographically, as a form of material culture that changes over time, is a crucial step towards decolonising archives, denaturalising their authority and questioning their spatial limits. Why must we only look for legal records in state archives? Does this methodological presumption mean that our legal histories must be confined to societies that had a state, whose forms of judicial power were exercised within courts, or whose practices of governance were literate, transcribed on paper and authenticated through archival practices? Must we only look for law in English-language sources? If the answer is yes, then we are confining our histories of law and emotions to the West.

For many years, colonised peoples have exposed the complicity of European research in colonial domination by showing how systems of knowing are also

systems of power as Linda Tuhiwai Smith argued most famously in her book *Decolonising Methodologies*. [39] Orders of classification and representation in European archives worked to exclude indigenous knowledges, to assert the superiority of Western forms of knowing and reformulated archival fragments for political and violent purposes. State archives were also seen as the natural homeland for law which was a term that was attached to Europeans and their history, unlike the term 'custom' that signified a lesser form of law indicative of uncivilised status, and that was attached to indigenous peoples and anthropology. [40] A recent efflorescence of scholarship devoted to analysing legal relations between people in a colonial and imperial context has worked to undermine these colonialist dichotomies by demonstrating how colonised people used legal argument against Europeans and by exposing pre-existing indigenous understandings of treaty, property, contract and sovereignty. [41] In seeking to incorporate indigenous voices into the legal record, these histories are also finding new legal archives and methodologies in areas such as archaeology, oral testimony, ethnography and material culture.

In many of these multi-sided histories, emotion moves to centre stage as the medium for law's expression; like law, sentiment is a language spoken on both sides of the frontier. For instance, Rebecca Shumway has examined how intimate diplomatic rituals, known as the palaver system operated between Europeans and Africans on the Gold Coast of Ghana to effect treaties through oaths and visits. 'Gifts were delivered to satisfy wrongs done, to signify a promise of loyalty and demonstrate respect for authorities', she argues. [42] I have similarly suggested that performances of 'taio' or friendship between Australian and Tahitian political elites in the early nineteenth century 'enabled the negotiation of trade, sentiment and authority between cultures; it was where European and Pacific traditions of friendship became entangled'. What at first glance appeared to be an exchange of hogs and muskets between Australians and Tahitians dressed up in the finery of friendship, upon closer examination revealed an elaborate system of contract that was neither entirely Tahitian nor entirely European, it was an example of legal hybridity effected through sentiment, gifts and epistolary exchange. [43] Writing postcolonial legal histories of the emotions means being attentive to juridical structures outside of European legal registers and it means expanding our definition of a legal record beyond its European archival form.

### Conclusion

Once imagined as a 'vast filing cabinet'[44] ministered by bloodless bureaucrats, the archives of law in fact pulse with emotions. They are sites of affective encounter between vulnerable people, historians and the state. We can dwell within the folds of a writ and eavesdrop on the panicked pleas of the poor and the marginalised as they seek to make their feelings legible to courts in a quest for freedom, reputation, money or their life. We can see how litigants shape sentiment according to legal formula and we can listen to the jumble of voices – lawyers, scribes and clerks – that assist in the process of attaching personal pain to public legal meanings. Through comparing these archival records with

extra-legal sources such as newspapers, etiquette manuals, oral histories or diaries, we can gauge how the law could both shape and respond to shifts in collective emotional standards over time. Our task as archival historians can also be both extractive and ethnographic – to examine legal records for their content but also for their form. Archives can be analysed as a type of material culture created by Western states to serve empires and nation, and as a site of Western knowledge production that excluded indigenous legal traditions and ways of knowing the past. To this extent, while traditional legal archives found in state records offices are still rich sources for historians of the emotions, future directions point towards finding new archives of law outside Western states and taking seriously non-Western forms of knowing, recording and narrating the past.

# Notes

1 Kathryn Abrams, 'Emotions in the Mobilization of Rights', *Harvard Civil Rights-Civil Liberties Law Review* 46, no.1 (2011): 551–89 (568). For law and emotions scholarship see: Susan A Bandes, ed., *The Passions of Law* (New York: NYU Press, 1999); Terry A. Maroney, 'Law and Emotion: A Proposed Taxonomy of an Emerging Field', *Law and Human Behavior* 30, no. 2 (2006): 119–42; Renata Grossi, 'Understanding Law and Emotion', *Emotion Review* 7, no. 1 (2015): 55–60; Kathryn Abrams and Hila Keren, 'Who's Afraid of Law and the Emotions?', *Minnesota Law Review* 94 (2010): 1997–2074.
2 On feeling rules see Peter N. Stearns and Carol Z. Stearns, 'Emotionology: Clarifying the History of Emotions and Emotional Standards', *The American Historical Review* 90, no. 4 (1985): 813–36; for emotional regimes see William Reddy, *The Navigation of Feeling: A Framework for the History of Emotions* (Cambridge: Cambridge University Press, 2001). For a discussion of the history of the emotions more generally see: Jan Plamper, 'The History of Emotions: An Interview with William Reddy, Barbara Rosenwein and Peter Stearns', *History and Theory* 49 (May 2010): 237–65; see also Barbara Rosenwein, 'Worrying about Emotions in History', *American Historical Review* 107, no. 3 (2002): 821–45.
3 Natalie Zemon Davis, *Fiction in the Archives: Pardon Tales and their Tellers in Sixteenth-Century France* (Cambridge: Cambridge University Press, 1987); Laura Gowing, 'Gender and the Language of Insult in Early Modern London', *History Workshop Journal* 35 (1993): 1–21; Carlo Ginzburg, *The Cheese and the Worms: The Cosmos of a Sixteenth-Century Miller* (London: Penguin, 1982); V.A.C. Gatrell, *The Hanging Tree: Execution and the English People, 1770–1868* (Oxford: Oxford University Press, 1994).
4 Natalie Zemon Davis developed the methodology of reading legal sources as collectively crafted and deliberately framed narratives. See Natalie Zemon Davis, *Fiction in the Archives*.
5 Merridee Bailey and Kimberley Joy-Knight, 'Writing Histories of Law and Emotion', *The Journal of Legal History* 38, no. 2 (2017): 117–29; Joanne McEwan, 'Judicial Sources', in *Early Modern Emotions: An Introduction*, ed. Susan Broomhall (London: Routledge, 2016), Section III, Chapter 8.
6 Ann Laura Stoler, 'Colonial Archives and the Arts of Governance: On the Content in the Form', in *Archives, Documentation and Institutions of Social Memory: Essays from the Sawyer Seminar*, ed. Francis X Blouin Jr and William. G Rosenberg (Ann Arbor: University of Michigan Press, 2010), 267–80.
7 Ann Laura Stoler, *Along the Archival Grain: Epistemic Anxieties and Colonial Common Sense* (Princeton: Princeton University Press, 2009), 20.

8 Carolyn Steedman, *Dust: The Archive and Cultural History* (New Brunswick: Rutgers University Press, 2002); Antoinette Burton, 'Introduction: Archive Fever, Archive Stories', in *Archive Stories: Facts, Fictions and the Writing of History*, ed. Antoinette Burton (Ann Arbor: Duke University Press, 2005); Arlette Farge, *Le Gout de l'Archive* (Paris: Editions du Seuil, 1989).

9 See Ann Curthoys, Jessie Mitchell and Saliha Belmessous, *Native Claims: Indigenous Law against Empire, 1500–1920* (Oxford: Oxford University Press, 2011); Alecia Simmonds, 'Cross-Cultural Friendship and Legal Pluralities in the Early Pacific Salt-Pork Trade', *Journal of World History* 28 no. 2 (2017): 219–48.

10 Lawrence Stone, *The Family, Sex and Marriage in England, 1500–1800*, abr. ed. (New York: Harper Perennial, 1983); Ellen Rothman, *Hands and Hearts: A History of Courtship in America* (Cambridge, MA: Harvard University Press, 1987); Karen Lystra, *Searching the Heart: Women, Men, and Romantic Love in Nineteenth-Century America* (New York: Oxford University Press, 1989); John R. Gillis, *For Better, For Worse, British Marriages 1600 to the Present* (New York: Oxford University Press, 1985); Clare Langhamer, *The English in Love* (Oxford: Oxford University Press, 2015).

11 Stephen Robertson also makes this point. See 'What's Law Got to Do with It? Legal Records and Sexual Histories', *Journal of the History of Sexuality* 14, no. 1 (2005): 161–85.

12 Ibid.

13 T. Littleton, *Tenores Novelli* (London, 1489) as cited in A.W.B Simpson, 'The Rise and Fall of the Legal Treatise: Legal Principles and the Forms of Legal Literature', *University of Chicago Law Review* 48, no. 3 (1981): 632–79

14 See, for example: Joseph Chitty, *A Practical Treatise on the Law of Contracts not under Seal, and upon the Usual Defences to the Actions Thereon* (London: G. and C. Merriam, 1826); William Blackstone, *Commentaries on the Laws of England: in four books* (Lipincott: Grambot and Company, 1855).

15 Alecia Simmonds, 'Possessive Love: The Romantic Life of Legal Objects in Breach of Promise of Marriage Cases 1880–1940', chapter to be published in *Courting: A History of Love and Law in Australia* (Melbourne: Black Inc., 2021).

16 David Paul Nord, *A History of American Newspapers and Their Readers* (Urbana: University of Illinois Press, 2001).

17 Michael Bryan, *The Modern History of Law Reporting* (Melbourne: University of Melbourne Collections, 2012), 11.

18 See: David Lemmings, ed., *Crime, Courtrooms, and the Public Sphere in Britain, 1700–1850* (Farnham: Ashgate, 2013); Katie Barclay, 'Singing, Performance and Lower-Class Masculinity in the Dublin Magistrates' Court, 1820–1850', *Journal of Social History* 47, no. 3 (2014): 746–68; Alecia Simmonds, '"She Felt Strongly the Injury to her Affections": Breach of Promise of Marriage and the Medicalisation of Heartbreak in Early Twentieth-Century Australia', *Journal of Legal History* 38, no. 2 (2017): 179–202.

19 Reddy, *The Navigation of Feeling*, 260.

20 Ginzburg, *The Cheese and the Worms*; Zemon Davis, *Fiction in the Archives*; Gowing, 'The Language of Insult'.

21 Narratology theory is most famously advanced in history by Hayden White. See Hayden White, 'The Value of Narrativity in the Representation of Reality', *Critical Inquiry* 7, no. 1 (1980): 5–27.

22 See Zemon Davis, *Fiction in the Archives*.

23 Joanne McEwan, 'Judicial Records'; Stephen Robertson also discusses distortions caused by interpreters, *Crimes against Children: Sexual Violence and Legal Culture in New York City, 1880–1960* (Chapel Hill: University of North Carolina Press, 2005), Chapters 4 and 6.

24 Farge, *Le Gout de l'Archive*; Robertson, 'What's Law Got to Do With It?', 161–3.

25  Edward Muir and Guido Ruggiero, 'Introduction: The Crime of History,' in *History from Crime*, ed. Edward Muir and Guido Ruggiero (Baltimore: Johns Hopkins University Press, 1994), ix.

26  Reddy, *The Navigation of Feeling*, 260.

27  For research on coronial courts see: Ian A. Burney, *Bodies of Evidence: Medicine and the Politics of the English Inquest 1830–1926* (Baltimore: Johns Hopkins University Press, 2000); Catie Gilchrist, *Murder, Misadventure and Miserable Ends: Tales from a Colonial Coroner's Court* (Sydney: HarperCollins, 2019); Alecia Simmonds, *Wild Man: A Police Killing, Mental Illness and the Law* (Melbourne: Affirm Press, 2014), Chapter 2.

28  Alecia Simmonds, 'Promises and Pie-Crusts were Made to be Broke: Breach of Promise of Marriage and the Regulation of Courtship in Early Colonial Australia', *Australian Feminist Law Journal* 23, no. 1 (2005): 99–120.

29  Barbara Rosenwein, 'Worrying about Emotions in History', *American Historical Review* 107, no. 3 (June 2002): 821–45.

30  Stoler, *Along the Archival Grain*; Steedman, *Dust*; Farge, *Le Gout de l'archive*.

31  Michel Foucault, *The Archaeology of Knowledge* (London: Tavistock Publications, 1972), 128–30.

32  Stoler, *Along the Archival Grain*, 68–69.

33  Max Weber, *Economy and Society* (Berkeley: University of California Press, 1978), 225.

34  Stoler, *Along the Archival Grain*.

35  *Cox v Payne* 1825, NSW State Archives, NRS 13471 [9/5198].

36  Ibid.

37  Weber, *Economy and Society*, 254.

38  *Lundgren v O'Brien* (VICSC), (1921) Public Records Office of Victoria VPRS 267, P0002, unit no 000016, number 70.

39  Linda Tuhiwai Smith, *Decolonising Methodologies: Research and Indigenous Peoples* (Dunedin: University of Otago Press, 1999); Aileen Moreton-Robertson, 'Whiteness, Epistemology and Indigenous representation', in *Whitening Race: Essays in Social and Cultural Criticism*, ed. Aileen Moreton-Robinson (Canberra: Australian Studies Press, 2004), 75–88.

40  See Curthoys et al., *Native Claims*; Saliha Belmessous, ed., *Empire by Treaty: Negotiating European Expansion, 1600–1900* (New York: Oxford University Press, 2015); Alecia Simmonds, 'Cross-Cultural Friendship', ed. Lauren A. Benton and Richard Jeffrey Ross, *Legal Pluralism and Empires, 1500–1850* (New York: New York University Press, 2013), 6.

41  See Belmessous *Empire by Treaty*. See also: Lauren Benton, *Law and Colonial Cultures: Legal Regimes in World History* (Cambridge: Cambridge University Press, 2002); John Griffiths, 'What Is Legal Pluralism?' *Journal of Legal Pluralism and Unofficial Law* 24, no. 1 (1986): 1–55; Sally Engle Merry, 'Legal Pluralism', *Law and Society Review* 22, no. 5 (1988): 869–96 (869); Sally Falk Moore, 'Law and Social Change: The Semi-Autonomous Social Field as an Appropriate Subject of Study', *Law and Society Review* 7, no. 4 (1973): 719–46.

42  Rebecca Shumway, 'Palavers and Treaty Making in the British Acquisition of the Gold Coast Colony (West Africa)', in *Empire by Treaty*, ed. Belmessous, 162.

43  Simmonds, 'Cross-Cultural Friendship'.

44  Moser Benjamin, 'In the Sontag Archives' (2014), *The New Yorker*, blog 30 January 2014, as cited in Trish Luker and Katherine Biber, 'Evidence and the Archive: Ethics, Aesthetics, and Emotion,' *Australian Feminist Law Journal* 40, no. 1 (2014), http://classic.austlii.edu.au/au/journals/UTSLRS/2014/3.html, accessed 12 November 2019.

# 8 Institutional records

## A comment

*Catharine Coleborne and Peter N. Stearns*

Legal records, discussed in the previous chapter, offer a vivid illustration of how institutional records can be used to further the history of emotion. There are other opportunities, and this comment suggests some of the possibilities – but also highlights some real challenges.

For many historians, institutional records and archives are the backbone of historical research. After all, institutions – government agencies, hospitals, orphanages, business firms, trade unions – can be fairly clearly identified, and while many do not have archives, or do not permit access, some are readily available. Many crucial institutional archives are centred in the seats of governments, but there are many local opportunities as well. In some cases – most clearly with government agencies, but in some other instances beyond these – archives are quite well organised, even offering professional guidance to the materials available. Many historians also simply find archives enjoyable. They can be treasure troves of data, inviting discovery, sometimes offering unexpected materials in what seems to be a routine collection of documents.

For historians of emotion, however, institutional sources did not initially figure prominently in the research base, simply because institutions often do not seem deeply involved with emotional experience. Other kinds of materials, discussed in several of the chapters in this book, seemed more directly relevant. Institutional records, in contrast, fell more into the province of political or business historians, or sometimes local history enthusiasts. And some kinds of institutional records – for example diplomatic archives or trade union holdings – have only just recently been approached with the history of emotions in mind, allowing for considerable space for future developments (for example, in dealing with varied emotional presentations and expectations during treaty negotiations).[1]

Yet certain kinds of institutional records turn out to be highly relevant to work on the history of emotion, though it is fair to say that many opportunities remain to be explored. They may offer data on four aspects of emotions history: first, policies that help shape emotional experience, or at least are intended to do so; second, attitudes of officials towards the emotions of others (sometimes in the form of marginal notations on some official report); third, comments directly from affected individuals, clients

or victims of the institution whose emotional experience is otherwise hard to locate; and fourth, in providing access to the emotional culture or norms of the institution itself.

On the policy side, many modern institutions deliberately seek to shape emotional presentations to the advantage of the institution. This process has been traced, for example, in the case of department store assistants and other mainly white-collar employees from the late nineteenth century onward. Using records from personnel departments, several historians have explored how stores sought to train sales personnel, sometimes from working-class backgrounds, in the emotional expectations of middle-class customers. The premise that 'the customer is always right' often carried emotional components, particularly when the customers involved were angry and abusive. Presentations of a cheerful persona were seen as vital components of successful sales strategies, often at real emotional cost to the employees involved.[2]

Other modern institutions invite attention in terms of emotion-shaping policies. The records of schools and educational districts are only beginning to be examined closely in terms of the emotional intent or impact of policies that sought to condition children's emotional experience. Work by historians such as Kristine Alexander, Karen Vallgårda and Stephanie Olsen, however, has indicated that schools are key sites of 'emotional formation', where children are socialised into the emotional norms and standards of their society, and 'emotional frontiers', where students encounter and have to reconcile a different set of emotional norms to those they were socialised with at home.[3]

Equally important is the opportunity to use institutional archives to gain information about emotional judgements by officials of various sorts on populations they dealt with. Most institutional archives themselves were assembled and organised by people in power, and reflect strong emotional biases. Reports, but also side notes, frequently conveyed disdain for the emotional cultures, or ascribed emotional cultures, of lower-class, or minority or (in the case of imperial archives) indigenous peoples. Some comments may be fairly predictable, as officials sought to contrast their 'rationality' with the apparently undisciplined emotional outbursts of others, but they nevertheless reveal some of the emotional tensions with which various government agencies grappled in the past. In other cases, however, reactions may be particularly revealing, occasionally including expressions of emotional sympathy for groups (like domestic servants) easily victimised by others.[4] In a similar vein, welfare records tell deeply personal stories of interventions into the lives of others, and also hint at the expectations of emotional behaviours, responses and protocols, often in the face of traumatic experience, or the mundanity of poverty and dependency.[5]

Probably the most exciting opportunities in institutional records, however, lie in what they can reveal about groups and individuals whose emotional experience is otherwise almost impossible to recapture. The discussion about legal records in this volume has already suggested some of these possibilities, but other kinds of institutions are relevant as well. For example, from the

mid-nineteenth century onward various government agencies, sometimes supplemented by private research operations, sought to gain a better understanding of suicide rates, as suicide began to shift from a religious offence to a legal and then psychological problem. Institutions began to collect data on suicides, with some published reports, and sought to correlate their findings with other kinds of indicators – age groups and gender, economic conditions and so on. Institutional records also sometime included suicide notes or other reactions that more explicitly suggest emotional components; commentary on attempted suicides can also be revealing. Historians including John Weaver have been using these institutional data, including coroners' reports, revealing rich and disturbing evidence about the emotional components of the act, though he also reminds us that 'the ambition to probe people's lives through the exceptional act of suicide is fraught with epistemological difficulty'.[6]

Institutional records of suicide and other signs of emotional disturbance sometimes offer opportunities for quantification. Several suicide studies have used institutional records, both published and unpublished, to try to analyse not only changes in incidence but also shifts in causation. To date, however, it is not clear whether quantitative techniques are entirely compatible with the exploration of emotional factors as opposed to more easily measurable data such as economic cycles or participation in war.

The most elaborate use of institutional records for the history of emotion (outside of the legal domain) involves the archives and published reports of hospitals, mental institutions and some other social agencies such as orphanages. In the case of orphanages, for example, materials highlight often shocking emotional abuse or attempts to shape children's emotional responses, but also, occasionally, comments from children themselves or other relatives expressing deep emotional attachment despite economic constraints that prevented other forms of care.[7] Some recent work has also highlighted positive emotional relationships developed within such institutions.[8]

Other psychiatric and welfare institutions offer even greater opportunities. The case record, a record of a patient's illness, treatment and recovery, is an artefact of the nineteenth century that has been especially useful for historians of emotions. 'Knowing' populations, especially those people who came into contact with the social institutions of the period, including medical, welfare and correctional institutions, was a fundamental ambition of the age.[9] The invention of the 'case' as a technology of seeing and understanding institutional populations gave rise to the rich and detailed archival collections housed in national, state and local repositories and public records offices. These collections later proved to be vital to the development of social histories of mental health, state dependence and care, and crime and incarceration in the twentieth century.[10] Following proforma conventions as required by legislation in the 1860s, case notes in both imperial and colonial worlds arguably produced forms of narrative. The 'shifting subjects' of, for example, mentally unwell women, present historians with opportunities to write about their resistance to institutional regimes and the possible meanings of their

utterances and beliefs.[11] John Harley Warner's work on the transformation of the medical clinical case record over time, and his argument that clinical cases expressed 'narrative preferences', highlight the opportunities for tracking changing emotional norms and their applications in relation to health and institutional life.[12]

In these psychiatric cases, historians have been able to 'read against the grain' to hear and listen to the emotions of the past; psychiatry and its institutions placed great emphasis on emotions, both excesses of emotion and the absence of emotion. Productive methods include attention to case note language, patient utterances (the comments of the mad themselves), paying attention to the observations of others, and to the tiny shards of emotion as recorded in marginal notations.[13] Understanding the communication flows between medical authorities, patients and families reveals depth of emotion – from sorrow, anger and bewilderment to resignation, love and gratitude. In the same way, interpreting the material cultures of former psychiatric hospitals can remind us of the objects of everyday life, personal effects, and the remembrances of those people who were institutionalised and who lost their things, or left them behind. These are sometimes stark reminders of emotional cultures in the midst of regimes of care and control.[14] We might go so far as to describe institutional records as an 'emotional archive'.[15]

Evidence around emotions also surfaced in projects about families and their advocacy for inmates, as well as the patterns of emotional detachment and withdrawal witnessed in the case files of indigenous peoples confined in asylums. Take, for instance, the case of aboriginal patients in the hospitals for the insane in Canada or New Zealand, and historians' insightful readings of their patient journeys. The stories of people who were confined inside European institutions, out of place and culturally dislocated, provide powerful reminders of the emotional traces of violent dispossession of land in colonised places.[16] The work to 'locate' understandings of ethnicity and disability in past institutional records also provided methodological insights. Were these categories and labels even relevant in the nineteenth century? Much like the question of where we might 'find' emotion, historians can see representations of ethnic difference and bodily difference as evidence of an emerging story of these categories applying in context to specific people.[17] As is explored in the chapter on intersectional identities, these shifting ideas about bodies and identities framed how the emotions of the patient and their capacity to exercise agency were interpreted.

One important question about the historical use of case records is the question of how far these sources could be said to 'produce' meanings about their subjects for contemporaries that were then put into wider circulation; and just how far we might understand the relevance of the surrounding contexts that also created the 'material' for cases. This gets to the heart of the idea of emotional cultures. In other words, what discursive power do clinical cases hold? When considering past emotions, how should we understand the intersections between the social worlds of the past and the emotions we perceive in the case records? Did these

emotions surface, infiltrate spaces and move between peoples in the past? What evidence do we have to understand the emotions we find? When placed into context alongside other records from the period, the circulation of ideas about emotion, their application to individual bodies and how people experienced those emotions can become clearer.

If the case notes offer one critical source for understanding emotion, institutions have produced a further array of records. Even something as seemingly dry as the account book are now being put to scrutiny by historians of emotion. Susan Broomhall has suggested how hospital accounts, with their meticulous record of individual property, could be read as an act of care; Katie Barclay has highlighted how keeping accounts structures relationships between individuals and institutions, acting to produce certain forms of emotional encounter.[18] That numbers, accounting and statistics can make the people who are measured feel anxious – especially if they might be deemed to 'underperform' – highlights their potential as a record of emotion; conversely numbers can help people feel safe, such as when we are told that the chances of getting an illness are especially low. Institutional records play important roles within their institutions that have impact on human bodies and so provide an opportunity to access the emotional worlds of those who engage with such organisations. Future research about institutional records looks to be an especially fruitful area for further research for historians of emotion, and can be especially important for groups – like the very poor or indigenous – whose experiences can be challenging to identify outside of these records.

Finally, the researcher's own emotions provide fertile ground for self-reflexive examinations of the sober institutional archive. Reflecting again on institutional records of the former hospitals for the insane, Sally Swartz writes about the frustrations and 'inner despair' of the archival researcher whose own 'apathy, protest or depression' is like that of the confined psychiatric patient. This frustration, she suggests, springs from the sheer impossibility of 'matching word to feeling' in the 'landscape of narrative' that is writing history using case records.[19] If the archive is, as scholars have claimed, a 'contact zone', or an 'emotional arena' where researcher and source materials collide, connect and find meaning through a new encounter, there may well be an intimacy in this encounter, with the researcher bringing her own emotions to the search for specific sources and trails of knowledge.[20]

## Notes

1 Jack Saunders, 'Emotions, Social Practices and the Changing Composition of Class, Race and Gender in the National Health Service, 1970–79: "Lively Discussion Ensued"', *History Workshop Journal* 88 (2019): 204–28; On emotional features of diplomatic history, see David Taylor, 'Trauma and Emotion in the Battlefield Correspondence of Andrew Mitchell', *Emotions: History, Culture, Society* 2, no. 2 (2018): 292–311; Susan Butler, *Roosevelt and Stalin: Portrait of a Partnership* (New York: Random House, 2015).

2 Susan Porter Benson, *Counter Cultures: Saleswomen, Managers, and Customers in American Department Stores, 1890–1940* (Urbana: University of Illinois Press, 1988); Arlie Hochschild, *The Outsourced Self: Intimate Life in Market Times* (New York: Metropolitan Press, 2012).

3 Stephanie Olsen, 'The History of Childhood and the Emotional Turn', *History Compass* 15, no. 11 (2017): 1–10; and, Peter N. Stearns and Clio Stearns, 'American Schools and the Uses of Shame: An Ambiguous History', *History of Education* 46, no. 1 (2016): 58–75.

4 Theresa McBride, *The Domestic Revolution: The Modernisation of Household Service in England and France* (London: Croom, Helm, 1976); Kenneth Wheeler, 'Infanticide in Nineteenth-Century Ohio', *Journal of Social History* 31 (1997): 407–18.

5 Bronwyn Labrum, 'Negotiating an Increasing Range of Functions: Families and the Welfare State', in *Past Judgement: Social Policy in New Zealand History*, ed. Bronwyn Dalley and Margaret Tennant (Dunedin: Otago University Press, 2004). 157–74.

6 John C. Weaver, *A Sadly Troubled History: The Meanings of Suicide in the Modern Age* (Montreal: McGill-Queens University Press, 2009), 4–5.

7 Timothy Hacsi, *A Second Home: Orphan Asylums and Poor Families in America* (Cambridge: Harvard University Press, 1997).

8 Susan Broomhall, 'Beholding Suffering and Providing Care: Emotional Performances on the Death of Poor Children in Sixteenth-Century French Institutions', in *Death, Emotion and Childhood in Premodern Europe*, ed. Katie Barclay, Kim Reynolds, with Ciara Rawnsley (Basingstoke: Palgrave, 2016), 65–86.

9 Catharine Coleborne, *Insanity, Identity and Empire: Colonial Institutional Confinement in Australia and New Zealand, 1870–1910* (Manchester: Manchester University Press, 2015).

10 France Iacovetta and Wendy Mitchinson, eds, *On the Case: Explorations in Social History* (Toronto: University of Toronto Press, 1998).

11 Catharine Coleborne, 'Institutional Case Files', in *Sources and Methods in Histories of Colonialism: Approaching the Imperial Archive*, ed. Kirsty Reid and Fiona Paisley (London: Routledge, 2017), 113–28.

12 John Harley Warner, 'Narrative at the Bedside: The Transformation of the Patient Record in the Long Nineteenth Century', unpublished public lecture, King's College London, 16 January 2013.

13 For examples of these reading techniques, see Catharine Coleborne, 'Families, Patients and Emotions: Asylums for the Insane in Colonial Australia and New Zealand, 1880s-1910', *Social History of Medicine* 19, no. 3 (2006): 425–42; and Stef Eastoe, 'Excitement, Tears and Sadness: The Meaning, Experience and Expression of Emotion in the Long-Stay Asylum', unpublished paper, Society for the Social History of Medicine Conference, Liverpool, 11–13 July 2018.

14 Linnea Kuglitsch, '"Kindly Hearts and Tender Hands": Exploring the Asylum and Patient Narratives through the Archaeological Record', unpublished paper, Society for the Social History of Medicine Conference, Liverpool, 11–13 July 2018.

15 See Eastoe, 'Excitement, Tears and Sadness'.

16 Robert Menzies and Ted Palys, 'Turbulent Spirits: Aboriginal Patients in the British Columbia Psychiatric System, 1879–1950', in *Mental Health and Canadian Society: Historical Perspectives*, ed. James E. Moran and David Wright (Montreal: McGill-Queens University Press, 2006), 149–75.

17 Catharine Coleborne, 'Locating Ethnicity in the Hospitals for the Insane: Revisiting Casebooks as Sites of Knowledge Production about Colonial Identities in Victoria, Australia, 1873–1910', in *Migration, Ethnicity, and Mental Health: International Perspectives, 1840–2010*, ed. Angela McCarthy and Catharine Coleborne (London: Routledge, 2012), pp. 73–90; and, Catharine Coleborne, 'Disability in Colonial

Institutional Records', in *The Oxford Handbook of Disability History*, ed. Michael A. Rembis, Kim Nielsen and Catherine Kudlick (Oxford: Oxford University Press, 2018), 281–92.

18 Broomhall, 'Beholding Suffering'; Katie Barclay, 'Illicit Intimacies: the Many Families of Gilbert Innes of Stow (1751–1832)', *Gender & History* 27, no. 3 (2015): 576–90.

19 Sally Swartz, 'Asylum Case Records: Fact and Fiction', *Rethinking History* 22, no. 3 (2018): 289–301 (295, 291).

20 See Antoinette Burton, ed., *Archive Stories: Facts, Fictions, and the Writing of History* (Durham: Duke University Press, 2005), 25; Florencia E. Mallon, 'The Promise and the Dilemma of Subaltern Studies: Perspectives from Latin American history', *American Historical Review* 99 (1994): 1491–1515; and Adrian R. Bailey, Catherine Brace and David C. Harvey, 'Three Geographers in an Archive: Positions, Predilections and Passing Comment on Transient Lives', *Transactions of the Institute of British Geographers* 34 (2009): 254–69.

# 9 Narratives of the self

*Marcelo J. Borges*

First-person accounts, documents of life, life writing, ego-documents: called by different names according to discipline and approach, narratives of the self have attracted attention from historians and other scholars in the humanities and social sciences for over a century.[1] By providing a personal perspective into how individuals named, made sense of and communicated what they felt in connection to self and others, these narratives provide a window into the emotional experiences of the past. They also show how feelings and their related emotions varied according to life and historical circumstances, with shifting conceptions of self along the narrator's life cycle, and with the influence of different cultural, socio-political and spatial contexts. This chapter offers a methodological discussion about the use of personal narratives to explore emotion work in the past, and points to selected scholarly examples published mostly in English. Narratives of the self take a variety of forms, including letters, dairies, memoirs, autobiography and oral history. Each type has a rich scholarly tradition and methodological trajectory. The discussion that follows focuses on personal letters, with a few references to personal diaries. It considers the methodological implications of writing practices, form and materiality.

## Writing, self-making and emotions

As the main medium of expression, writing is central for most narratives of the self (except for oral histories and testimonies). Therefore, students interested in personal narratives need to consider writing practices and conventions. Access to writing has evolved over time. The expansion of literacy around the world was uneven, with marked national and regional variations, and clear differences along sex, class and ethno-racial lines.[2] But the last two hundred years witnessed a steady upward expansion that included once marginal groups resulting in a diversification of voices and perspectives. This is clear when looking at letter writing, the most common of all personal writing practices. Originally reserved for lettered men in the upper echelons of society, in the eighteenth century letter writing began a steady expansion that initially included elite and middle-class women, and during the nineteenth century it reached a growing number of individuals from the popular classes.[3]

Increasing levels of literacy and schooling were important factors in this evolution, but focusing only on formal education obscures a more complex reality characterised by a broader exposure to and experience with the written word among the barely literate and purportedly illiterate. Literacy and illiteracy were part of a fluid continuum, as were the connections between oral and written communication. Among peasant cultures in Europe and Latin America, for example, where levels of formal literacy were lower than among the middling urban sectors, 'literacy was not', in the words of Martyn Lyons, 'a stable level of skill but rather a process, which developed independently of formal schooling and grew or declined within a context of primary oral culture'.[4]

Writing is also important for personal narratives because its practice contributes to self-making, a process that occurs in relation with others and in interaction with the writer's social and cultural world. In her study of female writing culture in eighteenth-century France, Dena Goodman states, 'Writing helps individuals who are socially embedded to reflect on themselves, their relationships, their society, their world, and to make choices based on their own standards and values'.[5] This is 'the paradox of correspondence', Goodman adds, 'that one addresses the other to find oneself'.[6] Thus, what a person discovers as part this reflection, how it is felt and interpreted, and the emotional dispositions and actions that emerge from this process vary in different contexts and according to different audiences. It is this relational character that makes personal correspondence a rich source for emotion history.

This may happen in ways that writers themselves are not fully aware. As Michael Roper observes in his study of letters exchanged by British soldiers and their families during the First World War, 'emotional states are incited by and fostered through communication – conscious or unconscious – with others'.[7] The presence of the other may be more evident in personal letters because they require a correspondent, but it is equally present in other forms of personal narratives. This is illustrated by diverse historical examples, such as diaries written by women who shared them with their husbands, and of diaries written for specific audiences under the auspices of state organisations or research initiatives.[8] In this way, the line between private and public became fluid, as it did in the many ways that the emotional conventions and language of literature and popular culture fashioned the emotion work that took place in the intimate context of diary writing.[9]

The insight that narratives of the self are not made in isolation but in the world make them particularly suitable sources to explore emotional dynamics in historical contexts. Since its inception as a field of historical enquiry, emotion history has situated individuals and their feelings in their wider sociocultural environment.[10] 'There is no practice of the mind that is not in the world', in the words of the historian of emotions Rob Boddice.[11] As a biocultural phenomenon, emotions are intrinsically social and are embedded in a broader historical and cultural context. 'For what happens in private', continues Boddice, 'is no less of a social barometer of emotional prescription that what happens in social interactions.'[12] Dominant cultural values and social mores shape private

narratives; and even when personal narratives are used to express sentiments that fall beyond commonly accepted values and social prescriptions, there is an awareness of this transgressive position, thus reinforcing the interconnectedness of private and public in narratives of the self. This dynamic interaction has been observed by scholars in diverse cultural and historical contexts, from colonial Ghana to Second World War Japan to Stalin's Russia.[13] Writing in society connects with another fundamental principle of emotion history. As an expression of thoughts and feelings, personal writing not only contributes to self-making but, through textualisation, it also shapes feelings and creates emotional experiences. In turn, emotional dispositions created in this interconnected way, condition choices and effect action.

## Accessing sources

Their relational nature and their capacity for self-building and emotion-building make personal letters promising sources to explore the emotion work of individuals in historical context. Because epistolary writing was more widespread than other types of personal documents, letters also have the potential of illuminating the emotional expressions and experiences of larger and more diverse populations of the past. In addition to the caveat of unequal access to literacy, another potential limitation of this source results from the relative scarcity and fragmentary character of archival sources. Only a small fraction of the millions of letters exchanged since the upswing in letter writing in the nineteenth century has survived, and only a small part of that is available in archives. The serendipity of archival preservation needs to be considered by researchers.

Letters from prominent people outnumber those from people from the popular sectors. There has been, however, a growing effort to uncover and preserve personal writings from common people. Interest in the commemoration of people's efforts during times of struggle and sacrifice, such as international conflicts and prolonged economic downturns, and in transformative historical phenomenon at a large scale, such as mass migrations, have led the way. In Great Britain, the National Archives and the Imperial War Museum, for example, house extensive collections of personal letters exchanged between soldiers and their families during the two world wars, as does the Australian War Memorial, the German National Archives and the Museo Storico del Trentino in Italy.[14] Collections are also archived in numerous local, regional and university repositories.

Only a small portion of this material is available online, but this situation is changing rapidly with ongoing digitisation initiatives. The Canadian Letters and Images Project provides an online digital archive with personal writings and photographs exchanged during several international conflicts from the nineteenth and twentieth centuries.[15] In the case of migrant letters, the University of Minnesota's Immigration History Research Center has created an online platform with a selection of correspondence from migrants and their

families in the United States, Europe, Asia and Latin America.[16] These are only two examples of multiple ongoing digitisation projects. In Italy, Spain and Scandinavia, interest in the writings of common people have led to outreach efforts in local communities to solicit personal documents, including letters, diaries and photographs, as has an interest in life-writing practices in Great Britain and France.[17] Taking advantage of these undertakings, the digital platform Europeana Collections is working with national archives and libraries to provide a mega-portal at the pan-European level for hundreds of thousands of items, including personal documents.[18]

In addition to these archival projects, historians have used their skills and imagination to uncover hidden epistolary treasures in private possession and in official archives where personal letters sometimes appear together with records of official business such as criminal proceedings, land tenure disputes, passport applications, censorship offices and welfare assistance. Finally, since the early efforts of William Thomas and Florian Znaniecki's study of first-person accounts of Polish migration in the United States, scholarly interest in narratives of the self gave way to published collections of original sources.[19] The editorial intervention on these collections, however, has varied widely – from selections to transcriptions in full. Researchers interested in using these personal documents need to consider the impact of these interventions on the sources and its consequences for a study that seeks to uncover emotion work at the individual level through the perspective of the self.[20]

## Epistolary practices and materiality

Writing is highly dependent on personal circumstances and perceived needs. People felt the desire or obligation to write for a host of reasons, but the one circumstance that propelled increasing numbers of individuals to engage in letter writing was growing geographic mobility. From approximately the mid-nineteenth to the mid-twentieth century, the twin phenomena of international wars and migrations put tens of millions of people on the move, at the same time that a standardised and globally connected postal system made the exchange of letters more reliable. What followed was a continuous expansion of personal writing and its diversification, as increasing numbers of common individuals made writing their own, overcoming limitations of form and grammar, thus opening new avenues for self-expression. There is a vast historical scholarship that uses letters of migrants, soldiers and their families to explore the emotional dynamics created by mobility and separation, and their impact on social relations and identity. This was a worldwide phenomenon, but the cases used in this chapter come mostly from Europe and the transoceanic spaces connected to it through migration and war. With the socio-cultural diversification of writing practices, other forms of personal writing, such as diaries and memoirs, also expanded in this period as ordinary people acquired more tools to reflect on their experiences in a world rapidly changing around them.

Whether mobilised by war, in the case of soldiers, or by the prospect of better opportunities, in the case of migrants, letter writers were connected to home and sought to reassure those left behind and be reassured by them that personal bonds stayed strong. Letters also provided the vehicle to cope with the emotional strains and tensions in family relations that came from separation and distance. The exchange of letters was the main conduit to keep relationships alive and restore them when they were under stress. Most historians who have analysed family letters would agree that the main emotional work letters did was to reassure that relationships continue. Reciprocity is a fundamental principle of personal correspondence. 'What remains constant is the commitment to remain in communication', writes David Gerber, who characterises this principle as an 'aversion of discontinuity' that was 'at the heart of these epistolary ties'.[21] Other scholars use the term 'epistolary pact' to refer to the principle of writing reciprocity.[22] As a result, researchers who venture in personal letter collections soon notice that letters are often about other letters. The flow of letters is a central emotional component of the epistolary practice. References to the sending and arrival of letters, promises of writing or recrimination for not keeping a regular writing schedule were among the most common topics. We must resist the temptation to dismiss these references as busy talk or formulaic, as they contributed to the emotional experience of letter writers and readers. In the case of war, the arrival of a letter acquired a vital sense, as it was proof of a loved one's survival; but, if less extreme, a similar effect was produced by the arrival of missives among families separated by migration, for whom the threat of oblivion and abandonment were constant reminders of the fragility of living apart.

By 'making the absent correspondent seem almost palpably present', as Martha Hanna puts it, the physicality of the letter contributed to the intimate experience brought about by personal correspondence.[23] Writers included regular references to ways in which the letter became a representation of the faraway correspondent – the paper that readers were holding in their hands had been touched by writers; the personal marks of handwriting imprinted the writer's identity; holding the letter was like holding the absent person; long-awaited letters were kept in pockets close to the heart or under pillows. In these and myriad other ways, the letter itself became the absent other, a quality that Karen Lystra, in her study of love letters in nineteenth-century United States, calls anthropomorphising.[24] The letter as a stand-in for the absent person was a habitual sentiment in the correspondence among lovers, married couples and family members. 'Is it true or did it just seem to me that when the letter arrived it was laughing and it had a joyful air about it' – wrote a Portuguese migrant from Brazil to his wife – 'or was it just I who imagined it because I see that I make you happy when I am in your company?'[25] The letter could also become the materialisation of absence: 'You know, dear father, whenever I receive a letter from you, and I open it, I can't even read it', wrote a migrant from Mexico to his father in Galicia, north-western Spain. 'The other employees always asked me if there was a disgrace at home and I can't even answer them, thinking only in how far from each other we are.'[26]

Personal letters also routinely included references to general feeling states and physical sensations connected with the anticipation and reception of letters, such as hearts full of joy or burdened with despair and concern, tearful eyes or weakened knees. It could be tempting to discard these regular references as tropes or clichés. Writers may have used known formulas, but the ubiquity of these references in personal correspondence needs to be taken as an important expression of intimacy. Routine references to the feelings associated with writing, sending, receiving and reading letters (observed by scholars of family correspondence in diverse historical and cultural contexts) alert us to an emotional dimension that was so central to the experience of correspondence that, as David Gerber suggests, appears akin to a ritual.[27] As researchers, we should not discount them as insincere commonplaces but try to decipher their evocative power. As in other expressions of feelings, the vocabulary and forms used in these cases tell us about the cultural traditions and expressive tools at the disposal of writers and recipients of letters, and of what was expected from them as sons, daughters, parents, siblings, spouses, lovers or friends living apart.

## Language and rhetorical strategies

Since written language was the medium for emotion work in personal letters, historians have devoted considerable attention to the varied linguistic content and rhetorical strategies used by letter writers and to analyse the vocabularies of emotion that sustained epistolary relations. Through letters, people separated by migration, war and a variety of other life's circumstances managed the feelings created by this separation and the forces that caused it, and their associated emotions – anxiety, love, grief, joy, envy, honour, jealousy, shame, homesickness and a variety of others. Many of these emotional dispositions prompted people to leave behind the familiar world of their villages and towns to work, fight or make new lives. Historians have explored a wide variety of historical cases, among them: soldiers and their loved ones as they kept connections to idea of home; spouses, siblings and parents coping with the challenges of transnational living as a result of migration; lovers and their prospects of a future together; and relatives and friends who relied on epistolary relationships to assuage feelings of nostalgia and a changing sense of self shaped by distance and separation.[28] Letters and other narratives of the self were used by them to reflect on their actions and to cope with and adapt to new circumstances. This emotion work was performed equally by those who left and those who remained behind. Correspondence is particularly well suited among personal writings to capture this dynamic, including the often overlooked emotional labour of waiting. This line of analysis, however, is often unfeasible as in most cases only one side of the correspondence has survived. But because of the dialogical nature of epistolarity it is possible to access this dimension, at least partially, even if just one side of the correspondence is available.

Historians have also used personal letters to explore other forms of affective ties beyond the immediate circle of family and friends, and their capacity to effect action. Personal narratives offer researchers a window into the tension between familial and societal claims and obligations and their associated emotion work. Sometimes emotion dispositions and standards reinforced each other; sometimes they were at odds. This tension is clear in times of perceived national emergencies like revolutions or wars. Letters from soldiers to their families have provided a fertile ground for this analysis as it is illustrated by a vast scholarship related to the main international wars of the twentieth century. Historians have analysed personal narratives to uncover such tensions as those emerging between love of family and love of country, and duty to family and calls for allegiance to patriotic goals. States mobilised an array of emotional discursive strategies in this effort with mixed results.[29] Nationalists' use of emotions to mobilise people for larger ends were also present in countries of emigration and immigration. In times of international turmoil, conflicting national claims also had generational repercussions, as children of migrants were sometimes pulled in opposite directions, creating tensions within families and between countries of ancestral origin and countries of birth.

Nations were not the only sources of alternative senses of belonging or the only ones claiming allegiance on emotional grounds. There were many others, such as fraternal societies, labour associations, political groups and religious organisations. As multi-dimensional individuals, letter writers participated in multiple emotional communities that sometimes complemented and sometimes challenged one another. Different audiences and writing communities connected through correspondence shaped emotional expressions and experiences. The language and emotional disposition will likely be different when addressing family members, friends, lovers, fellow workers or political comrades. As students of personal narratives, we need to take the multidimensionality of historical actors into account, even if source limitations do not allow us to access this dimension of analysis in all its complexity.

The analysis of emotional vocabularies and rhetorical strategies used in personal narratives achieves its full potential when considered in context. Sources of the self must be read in light of other expressions of sentiment, social mores, cultural expectations, and feeling rules and standards; they must also be mindful of the power dynamics that permeated society at large and specific groups within it (with attention to gender, class and ethno-racial factors). Literature, art and popular culture can help in constructing this larger context, as can media accounts and socio-political and philosophical essays. Just as, as researchers, we need to be alert to the weight of privilege and power in most of these accounts that tend to tilt the balance in favour of the view of the urban middling and upper classes, so also we must be vigilant of the potential impact of projecting contemporary culture- and class-specific emotional standards and vocabularies onto past lives. Equally important is to look deeper into the full manifestation of emotional work at play in personal

sources even when outwardly unsentimental or mundane issues are discussed, such as business, economy and a host of other material topics.[30] Far from polar opposites, the emotional and the material were entangled dimensions of people's lives, and unlocking these connections and finding the logic, language and actions that resulted from them can offer a more nuanced understanding of the emotional experiences of the past.

It is not only what was expressed in writing that has attracted the attention of historians interested in emotion work in personal narratives, but also how it was expressed, what was left out, and what traces writers left in these sources beyond the intentional and volitional. Early historical work with personal narratives treated these features – which are inherent to narratives of the self – as a threat to authenticity. Since the 1990s, however, in dialogue with literary analysis, feminist studies and other disciplines, historians have increasingly valued these characteristics for what they may illuminate about the intimate and subjective experiences in the past.[31] As David Gerber explains in his discussion of migrant letters, omissions, exaggerations and contradictions were part of the emotional negotiation in which letter writers engaged and, in this sense, authenticity had to do less with truth and openness and more with 'the faithful execution of an obligation to maintain the bond' between them.[32] In this context, omissions and misrepresentation can be considered as a self-making strategy.

There is also the challenge of capturing the emotional labour of the unintentional. Focusing on letters sent from English soldiers to their families during the First World War, Michael Roper argues that this is an important dimension of analysis as writers were not always 'fully aware of the emotional impulses that animated them'.[33] Applying insights from psychology, he proposes to go beyond the narrative content of letters in order to capture more fully writers' emotional experiences. Roper offers two possible ways to look for clues: in the nature of the writing (omissions, sudden changes of topics, repetitions, contradictory claims of not being able to talk about a topic by referring to it with insistence) and in the marks left by the writing process itself (crossed-out words, change of writing style, impact on penmanship) and on the paper (traces of slip of the pen).[34] The possibility of analyses of material traces of emotional experiences depends on the availability of original letters or the quality of reproduction. In many cases, researchers are limited to working with faded copies, transcripts or published collections.

## Form and medium

Together with language, rhetorical structures and intended or unconscious levels of communication, the form and medium through which feelings were communicated also moulded emotional experiences. In the case of modern correspondence, letter-writing practices that consolidated among the bourgeoisie during the nineteenth century set the rules of suitable epistolary form, including its material aspects. Increased exposure to writing pedagogy in

schools, which included lessons in epistolary practices, and the popularity of letter-writing manuals or secretaries resulted in an expansion of conventions and socially prescribed expectations beyond its initial niche audience to the middle and working classes.[35] Letter writers also took clues from letters they read and, in this way, with increased familiarity and practice, they adapted form and social conventions to fit their needs.

The distance between social prescription and practice, however, varied widely. Cécile Dauphin and Danièle Poublan depict family letter-writing practices as a form characterised by norm-bending and excesses.[36] Letter-writing manuals may have praised the qualities of clarity and simple prose and reproved formulaic language and repetition. Nonetheless, among the popular classes, formulas abounded, the most diverse topics appear in successive sentences in hard-to-identify paragraphs, and important points were often repeated. Likewise, manuals and school lessons in epistolarity prescribed clear presentation of writing on the paper, including judicious use of spaces. Still, cost and availability of materials often became more important considerations for letter writers. When weight determined the cost of sending letters, writers often took advantage of all available spaces on the page, including cross-writing, despite what letter-writing etiquette indicated.

The same distance between prescription and practice is observable in the use of writing materials. Bourgeois standards of epistolary taste prescribed specific type of paper for different occasions and required a quill and later a steel-point or a fountain pen as preferred writing instrument.[37] For non-elite writers, these conventions could be aspirational but not always practical – when proper paper was not available, writers used what they had at their disposal; when ink was inaccessible, pencils were used. But material elements carried meaning and writers were aware of how transgressions to their epistolary etiquette could be read, often compelling them to explain how situational constrains limited their choices. For example, a Spanish migrant residing in the rural interior of Cuba delayed writing home until she could secure black-edged mourning stationery to honour the death of her grandfather at home.[38] Even in the precarious conditions of the French front during the First World War, a writer lamented that he had no recourse but to use a torn notebook page to write a letter, stating that at home he 'would be sickened to find [him]self in such a situation'.[39] Material conventions not only followed social prescriptions in postal culture, but they also carried emotional meaning and contributed to the emotional disposition of writers and readers.

Considering the full range of analytical dimensions of letters as narratives of the self – language, rhetorical strategies, form and convention, and materiality – is important for an analysis that seeks to uncover emotion work because it calls attention to the multisensoriality of the associated writing and reading experiences. A final dimension we need to take into account is the impact of orality. In addition to the many ways in which orality is present in the narrative of personal letters, the common experience of reading letters aloud added to its emotional experience. The influence of orality in personal

letters is twofold. On the one hand, there was a long-established tradition for personal letters to resemble a conversation.[40] On the other hand, among writers with limited command of grammatical rules, letters were often written in a style that was closer to oral patterns, and their minimal or complete lack of punctuation rested on flow and pauses better understood through oral delivery. Martha Hanna argues that because of the closeness between oral and written practices 'semi-literate letters might have carried with them an element of intimacy not present in more grammatically precise prose'.[41]

Since it was also common for letters to be dictated to people with a better command of writing skills or to a variety of scribes (usually within the sender's social circuits, such as family members, friends or co-workers), this also led to visible signs of orality in the written text. For example, traces of oral conversation such as 'did you hear?' (*ouviste?*) appear regularly in letters written by Portuguese migrants that I have studied. A polysemic word or phrase that occurs frequently in vernacular oral dialogues, this question was used to call the interlocutor's attention, but it also served as a way of exerting authority (as in, 'Have I made myself clear?'). When read in context, this apparently simple utterance can illuminate the emotional consequences of living apart and the tension it created on socially prescribed gender roles. This was an important dimension in the letters exchanged by family members separated by migration – in particular, among couples for whom letters were vehicles to assert and negotiate ideas of marital duty and affection.[42] Expressions such as these, deeply embedded in the oral world of writers, were common in personal letters from a variety of cultural contexts.[43]

## Diaries

In this methodological discussion of personal letters as sources for the history of emotions, I have made several references to diaries, another important form of written personal narrative of the self that has received extensive scholarly attention. There are, indeed, many parallels between the two types of sources. Diaries may appear as the most intimate of personal written sources, but as in the case of letters, studies have shown the blurred lines between private and public, the influence of cultural conventions, the presence of an imaginary or future reader (who may be the author at a later time in life), and the influence of form and materiality on the writing. A hybrid and fragmentary content also characterises most diaries, which include mundane observations about daily life, social commentary, and reflection and self-fashioning. These features apply to the tradition of diary writing that evolved in the Western world from earlier forms as diverse as account books, travel journals or notes on religious self-examination, which may differ from diary-writing practices in other cultural traditions.[44]

Diverse conceptions of the self and the dynamic interaction between ideas of individuality and social cohesion across cultures contributed to diverse experiences of diary writing in different societies, as did the chronology of

selfhood itself in different parts of the world.[45] Feminist scholars have shown how diary writing was a conduit for elite and middle-class women to engage in emotional expression and self-making as they coped with changing ideas of female sensibility and gender relations in periods of rapidly changing social and cultural conventions.[46] Diary writing was more common among the more educated, well-to-do sectors of society but, as with letter writing, an expansion in literacy resulted in an extension of this practice into the working classes – even though not at the same level than letter writing. Life-changing experiences like migration and war also prompted people from diverse social backgrounds to make diary writing their own as vehicles of emotion work.[47] The methodological considerations presented in this chapter about personal correspondence – with their attention to language, form, writing conventions, and their cultural and historical contexts – can be adapted to the analysis of diaries as narratives of the self.

## Conclusion

In recent decades, technological changes have transformed personal communication in terms of speed and volume, at the same time creating new narrative forms and conventions. This transformation has had different consequences for different types of narratives of the self. New media and new forms of information and communication technologies have opened novel outlets for self-expression that have transformed some narratives of the self, such as diaries and journals, and created new possibilities for others, such as oral histories and digital story-telling. For many observers, this technological transformation has resulted in the demise of the most popular type of narratives of self, namely traditional personal letter writing. In this way, a form that withstood the threat of earlier technological innovations, like the telephone, could not endure the threat posed by the new forms of electronic and digital communication. As Liz Stanley argues, however, the end of traditional letter writing does not necessarily mean the end of epistolarity, as most digital communication is based on 'epistolary intent' and often adopts 'letter-like' forms.[48] In addition, Stanley observes that even if communication seems ephemeral, material traces of these new narratives can be recovered and are often preserved. Nevertheless, the archival challenges created by digital communication and its future access remain open questions. Similarly, it remains to be seen how personal writing changes as these emerging 'letter-like' narratives adapt to the form, materiality and expressive possibilities of new media; the consequences of the interaction between new technologies and self-making; and the emotional underpinnings of these processes.[49] Finally, if new technologies pose challenges, they also create stimulating opportunities for the preservation, access and analysis of traditional sources of the self, as illustrated by the many digital initiatives and research collaborations that have emerged in recent years.[50]

## Notes

1 Early work with personal narratives was conducted at the beginning of the twentieth century by scholars interested in contemporary social phenomena like immigration and urbanisation, such as the pioneering analysis of the Polish migration experience in the United States by William I. Thomas and Florian Znaniecki, *The Polish Peasant in Europe and America* (Chicago: University of Chicago Press; Boston: Badger: 1918, 1919–1920), vols 1–2 and 3–5. For methodological and historiographical overviews of scholarly uses of personal accounts from different disciplines, see Ken Plummer, *Documents of Life 2: An Invitation to a Critical Humanism* (London: Sage, 2001); Mary Jo Maynes, Jennifer L. Pierce and Barbara Laslett, *Telling Stories: The Use of Personal Narratives in the Social Sciences and History* (Ithaca: Cornell University Press, 2008); and Penny Summerfield, *Histories of the Self: Personal Narratives and Historical Practice* (London: Routledge, 2019).
2 For a historical overview with focus on Europe and North America, see Martyn Lyons, *A History of Reading and Writing in the Western World* (Basingstoke: Palgrave Macmillan, 2010).
3 Dena Goodman, *Becoming a Woman in the Age of Letters* (Ithaca: Cornell University Press, 2009); Armando Petrucci, *Scrivere lettere: una storia plurimillenaria* (Rome: Laterza, 2008); Martyn Lyons, *The Writing Culture of Ordinary People in Europe, c. 1860–1920* (Cambridge: Cambridge University Press, 2013).
4 Lyons, *Writing Culture*, 248. For Latin America, see Frank Salomon and Mercedes Niño-Murcia, *The Lettered Mountain: A Peruvian Village's Way with Writing* (Durham: Duke University Press, 2011); and William E. French, *The Heart in the Glass Jar: Love Letters, Bodies, and the Law in Mexico* (Lincoln: University of Nebraska Press, 2015).
5 Goodman, *Becoming a Woman*, 3.
6 Ibid. Goodman takes this phrase from the work of Brigitte Diaz.
7 Michael Roper, *The Secret Battle: Emotional Survival in the Great War* (Manchester: Manchester University Press, 2009), 24.
8 Summerfield, *Histories of the Self*, 52, 64–71.
9 See, for example, Martha Tomhave Blauvelt, *The Work of the Heart: Young Women and Emotion, 1780–1830* (Charlottesville: University of Virginia Press, 2007).
10 For a recent introduction to the field, see Barbara H. Rosenwein and Riccardo Cristiani, *What is the History of Emotions?* (Cambridge: Polity, 2018).
11 Rob Boddice, *The History of Emotions* (Manchester: Manchester University Press, 2018), 81.
12 Ibid.
13 Audrey Gadzekpo, 'Public but Private: A Transformational Reading of the Memoirs and Newspaper Writings of Mercy Ffoulkes-Crabbe', in *Africa's Hidden Histories: Everyday Literacy and Making the Self*, ed. Karin Barber (Bloomington: Indiana University Press, 2006), 314–37; Aaron William Moore, 'The Chimera of Privacy: Reading Self-Discipline in Japanese Diaries from the Second World War (1937–1945)', *Journal of Asian Studies* 68, no. 1 (2009): 165–98; Jochen Hellbeck, *Revolution on My Mind: Writing a Diary under Stalin* (Cambridge: Harvard University Press, 2006).
14 More information about these collections is available in their websites: http://www.nationalarchives.gov.uk,http://www.iwm.org.uk,http://www.bundesarchiv.de,http://www.awm.gov.au, and http://900trentino.museostorico.it/Archivio-della-Scrittura-Popolare.
15 See https://www.canadianletters.ca.
16 The collections of the Digitizing Immigrant Letters project can be explored at https://www.lib.umn.edu/ihrca/dil.

17  For information on southern European efforts, see Lyons, *Writing Culture*, Chapter 2. For a Scandinavian example, see the work of the Finnish Literature Society (https://www.finlit.fi/en). In addition to personal letters, diaries have also been the object of efforts at archival preservation and digitisation. Examples include The Great Diary Project (https://www.thegreatdiaryproject.co.uk), in Great Britain, and the Fondazione Archivio Diaristico Nazionale (http://www.archiviodiari.org), in Italy. For life writing, see the online resources of the University of Sussex's Centre for Life History and Life Writing Research (http://www.sussex.ac.uk/clhlwr) and the Association pour l'autobiographie et le patrimoine autobiographique (http://a utobiographie.sitapa.org).

18  See https://www.europeana.eu. Resources are organized thematically. The thematic portals on World War I (https://www.europeana.eu/portal/en/collections/world-wa r-I) and migration (https://www.europeana.eu/portal/en/collections/migration) contain personal documents such as letters, diaries and photographs.

19  For examples of edited collections of migrant letters translated from their original language into English, see Witold Kula, Nina Assorodobraj-Kula and Marcin Kula, *Writing Home: Immigrants in Brazil and the United States, 1890–1891*, ed. and trans. Josephine Wtulich (Boulder, Col: East European Monographs, 1986); Samuel L. Baily and Franco Ramella, ed., *One Family, Two Worlds: An Italian Family's Correspondence across the Atlantic, 1901–1922*, trans. John Lenaghan (New Brunswick Rutgers University Press, 1988); and José Orozco, *Receive Our Memories: The Letters of Luz Orozco, 1950–1952* (New York: Oxford University Press, 2017).

20  For contrasting examples about editorial interventions in the case of collections of migrant letters, readers can compare the heavy editorial approach applied by Charlotte Erickson, *Invisible Immigrants: The Adaptation of English and Scottish Immigrants in Nineteenth-Century America* (Coral Gables: University of Miami Press, 1972) with later examples such as David Fitzpatrick, *Oceans of Consolation: Personal Accounts of Irish Migration to Australia* (Ithaca: Cornell University Press, 1994) and Kerby Miller et al., *Irish Immigrants in the Land of Canaan: Letters and Memoirs from Colonial and Revolutionary America, 1675–1815* (New York: Oxford University Press, 2003).

21  David A. Gerber, *Authors of Their Lives: The Personal Correspondence of British Immigrants to North America in the Nineteenth Century* (New York: New York University Press, 2006), 96, 139.

22  Janet Gurkin Altman, *Epistolarity: Approaches to a Form* (Columbus: Ohio State University Press, 1982).

23  Martha Hanna, 'A Republic of Letters: The Epistolary Tradition in France during World War I', *American Historical Review* 108, no. 5 (2003): 1338–61 (1348).

24  Karen Lystra, *Searching the Heart: Women, Men, and Romantic Love in Nineteenth-Century America* (New York: Oxford University Press, 1989), 22–24.

25  Letter from José to his wife Maria Rosa, Estação Livramento (Liberdade), Minas Gerais, Brazil, 11 October 1912, Arquivo Distrital, Viana do Castelo, Portugal, box 1973, file 64.

26  Letter from Cayetano to his father Francisco, Mexico City, 20 September 1908, Arquivo da Emigración Galega, Santiago de Compostela, Spain.

27  Gerber, *Authors of Their Lives*, 117.

28  Here I point the reader to just a few examples of analyses of these emotional dynamics through correspondence published in English: Martha Hanna, *Your Death Would Be Mine: Paul and Marie Pireaud in the Great War* (Cambridge, MA: Harvard University Press, 2006); Roper, *Secret Battle*; Cancian, *Families, Lovers and Their Letters: Italian Postwar Migration to Canada* (Winnipeg: University of Manitoba Press, 2010); Lystra, *Searching the Heart*; Gerber, *Authors of Their Lives*; and the articles in Marcelo J. Borges and Sonia Cancian, ed., *Migrant*

*Letters: Emotional Language, Mobile Identities, and Writing Practices in Historical Perspective* (New York: Routledge, 2018). For examples in other cultural contexts, see Keith Breckenridge, 'Reasons for Writing: African Working-Class Letter-Writing in Early-Twentieth-Century South Africa', in Barber, *Africa's Hidden Histories*, 143–54; Gregor Benton and Hong Liu, *Dear China: Emigrant Letters and Remittances, 1820–1980* (Oakland: University of California Press, 2018).

29  Emilio Franzina, 'Corrispondenze popolari fra le Americhe e l'Italia durante la prima Guerra mondiale', *Archivio Storico dell'Emigrazione Italiana* 11 (2015): 118–43; Linda Reeder, 'The Emotions of War: Italian Emigrant Soldiers and Love of Country', in *Emotional Landscapes: Love, Gender, and Migration*, ed. Marcelo J. Borges, Sonia Cancian and Linda Reeder (Urbana: University of Illinois Press, forthcoming).

30  For an example of the interaction of emotion and interest in context of migration, see Marcelo J. Borges, 'What's Love Got to Do with It? Language of Transnational Affect in the Letters of Portuguese Migrants', in Borges, Cancian and Reeder, *Emotional Landscapes*.

31  For an overview of the epistemological and methodological changes in the analysis of personal narratives, see Summerfield, *Histories of the Self*.

32  Gerber, *Authors of Their Lives*, 91.

33  Roper, *Secret Battle*, 68.

34  Marks left by writers as readers as forms of 'emotional residue', in the words of Diana Barnes, have also received interest from scholars interested in letters as artefacts. See Diana G. Barnes, 'Emotional Debris in Early Modern Letters', in *Feeling Things: Objects and Emotions Through History*, ed. Stephanie Downes, Sally Holloway and Sarah Randles (New York: Oxford University Press, 2018), 114–32.

35  There is a vast scholarship on correspondence manual. See Roger Chartier, Alain Boureau and Cécile Dauphin, *Correspondence: Models of Letter-Writing from the Middle Ages to the Nineteenth Century*, trans. Christopher Woodall (Princeton: Princeton University Press, 1997); Eve Tavor Bannet, *Empire of Letters: Letter Manuals and Transatlantic Correspondence, 1688–1820* (Cambridge: Cambridge University Press, 2005). Medieval and early-modern epistolary practices also followed conventions and rules. For a discussion of letter-writing practices in this period, see Karen Cherewatuk and Ulrike Wiethaus, eds, *Dear Sister: Medieval Women and the Epistolary Genre* (Philadelphia: University of Pennsylvania Press, 1993); Gary Schneider, *The Culture of Epistolarity: Vernacular Letters and Letter Writing in Early Modern England, 1500–1700* (Newark: University of Delaware Press, 2005); and Antonio Castillo Gómez and Verónica Serra, eds, *Cinco siglos de cartas: historias y prácticas epistolares en las épocas moderna y contemporánea* (Huelva: Universidad de Huelva, 2014). For examples from the pre-modern period beyond the Euro-Atlantic world, see Antje Richter, ed., *A History of Chine Letters and Epistolary Culture* (Leiden: Brill, 2015).

36  Cécile Dauphin and Danièle Poublan, 'La correspondencia familiar como objeto histórico', in Castillo Gómez and Serra, *Cinco siglos de cartas*, 211.

37  Nigel Hall, 'The Materiality of Letter Writing: A Nineteenth Century Perspective', in *Letter Writing as a Social Practice*, ed. David Barton and Nigel Hall (Amsterdam: John Benjamins, 2000), 91–102; Petrucci, *Scrivere lettere*.

38  Elvira R. to her brother Avelino, San Lino, Cuba, no date, A11/5–69, Museo del Pueblo de Asturias, Gijón, Spain.

39  Hanna, *Your Death Would Be Mine*, 14.

40  Schneider, *Culture of Epistolarity*; David Fitzpatrick, 'Irish Emigration and the Art of Letter-Writing', in *Letters across Borders: The Epistolary Practices of International Migrants*, ed. Bruce S. Elliott, David A. Gerber and Suzanne M. Sinke (New York: Palgrave Macmillan, 2006), 97–106.

41  Hanna, 'Republic of Letters', 1349.
42  Marcelo J. Borges, 'For the Good of the Family: Migratory Strategies and Affective Language in Portuguese Migrant Letters, 1870s-1920s', *The History of the Family* 3 (2016): 368–97.
43  Lyons, *Writing Culture*, 142–43, 247–48.
44  Robert A. Fothergill, *Private Chronicles: A Study of English Diaries* (London: Oxford University Press, 1974); Philippe Lejeune, *On Diary*, ed. Jeremy D. Popkin and Julie Rank; trans. Katherine Durnin (Manoa: Biographical Research Center-University of Hawai'i Press, 2009); Shiba Keiko, *Literary Creations on the Road: Women's Travel Diaries in Early Modern Japan*, trans. Motoko Ezaki (Lanham: University Press of America, 2012); Summerfield, *Histories of the Self*.
45  Barber, *Africa's Hidden Histories*; Peter Heehs, *Writing the Self: Diaries, Memoirs, and the History of the Self* (New York: Bloomsbury, 2013); Marjorie Dryburgh and Sarah Dauncey, eds, *Writing Lives in China, 1600–2010* (Basingstoke: Palgrave Macmillan, 2013).
46  Blauvelt, *Work of the Heart*.
47  Lyons, *Writing Culture*; Aaron William Moore, *Writing War: Soldiers Record the Japanese Empire* (Cambridge: Harvard University Press, 2013).
48  Liz Stanley, 'The Death of the Letter? Epistolary Intent, Letterness and the Many Ends of Letter-Writing', *Cultural Sociology* 9, no. 2 (2015): 240–55. See also Liz Stanley and Margaretta Jolly, 'Epistolarity: Life after Death of the Letter?', *a/b: Auto/Biography Studies* 32, no. 2 (2017): 229–33.
49  See Yasmine Abbas and Fred Dervin, eds., *Digital Technologies of the Self* (Newcastle upon Tyne: Cambridge Scholars, 2009) and the online project Ego Media (http://www.egomedia.org).
50  A few recent examples of international digital collaboration include the projects Digitising Experiences of Migration (http://lettersofmigration.blogspot.com), Reassembling the Republic of Letters (http://www.republicofletters.net), and Whites Writing Whiteness (https://www.whiteswritingwhiteness.ed.ac.uk).

# 10 Emotions in fiction

*Louise D'Arcens*

When we think about emotions in fictional texts, it has often been focused on the ways they use aesthetic and narrative techniques to prompt affective responses in audiences. In particular, scholars such as Suzanne Keen have explored the complex ways in which audiences are moved to experience empathetic states that range from sorrow or anger to amusement or joy.[1] But fictional texts also raise a number of complicated and fascinating questions for the study of emotions history, the primary one being: how can fictional texts, and the emotions encountered within them, be understood as resources contributing to histories of emotion? Another key question is: how do we identify and analyse 'historical emotions' in textual forms that create fictional worlds? What is the emotional historicity of fictional worlds that allude to history and fact but do not have primary allegiance to accurate representation of them? How might we account for the powerful transhistorical emotional-aesthetic resonances some fictional texts continue to provoke in audiences decades and centuries after they were written?

I begin my reflection on these questions by considering two images that appear in the late fourteenth-century English poem *Pearl*, a dream-vision in which the grief-stricken narrator is united briefly with his dead infant daughter. This anonymous poem is renowned for its elegant, densely textured patterning of both language and imagery. Late in the vision, the central image of the pearl, which signifies perfection and changelessness, is brought into a striking visual pairing with a similar but contrasting white sphere: the moon, which represents imperfection, variance and terrestrial flux.[2] I will return to a fuller discussion of *Pearl* later; for now I evoke these paired images because they offer a metaphoric way of understanding the two timescales that must be negotiated by literary scholars working in the area of emotional history. An account of emotions in fictional texts, and the link between emotions and cognitive, biological and existential states, must negotiate two potentially competing ideas of how emotions have figured throughout time. On the one hand, it must take into consideration the long human evolutionary timelines that underpin cognitive emotions theory, in which, to quote Paula Leverage, 'the time lapse between the Middle Ages and the twenty-first century is insignificant in terms of the evolution of the human brain … the neural

hardware is the same'.[3] On the other hand, it must trace the briefer and more volatile course of historical change, undertaking a nuanced interpretation of the specific ways in which the 'software' of culture has enabled this apparently unchanging cognitive-emotional hardware to express itself.

The implications of negotiating these two timelines are considerable, as they underpin two opposing approaches to how the emotional past relates to the present. Embracing the longer, evolutionary timeframe underpins a more 'universalist' approach that emphasises continuities in the emotional experiences of the past and the present. Some, including Aranye Fradenberg, have pointed to the potential for this approach to move beyond an 'alterist' division of the medieval from the modern, in order to develop an emotional 'epistemology of contact' based on a desire to register a space of shared emotion between the Middle Ages and the present.[4] Others have cautioned against its promotion of a reductionism that does not sufficiently acknowledge the deeply contextual nature in which emotions are elicited and understood. This latter 'lunar' position, which favours focusing on the social and temporal contingencies of emotional life, its historical waxing and waning, is summed up by Barbara Rosenwein's argument that 'to assume that our emotions were also the emotions of the past is to be utterly unhistorical'.[5] The rejection of a neuro-continuist model of emotional history is put most bluntly by Daniel Gross, who argues 'we do not just naturally express emotions converging on our amygdala or whatever, but rather [...] are constituted as expressive agents by what the philosophers of the Scottish enlightenment called "social passions"'.[6] Monique Scheer issues a comparable rejoinder to those who invoke the physiological dimension of emotions, arguing that 'the body is not a static, timeless, universal foundation that produces ahistorical emotional arousal, but is itself socially situated, adaptive, trained, plastic, and thus historical'.[7]

The investigation of emotions in and through time is even more challenging methodologically when dealing with fictional texts. This is because we must also consider the extent to which expressions or depictions of emotion have been shaped by the text's often self-conscious use of the aesthetic, technical and rhetorical resources offered by their creative form, and with a view to creating emotions that are part of the texts' fictional world rather than the 'real world' in which it is produced. This fictive shaping in turn reflects the centrality of emotional content to fictional texts' distinctive appeal to audiences, in whom corresponding emotions are produced. At the same time, it is vital to recognise how these 'fictionally shaped' emotions intersect with the social and institutional vocabularies of emotion that are particular to the context in which the fictional text is produced.

These challenges and opportunities apply to all fictional texts and all emotions represented within them; but this chapter will demonstrate these methodological challenges by way of two case studies from medieval literature, exploring the representation of grief in the work of the fifteenth-century Italo-French writer Christine de Pizan and in *Pearl*, the text with which I opened this chapter. Despite having moving depictions of grief in common, these texts will be used to

explore the competing arguments about the history of emotions outlined above. I will take a literary historicist approach to Christine's writings to show how apparently personal depictions of emotion in literary texts can be seen to be tropes in which multiple elements of their context of production have converged. *Pearl*, conversely, will be brought into dialogue with Terrence Malick's 2011 film *The Tree of Life* to explore how one might use hermeneutic approaches to explore the idea of creative texts as evidence of emotional continuity across history. The point here is less to arbitrate between these approaches than to prompt reflection on the range of methodological, epistemological and ethical issues that are raised by studying fictional texts as indices of emotions history. Medieval texts' age makes them particularly serviceable on both positions: on the one hand, their temporal distance from the present requires us to undertake a careful contextualisation in order to understand their emotional content, while on the other hand the evidence of the longevity of their appeal into the present raises the question of the transhistoricity of emotion.

## Christine de Pizan's idiocultural tears

A medieval author whose work contains powerful emotions of grief is the Franco-Italian Christine de Pizan (1365–c. 1429), who is often referred to as Europe's first professional woman writer. A lifelong widow from the age of twenty-five who lived through civil conflict and the Hundred Years War, Christine produced poetic, allegorical, epistolary and historical works, many of them with strong anti-misogynist content, across a span of four decades. Her expressions of grief begin in her early verse of the 1390s, in which she repeatedly describes herself as a 'seulette' (a solitary little woman), and continue throughout her oeuvre to her final work, the *Song of Joan of Arc* (c. 1429), where she refers to herself as 'Christine, who have wept for eleven years in a walled abbey'.[8]

Charity Cannon Willard asserts of Christine that 'the most original of her poems are those expressing her own emotions as she continued to mourn the loss of her husband'.[9] Without denying the biographical foundation of Christine's literary emotions, and the many tantalising portrayals of her life throughout her work, her texts demonstrate the extent to which her representation of her widowed status is crucial to the development of her distinctive literary persona. The repeated appearance of tears at the beginning of her texts constitutes one of Christine's more important self-authorising gambits. Barbara Stevenson reminds us that these are public courtly performances of private grief in which Christine, as a professional writer, creates what Daniel Poirion has described as a '*personnage* triste', a 'melancholy character'.[10] For this reason, as I will go on to demonstrate, Christine's writings exemplify the value of careful historical and discursive contextualisation for understanding the complex valencies of the emotions they contain, and the importance of recognising that what appear to be 'natural' or 'universal' expressions of emotion in fact reflect quite specific strategies for establishing and maintaining the author's enunciative authority. Such an

approach reveals that Christine's ingenious construction of an emotional identity is a result of her multifaceted engagement with what, using literary theorist Derek Attridge's term, we can call her *idioculture*. For Attridge the author's idioculture is 'the internal, singular manifestation of the broader cultural field, registered as a complex of particular preferences, capabilities, memories, desires, physical habits, and emotional tendencies', out of which literary acts of invention emerge, in turn transforming the idioculture.[11] Attridge develops this dynamic idea of historical context to counter ideas of culture as a 'seamless and monolithic' environment that determines the content and form of fictional works.[12]

Although Christine's idioculture cannot be rendered fully in a brief essay, examining some significant facets of it, such as how female tears were understood within late medieval Christian discourse and how she mobilises this to address her circumstances of turmoil and warfare, allows us to understand that her tearful literary persona is also a complex political persona. What becomes apparent from investigating Christine's religious context is that her tears are closely modelled on those of the *Mater Dolorosa*, the widowed Virgin of the Passion. The theological tradition of the *Mater Dolorosa*, or sorrowing Virgin mother, which entered Western Christendom from the East, had become a commonplace of devotion to the Virgin Mary by the Christine's time. Focusing on the Virgin's tearful grief at the Crucifixion, this tradition interpreted her behaviour as the fulfilment of Simeon's prophesy in Luke 2:35 that a sword of sorrow will pass through Mary's maternal heart.[13] While this Marian figure mostly functioned to inspire a tradition of affective devotion, its significance for Christine lies in the particular possibilities it offers for the authorising of her widow's voice. As both widow and mother, the *Mater Dolorosa* offers Christine, a fellow widow and mother of three children, a form of Marian identification which authorises her voice as a woman writer. A vast array of verbal and visual medieval representations of the *Mater Dolorosa* at the foot of the Cross portray her as weeping, wailing and rending her breast. The significance of this weeping for Christine was that it focused on a moment in the Virgin's life that marked a departure from her silence throughout the Gospels. By imitating the excessive grief of the Virgin at the Crucifixion, Christine as widow and mother is able to legitimate her own venture into public affairs. Acknowledging Christine's preoccupation with the sorrowing Virgin mother is vital to understanding the way she claimed tears as a form of political action. By evoking and emulating the *Mater Dolorosa* tradition Christine enacts a self-authorisation whereby she may, as widow and writer, lay claim to a unique form of compassionate intercession expressed in the *Mater*'s vocal, sorrowful widowhood.

A broader notion of women's tears as intercessionary is explicit in the section of her best-known book today, *The Book of the City of Ladies*, in which Christine is counselled by three allegorical ladies, Dames Reason, Rectitude and Justice, on how to build an alternative textual city to counter the representation of women in misogynist textual tradition. In this book, Dame Reason argues that it

is through the 'tears of devotion' of holy women such as St Monica and Mary Magdalen that many 'are saved'.[14] In *The City of Ladies*, moreover, we see intercessionary tears not just alluded to but actually enacted by Christine. In its famous opening scene, which is also a consummate portrayal of the textual dimension of Christine's idioculture, the Christine persona sits in her study weeping with self-loathing after consuming a diet of misogynist tracts. Her plaintive self-accusation acts to summon up the three allegorical ladies who guide Christine through the process of creating an alternative tradition in which women are honoured and praised.[15] On a more directly political note, we also see tearful intercession enacted in the epistles Christine writes in response to France's political turmoil, especially her *Letter to the Queen* (1405), in which she begs the queen to intervene in conflicts within the royal family. In articulating her own intercessionary authority, Christine deploys the trope of tearfulness, begging Queen Isabeau, wife of King Charles VI, not to despise 'this tearful voice of mine', thereby representing herself as a tearful supplicant calling upon the higher intermediary prerogative of the queen, inciting her to act.[16] In so doing, Christine writes the *Letter to the Queen* not merely as a political epistle, but as a *political prayer* to the queen.

The motif of tearfulness as political action is also threaded through *The Epistle of the Prison of Human Life* written in response to the French defeat at Agincourt in 1415, aimed at the wives, mothers and widows of the vanquished.[17] Here, furthermore, the trope of tearfulness represents the embattled nation of France not simply as a feminised state whose men have vanished or perished, but as one which Christine, as widow, figures in her own image. Her own well-documented widowhood brings a dramatic immediacy and authenticity to this depiction of the beleaguered state. This, together with her claim at the outset that sorrow has delayed the writing of the epistle, enables her to locate herself within the national community of women afflicted by their losses after Agincourt, lending her carefully constructed voice the authority of experience.

Two years later, having retired to the Abbey of Poissy, Christine returns for the last time to the tearful *Mater Dolorosa*, offering her fullest and lengthiest account of this figure in her prose meditation *Hours of Contemplation on the Passion of Our Lord*. Despite its early appeal to the stoic exemplum offered by Christ's suffering, we can trace a gradual but unmistakable shift in focus from Christ's Passion to the Virgin's compassion, so that the text's final stages are almost exclusively devoted to meditating on her role in the Passion and thus in salvation history.[18] Like the *Prison of Human Life*, we again encounter a portrayal of post-Agincourt France as a community of grieving women buffeted by hardship and loss and this text is offered as a form of consolation to them: Christine explicitly proffers her meditation on the Virgin's hopeful tears as a response to the recent losses suffered by the women of France. Even in the depths of her anguish, the Virgin is still able to commend her dead son to his heavenly Father, thereby affirming the painful process necessary to human redemption and embodying a commitment to justice and a refusal of despair that is exemplary to those women whose lives have been devastated by

the misfortunes of France. Change will, the text suggests, be brought about through tears of hopeful patience, tears that promise not only the salvation of the soul and the alleviation of personal suffering, but also, importantly, the deliverance of France.

Through a brief examination of some key aspects of Christine's historical context, we see her idiocultural forging of a complex emotional persona that is distinctively fictive but also heavily mediated by late medieval understandings of gender, grief and agency. Together these remind us as modern readers that it is vital to weigh the seemingly 'immediate' and 'universal' emotions we encounter in fictional texts against the density of their allusions to the prevailing discourses and conditions of their time – and, in Christine's case, the ingenuity of their responses to these discourses.

## *Pearl* and transhistorical emotion

The forensic historicist-contextualist approach presented above tends to be the dominant approach to interpreting emotions in fictional texts, especially those from the past. But this does not mean that debates about emotions through time are settled; indeed as I will now show, using my second medieval case study, responses to fictional texts continue to navigate the poles of the universal and the particular. Continuist positions in history of emotions research query what they argue are the limitations of the contextualist position. Critics of contextualist approaches argue that although they are valuable in challenging assumptions about universal and unchanging humanity, they have replaced these assumptions with an equally problematic culturalist metaphysics: that is, they espouse an account in which cultural-historical context operates as an ultimate source of meaning or value lying beyond one's own subjective experience but determining of it, with no quarter given to ideas of human continuity across time.

The potential objections to the culturalist approach are as much practical as theoretical. One might ask the question whether contextualism can only lead to an emotional history predicated on historical *dis*continuity, with no period being able to speak intelligibly to another. Willemijn Ruberg argues that contextualist approaches have 'made a meaningful history of emotions impossible by [...] avoiding any statement of the universality of emotions'.[19] Additionally, for those interested in the question of transhistorical emotion, the question arises as to whether, or how, cross-historical continuity can be figured in emotional histories that invest so heavily in the moment of a text's birth at the expense of the emotional, empathetic connections generated throughout its long emotional afterlife. This is argued by Rita Felski who, in her provocative essay 'Context Stinks!', says 'conventional models of historicizing and contextualizing prove deficient in accounting for the transtemporal movement and affective resonance of particular texts'.[20] The possibility, however, of a compromise between historicism and a position that seeks to develop a cross-historical epistemology is flagged in Jane Chance's envisaging of

an 'evolutionary literary studies' which 'might embrace a necessary [...] reductionism' that enables modern readers to recognise emotional and cognitive commonalities with earlier people, but which 'refus[es] mere reductionism in empirical approaches', always reflecting critically on its engagement with the cognitive sciences.[21]

Even before considering its emotional afterlife, *Pearl* is a poem intrinsically deserving of emotional analysis. Like later famous mourning texts, such as Alfred Lord Tennyson's *In Memoriam* (1849) which Tennyson dedicated to his late friend Arthur Henry Hallam, the emotional pitch of *Pearl*'s dreamer-narrator's voice is intense throughout the poem. The poem is studded with dense lexical clusters around grief ('playne', 'wreched', 'pensyf', 'pyne', 'langour', 'doel', 'sorwe') but also joy, wonder and gladness – though these are frequently shot through with grief.[22] Moreover, the poem reflects explicitly on the question of grief as a temporal experience, pitting it against the atemporal 'blisse' of the resurrected soul. Through the debates between resurrected daughter and her still-bereft father, the poem dramatises the agonistic relationship between human grief and theological wisdom, an agonism also reflected in its straddling of elegy and Christian *consolatio* genres. Within the Christian stoic *consolatio* tradition, consolation is not an emotive state but a spiritual recognition. The emotional tenor of *Pearl*'s teaching is often bracingly austere, with the occasional burst of exasperation: the Pearl maiden chides her grieving father for wilfully dwelling on his insignificant terrestrial loss ('dyne of doel of lures lesse') in the face of her eternal gain, and advises him to submit to divine will: 'Thou moste abyde that He schal deme.'[23] This struggle persists beyond the debate and into the poem's moving and complex final stanza, when the dreamer finally commends his daughter to God but is nevertheless still prostrate with grief ('pyty'); consolation wins a submission of will but does not ultimately eradicate, or even fully contain, emotion.

The persistence of emotion in *Pearl* extends to its modern reception. It is an example of an early fictional text that has elicited strong transtemporal empathetic responses in its two main domains of reception: academic and poetic. A particularly pointed academic example is David Aers's 1993 essay 'The Self Mourning: Reflections on Pearl'. Amid its careful contextualist reading, one finds a fascinating excursus worthy of an existential philosopher:

> Death is a massive challenge to human identity, the disclosure of an utter powerlessness framing our will to control others, our environments and ourselves. Death shatters networks in which human identity is created and sustained: we mourn, inevitably, for ourselves and the unwelcome reminder of the contingency of all that gives us a sense of identity, the reminder of the precariousness of all that we habitually take for granted. *Pearl* is a poem that confronts these challenges.[24]

The poem's treatment of child death, and parental grief in particular, here prompts otherwise historicist scholarship to identify transhistorical qualities

in the poem, invoking a universal 'we' and tracing what it shares with later poetic works of parental grieving such as Ben Jonson's early seventeenth-century elegy 'On My First Sonne'.

A similar balancing of approaches is visible in Sarah McNamer's deft recent account of *Pearl*. McNamer's reading is carefully literary-historicist, pointing to the ways the poem manifests a 'distinctive medieval perceptual framework: that rich conflation of the aesthetic, sensory, affective, and cognitive known as sweetness', which she argues is captured in its pleasing sonic richness.[25] But she also sees this same literariness as soliciting emotional engagement in a way that challenges a narrower contextualist interpretation, encouraging a view of literature

> not only as documentary witness reflecting or representing what already exists in a given culture but as 'source' in the generative sense—as font, wellspring. For literary texts have always served—some kinds and genres more overtly than others, and in some cultures more overtly than in others—as affective scripts, capable of generating complex emotional effects in those who engage with them.[26]

The idea of fictional texts as offering 'affective scripts' for 'those who engage with them' emphasises their capacity to take an active role in shaping their idioculture and to actually produce emotional experiences and expression for audiences, whether that engagement is contemporary to the text or reaching back through time.

This idea of parental grief as a transhistorical experience with shared emotional contours is also present in the poem's reception beyond academia. In his introduction to Jane Draycott's 2011 poetic translation of *Pearl*, poet Bernard O'Donoghue, himself a translator of the *Pearl*-poet's other triumph *Sir Gawain and the Green Knight*, claims that the poem 'invites comparison with other bereaved English poetic fathers, Wordsworth and Ben Jonson'.[27] Draycott's own comments about her translation bear out Rebecca McNamara and Stephanie Downes's statement that 'emotions exist outside the text as well, in the potentialities opened up by reading and performance'.[28] Draycott has said of *Pearl* 'what's most powerful for me [...] is the power of the expression of grief, which connects the modern reader to the poet's experience like an electric arc across the centuries'.[29] Her *Pearl* can, then, be described as an 'emotional translation': she is engaged by a powerful identification with its exploration of parental grief. Her sense of transhistorical affinity with the *Pearl* poet leads her to downplay the Christian vision and consolation in favour of the poem's elegiac strain, and to simplify the poem's alliterative textures to create spare modern cadences, as seen in the penultimate stanza's forlorn reflection 'Always we strive for more good fortune / Than is due to us. And so / My happiness is torn in two' (ll.1195–97).

Downes and McNamara state that 'those describing the effects of affect, in particular, are attuned to an experience of emotion as elastic, stretching from text to reader'.[30] For this reason scholars should treat transhistorical

emotional responses to earlier texts as sophisticated rather than naive responses to that emotional elasticity. The *Pearl*-poet, furthermore, should be seen to have created an existential-affective text that reaches beyond its time, creating what Reddy calls an 'emotional environment' that accommodates readers across historical periods. The trans-temporality of the poem's affective-visionary structure, despite it being grounded in the practices of its own time, can be understood via Reddy's influential concept of 'emotives'; that is, emotional expressions that are 'similar to performatives' in that they are not merely influenced by emotional states but also create, change or intensify the emotions they relate or describe, and in so doing create or alter 'emotional environments', generating empathetic states in readers.[31]

A scholar who has argued compellingly for the use of transhistorical empathy in relation to Middle English literature is Nicholas Watson, in his essay 'Desiring the Past'. In this essay Watson argues that historical scholarship has pursued an ethos in which respect for the alterity of historical people engages a sense of professional and intellectual responsibility to depict the people of the past 'accurately'. While this appeals to a normative sense of fairness that applies to both people of the past and the present, Watson nevertheless argues that this is a 'weakly satisfying' ethos that closes off the emotional and imaginative dimensions of empathetic historical knowledge. He proposes instead a practice of interpretation which does not 'rid itself of empathetic entanglements', but rather balances a 'hermeneutic of suspicion' – that is, an interpretive practice in which the historical alterity of the early text is acknowledged – against a 'hermeneutic of intuition' in which the text becomes familiar. Watson performs this empathetic work by reading the affective mystical texts of the medieval women mystics Hadewijch and Julian of Norwich not as historical 'objects of study' but rather 'as though they were theoretical essays in affective historicity' which are simultaneously of their moment and 'part of a thinking and feeling life that still goes on'.[32] He insists that this interpretive practice must always retain a reflexive consciousness of the gap between subject (reader) and object (text) that prevents the treatment of the past from turning into presentist assimilation.

In proposing this hermeneutic of empathy Watson is, perhaps unknowingly, returning to an idea strikingly close to that developed within German historical hermeneutics by such thinkers as Friedrich Schleiermacher, Johann Gottfried Herder, Wilhelm Dilthey and Theodor Lipps, who attempted to elucidate the non-positivistic means by which modern historians come to understand and interpret people of the past. The most influential ideas emerging from this are *Einfühlung*, which has been translated into English as 'empathy' or 'empathic understanding', although it literally means 'feeling into', and *Nachfühlen*, Dilthey's favoured term, which can be glossed as a reflective 're-feeling' and 're-experiencing', a reflective experiencing of transhistorical feeling.[33]

## *The Tree of Life* and emotions as contingent universals

Having considered the idea of cross-historical emotion in the case of textual reception, I wish to explore how, or whether, history of emotions scholarship might use this idea to compare texts from different historical and cultural contexts that nevertheless bear striking resemblances to one another not just in the emotions they foreground but in how these are expressed. What are the implications of comparative analysis in history of emotions research: should it only point to parallels, or perhaps affective traditions, or can it develop from comparative analysis a theory of emotional continuity? A text that elicits this question in relation to *Pearl* is Terrence Malick's 2011 film *The Tree of Life*, which at its heart is an elegiac dream-vision that is also a response to grief. Like the *Pearl* poet, Malick uses highly sophisticated artistry to address the fundamental question of grief. In this film Jack O'Brien, played by an emotionally numb Sean Penn, finds himself still unable to reconcile himself to the death of his younger brother, killed at nineteen, whose voice he hears early in the film saying 'find me'. Jack enters into an extended reverie which encompasses childhood memories but also visions of creation and of the afterlife, and culminates in a moving reunion with his dead brother on an otherworldly shoreline. Through its use of ambiguous point-of-view and free indirect voiceover, the film's exploration of grief moves beyond Jack's mourning subjectivity and includes that of his mother. As a bereaved parent, the course of her grief traces the same arc as *Pearl*'s dreamer, as her initial whispered accusation to God 'where were you?' gives way at the end, after the visionary reunion in the afterlife, to a final moment of release. Her final whisper, 'I give him to you; I give you my son', parallels directly the *Pearl*-dreamer's final commendation of his daughter to God: 'to God I hit bytaghte' (l. 1207). The film's pattern of grief forms a kind of inverse pairing with *Pearl*, for rather than having a grieving father encountering his dead infant daughter in the grown form of the Pearl maiden, here a mother mourns her dead son, who in the afterlife is transformed from a teenager back to a child.

Like *Pearl*, *The Tree of Life* too has at its core an affectively asymmetrical exchange in which the griever is enjoined to accept grace and God's will. This dialogue, though, differs from *Pearl*'s in that the complaint of the bereaved does not receive verbal answers but rather a cosmic response in the form of the spectacular creation sequence, which suggests that death and grief are as much a part of creation as life and joy. The fact that the film begins by quoting the lines from Job 38: 'where were you when I laid the earth's foundations […] while all the morning stars sang together, and all the sons of God shouted for joy?' frames this lengthy creation sequence as a visual parallel to Job 38–41, in which God curbs Job's questioning of divine justice via a thunderous barrage of humbling rhetorical counter-questions that walk Job step-by-step through creation. While Malick's exploration is more obscure than *Pearl*'s, in both texts loss through death is ultimately accepted as an unfathomable part of God's will, though Jack's half-smile at the end of the film again expresses the emotional ache that spiritual consolation cannot fully efface.

Because the direct line of influence between *Pearl* and Draycott's poetry is missing with *The Tree of Life*, what history of emotions approach best accounts for understanding their arresting parallels? Are they best understood as a product of the texts' participation in shared elegiac and stoic traditions? Or, returning to my opening discussion of the long timelines demanded of cognitive and existential accounts, can the emotions represented in these very different texts be seen as part of a longer transhistorical emotional experience? A useful term to describe such transhistorical emotions is the notion of contingent universals; that is, phenomena that are responsive to historical and contextual circumstance (and hence are contingent rather than necessary), but also exceed circumstantial particularity, being practices that are common to many, if not all, cultures. For philosophical anthropologists such as Helmuth Plessner this concept goes beyond practices and can also refer to existential, cognitive, affective and phenomenological commonalities among humans which may nevertheless manifest differently and be given different meanings across cultures and times.[34] Losing a loved one to death, for instance, generates cross-culturally an existential consciousness of human finitude and accompanying emotional grief responses, though these will be framed discursively in any number of different ways. Applying this approach, we see that the representation of parental grief at the heart of *Pearl* becomes a contingent universal that enables the poem, despite its embeddedness in its own society, to elicit emotional responses in later readers, and to bear valid comparison to much later, apparently unconnected texts that also deal with the aftermath of a child's death.

## Conclusion

Fictional texts, then, offer specific opportunities to students of emotions history, enabling them to explore the rich intersection of the aesthetic and the historical. Careful analysis of the ways they draw on the many available resources of fictional form – resources of narrative as well as a huge range of aesthetic techniques – offers insight into, and appreciation of, the means by which emotion is both represented and expressed in these texts. Recognising this in turn illuminates the aesthetic-emotional appeal they offer to audiences, whose engagements with fictional texts lead them to have emotional experiences. A key challenge that comes with these texts lies in developing an approach that identifies how these aesthetic-emotional features are also shaped by, and in turn shape, the emotional discourses and practices particular to their own place and time, yet with an awareness of how they continue to participate in a longer and larger history of human emotion.

The issues and opportunities involved in using literature as a source for the history of emotion apply to many periods and regions beyond medieval Europe. Another later period that draws particular attention, for example, involves the rise of such popular and conspicuously psychological forms such as the novel in Western society. Some historians have used novels to help

explain new approaches to emotions like love – literature, in this case, helping to cause changes in emotional expectations in a wide audience. Others simply argue that novels reflect a broader cultural shift. But even in this case, where literary innovations (including a significant rise in literacy) are clearly involved, the tension between universal emotional experiences – for example, concerning love – and the particular cultural characteristics of a period in time continues to apply. When additional media are added to popular exposure to fictional representations – for example the rise of radio and then television soap operas – the array of potential sources and the challenges to historical evaluation expand still further. Connections between literary history and the broader history of emotions, in many time periods, are complex, but the resulting analysis can be extremely rewarding.[35]

## Notes

1  Suzanne Keen, *Empathy and the Novel* (Oxford: Oxford University Press, 2007).
2  Anonymous, *Pearl*, ed. Sarah Stanbury (Kalamazoo, Mich: Medieval Institute Publications, 2001), ll. 1069–70.
3  Paula Leverage, *Reception and Memory: A Cognitive Approach to the Chansons de Geste* (Amsterdam: Rodopi, 2010), 110
4  Aranye Fradenberg, 'Going Mental', *Postmedieval* 3, no. 3 (2012): 361–72 (369).
5  Jan Plamper, 'The History of Emotions: An Interview with William Reddy, Barbara Rosenwein, and Peter Stearns', *History and Theory* 49 (2010): 237–65 (253).
6  Daniel Gross, *The Secret History of Emotion: From Aristotle's Rhetoric to Modern Brain Science* (Chicago: Chicago University Press, 2007), 5.
7  Monique Scheer, 'Are Emotions a Kind of Practice (and is that what makes them have a history)? A Bourdieuian Approach to Understanding Emotion', *History and Theory* 51 (2012): 193–220 (193).
8  Christine de Pizan, *Le Ditié de Jehanne D'Arc*, ed. Angus J. Kennedy and Kenneth Varty, *Nottingham Medieval Studies* 18 (1974): 29–55 and trans. 19 (1975): 53–76 (66).
9  Charity Cannon Willard, *Christine de Pizan: Her Life and Works* (New York: Persea, 1984), 53.
10  Barbara Stevenson, 'Revisioning the Widow Christine de Pizan', in *Crossing the Bridge: Comparative Essays on Medieval European and Heian Japanese Women Writers*, ed. Barbara Stevenson and Cynthia Ho (New York: Palgrave, 2000), 29–44; Daniel Poirion, *Le Poète et le Prince: L'évolution du lyrisme courtois de Guillaume de Machaut à Charles d'Orléans* (Paris: Presses Universitaires de France, 1965), 252.
11  Derek Attridge, 'Context, Idioculture, Invention', *New Literary History* 42, no. 4 (2011): 681–99 (683).
12  Attridge, 'Context, Idioculture, Invention', 684.
13  See, for instance, Spurgeon Baldwin and James W. Marchand, 'The Virgin Mary as Advocate before the Heavenly Court', *Medievalia et Humanistica* 18 (1992): 79–94 (93, no. 2).
14  Christine de Pizan, *The Book of the City of Ladies,* trans. Earl Jeffrey Richards, foreword Marina Warner (New York: Persea Books, 1982) §1.10.4, 28.
15  Christine de Pizan, *The Book of the City of Ladies*, §1.2.1, 6.
16  Christine de Pizan, 'Epistle to the Queen', in *Lamentacion sur les maux de la guerre civile, Epistre de la prison de vie humaine, and Epistre a la royne*, ed. and trans. Josette A. Wisman (New York: Garland, 1984), 71.
17  Christine de Pizan, 'Epistle on the Prison of Human Life'.

18   Christine de Pizan, 'Hours of Contemplation of the Passion of Our Lord' / *Heures de contemplacion sur la Passion de Nostre Seigneur Jhesucrist*, ed. and trans. Liliane Dulac and René Stuip, with the collaboration of E. J. Richards (Paris: Honoré Champion, 2017), ll. 1332–4.

19   Willemijn Ruberg, 'Interdisciplinarity and the History of Emotions', *Cultural and Social History* 6, no. 4 (2009): 507–16 (509).

20   Rita Felski, 'Context Stinks!', *New Literary History* 42, no. 4 (2011): 573–91 (574).

21   Jane Chance, 'Cognitive Alterities: from Cultural Studies to Neuroscience and Back,' *Postmedieval* 3, no. 3 (2012): 247–61 (257).

22   Anonymous, *Pearl, passim.*

23   Anonymous, *Pearl*, ll. 339 and 348.

24   David Aers, 'The Self Mourning: Reflections on Pearl', *Speculum* 68, no. 1 (1993): 54–73 (56).

25   Sarah McNamer, 'The Literariness of Literature and the History of Emotion', *PMLA* 130, no. 5 (2015): 1433–42 (1438).

26   McNamer, 'Literariness', 1436.

27   Bernard O'Donoghue in Jane Draycott, *Pearl* (Manchester: Carcanet Press, 2011), 9.

28   Stephanie Downes and Rebecca J. McNamara, 'The History of Emotions and Middle English Literature', *Literature Compass* 13, no. 6 (2016): 444–56 (452).

29   Jane Draycott, Commentary, http://www.stephen-spender.org/_downloads_general/Stephen_Spender_Prize_2008.pdf, accessed 5 November 2019.

30   Downes and McNamara, 'History of Emotions', 452.

31   William M. Reddy, *The Navigation of Feeling: A Framework for the History of Emotions* (Cambridge: Cambridge University Press, 2001), 105. For 'emotional environments' see William M. Reddy, 'Against Constructionism: The Historical Ethnography of Emotions', *Current Anthropology* 38 (1997): 327–51 (331).

32   Nicholas Watson, 'Desire for the Past', *Studies in the Age of Chaucer*, 21 (1999): 59–97.

33   Magdalena Nowak, 'The Complicated History of *Einfühlung*', *Argument* 1, no. 2 (2011): 301–26.

34   Helmuth Plessner, *Laughing and Crying: A Study of the Limits of Human Behavior*, trans. James Spencer Churchill and Marjorie Grene (Evanston: Northwestern University Press, 1970).

35   For a recent assessment of the important but changing role of English-language literature in emotional expression from the eighteenth century onward, see Olivier Morin and Alberto Acerbi, 'Birth of the Cool: A Two-Centuries Decline in Emotional Expression in Anglophone Fiction', *Cognition and Emotion* 31, no. 8 (2017): 1663–75.

# 11  Performing emotions

*Alan Maddox*

While almost all human interactions can be read as 'performative', the focus of this chapter is primarily on sources dealing with organised performances of music, dance and drama in the Western tradition. Particular attention is given to the early modern period, when the representation of emotion became a primary goal in the performing arts, with some exploration of sources that show how understandings of emotions, and how they could be presented in performance, changed in the nineteenth and twentieth centuries. In the first part of the chapter I discuss the broad categories of sources that can provide insights into the history of emotions in the performing arts, and what we can (and cannot) learn from them. The second part examines in more detail the sources for music, dance and drama in the Western tradition, with brief attention given to more informal performance genres and non-Western traditions.

It is important at the outset to acknowledge the problems of defining what emotions are and how we can 'read' them in cultural and historical context. Human responses to the performing arts are inevitably individual and culturally conditioned, yet at the same time people in different times and cultural contexts have often felt strong emotional responses to performance and felt the need to try to account for these in systematic ways. Thus emotions – however understood – have long been a central concern in the study of performance, with attention typically focused on how creators have attempted to convey emotions in their compositions, and how these have been expressed by performers and experienced by audiences.

The boundaries between composition, performance and audience remain indistinct, however; for instance, improvised performances such as *commedia dell'arte* combined composition and performance, while in the well-lit auditoria of eighteenth-century opera theatres the audience was often there as much to be seen as to see, and to perform as much as to observe a performance. The transmission of emotions through the stages of creation, performance and reception is also not necessarily direct or linear: performers might misinterpret or re-interpret the affective message of a piece, an audience might respond with laughter to something intended by both creator and performers to be sad, and despite the emotional entrainment common to the audience experience, individual audience members or groups may respond quite differently to others.

The definition of performance itself can also be difficult to pin down: a Beethoven piano sonata might be performed with no one but the pianist present, while conversely some civic or ecclesiastical rituals such as the annual ceremony of the marriage of Venice to the sea had a distinctly theatrical flavour. While Western cultures have generally distinguished clearly between the arts of acting, dance and music, in practice they often overlap: dance almost always involves music and often an element of acting, and spoken plays contained many songs and dances, while opera most thoroughly integrated all three arts (as well as those of painting, textiles, lighting and so on).

Accounts of the experience of being in various performance venues can also provide insights into the way these spaces have been constructed as emotional communities.[1] For instance, accounts of boisterous audience behaviour at both spoken drama and opera until the early nineteenth century suggest a very different kind of emotional community from that of the modern darkened theatre where 'audiencing' is constructed as a much more individual practice, characterised by emotional responses that are largely internalised and private, yet experienced, paradoxically, in a communal, public space.[2] Similarly, visual artworks and verbal accounts including letters and novels confirm that the emotional experience of both performing and listening was very different in environments such as the church, tavern, court or private home.

## Types of sources

As with most fields of historical study, books, journals, letters, archival documents and so on provide valuable information about the history of emotions in the performing arts, but non-verbal texts such as music scores, dance notations and visual representations of performance can be equally important, supplemented over the past century by audio and video recordings. The usefulness of each type of source varies to some extent for each art form and for each stage of the creative process, and each has its own particular limitations. The most valuable insights often arise when different kinds of sources, providing different perspectives, can be combined and analysed together.

Verbal texts provide the most direct evidence of an author's work in the case of drama, where the creative 'product' is a verbal script; however, in any of the arts, theoretical treatises and authors' writings about their compositional process can provide valuable insights into both the emotions they intended to convey and the technical means used to achieve this. As with any source, though, we need to take into account the purpose of writing and the intended audience. Authors' accounts of their own motivations and processes may be products of faulty memory or attempts at self-promotion or image building. The emotions they intended to express may also not be what performers or audiences at the time experienced in response, let alone what we would today – indeed the differences between historical and modern responses to the same composition may be particularly revealing. For example, some of the humour in *The Taming of the*

*Shrew*, which relies for its effect on early modern assumptions about the subservient social roles of women, makes uncomfortable viewing for many modern audiences.

Verbal sources from a performer's point of view often take the form of auto-biographical accounts and letters. Performance treatises are also particularly useful, especially for the eighteenth and nineteenth centuries when the expression of emotion in singing, acting and dance became a central concern in the training and valuation of performers. While many treatises do not go beyond rudimentary technical matters such as fingering, bowing, dance steps or posture, others provide specific guidance on the expression of affections or emotional states, while acknowledging the limitations of describing in words the ephemeral nuances of sound or action. Archives also sometimes provide a surprising window into the emotional world of performers, for instance when administrative records document conflicts over precedence or payment, or punishments for indecorous behaviour.

After the early eighteenth century, published performance reviews became increasingly common but accounts of performances and their emotional impact from an audience point of view can also be found in letters, diaries and official records of court and ceremonial occasions. Audience accounts are particularly useful for dance, for which, despite an increasing theoretical literature after the late seventeenth century, the technicalities of composition and performance were largely conveyed through verbal instruction and embodied demonstration rather than in writing.

For music and dance in particular, non-verbal texts such as scores and chor-eographic notations provide the most concrete evidence we have of what creators intended to convey. Indeed, that is the specific purpose of making written records using specialised, fit-for-purpose notation of this kind for each domain. While the conventions of each idiom are highly culturally dependent, for readers familiar with them, emotional cues built into such non-verbal sources are often clear in patterns of dissonant or consonant harmony, vigorous or restrained movement and so on. As with verbal accounts, however, an unavoidable chal-lenge in reading these historical sources is that, however well we understand their idiomatic conventions, we cannot hear, see or feel in embodied action the same things that people of the past did. A modern listener to Mozart cannot un-hear all of the familiar music of later times, from Beethoven to jazz, hip-hop and world music, with all of the emotional associations that each carries. And con-versely, we cannot share the emotional habitus of his original listeners, including life-long patterns of religious observance, automatic deference to our betters, or the daily habitual experience of moving (whether to act, sing, play or dance) in a hooped skirt or while wearing a sword.

Although visual representations of performance do not directly record the experience of being in an audience, they can convey details of posture, gesture and staging which show practices of emotional representation. Portraits of authors and performers also convey elements of their emotional worlds such as pride in their social status and professional standing or, especially in the nineteenth and twentieth centuries, the artist's projection of the sitter's

emotional persona, from Beethoven's romantic scowl to the studied detachment of photographic portraits of Anna Pavlova.

Despite their technological limitations, early audio recordings and films provide tangible evidence of expressive performing practices of the late nineteenth and early twentieth centuries which is not available for earlier eras. While each reproduces an imperfect representation of a single, curated instance of a particular piece, collectively they demonstrate expressive vocabularies of gesture, musical phrasing and tempo modification, dance style and so on which are often surprisingly different from current practice. The correlations and sometimes contrasts between the evidence of recordings and other documentary sources can provide particularly rich resources for problematising assumptions about older modes of emotional expression. The sometimes unsettling combination of immediacy and unfamiliarity that early recordings can engender also serves as a reminder that emotions are culturally contingent. The more closely we examine historical sources of all kinds, the more apparent it becomes that neither the terminology for describing emotional experiences nor the experiences themselves correspond precisely across either languages or historical time periods.

## Types of performance

### *Drama*

Evidence for methods of portraying emotion on the ancient stage comes primarily from hundreds of visual images in vase paintings as well as figurines showing masks, facial expressions (where actors were unmasked) and gesture, and from verbal descriptions of various emotions and how they could be aroused by use of the voice and action. The latter come primarily from treatises on oratory, particularly Aristotle's *The Art of Rhetoric*, Cicero's *De oratore*, Quintilian's *Institutio oratoria* and the pseudo-Cicero *Rhetorica ad Herennium,* each of which continued to be influential in early modern Europe.

According to Quintilian, 'all delivery [*actio*] ... is concerned with two different things, namely, voice and gesture, of which one appeals to the eye and the other to the ear, the two senses by which all emotion reaches the soul.'[3] Some 150 years earlier, Cicero had provided detailed instructions for the vocal expression of various emotions, for example:

> Anger requires the use of one kind of voice, high and sharp, excited, breaking off repeatedly ... Lamentation and grief require another kind of voice, wavering in pitch, sonorous, halting, and tearful ... Happiness needs another tone, unrestrained and tender, cheerful and relaxed ... Distress needs yet another, earnest but without appeal to pity, muffled, and in one tone of voice.[4]

A concern with systematically expressing emotion in drama is particularly evident from the sixteenth century onwards, nurtured by humanist education

in which the study of classical rhetoric was an increasingly important part. Detailed discussions of the means of representing emotion appear in acting treatises including those of Leone de Sommi (1565), Andrea Perrucci (1699), Franziscus Lang (1727) and Johannes Jelgerhuis (1827).[5] Perrucci's treatise is particularly useful in showing the commonality as well as the differences in expressive styles between composed and improvised theatre. While both shared the goal of moving the audience, *commedia dell'arte* was less directly based on rhetorical principles. It used a largely consistent collection of stock characters, in turn loosely based on those of ancient Roman comedy, each of whom had predominant emotional attributes. For instance the lovers were characterised by joy, devotion and longing, while the braggart Capitano is by turns angry, proud and fearful, while the servant Brighella's mask shows his typical attributes of lust and greed.[6]

Many treatises also provided descriptions of gestures used to express particular emotions. For example, according to Lang, fear is shown 'by holding up the right hand to the breast with four fingers uppermost and held together and then the arm is pushed forward and outward'.[7] The treatises of John Bulwer (1644) (see Figure 11.1), Lang and Jelgerhuis also provide visual images of gestures, while Charles Le Brun presented many analytical drawings of facial expressions.[8] Gilbert Austin's *Chironomia* (1806) is particularly useful in that, in addition to copious illustrations, it includes a notation system for gesture with examples for practice.[9] Henry Siddons's *Practical illustrations of rhetorical gesture and action* (1807), too, provides illustrations based on Johann Jacob Engel's *Ideen zu einer Mimik* (1785), but his approach reflects the radical changes to acting introduced in the second half of the eighteenth century by David Garrick (1717–79), Sarah Siddons (1755–1831) and John Philip Kemble (1757–1823), in which the portrayal of a continuous emotional trajectory began to supersede the representation of distinct, individual passions.[10]

Gestures expressing particular emotions in many of these sources are analysed and compared in Dene Barnett's *The Art of Gesture* (1987),[11] while Joseph Roach's classic study *The Player's Passion* (1985) addresses many of the same sources, but with a focus specifically on 'how the inner workings of the actor's body have been variously understood by critics and theorists who knew something about the physiology of emotion'.[12] Roach argues that new, scientifically oriented understandings of emotion were behind Garrick's 'revolution in acting' which in turn provided the resources for the very different, radically emotive style of romanticism epitomised by Edmund Kean (1787–1833). Evidence for the emotional style of romantic acting comes less from treatises than from biographies, reviews and commentaries such as G.H. Lewes's *On Actors and the Art of Acting* (1875).[13] Much can also be gleaned from earlier biographical accounts of actors, such as Francesco Bartoli's monumental *Notizie istoriche de' comici italiani.*[14]

Play scripts are of course vital sources for dramatic emotions. In the early modern period, stage directions specifying emotional delivery are rare, but clues to emotions are often embedded in the spoken text, even where specific

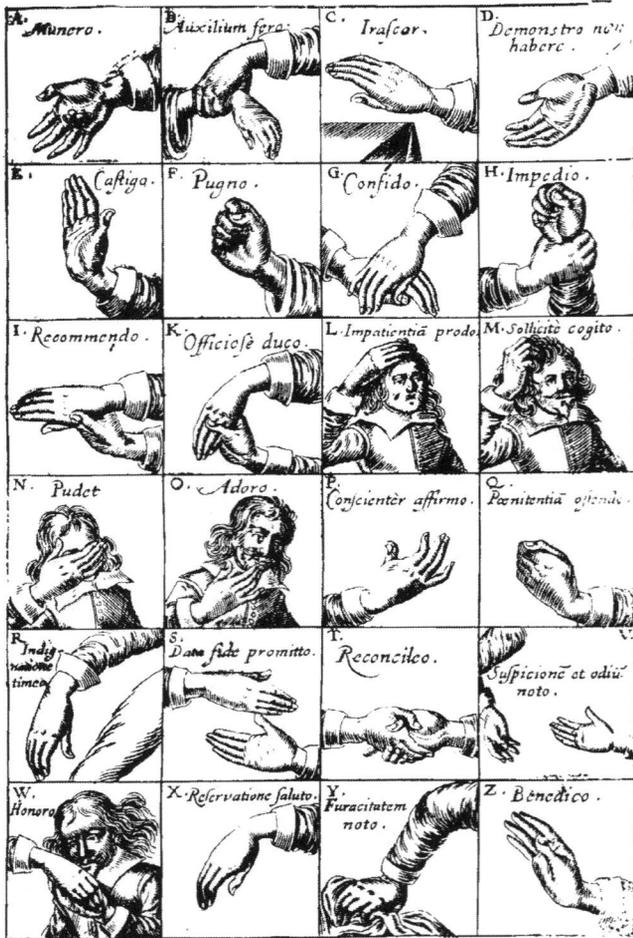

*Figure 11.1* Emotional gestures in John Bulwer's *Chirologia, or the Naturall Language of the Hand* (London: Thomas Harper, 1644)

emotion words are not used. For instance, Hamlet's or Romeo's sighing may be read as an 'emotional practice' in the sense proposed by Monique Scheer.[15] Emotions can also be implicit in practical stage directions such as Shakespeare's 'flourish', which indicates the sound of trumpets, audibly signalling the pride and majesty of a king and in turn demanding at least the appearance of deference and humility from his subjects.

While all of these kinds of sources can be useful individually, it is in combination that they often yield richer insights into the embodied experience of emotion in the theatre at a particular place and time, including different

understandings of what emotions are, how they work and how they may be conveyed in acting. Thus, the visual image of Hamlet encountering the Ghost (I.iv) which forms the frontispiece to Rowe's 1709 edition of the play (Figure 11.2) may be analysed in relation to the script, but a more nuanced perspective on eighteenth-century understandings of fear may come when it is also placed in the context of contemporary acting manuals and of observers' accounts of leading actor Thomas Betterton's famous 'start' – to which the image perhaps alludes – which was 'felt so strongly by the Audience, that ... they in some Measure partook of the Astonishment and Horror ... this excellent Actor affected'.[16]

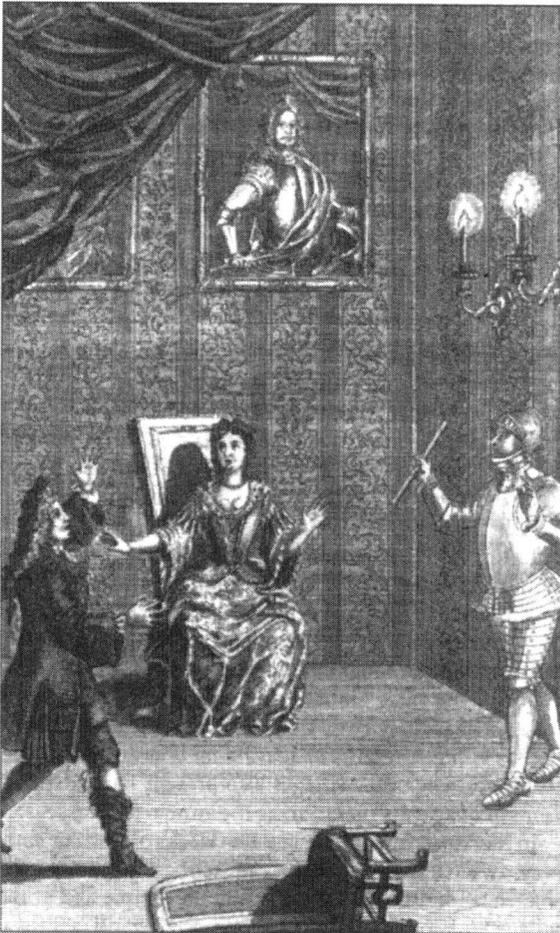

*Figure 11.2  Hamlet*, Act III, Scene 1. Frontispiece to *Hamlet* in Nicholas Rowe's 1709 edition (The Picture Art Collection/Alamy Stock Photo)

## Dance

The limitations of notations for recording historical dance mean that the most useful information about emotional expression in dance often comes from verbal texts rather than from choreographies and floor patterns, although these, too, can provide valuable clues, as can evidence about dance music.

The earliest European choreographies are recorded in fifteenth-century dance treatises in which a concern with the controlled display of emotion is clear. The physical poise and emotional control produced by dance training were essential attributes for Italian courtiers and understood as connected with ethical behaviour. Guglielmo Ebreo da Pesaro considered that dance reflected 'interior spiritual movements' corresponding with a harmony which travels through hearing to the intellect and the senses, where it generates 'certain sweet emotions … [which] try as much as possible to escape and make themselves visible in active movement'.[17] Choreographic sequences included dances such as *Gelosia* (jealousy), or expressing fickleness or fidelity.[18] Emotional expression, however, comes as much from the character of a dance type (bourée, sarabande, waltz) and the expressive manner of performing it, as from the specific steps and movements. Thoinot Arbeau noted in his *Orchesographie* (1588) (Figure 11.3) that 'the galliard is so called because one must be gay and nimble to dance it, as, even when performed reasonably slowly, the movements are light-hearted'.[19]

In the second half of the seventeenth century, theorists such as Claude François Ménestrier considered that theatrical dance was particularly apt for expressing emotion. According to the English dancer and theorist John Weaver, such

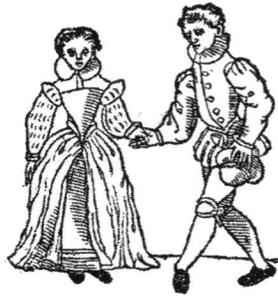

Ce faisant on a moyen de tourner le corps & la face deuers la Damoiselle, & luy ietter vn gracieux regard.

*Figure 11.3* Performing the *reverence* in a *basse danse*. 'Turn the body and face towards the lady and cast a gracious look upon her.' Thoinot Arbeau, *Orchesographie* (1588), 26v, Library of Congress

dance should be so clearly intelligible as to make a spectator 'able to distinguish the several *Passions, Manners* or *Actions*; as of *Love, Anger*, and the like'.[20] Although specific steps were not assigned for individual passions, increasingly complex dance notations, built on that of Beauchamps and Feuillet, did allow for detailed prescription of dancers' movement through space and of the precise connections between choreography and music. The concern with clear expression of emotions as well as technical virtuosity in turn laid the basis for the *ballet d'action* pioneered by Jean-George Noverre and his Italian rival Gasparo Angiolini in the mid-eighteenth century, establishing ballet as an autonomous narrative art form.[21] Dramatic scenarios for these ballets capture a new kind of authorial input in which intense emotion was a central element, seen, for example, in Jean Favier's scenario for the 'tragic pantomime ballet' *L'Ipermestra* (Venice, 1774). In Scene iv, the bloodied Danaïdes appear, trapped by 'a horrible group of furies' who lead figures representing Remorse, Guilt, Betrayal and Treachery which 'freeze the souls of the Danaïdes with fear' before they plummet into a 'horrible Inferno'.[22] Many of the dance manuals mentioned above include images of dancers showing posture, gesture and facial expression. In many cases these explicitly reproduce the modes of rhetorical gesture given in contemporary acting treatises, however some, such as that of Noverre, make the emotional intensity of danced pantomime particularly vivid.

Mid-nineteenth-century ballet manuals such as those of Carlo Blasis provide insight into both the compositional and performative contributions to emotional expression in ballet. Blasis made a clear distinction between pure dance elements and pantomimic action which advanced the plot by using the gestural language of classicistic acting. The pantomimic aspect he described as 'no less than a mute expression of feelings, passions, ideas, intentions, or any other sensations belonging to a reasonable being'.[23] He considered that 'almost every species of passion may be produced in a Ballet each in its place';[24] however, the range of appropriate emotions to be represented was to be limited. 'When selecting passages from history for the purpose of adapting them to the Ballet ... The composer should reject ... shocking and sanguinary events. ... We must in short banish from Ballet the Fausts the Manfreds and the Frankensteins.'[25]

In the nineteenth century, dance was increasingly a subject of public discourse which often drew attention to the emotional character of both performances and audience responses, as when an 1843 review of Fanny Elssler as Giselle observed that 'the gaze of the viewer, seized by the deepest pain, rests on [her] pale and devastated face'.[26] The performance reviews of Théophile Gaultier and Jules Janin were particularly influential in emphasising the sensory and emotional experience of ballet at the expense of the intellect. Thus, writing about the ballet *La Tentation*, Janin opined that 'the secret of ballet' was:

> to surrender to the impression of the moment, to be nonchalant enough not to scrutinise your pleasure, to let yourself be guided, without resistance, by the painter, the musician, the *danseuse*, to whichever place they lead you, in short, to allow yourself to be happy.[27]

While theoretical treatises since the late seventeenth century had focused on professional theatrical dance, social dance remained an important vehicle for public emotions. Many nineteenth-century manuals laid down etiquette for social dancing, helping to define the kind of emotional community that would be created by, for example, the hierarchical structure of a country dance, or the scandalous intimacy of couple dances such as the waltz. These themes are also traceable in novels and other literature; many relevant sources have been collated and analysed by authors including Allison Thompson, Cheryl Wilson and Molly Engelhardt.[28]

The music to which dancers performed is also an integral component of the emotional effect of dance, and much can be learnt from the musical scores used for particular dances; however, music notation before the late eighteenth century includes few explicit directions about emotional expression. Just as important as individual (often interchangeable) pieces of dance music, therefore, were treatises explaining how to play them with the appropriate character. For instance, Georg Muffat's *Florilegium Secundum* (1698) gives a detailed explanation of the intricate rhythmic nuances and melodic ornamentation used in violin playing in the Lullian style of French court ballet.[29] Simply playing the notes on the page without an understanding of these un-notated musical conventions would distort the relationship between choreography and music, and with it the affective character of each dance, whether Courante, Sarabande, Gigue or Canarie.

### Music

In Western cultures, music has almost universally been considered to express emotions, or at least to elicit emotional responses in hearers. Several ancient writers noted music's power to induce contrasting emotional states. Plato proposed to banish the 'dirge-like' Mixolydian, 'intense' Lydian and 'soft and convivial' Ionian *harmoniae* from his ideal republic as unfitting for the moral development of the young,[30] while Aristotle noted that:

> in the nature of the *harmoniai* there are differences, so that people when hearing them are affected differently and ... listen to some in a more mournful and restrained state, for instance the so-called Mixolydian, ... with the greatest composure to another, as the Dorian alone of the *harmoniai* seems to act, while the Phyrigian makes men divinely suffused.[31]

From the fifteenth century onwards, humanist fascination with this fabled affective power led to increasingly explicit associations being made between musical features and emotions. For instance, in his *Déploration* on the death of Jehan Ockeghem (d. 1497), Josquin de Prez illustrated the mourning words through dense texture, descending melodic lines, low pitch and extended phrases, punctuated by higher pitches for cries of lamentation. Once audible emblems of lament like these were established as identifiable musical gestures, they could also be conveyed in purely instrumental pieces such as J.J. Froberger's keyboard *Lamentation* on the death of the Emperor Ferdinand III (d. 1657).

The goal of not only portraying affections but arousing them in the listener was restated throughout the seventeenth and eighteenth centuries as the highest objective of music. J.J. Quantz considered that 'the orator and the musician have, at bottom, the same aim... namely to make themselves masters of the hearts of their listeners, to arouse or still their passions, and to transport them now to this sentiment, now to that',[32] while for theorist and composer Johann Mattheson, 'everything which occurs without praiseworthy affections signifies nothing, accomplishes noting, and is worth nothing'.[33] German theorists following Joachim Burmeister developed a theory of *musica poetica*, codifying musical figures through which the affections could be aroused by analogy with those of rhetoric,[34] and many composers associated particular keys with emotions; for instance, for Charpentier (c. 1692), C major was 'gay and militant', D minor 'serious and pious', and E minor 'effeminate, amorous and plaintive'.[35] The sound qualities of individual instruments such as the warlike trumpet or the amorous, pastoral recorder and flute, too, evoked particular emotions.

In the second half of the eighteenth century, composers including Joseph Haydn and W.A. Mozart were noted for their ability to convey humour as well as the 'sublime' passions such as fear, rage and wonder. This often depended on holding in tension the literal representation of emotions and the boundaries of theatrical decorum. In a letter to his father, Mozart wrote that 'just as a man in such a towering rage oversteps all the bounds of order, moderation and propriety and completely forgets himself, so must the music too forget itself. But ... passions, whether violent or not, must never be expressed in such a way as to excite disgust.'[36]

The Romantic movement brought attempts to induce ever more intense emotion in both vocal and instrumental music. Composers such as Hector Berlioz and Ferenc (Franz) Liszt wrote 'programme music' in which the score was often accompanied by a written programme describing a vivid scene. For instance, the note attached to Berlioz's *Symphonie Fantastique* describes a terrifying opium-induced dream in which the musician sees a Witches' Sabbath accompanied by 'moaning, bursts of laughter, distant cries' followed by a funeral knell and the *Dies irae* combined with a witches' dance. These effects are created in the music by devices such as tense harmonies, rapid changes of volume, tremolos and 'special effects' such as playing with the wood of the bow, which can be correlated directly with the narrative.

Many accounts in memoirs, letters and reviews attest, too, to the emotional impact on audiences of virtuoso instrumentalists, particularly Liszt (as pianist) and the violinist Niccolò Paganini, but also of the intense emotional engagement with which they played, not only projecting but apparently feeling powerful emotions as they performed. Author Hans Christian Andersen wrote of Liszt that 'as he sat there at the piano, pale and with his face full of passion, he seemed to me like a devil trying to play his soul free!'[37] This newly intensely personalised mode of performance was matched by an correspondingly personalised mode of listening, characterised on one hand by scenes of wild collective enthusiasm such as that depicted in Theodor Hosemann's 1842 cartoon *Lizst in Concert* (Figure 11.4), showing the pianist surrounded by swooning female admirers (what Heinrich

Heine called 'Lisztomania'), and on the other by the kind of withdrawn, inward contemplation in Albert Graefle's painting *Ludwig van Beethoven and Intimates, Listening to him Playing* (Figure 11.5). At the same time, debates on the aesthetics of music challenged the idea that music could express emotion at all. In *On the Musically Beautiful,* Eduard Hanslick argued that music does not express anything other than 'sonically moved forms'.[38]

An intrinsic limitation of written sources is that they can only indirectly convey how a past performance would have looked and sounded. Despite their technical limitations, it is abundantly clear from late nineteenth- and early twentieth-century recordings that performing styles of the period were different from those considered standard now and often different from what was prescribed in contemporary treatises and teaching manuals. Much of this difference concerns the representation of emotion through devices which are now often considered to be in poor taste, such as audible sobs on words like 'weeping', gliding between notes and a willingness to sacrifice beauty of sound in favour of intensity of feeling. Explicit connections with emotion are most easily identified in vocal music because of the verbal cues given in the sung text, but these in turn confirm the expressive intention behind the same devices when used in instrumental music.[39]

### Other modes of performance

Across many cultures, music has often been used in public civic, religious and diplomatic ceremonies and social rituals to create a suitable emotional tone,

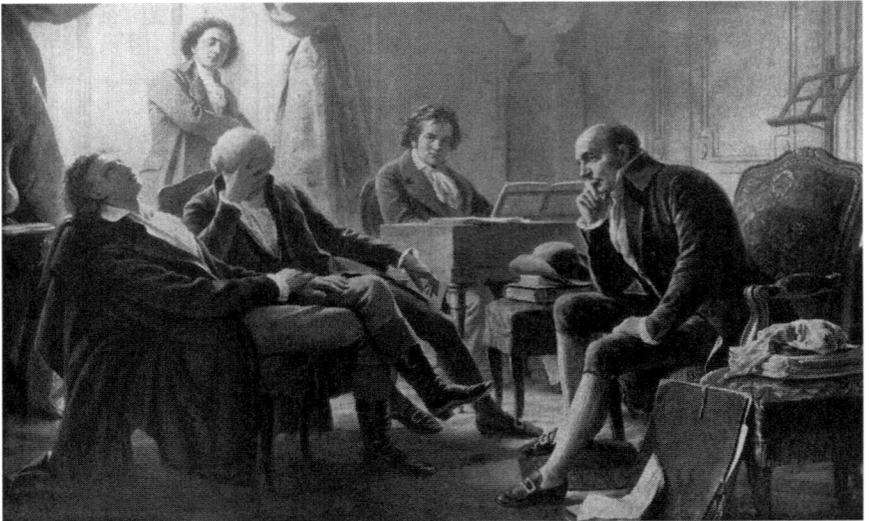

*Figure 11.4* Albert Graefle, *Die Intimen bei Beethoven.* Published by Franz Hanfstaengl, Munich, ca. 1892 (Lebrecht Music & Arts/ Alamy Stock Photo)

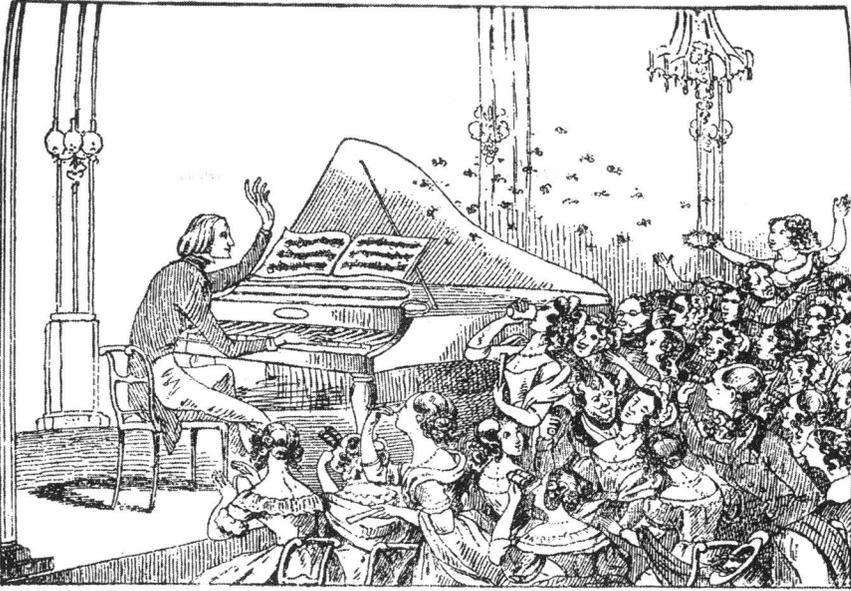

*Figure 11.5* Theodor Hosemann, *Liszt and his Admirers* (1842) (Granger Historical Picture Archive/ Alamy Stock Photo)

whether celebratory, penitent or mourning. Such events are often recorded in verbal accounts and visual images, and in some cases the music performed survives, allowing a rich analysis of the emotional tenor of the event. The use of music in inter-cultural ceremonial contexts can be particularly revealing. For instance, the reciprocal diplomatic visits between France and Siam in the 1680s were documented in chronicles, diaries, journals and visual art, including many detailed accounts of musical performances designed to impress, intimidate, entertain or move the respective ambassadors.[40]

Such inter-cultural encounters are a reminder that in human cultures throughout the world, people have expressed emotions which may be difficult or impossible to express directly in words through song, dance and performative representations such as ritual weeping.[41] Many such performative practices belong to unwritten traditions, meaning that they survive only in continuing traditional practices or in the historical accounts or recordings of ethnographers. Ethnographic studies make clear, however, that performed emotions are culturally encoded and therefore not directly translatable between cultures. For instance, a healing dance performed by Kalahari Bushmen both generates and communicates deep emotion which they describe as love, but of a kind that cannot be directly translated into other languages.[42] Such cases are a useful reminder that, for 'outsider' observers, ethnographic recordings that may appear to record cultural practices 'as they really are' need to be treated with

caution as sources for understanding performed emotions. Similarly, consideration of performance traditions that are generally unfamiliar to Western audiences, such as Japanese *Nōh*, confirm that performance is strongly culturally encoded. It may be impossible for someone outside a particular culture to access emotions which they may not share at all, expressed in a stylised idiom which they cannot read.

In recent years, ethnographic and social science methods have also revealed much about emotional engagement with music in Western cultures. For instance, Tia Denora's discussion of Jimi Hendrix's 1969 performance of *The Star-Spangled Banner* at Woodstock shows how the emotional meanings associated with a piece of music may be radically changed by the context and manner of its performance.[43] While many such studies are culturally contingent, it is possible that close reading of historical accounts of performance in the light of recent studies in music psychology and sociology may lead to new insights into historical emotions.

Sources for the performing arts are extremely varied and need careful interpretation; however they are also uniquely susceptible to practice-based research. Doing any kind of history inevitably involves an act of imaginative reconstruction of the past. In the performing arts this can be put to the test by using surviving performance materials such as music scores, play scripts and choreographies for their original purpose and performing them. Despite the highly contingent nature of any kind of reconstruction, historically informed performances of Shakespeare at the Globe with men playing the female characters, or of Bach's cantatas on period instruments in an eighteenth-century German church may provide insights into emotional practices in ways that are not accessible by studying the texts alone. In this way, present practice can generate new data – new sources – for the study of emotions history. Much remains to be discovered about historical sources but, just as importantly, about how to apply new theoretical and practical approaches to interpreting information about emotions that may be found in them.

## Notes

1 Barbara H. Rosenwein, 'Worrying about Emotions in History', *The American Historical Review* 107, no. 3 (2002): 821–45.
2 On this change in audience experience and its cultural context, see Nicholas Cook, *Music: a Very Short Introduction* (Oxford: Oxford University Press, 2000), Chapter 2.
3 Quintilian, *Institutio oratoria*, XI. III. 14. Translation in *The Institutio Oratoria of Quintilian*, trans. H. E. Butler, (London: William Heinemann, 1920–2).
4 *De Oratore*, III.216–219. Translation in Cicero, *On the Ideal Orator, De Oratore*, trans. James M. May and Jakob Wisse (New York: Oxford University Press, 2001), 292–3.
5 Leone de' Sommi, *Quattro dialoghi in materia di rappresentazioni sceniche: a cura di Ferrucio Marotti* (Milano: Il Polifilo, 1968); Andrea Perrucci, *A Treatise on Acting, from Memory and by Improvisation (1699)*, trans. and ed. Francesco Cotticelli, Anne Goodrich Heck and Thomas F. Heck (Lanham: Scarecrow Press, 2008); Franciscus Lang, *Dissertatio de Actione scenica* (Munich: Riedlin, 1727);

Alfred Golding, *Classicistic Acting: Two Centuries of a Performance Tradition at the Amsterdam Schouwburg; to which is appended an annotated translation of the 'Lessons on the Principles of Gesticulation and Mimic Expression' of Johannes Jelgerhuis* (Lanham: University Press of America, 1984).

6 Many relevant sources are collated in Cesare Molinari and Renzo Guardenti, *La commedia dell'arte* (Roma: Istituto poligrafico e Zecca dello Stato, 1999).

7 Lang, Dissertatio, 37. Translation in Ronald G. Engle, 'Lang's "Discourse on Stage Movement"', *Educational Theatre Journal* 22, no. 2 (1970): 179–87 (185).

8 John Bulwer, *Chirologia* (London: Thomas Harper, 1644); Charles le Brun, *Conférence sur l'expression … des passions* (Amsterdam: Picart, 1713).

9 Gilbert Austin, *Chironomia* (London: Cadell and Davies, 1806).

10 Henry Siddons and Johann Jacob Engel, *Practical Illustrations of Rhetorical Gesture and Action* (London: Richard Phillips, 1807).

11 Dene Barnett, *The Art of Gesture* (Heidelberg: C. Winter, 1987).

12 Joseph R. Roach, *The Player's Passion* (University of Delaware Press, 1985), 12.

13 George Henry Lewes, *On Actors and the Art of Acting* (London: Smith, Elder, & Company, 1875).

14 Francesco Bartoli, *Notizie istoriche de' comici italiani*, 2 vols (Padova: Conzatti, 1781–2; repr., Bologna: A. Forni, 1978).

15 Monique Scheer, 'Are Emotions a Kind of Practice (and is that what makes them have a history)? A Bourdieuian approach to Understanding Emotion', *History and Theory* 51, no. 2 (2012): 193–220; Naya Tsentourou, 'Hamlet's "Spendthrift Sigh": Emotional Breathing On and Off the Stage', in *Hamlet and Emotions*, ed. Paul Megna, Brid Phillips, and R.S. White (Cham: Springer, 2019), 161–76.

16 *The Laureat* (1740), 31; cited in Barbara Hodgdon, 'The Visual Record: the Case of Hamlet', in *The Cambridge Companion to Theatre History*, ed. Christine Dymkowski and David Wiles (Cambridge: Cambridge University Press, 2012), 249.

17 Guglielmo Ebreo da Pesaro, Guilielmi Hebraei pisauriensis de practica seu arte tripudii vulgare opusculum, incipit, 1463, MS fonds it., 973, f. 5v, Bibliothèque Nationale, Paris. Translation in Jennifer Nevile, 'Dance and Society in *Quattrocento* Italy', in *Dance, Spectacle, and the Body Politick, 1250–1750*, ed. Jennifer Nevile (Bloomington: Indiana University Press, 2008), 87.

18 Jennifer Nevile, 'The Early Dance Manuals and the Structure of Ballet: a Basis for Italian, French and English Ballet', in *The Cambridge Companion to Ballet*, ed. Marion Kant (Cambridge: Cambridge University Press, 2007), 10.

19 Thoinot Arbeau, *Orchesography*, trans. Mary Stewart Evans, American Musicological Society (New York: Dover Publications, 1967), 78.

20 John Weaver, *An Essay towards the History of Dancing* (London: Jacob Tonson, 1712), 161.

21 Jean-Georges Noverre. *Lettres sur la Danse, et sur les Ballets* (Stuttgart and Lyons: Delaroche, 1760)

22 Rita Zambon, 'Il 'grido della natura': il teatro di danza alla fine del Settecenta a Venezia', in *Naturale e artificiale in scena nel secondo Settecento*, ed. Alberto Beniscelli (Roma: Bulzoni, 1997), 254–5.

23 Blasis, Carlo, *Notes upon Dancing, Historical and Practical* (London: M. Delaporte, 1847), i.

24 Carlo Blasis, *The Code of Terpsichore*, trans. R. Barton (London: Edward Bull, 1830), 163–4.

25 Blasis, *Code of Terpsichore*, 165.

26 Anonymous review in *Revue et gazette musicale de Paris*, 1843. Cited in Lucia Ruprecht, 'The Romantic Ballet and its Critics: Dance Goes Public', in *The Cambridge Companion to Ballet*, ed. Marion Kant (Cambridge: Cambridge University Press, 2007), 181.

27  Jules Janin, Review of the ballet *La Tentation* in *Journal des débats*. 27 June 1832. Cited in Ruprecht, 'The Romantic Vallet', 181.

28  Molly Engelhardt, *Dancing out of Line: Ballrooms, Ballets, and Mobility in Victorian Fiction and Culture* (Athens: Ohio University Press, 2009); Cheryl A. Wilson, *Literature and Dance in Nineteenth-Century Britain: Jane Austen to the New Woman* (Cambridge: Cambridge University Press, 2009); Allison Thompson, *Dancing Through Time: Western Social Dance in Literature, 1400–1918* (Jefferson: McFarland, 2012).

29  Georg Muffat, *Georg Muffat on Performance Practice*, ed. and trans. David Wilson (Bloomington: Indiana University Press, 2000), 31–60.

30  *Republic*, 3. 398–9. Translation in Leo Treitler, ed., *Strunk's Source Readings in Music History* (New York: Norton, 1998), 10–11.

31  *Politics*, 8.7–9. Translation by Harris Rackham revised by Thomas J. Mathiesen in Treitler, *Source Readings*, 29.

32  Johann Joachim Quantz, *On Playing the Flute: A Complete Translation with an Introduction and Notes by Edward R. Reilly* (London: Faber and Faber, 1966), 119.

33  Johann Mattheson, *Der vollkommene Capellmeister* (Hamburg: Herold, 1739), 146. Translation in Dietrich Bartel, *Musica Poetica: Musical-Rhetorical Figures in German Baroque Music* (Lincoln, Nebraska: University of Nebraska Press, 1997), 138.

34  Bartel, *Musica Poetica*.

35  Rita Steblin, *A History of Key Characteristics in the Eighteenth and Early Nineteenth Centuries*, 2nd edn (Rochester: University of Rochester Press, 1996), 35.

36  Mozart to his father, Vienna, 26 September 1781. Translation in *Mozart Speaks: Views on Music, Musicians, and the World drawn from the Letters of Wolfgang Amadeus Mozart and other Early Accounts. Selected and with Commentary by Robert L. Marshall* (New York; Schirmer Books, 1991), 188.

37  *H.C. Andersens Dagbøger, 1825–1875*, ed. Kåre Olsen and H. Topsøe-Jensen (Copenhagen: G.E.C. Gad, 1971–76) II, 46–47. Translation in Anna Harwell Celenza, 'The Poet, the Pianist, and the Patron: Hans Christian Andersen and Franz Liszt in Carl Alexander's Weimar', *19th-Century Music* 26, no. 2 (2002): 130–54 (140).

38  Lee Rothfarb and Christoph Landerer, *Eduard Hanslick's On the Musically Beautiful: A New Translation* (Oxford: Oxford University Press, 2018), 41.

39  Neal Peres da Costa, *Off the Record: Performing Practices in Romantic Piano Playing* (Oxford: Oxford University Press, 2012).

40  David R.M. Irving, 'Lully in Siam: Music and Diplomacy in French–Siamese Cultural Exchanges, 1680–1690', *Early Music* 40, no. 3 (2012): 393–420.

41  See, for example, Gary Ebersole, 'The Function of Ritual Weeping Revisited: Affective Expression and Moral Discourse', in *Religion and Emotion*, ed. John Corrigan (New York: Oxford University Press, 2004), 185–222.

42  Kimerer L. LaMothe, 'Dancing on Earth: The Healing Dance of Kalahari Bushmen and the Native American Ghost Dance Religion', in *Dance and the Quality of Life*, ed. Karen Bond (Cham: Springer, 2019), 117–33.

43  Tia DeNora, *Music in Everyday Life* (Cambridge: Cambridge University Press, 2000), 33.

# 12 Visual sources

*Sarah Hand Meacham*

Even as historians cast an ever-wider net in their search for primary sources that explain the lives of non-elite people, they often shy away from using visual resources. Yet visual resources can be immensely valuable for the study of emotions history, and they have the added advantage of being relatively accessible through museums and reproductions. Artists often deliberately sought to create particular emotional reactions, and their work also might reflect changes in emotional standards and experiences at particular times.

For instance, nineteenth- and twentieth-century landscape art often documents artists' and audiences' mixed feelings about urbanisation and industrialisation. J.M.W. Turner's *Rain, Steam, and Speed – The Great Western Railway* (1844) portrays both the era's pride and its anxieties about mechanisation.[1] In contrast, expressionist artists of the late nineteenth and early twentieth centuries frequently focused on human suffering, often drawing beggars, the blind and the physically injured whom the artists believed agrarian households had cared for and modernity neglected. Edvard Munch's *The Scream* (1895), an early expressionist painting and perhaps the most famous work of expressionism, depicts a featureless, ungendered everyman with a head in the shape of an Edison light bulb screaming into a highly coloured sunset with what expressionists considered the inescapable *angst* of modern times.[2] The art-going public initially disliked *The Scream*, as well as much other expressionist art, and the history of the ways in which audiences receive art offers another category for the analyses of emotions history.

Art has continued to both reflect and shape the zeitgeist. Salvador Dali's surrealist (subconscious art) work titled *The Persistence of Memory* (1931), with its melting clocks, summarised the era's fears about war, economic depression and moral decay. Other artists have used their art to protest against war.[3] The Spanish Republican government commissioned Pablo Picasso to make a large mural for the Spanish Pavilion at the 1937 World's Fair. His *Guernica* (1937) is a large mural painted in grey, black and white – deliberately like a photograph – in the cubist style. It documents Nazi Germany's and Fascist Italy's bombing of the town of Guernica in Northern Spain. Picasso highlighted a screaming woman with a dead baby, a dismembered man, a gored horse and a bull, all overseen by a light bulb exploding like a bomb. Some Spanish officials at the World's Fair did

not find *Guernica* sufficiently 'Spanish' and wanted to replace it. *Guernica* has since become an anti-war icon to multiple generations around the world. The history of works like *Guernica* underline the usefulness of World's Fair materials and art as sources to study emotions such as patriotism and fervour.[4]

While modern art offers some distinctive opportunities and challenges for the history of emotion, earlier styles are at least as revealing for the evolution of emotional cues. The rest of this essay will focus on portraits, which are a particularly fruitful source for the history of emotions because they display faces and relationships, between individuals or between people and animals. Portraits can reveal changing marital and family relations and emotion ideals of motherhood, fatherhood and childhood. They can help bring to light the emotion experiences of marginalised people and people who did not leave written records. They can show how technology has shaped both art and emotions, and they can challenge viewers to consider the relationships between facial expressions, body language and 'real' feelings. Finally, portraits invite viewers to enter other times and places in new and powerful ways.[5]

## Portraits are extraordinarily diverse

Portraits can be painted or photographed, or they can be made of clay, wood or other three-dimensional sculptural materials. They may be painted miniatures in lockets, or large collections of life-sized carvings. They can be single pendants, or paired pendants, which historically have shown a husband and wife, perhaps one with a child or children, in gendered activities in separate frames. Or portraits can be what art historians call 'conversation pieces', portraits of family members or other groups ostensibly engaged in conversation or another activity, and often out-of-doors. Portraits can be staged formally or seemingly informally. They can be made by a third party, such as an artist, or they can be made by the subject, as in self-portraits and photographed selfies. Almost all forms of portraits that sitters purchase fall into a category that art scholars call 'likenesses'. Likenesses are faces and figures that are recognisable as the subjects of the portraits but are, to the subjects' minds, improved. Likenesses show subjects with the fashionable beauty, emotions, poses and clothes of their day. They show their subjects' best selves for their moment in time.[6]

Portraits in all their forms matter deeply to humans in part because of their extraordinary symbolism. 'Some of the most recognisable and popular works of art in the world are portraits, although these examples have transcended their original role as likenesses', art historian Richard Saunders has noted. 'Whatever we think of da Vinci's *Mona Lisa*, Velasquez's *Las Meninas*, Whistler's *Arrangement in Grey and Black No. 1*, or Stuart's *George Washington*, they are in fact portraits.' During wars, soldiers and civilians have destroyed portraits of the enemy: during the American Revolution, New Yorkers tore down a statue of King George III and rendered it into bullets; in 2003, American soldiers invading Baghdad destroyed portraits and statues of Saddam Hussein.[7] Portraits are diverse and intensely meaningful.

## People use portraits to advertise their virtues

The majority of portraits have been of private individuals. Over centuries, people have commissioned portraits, or painted self-portraits, to provide likenesses for posterity, to create or expand family histories and genealogies, to continue friendships, and to remind youth of their family responsibilities. Despite the apparently private nature of family portraits, they have been displayed regularly in public spaces such as artists' studios, exhibitions, hotels and, recently, restaurants. Most commonly, sitters have hung portraits in the public spaces of private homes, such as parlours, drawing rooms, dining rooms and ballrooms, where guests can see the wealth, lineage and status that portraits are intended to advertise. This public displays of family portraits, including on social media, lets adults promote their claims to the virtues valued by their era such as educational achievement, athletic prowess, wealth, beauty or admirable parenting. These private virtues that people hang or post publicly are place- and time-specific. People with similar cultural backgrounds tend to take photographs of similar events. Their portraits, photo albums and social media often look alike because families curate their portraits to show that they are 'secure, sheltered, respectable and prosperous'.[8] Displaying portraits of moments of emotionally intense personal or family moments lets members claim social achievement.

## Selfies are not new

Self-portraits and photographic selfies are related subsets of portraits. In some ways they are different. Artist-rendered self-portraits require expensive materials, like paints and canvases; require advance planning; and have usually been limited in number. Diego Velazquez was notorious for depicting himself, yet only about four of his approximately 120 paintings are self-portraits. Albrecht Dürer, also known and criticised for painting pictures of himself, made only three self-portraits. It is true that Vincent van Gogh made 43 or more self-portraits, and Egon Schiele, Edvard Munch, and Frida Kahlo were similarly inclined to paint themselves. Nevertheless, they were limited in the number of self-portraits they could produce by both costs and time. In contrast, a photographic selfie is nearly cost-free, can take mere seconds, requires no forethought, and can be reproduced quickly and endlessly.

Still, makers of both self-portraits and selfies have embraced technological advances. Painters quickly adopted the tin-mercury amalgam mirror when it was invented around 1400 because this clearer, brighter mirror distorted faces less than its predecessors and made creating self-portraits more feasible. It was the spread of front-view cameras in mobile phones and smartphones in the 2000s that let selfie culture mushroom. The front-view camera let posers shape their portraits more than ever before, continuing the tradition begun with painted self-portraits.[9]

Most importantly both self-portraits and modern photographed selfies are effective at advertising self-images, and historians can use these images to identify the values that are important to different times and places. Girls in Japan have often posted selfies showing themselves as cute and playful, because Japanese culture values that in girls. Americans have generally posted selfies that present them as cheerful and financially successful or socially desirable: winning sports events, being on vacations, buying new houses, having 'girls' night outs', or going on expensive dates. Humans have used portraits, self-portraits and selfies to display themselves as having achieved the emotion expectations of their day.

## Be cautious: who was the subject? Who was the art for?

Using any sort of portrait to analyse emotions history requires some caution. To begin with, it is sometimes unclear who the subject was or who the art was for. Some art has been buried or hidden. For instance, the colossal Olmec heads of ancient Mesoamerica (see Figure 12.1) were buried in about 900 BCE. They were uncovered mostly after 1958. They have facial expressions that today read as ranging from stern to tranquil to joyous. But we do not yet know what the heads were for, or who they represent. Perhaps they were gods, or they depict individual rulers. We do not know why they are so large or why they are severed at their chins. We do not know why their expressions vary, or how contemporary viewers interpreted their facial expressions.[10]

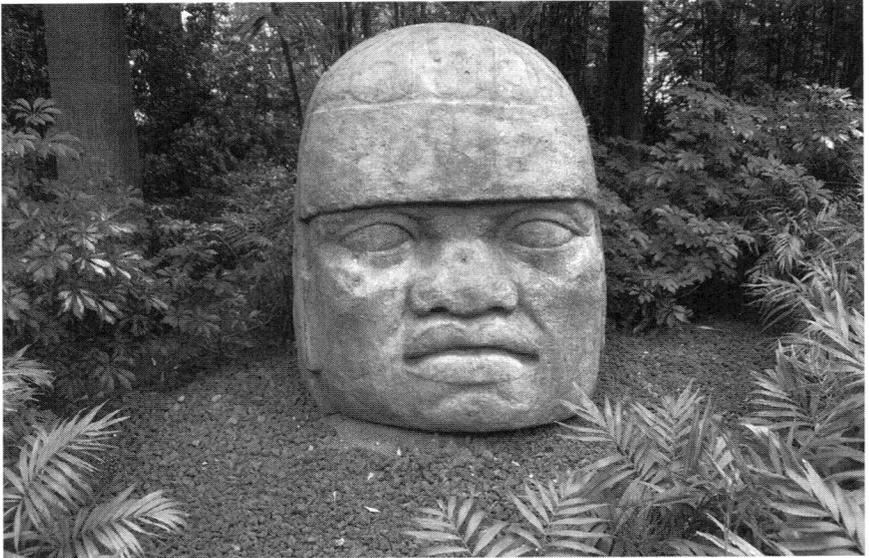

*Figure 12.1* Colossal heads of Olmec statue in Museo Nacional de Antropología, Federal District, Mexico (Pascopi/Alamy Stock Photo)

In a later example, living humans were never intended to see the funerary terracotta army that was buried with Qin Shi Huang, First Emperor of China, in 210 BCE. Farmers digging a well in 1974 accidently discovered the statues. So far, around 8,000 life-sized statues have been discovered, and new pits with more figures are exposed regularly. Craftsmen made the soldiers using a set menu of choices of moustaches, hairstyles and eyebrows. These features appear to give the figures something like facial expressions. However, as one archaeologist explained, their faces are likenesses, but they are like-nesses of no one. Their features are interchangeable, and much of their pur-pose remains a mystery to us.[11]

Finally, the Royal Necropolis in the Valley of Kings in Egypt was where the nobility and pharaohs buried their dead from the sixteenth to eleventh centuries BCE. The 63 known tombs in the Royal Necropolis were decorated with religious images. The most famous tomb is that of Ramses II, born around 1300 BCE, who had his tomb and temple, now known as the 'Ramesseum', built on the banks of the Nile. In his public temple, he had battle scenes painted that show himself as a giant trampling small enemies and winning battles that he had in reality lost. (Ramses is not the only political leader to have engaged in such self-promotion.) More perplexing are the images that Ramses had built on the *inside* of his temple, a space that most people were not allowed to see. Here, Ramses erected eight pillars in the form of the god Osiris, each ten metres high and each bearing the features of Ramses himself. Perhaps Ramses had the statues constructed to remind himself of his own power, or to remind the small number of priests and political elites who could enter the temple of that power. We still do not know. Clearly, one of the first challenges of using visual sources can be figuring out who saw them and why.[12]

## Be cautious: some artists wanted to shape social mores

Some works of art require careful study because their creators aimed to preach and change human behaviour with them. For instance, seventeenth-century Dutch artist Johannes Vermeer converted to Catholicism as an adult and used his domestic scenes to urge viewers to keep their eyes on eternal judgment. Vermeer's characters – the whore in *The Procuress* (1656), the maidservant in *Officer and Laughing Girl* (1660), his pregnant young women reading and writing letters, his grinning soldiers offering money for sex – are characters in moral lessons. *Woman Holding a Balance* (1664), for example, shows a woman dressed in an expensive blue jacket with fur trim standing quietly holding a jeweller's balance in her right hand (Figure 12.2). A large painting of the Last Judgment (which depicts the common Christian belief that God will return Jesus Christ to earth someday to judge every human and reward or penalise him in an afterlife) hangs on the back wall behind her. Before her lies a blue cloth and an open jewellery box with two strands of pearls and a gold chain. The woman's gaze at the balance, when considered in the context of the Last Judgment on the wall behind her, suggests Saint

Ignatius of Loyola's instruction to the faithful to examine their consciences and weigh their sins as if facing Judgment Day. The woman not only holds a jeweller's balance, she balances herself between the earthly treasures of pearls and gold before her and the eternal consequences of her actions behind her.[13]

In contrast with Vermeer's quiet interior struggles between materialism and morality, eighteenth-century Englishman William Hogarth loudly satirised vice. Hogarth invented presenting moral tales through series of affordable pictures. He staged worst-case scenarios with the goal of improving human behaviour. Hogarth knew first-hand what it was like to have a father in debtors' prison. *The Rake's Progress* (1735), one of Hogarth's most popular works, is a series of eight plates showing Londoner Tom Rakewell inheriting wealth from his miser father, wasting it on clothes, wine, sex and gambling, landing first in Fleet Prison, and then in the Bedlam insane asylum. Along the way he jilts his honest, common-law wife and their child. Like many of the prints that Hogarth and his admirers created, the series was intended to change behaviour. It is critical to keep Hogarth's and Vermeer's motivations

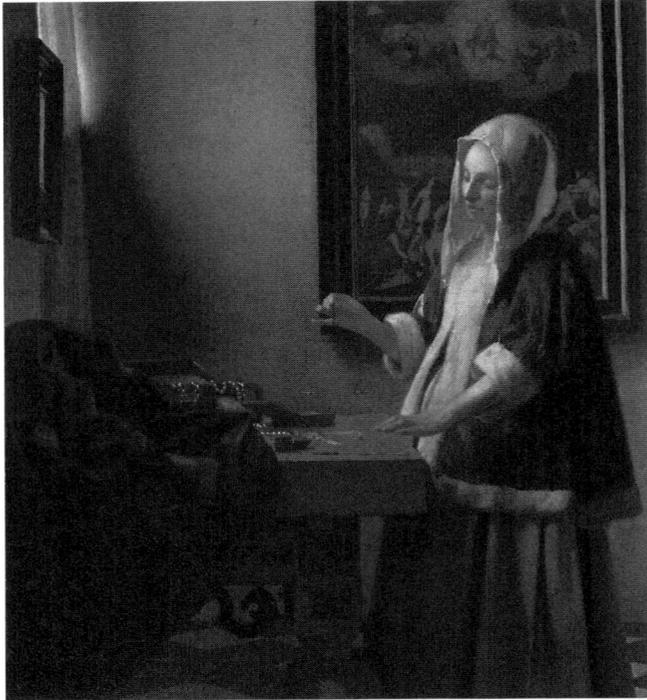

*Figure 12.2* Johannes Vermeer, *Woman Holding a Balance*, c. 1664, oil on canvas, Widener Collection, 1942.9.97, National Gallery of Art, Washington

in mind and not take their work as mere mirrors of the past. Still, their art lets us see the struggles they believed their times and places confronted, who they thought made the most sympathetic characters, and how they believed people should act and feel.[14]

## Be cautious: artists needed commissions

Still other artists worked without ever seeing the people or scenes they portrayed. Currier & Ives was a business that provided cheap prints of 'pleasant and reassuring images' for middle-class American homes from 1835 to 1907. The Currier & Ives workshop churned out prints at six for a dollar in a five-storey building in downtown Manhattan. An artist named Frances 'Fanny' Flora Bond Palmer drew at least 200 of their prints. In the latter nineteenth century, her images 'decorated the homes of ordinary Americans [more] than those of any other artist, dead or alive'. Among other images that Palmer was asked to paint were scenes of the American South. But Palmer never saw the American South. In fact, she had migrated from England and never saw more of America than New York City and its nearest suburbs. She took her cues from Currier & Ives' *Dark Town Series*, a collection of 170 racist caricatures that ridiculed the aspirations of black people between 1884 and 1896, and from popular blackface minstrel performances. Palmer' resulting images like *Low Water in the Mississippi* (1867) was meant to be interpreted as an enslaved family dancing happily to banjo music in a sturdy, pastoral cabin (see Figure 12.3). This specific image was reprinted until 1883, and similar ones appeared regularly in educational materials until at least the 1970s.[15]

Even when artists saw the people they portrayed, portraits frequently have been aspirational displays of how sitters think they *ought* to look. Clients often have refused to pay for portraits that failed to portray them as they wished. Sitters are shaped by prescriptive literature and cultural mores of their time and they want their portraits to reflect those values.[16] For instance, most eighteenth-century Anglo-American portraits display sitters with perfect alabaster skin without marks or facial hair. Very rarely do sitters have freckles or scars. No cheeks have sunken from tooth loss, a common problem. Faces are generally symmetrical, with high foreheads and aquiline noses, as was the aesthetic ideal. Men are frequently clean-shaven in portraits despite the fact that even elite men shaved only once a month until the invention and spread of the safety razor in the late nineteenth century. This clean-shaved look is in contrast to the portraits of European men between 1550 and 1650 that often show pointed beards, then considered signs of virility. Being able to see men's facial expressions has gone in and out of style. In the eighteenth century, the new 'man of letters' was clean-shaven, with an 'open countenance' better to showcase an enlightened mind and a thoughtful or kind expression.[17]

Jonathan Richardson's *Lady Mary Wortley Montagu* (c. 1725) offers a stark example of the role these kind of cultural mores have played in making portraits. Montagu had already refused to pay for several portraits by a different artist when she hired Richardson to paint her. At this point, Montagu was around age

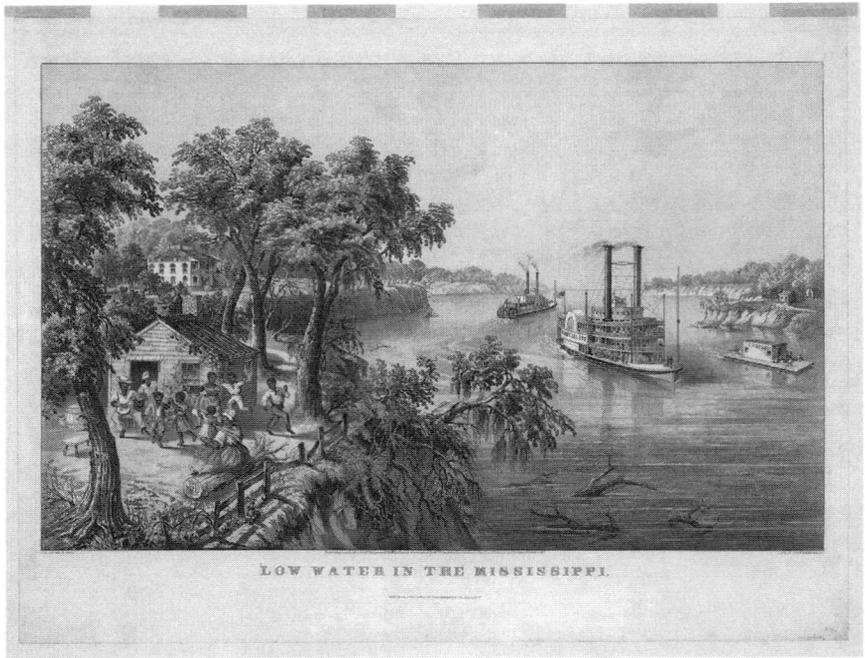

*Figure 12.3* Currier & Ives, *Low Water in the Mississippi*, ca. 1867. New York: Currier & Ives, photograph, Library of Congress

36 and unmarried, and a smallpox attack ten years earlier had left her with severely pitted skin and no eyelashes. Nonetheless, this portrait shows her with perfect alabaster skin and with eyelashes. The painter went beyond just removing scars though; he gave her almost iridescent white skin, which he highlighted by painting her next to an enslaved boy with dark skin. Lady Montagu is painted in Turkish style against a view of Constantinople, a setting and painting that transform her from a middle-aged, unmarried, disfigured woman, into an exotic, shimmering pearl.[18]

Occasionally customers and painters have changed far more than scars. Some family portraits include family members who had died. For instance, John Singleton Copley's *The Pepperrall Family* (1778) displays a central mother who has established a stable, cheerful and elite household, while her husband peers on admiringly. In reality, the mother pictured died before the painting was made and the family had recently fled to England from America after losing land and fortunes during the American Revolution. This family portrait, then, is not a glimpse of a specific, single afternoon, but rather a dream of how Mr. Pepperrall, the family's father, thought their lives could have been had his wife lived.[19] Portraits are not unthinking reflections; their histories often reveal complex histories of emotion of the artists, their views on their potential buyers or their sitters.

## Be cautious: photographs can also deceive

Like *The Pepperrall Family*, photographs too can deceive. People being pho-
tographed often make the fashionable facial expressions of their time whether
consciously or unconsciously. For example, the fashion in mid-nineteenth-
century England was for women to have very small, close-lipped smiles. In
early photography studios in the mid-nineteenth century in England and
America women were told to 'say prunes' in order to form this smile correctly.
In 1900, Kodak wanted to expand their film sales and film development to
amateur photographers, especially in America. Selling photography was a
challenge because most people found getting their picture taken a serious,
even unpleasant, endeavour. Kodak thus developed the 'Kodak Girl', a widely
smiling, fun-loving, pretty young woman to convince the market that taking
pictures was fun. Kodak also ran competitions that favoured photographs
showing people smiling widely. Kodak trained Americans to smile broadly for
the camera. Those big American smiles do not necessarily mean that people
in a photograph are happy; they reflect training, much like covering one's
mouth when coughing. It is necessary to be as cautious when interpreting
facial expressions and emotions in photographs as it is in other art.[20]

## Be confident: 'likeness' limited deception

Despite the cautions it is necessary to take when using portraits, portraits
remain a fruitful source for the history of emotions because they are like-
nesses. Customers' demands that portraits show their 'likeness' have limited
the perfection of the faces, expressions, bodies and relationships in the por-
traits. The vast majority of early modern people's surviving remarks on their
portraits discuss likeness. One of painter Henry Pelham's customers was quite
clear: 'a likeness is what I want, otherwise the picture will be of no value to
me, save as a piece of paint'. Portraits do show imperfections. John Singleton
Copley's portrait of Henry Pelham, *A Boy with a Flying Squirrel* (1765), dis-
plays Pelham's malformed ear; Copley's portrait of *Mrs. Ezekial Goldthwait
(Elizabeth Lewis)* (1771) shows her mole on her forehead and her double
chin. Customers have wanted, and obtained, portraits that display their best
selves with still recognisable faces, expressions, postures and context.[21]

## Be confident: portraits reveal changing ideals of emotions in relationships

Portraits can corroborate suggestions found in other historical sources. For
instance, eighteenth-century Western European prescriptive literature and
novels urged fathers to become more paternal and less patriarchal. Men were
told to lead by gentle example, rather than to demand and punish. It is hard
to know from written sources alone whether families put these recommenda-
tions into practice, or if they did, when. Portraits from Western Europe and

America indicate that they at least aspired to the new paternalistic, affectionate families especially in the second half of the eighteenth century. In portraits fathers stop towering over their families and sit or stand near the level of their wives. Husbands lean towards wives as well. Fathers touch their children, even play with them. Contrasting portraits from the early and latter parts of the eighteenth century make changes in emotion regimes immediately clear in ways that other historical sources do not.[22]

John Smibert's *The Bermuda Group* (1728, reworked in 1739) commemorates the intended founding of a college in Bermuda (Figure 12.4). The principal figure is Irish philosopher Dean George Berkeley, who was to lead the new college. The artist himself is on the far left, looking at the viewer (or at the mirror as he painted himself), holding a rolled-up sketch and paintbrush. He was to be a faculty member, lecturing on painting and architecture. The other men behind the table are John James and Richard Dalton, wealthy gentlemen involved in the college's founding. The man seated in front of the table is John Wainwright, who commissioned the painting. The women are Anne Forster, Berkeley's new wife who holds their infant, and her travelling companion, Miss Handcock.

The imposing painting measures nearly 1.77 x 2.36 metres (6 x 8 feet) rendering the eight figures nearly full-sized. The men tower over the women, doing physically what was required morally in the early eighteenth century.

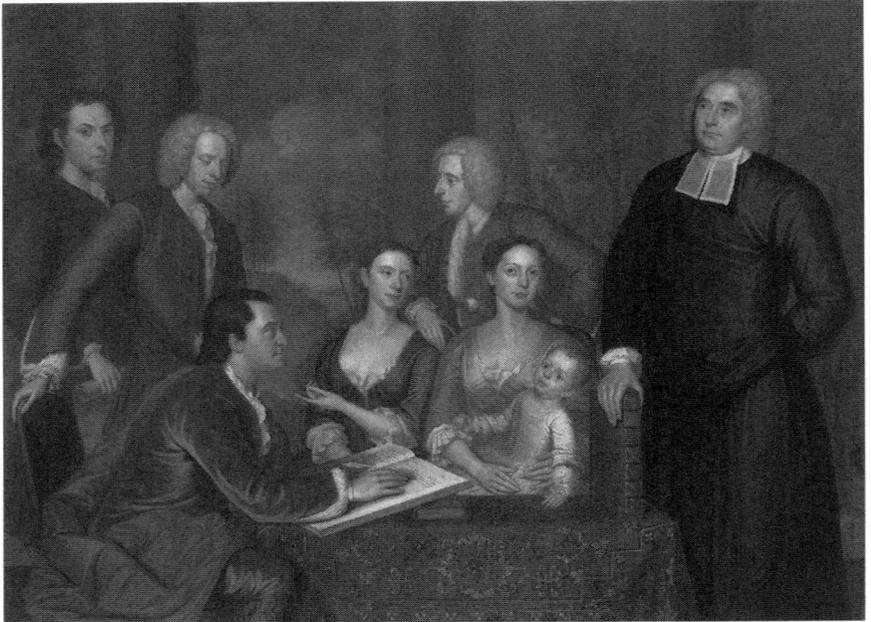

*Figure 12.4* John Smibert, *The Bermuda Group (Dean Berkeley and his Entourage)*, 1728, reworked 1739, oil on canvas, Yale University Art Gallery

The exception is the man who must sit to write. Dean Berkeley heads the group, dressed in Anglican robes, and shows his learning with his hand on his book. Unlike the affectionate Pepperrall family painted around forty years later, this patriarch does not lean towards, touch or look at other members of his flock. Instead he casts his eyes heavenward. In fact, none of the members of *The Bermuda Group* look at or touch another person more than necessary. Rather, they are upright and distant like the columns behind them. They display a seventeenth-century etiquette that focused on discretion and deference. Even the infant stands straight and obedient.

In contrast, in *The Pepperrall Family* (1778), the mother is the moral head of the family. The father leans, touches and smiles fondly on her and their children. The family now has children's toys and a dog, a symbol of fidelity and a gentle way to teach children responsibility. A curving curtain softens the lines of the single column behind the family, just as Mr Pepperrall's leaning, curving lines soften his patriarchy. The children eschew obedience; rather, they clamber on their parents in their play and affection. These changes between *The Bermuda Group* and *The Pepperrall Family*, from discretion to intimacy, patriarchy to paternalism, and obedience to affection, are not merely the results of different painters or skills; they reflect new ideals about the desirability of loving relationships.[23]

## Be confident: portraits can disclose emotions of marginalised people

Portraits can also detail areas of human events that other historical sources are silent on. On a trip to America in 1852 to assist author William Makepeace Thackeray, who was giving readings across eastern America, artist Eyre Crowe read a copy of *Uncle Tom's Cabin* and found himself 'properly harrowed'. While Thackeray defended slavery, Crowe wanted to see slavery for himself. His first morning in Richmond, Virginia, Crowe set off to sketch a slave auction. Few images of auction rooms survive which makes Crowe's *Slaves Waiting for Sale* (1861) immediately useful. But it is Crowe's images of enslaved men and women that have been especially valuable. Crowe shows that enslaved people to be sold were often fed bacon and lard to fatten them, and dressed in new, or often rented, clothing and earrings. Businesses sprang up near auction rooms to provide clothing, disguising past histories and punishments. Crowe's painting documents the private room behind the auction block where male purchasers took enslaved men and women they were interested in buying, stripped them, and inspected them – unobserved.[24]

The emotions in this painting, and in other anti-slavery art, are striking. Crowe emphasised that some family members had *already* been sold apart. The enslaved man is alone and angry, already sold away from what was perhaps a family like the one in the centre of the picture. Two women's eyes are filled with tears. The middle girl plays with her toddler trying to keep from bursting into tears, but also perhaps to try and keep her daughter with her. If she uses a double-consciousness and appears good-humoured, she might be able to win over a purchaser who will buy them both.[25]

Crowe's painting, part of a series, has inspired historians to re-examine American slavery. It stresses that enslaved families were sold apart, tried to make new families and were sold apart again. It points to the scale and variety of businesses and families that were involved in the slave trade. Most controversially, Crowe considers whether enslaved men and women did what they could to assess and manipulate buyers, to look for purchasers who would keep their families together. Then they could appear 'likely' for a promising buyer or sullen for an unpromising one.[26] Visual sources can offer a broad array of the emotions of marginalised people that very few written sources can match.

## Be confident: portraits show the emotion standards of the age

As in *Waiting for Sale*, the powerful emotions in portraits can prompt viewers to empathise with life in other times and places. Francisco Goya's *The Third of May 1808* (1814) launches viewers into terror. Goya painted the work one year after the conclusion of a French occupation of Madrid following an anti-Napoleon rebellion. As art historian Kelly Grovier has explained, Goya contrasts the humanity of those being executed with the faceless military machine that recedes to the right. Likely because Goya had lost most of his hearing, he was attuned to hands and sign language. The lamp in the painting shines not only on the Madrileno's shirt and face, but also on his hands, revealing that one hand has a deep dimple – a bloodless stigma, like Christ's on the cross. And like Christ's arms, the Madrileno's arms are raised and spread. Viewers cannot escape the Madrileno's fear. Still he does not cry, or beg, or otherwise betray the courage expected of him.[27]

There are quieter, but equally disquieting, portraits of war. James Abbott McNeill Whistler's *Arrangement in Grey and Black No. 1 (Portrait of the Artist's Mother)* (1871) is often assumed to be a general homage to motherhood. The painting is really about Confederate (pro-slavery) resentment of the US Civil War, which had ended six years previously. The etching on the wall above elderly Anna Whistler shows Wapping, England, whose wharves and warehouses played a critical role in the transatlantic slave trade. Anna Whistler herself was part of a slave-trading, plantation-owning family. Her son William was a surgeon in the Confederate Army. Anna had sued her uncle's widow, an enslaved black woman, to prevent her from receiving an inheritance. James Whistler had assaulted African-Americans in public, used racist epithets and slapped abolitionists in the face. The grey of the *Arrangement in Grey and Black* refers to the grey of Confederate uniforms: the painting is a homage to racism, bigotry and hate.[28]

The despair of the barmaid in Edouard Manet's *A Bar at the Folies-Bergère* (1882) beckons viewers to imagine what it was like to work in the Parisian cabaret in the late nineteenth century. Folies-Bergère was known for having barmaids who were also prostitutes. While the ladies in the wealthy crowd wear gloves and use opera glasses to watch the trapeze artist in the upper left corner,

the barmaid is isolated, separated by the bar, and her class is indicated by her gloveless, hatless state. Moreover, she works for other people's leisure, selling drinks and perhaps herself to customers like the one shown on the far right. She wears the same colours as many of the drinks she sells: the copper of the champagne tops matches her hair and her gold slave bracelet, the rosé wine matches the flowers in her bosom. She is in many ways only another item to be sold and her hopelessness makes clear that she knows this.[29]

In contrast, Frida Kahlo's *Self-Portrait with Thorn Necklace and Humming-bird* (1940) hums with disdain. Kahlo filled her small portrait with stark symbols of the indigenous Mexican culture with which she identified. Here, both the black cat and the spider monkey symbolise death. The monkey was a gift from Kahlo's husband, Diego Rivera; considering their notoriously troubled marriage, the image of the monkey pulling the necklace of thorns tighter around Kahlo's neck makes this symbol particularly potent. The hummingbird on the necklace would usually connote good fortune in love, but here it appears crucified. Kahlo memorialises two of her miscarriages with dragonflies that fall downward as plucked flowers. She is a woman attacked, but Kahlo fights back. The background greenery symbolises fecundity and the possibility of other children. And woven into her hair is a lemniscate, a symbol of infinity and frequently of strength. The butterflies on the lemniscate symbolise resurrection. This is a painting about pain, survival and endurance.[30]

Sometimes portraits summarise an era. Gerhard Richter's *Betty* (1998), a painting made from a photograph, challenges the concept of portraiture. It shows the back of Betty's head; the viewer cannot read her likeness for clues to her emotions. Her gaze is the same as that of the audience, into the fearful abyss that she, and we, try to escape. But Betty in her red riding-hood robe has fallen and she may not – we may not – scramble out of danger in time. It is a portrait of our own age of anxiety.[31]

## Conclusion

This essay has demonstrated that historians need not be so wary of using portraits and other visual sources. True, students of visual work are obliged to consider why someone commissioned a portrait and how the cultural mores of the time might have shaped the final product. It is necessary to ask whether the artist, like Vermeer, Hogarth or Crowe, had a message beyond the likeness. Was the image meant to change behaviour? Was it aspirational? Was it constructed to sell popularly, like *Low Water in the Mississippi*, or was it intended to rehabilitate someone's reputation, like *Lady Mary Wortley Montagu*? But historians ask questions about the creation and purpose of other sorts of primary sources regularly, and such a requirement to discern the author's intent has not hampered research in other sources.

Meanwhile there is much to be gained from embracing visual sources for the study of emotions history. This essay has only hinted at a few possible topics, such as changes in the emotion regimes expected in marital and family

relations; the emotion experiences of marginalised people; evidence of how people thought they should behave or feel in different times and places; and the embrace of portraiture, to begin to get a sense of the emotion regimes during notable moments in the past. Visual sources offer the opportunity to research the emotion effect that the artist sought to generate, or the emotions of the artist himself. Scholars can ask if the art reflects or challenges the emotion regime of the time. Researchers can explore how technology shaped both the way that the artist depicted emotion in art and the content of the emotions themselves. Studying relationships between facial expressions, body language and 'real' feelings is also productive. Scholars of emotions history are only beginning to employ visual sources, and the field can look forward to an informative – and revelatory – future.

## Notes

1  Links to images of the works of art discussed in this essay can be found in the endnotes. For Turner see: https://www.nationalgallery.org.uk/paintings/joseph-ma llord-william-turner-rain-steam-and-speed-the-great-western-railway, accessed 26 November 2019.
2  See: http://www.nasjonalmuseet.no/en/collections_and_research/our_collections/edva rd_munch_in_the_national_museum/, accessed 26 November 2019.
3  See https://www.moma.org/collection/works/79018, accessed 26 November 2019.
4  See https://www.museoreinasofia.es/en/collection/artwork/guernica, accessed 26 November 2019.
5  Attacks on Philippe Aries's *Centuries of Childhood* (New York: Alfred A. Knopf, 1962), Lawrence Stone's *The Family, Sex and Marriage in England, 1500–1800* (London: Weidenfeld & Nicolson, 1977), which used portraits badly, made historians fearful of using art as a historical source. See Kate Retford, *The Art of Domestic Life: Family Portraiture in Eighteenth-Century England* (New Haven: Yale University Press, 2006), 4.
6  On using portraits to study human–animal relations see Sarah Hand Meacham 'Pets, Status, and Slavery in the Late-Eighteenth-Century Chesapeake', *The Journal of Southern History* 77, no. 3 (2011): 521–54; on similarities between self-portraits and selfies see Claus-Christian Carbon, 'Universal Principles of Depicting Oneself across the Centuries: From Renaissance Self-Portraits to Selfie-Photographs', *Frontiers in Psychology* 8, no. 245 (2017): 2–9; on conversation pieces see Kate Retford, *The Conversation Piece: Making Art in Eighteenth-Century Britain* (New Haven: Yale University Press, 2017).
7  Richard H. Saunders, *American Faces: A Cultural History of Portraiture and Identity* (Hanover: University Press of New England, 2016), xiii. For artwork see: https:// www.louvre.fr/en/oeuvre-notices/mona-lisa-portrait-lisa-gherardini-wife-francesco-del-giocondo, accessed 26 November 2019; https://www.museodelprado.es/en/the-collection/art-work/las-meninas/9fdc7800-9ade-48b0-ab8b-edee94ea877f, accessed 26 November 2019; https://www.musee-orsay.fr/en/collections/works-in-focus/search/commentaire/commentaire_id/portrait-of-the-artists-mother-2976.html, accessed 26 November 2019; https://npg.si.edu/blog/gilbert-stuart-paints-george-washington, accessed 26 November 2019.
8  On why people commissioned portraits and exhibitions see Retford, *Conversation Piece*, 14, 321; on portraits displayed in hotels see Susan Rather, *The American School: Artists and Status in the Late Colonial and Early National Era* (New Haven: Yale University Press, 2016), 147, Marcia Pointon, *Hanging the Head:*

*Portraiture and Social Formation in Eighteenth-Century England* (New Haven: Yale University Press, 1993), 41, and Jennifer Van Horn, *The Power of Objects in Eighteenth-Century British America* (Chapel Hill: University of North Carolina Press, 2019), 127; on where in homes portraits have hung see Retford, *Conversation Piece*, 322, 17, Zara Anishanslin, *Portrait of a Woman in Silk: Hidden Histories of the British Atlantic World* (New Haven: Yale University Press, 2016), 238, and Margaretta M. Lovell, *Art in a Season of Revolution: Painters, Artisans, and Patrons in Early America* (Philadelphia: University of Pennsylvania Press, 2005), 11; on displaying portraits for status affirmation see Saunders, *American Faces*, 8; for the public display of private virtues, see Retford, *Conversation Piece*, 11; on culture and similarity of photos see Saunders, *American Faces*, 49.

9 Sabine Melchoir-Bonnet, *The Mirror: A History* (New York: Routledge, 2000) and Carbon, 'Universal Principles'.

10 Christopher Pool, *Olmec Archaeology and Early Mesoamerica* (Cambridge: Cambridge University Press, 2007), 106; Mary Beard, *How Do We Look: The Body, The Divine, and the Question of Civilization* (New York: Liveright, 2008), 53–60. For examples see: http://www.latinamericanstudies.org/xalapa-museum-5.htm, accessed 26 November 2019.

11 Ladislav Kesner, 'Likeness of No One: (Re)Presenting the First Emperor's Army', *Art Bulletin* 77 (1995): 115–32; see also, Jane Portal, *Terracotta Warriors: Guardians of China's First Emperor* (Washington, DC: National Geographic Museum, 2008), 27. For images see: http://www.bmy.com.cn/2015new/bmyweb/index.html, accessed 26 November 2019.

12 For more on Ramesses generally see Joyce Tyldesley, *Ramesses: Egypt's Greatest Pharaoh* (London: Penguin, 2000); on images, see Campbell Price, 'Ramesses, "King of Kings": on the Context and Interpretation of Royal Colossi', in *Ramesside Studies in Honour of K.A. Kitchen*, ed. M. Collier and S. Snape (Boston: Rutherford Press, 2011), 403–11. For images see: https://www.alamy.com/stock-p hoto-giant-limestone-statues-of-ramses-ii-rameses-1304-1237-bc-holding-57304164. html, accessed 26 November 2019.

13 Madlyn Millner Kahr, *Dutch Painting in the Seventeenth Century* (New York: Harper & Row, 1978), Chapters 5 and 12, 67–88 and 258–98; Lisa Vergara, 'Perspectives on Women in the Art of Vermeer', in *The Cambridge Companion to the History of Art*, ed. Wayne E. Franits (Cambridge: Cambridge University Press, 2001), 54–72. See: https://skd-online-collection.skd.museum/Details/Index/415421, accessed 26 November 2019; https://collections.frick.org/objects/275/officer-and-la ughing-girl, accessed 26 November 2019.

14 See: http://collections.soane.org/object-p40, accessed 26 November 2019.

15 On popularity of Fanny Palmer prints see Ewell L. Newman, *Currier & Ives: Nineteenth-Century Printmakers to the American People* (Sandwich: Heritage Plantation of Sandwich, 1973), 10; John Michael Vlach, *The Planter's Prospect: Privilege and Slavery in Plantation Paintings*, (Chapel Hill: University of North Carolina Press, 2002), 111–31; on similar images in textbooks see Adam W. Dean, '"Who Controls the Past Controls the Future": Southern Textbooks in an Era of Civil Rights', *Virginia Magazine of History and Biography* 117 (2009): 315–55. See: https://www.loc.gov/photos/?q=currier+ives+darktown+series, accessed 26 November 2019.

16 For refusing portraits see Saunders, *American Faces*, 6 and Pointon, *Killing Pictures*, 49.

17 Pointon, *Killing Pictures*, 131, on tooth loss; David M. Turner, 'The Body Beautiful', in *A Cultural History of the Human Body in the Age of Enlightenment*, ed. Carole Reeves (London: Bloomsbury, 2010), 119; On shaving see Alun Withey, *Technology, Self-Fashioning, and Politeness in Eighteenth-Century Britain* (Basingstoke: Palgrave Pivot, 2015), 225, Will Fisher, 'The Renaissance Beard:

Masculinity in Early Modern England,' *Renaissance Quarterly* 54, no. 1 (2001): 155–87, John Brewer, *The Pleasures of the Imagination: English Culture in the Eighteenth Century* (London: Routledge, 2013), and Philip Carter, *Men and the Emergence of Polite Society, 1660–1800* (London: Routledge, 2000).

18  Pointon, *Killing Pictures*, 49, 39–40. See: http://jenniferleecarrell.com/lady-mary-by-richardson/, accessed 26 November 2019.

19  Lovell, *Art in a Season*, 172. See: https://learn.ncartmuseum.org/artwork/sir-william-pepperrell-1746-1816-and-his-family/, accessed 26 November 2019.

20  Christina Kotchemidova, 'Why We Say "Cheese": Producing the Smile in Snapshot Photography', *Critical Studies in Media Communication* 22 (2005): 2–25, especially
    2, 4, 10, 17. See: https://library.ryerson.ca/asc/2013/10/the-kodak-girl-women-in-kodak-advertising/, accessed 26 November 2019.

21  Mrs. Margaret Mascarene to Henry Pelham, Salem, 14 September 1772, *Letters and Papers of John Singleton Copley and Henry Pelham*, ed. Charles Adams (New York: AMS Press, 1972), 189. See: https://collections.mfa.org/objects/34280; https://collections.mfa.org/objects/32756, accessed 26 November 2019.

22  On affection in portraits see Retford, *Domestic*, 8; on levels see Lovell, *Art in a Season*, 148–9; on family dogs see Meacham, 'Pets, Status'.

23  Lovell, *Art in a Season*, 156.

24  Maurie D. McInnis, *Slaves Waiting for Sale: Abolitionist Art and the American Slave Trade* (Chicago: University of Chicago Press, 2011), 19, 22–3, 76, 136. See: https://www.encyclopediavirginia.org/media_player?mets_filename=evr7164mets.xml, accessed 26 November 2019.

25  McInnis, *Slaves Waiting for Sale*, 86.

26  Walter Johnson, *Soul by Soul: Life Inside the Antebellum Slave Market* (Cambridge, MA: Harvard University Press, 2001), 162–67.

27  Kelly Grovier, *A New Way of Seeing: The History of Art in 57 Works* (London: Thames & Hudson, 2019), 146–7. See: https://www.museodelprado.es/en/the-collection/art-work/the-3rd-of-may-1808-in-madrid-or-the-executions/5e177409-2993-4240-97fb-847a02c6496c, accessed 26 November 2019.

28  Grovier, *A New Way of Seeing*, 158. See: https://www.musee-orsay.fr/en/collections/works-in-focus/search/commentaire/commentaire_id/portrait-of-the-artists-mother-2976.html, accessed 26 November 2019.

29  See: https://courtauld.ac.uk/gallery/collection/impressionism-post-impressionism/edouard-manet-a-bar-at-the-folies-bergere, accessed 26 November 2019.

30  Lis Pankl and Kevin Blake, 'Made in Her Image: Frida Kahlo as Material Culture', *Material Culture* 44, no. 2 (2012): 1–20; Oriana Baddeley, 'Her Dress Hangs Here: De-Frocking the Kahlo Cult', *Oxford Art Journal* 14, no. 1 (1991): 10–17. See: https://www.fridakahlo.org/self-portrait-with-thorn-necklace-and-hummingbird.jsp, accessed 26 November 2019.

31  See: https://www.slam.org/collection/objects/23250/, accessed 26 November 2019.

# 13 The material world

*Sarah Randles*

The study of how human emotions interact with materiality is a relatively new field, despite growing out of well-established bodies of research both in material culture and the history of emotions.[1] This work attempts to carve a theoretical space at the intersection of historical emotions and materiality, in which to consider how emotions affect the material world, and how materiality defines and changes human emotions. Using material culture as a source and focus for the history of emotions, based on an understanding that both emotions and materiality are historically and culturally constituted, provides a way of looking beyond the textual sources which have previously dominated the field.

The term 'material culture' is usually taken to mean the physical items that a society produces and uses for itself, including built environments and the adaptation of naturally occurring objects and places. 'Materiality' is a broader term, which includes aspects of the material world which are experienced and adapted, but not necessarily created by people. Humans also interact emotionally with phenomena that have materiality but which are neither objects nor places. Fire, for example, is material, but becomes part of material culture only as it is used deliberately, or when it impinges on the built environment or other objects. Light, similarly, is produced both artificially and naturally, and can be manipulated through building orientation and glass windows. Humans also have emotional relationships with the natural environment, ascribing it meaning within cultural and religious frameworks and reacting to it aesthetically. The study of the material world through the history of emotions is, therefore, inherently interdisciplinary, drawing on anthropology, archaeology, art history, religious studies, philosophy, museum studies and literary studies among other disciplines.

## Interacting emotionally with the material world

Humans respond directly to the material world in emotional ways. They may be filled with delight or awe when standing in a Gothic cathedral, be overcome with terror at the edge of a precipice, or disgust when confronted with the physical manifestations of illness. They also modify and manipulate materiality, creating objects and environments in order to express, produce and regulate emotion. They exchange love tokens as both private and public

testaments of affection; build churches, mosques and temples to express religious devotion; landscape wilderness into pleasure gardens, and give flowers in celebration or leave them on graves. Some objects are not specifically created for emotional purposes but acquire emotional meaning as they are used: a child's shoe becomes a sentimental treasure, or an apotropaic talisman; the site of a massacre becomes a shrine; a brick becomes a symbol of political anger when hurled through a window in protest. Just as humans respond to materiality with emotions, so too are those emotions manifested materially. Sara Ahmed labelled this the reciprocity of objects and emotions, maintaining that emotions are 'about objects, which they hence shape, and [which] are also shaped by contact with emotions'.[2] Oliver Harris and Tim Flohr Sørensen described emotions and materiality as existing 'in a continuous, recursive and co-constitutive relationship'.[3]

As objects and places are invested with emotional significance, they reflect the social, cultural and historical frameworks in which they are encountered, created or adapted, and these in turn influence the ways that such things function in the world. These 'emotional' objects and places provide sources which allow historians to understand not only how people in the past felt about their material world, but also how they felt about each other, and the events and culture that they experienced.[4]

## Embodied emotions

Human emotions may be intangible and sometimes elusive, but they exist within a material world which includes the human body. Monique Scheer, drawing on Pierre Bourdieu's concept of 'habitus' as a system of embodied mental and physical dispositions, posited that emotions can be understood as an embodied practice. In Scheer's theory:

> practices not only generate emotions, but ... emotions themselves can be viewed as a practical engagement with the world. Conceiving of emotions as practices means understanding them as emerging from bodily dispositions conditioned by a social context, which always has cultural and historical specificity. Emotion-as-practice is bound up with and dependent on 'emotional practices,' defined here as practices involving the self (as body and mind), language, material artifacts, the environment, and other people.[5]

Margrit Pernau developed Scheer's ideas in the context of architectural space, and argued that emotions are 'not only expressed but learned through the body', linking the human body to cultural performance, and understanding it as a 'site where culture is played out'. She argued that 'bodies are necessarily situated in space, and they bear the imprint of the spaces they are moving through and have moved through'.[6] This echoes Sara Ahmed, who wrote about emotions in terms of 'impressions': '*We need to remember the "press" in an impression.* It allows us to associate the experience of having an emotion with the very affect of one surface with another, an affect that leaves its mark or trace.'[7]

If emotions are something that we *do*, as Scheer claimed, then materiality is frequently the means by which we enact them – what we do them *with*. [8] We do emotions in cultural, historical, and material-cultural ways. We might show our love with red roses, our political dissent by burning a flag. These are conventions which are well understood within particular cultures. But emotional objects, places and spaces need to be considered as more than just props. We need to focus on how they are made, how they are used, what kinds of afterlives they have, how their meanings and matter change over time, and what they do, materially and emotionally, to the people who interact with them.

## Objects with agency

The anthropologist Alfred Gell referred to a particular category of things as 'art objects', which he understood as things defined, not by their forms, but by their effects. Such things could elicit responses, which he described in emotional terms: 'terror, desire, awe, fascination'.[9] He did not limit the category of art objects to things valued for their aesthetic properties, but stated that they could be, potentially, 'anything whatsoever'.[10] Gell considered art objects as being those that had what he called 'agency' – the ability to do things and effect changes.[11] Jane Bennett argued for a similar agency in matter, which she described as 'the curious ability of inanimate things to animate, to act, to produce effects dramatic and subtle'.[12]

Gell also described an art object as an 'index', something which represents or stands for one or more 'prototypes', and which can produce effects in its 'recipients' – those who are in a social relationship with the index – a role not limited to that of audience, but one which could include agents such as makers or patrons.[13] Indices, therefore, could 'do duty as persons'.[14] An example of objects operating as indices and doing duty for persons are the objects known as 'convict love tokens' or 'leaden hearts' at the Australian National Museum.[15] These were created by or for convicts who were to be transported from Britain to Australia in the eighteenth and nineteenth centuries, as a way of managing the near certainty that they would never see their loved ones again. The tokens were created by erasing the images of the king and Britannia from copper coins (an emotional act in itself) and replacing them with incised or punched text and images, often exhorting the recipient to remember the departed convict. In this way the tokens could act as substitutes for absent physical bodies, transcending distance and providing emotional comfort to both parties.[16]

## Places and atmosphere

Harris and Sørensen drew upon Gell's theory of agency to develop a theory of materiality and emotion in the context of pre-historical archaeology. They proposed, amongst other concepts, the term 'atmosphere', an aspect of emotionality

which occurs 'at the intersection of people, places and things, typically in archi-tectonic settings', produced by the relationship between people's mood and the physical spaces they experience. It takes into account not just the materiality of the space and the things in it, but the nature of particular events and other people within it. Harris and Sørensen made the point that 'very dissimilar atmospheres can arise in the same environment, as is evident, for example, in the case of a church, where an atmosphere at a wedding can be significantly different from that of a funeral'.[17] Similarly, people from different cultural backgrounds or at different points in history may experience very different atmospheres in same place.[18]

## Cultural and historical contexts

Even when objects or places are naturally occurring, the emotional response to them is framed by the cultures in which they are encountered and under-stood, and the qualities that people attribute to them. Kenneth McNamara has shown how naturally occurring fossil echinoids have been used for ritual and apotropaic purposes from the paleolithic to modern times. Their deliber-ate placement in homes, churches and burials shows that they were used to regulate fear, or bring good luck in ways that could be reframed in response to changing belief systems.[19] Although, as Bennett has demonstrated, there are objects and substances, such as germs or pollution, which can directly affect human emotions irrespective of any human cognition or awareness, the emotional responses to these effects are still culturally and historically inflec-ted.[20] An individual's reaction to disease, for example, will depend on whether they understand it as the result of personal sin or of bacteria.

Similarly, the emotional responses to larger-scale natural phenomena are also culturally and contextually determined. Grace Moore has explored the nuances of reactions to fire amongst nineteenth-century European settlers in Australia, from positive associations with the warmth and cosiness of the domestic fire to the terror induced by out-of-control bushfires.[21] Mikkel Bille and Tim Flohr Sørensen demonstrated that light can be understood as 'something that materialises as an aesthetic effect and an emotional impres-sion' and that it 'belongs more closely to an affective and subjective field than to conventional archaeological facts and artefacts'. They showed how this understanding and its role in spiritual traditions have underpinned the use of light as an emotional phenomenon in Christian church architecture.[22]

## Aesthetics

Part of the emotional response to materiality is based on the perception of beauty, with people reacting to things or places as 'objects of desire' based on their perceived aesthetic qualities. While these perceptions are historically and culturally mediated, artists, architects and landscapers have exploited this emotional attraction to beauty to create object and places which draw people

to them, sometimes in order to inculcate emotions such as religious devotion. The makers of medieval reliquaries, for example, used precious materials to enhance the power of the saints' relics they contained, by producing an intentional slippage between the materiality of the reliquary and the body of the saint which they contained.[23] However, even unadorned human remains were also valued as objects of desire, with both individuals and religious institutions wanting to see, touch and possess relics as well as collect them in ever increasing quantities.[24]

Alain de Botton in his book *The Architecture of Happiness*, discussed the ability of buildings to have an effect on human emotions:

> Taking architecture seriously ... makes some singular and strenuous demands upon us. It requires that we open ourselves to the idea that we are affected by our surroundings ... It means considering that we are inconveniently vulnerable to the colour of our wallpaper and that our sense of purpose may be derailed by an unfortunate bedspread.[25]

Pernau argued that the senses, along with individual and collective memories, are the media through which spaces affect the emotions.[26] The deliberate production of emotions through aesthetic materiality often relies particularly on sight to inculcate certain emotional states. However, Sally Holloway has shown how the highly ritualised exchange of love tokens between men and women in Georgian England also exploited smell and touch to reflect and produce romantic love, through gifts such as perfume bottles, nosegays and rings.[27]

## Emotional value and affective economies

By being used and contemplated in particular, ritualised ways, objects and places could become more than their constituent materiality, acquiring a metaphysical currency within the belief systems and cultural practices of the people who used them. Ahmed's concept of 'affective economies' provides a useful explanation of this. She asserts that emotions '*do things*', and considers them as analogous to the Marxian idea of capital, so that 'affect does not reside positively in the sign or commodity, but is produced only as an effect of its circulation'.[28] Ahmed sees emotions as located not within, but rather between bodies and objects, allowing them to 'align individuals with communities, or bodily space with social space – through the very intensity of their attachments', working by 'sticking figures together (adherence), a sticking that creates the very effect of a collective (coherence)'.[29]

In this system, 'some signs ... increase in affective value as an effect of the movement between signs: the more they circulate, the more affective they become, and the more they appear to "contain" affect'.[30] This circulation is what Ahmed called the 'affective economy'. Some objects can become what she calls 'sticky signs' – things to which emotions become 'stuck'.[31] One such sticky object is the Stone of Scone, on which the medieval kings of Scotland

were crowned. Alicia Marchant has detailed its long and varied affective history, including its removal from Scotland and subsequent installation in the Coronation Chair in Westminster Abbey by Edward I of England, as a potent symbol of conquest, and its ongoing association with ideas of Scottish national identity.[32]

The mechanism by which some items become emotionally sticky and others do not finds some explanation in the work of philosopher Guy Fletcher, who considered the way that some objects can acquire 'sentimental value',

> if and only if the thing is valuable for its own sake in virtue of a subset of its relational properties, where the properties include any or all of having belonged to, or been given to or by, or having been used by, people or animals, within a relationship of family, friendship or romantic love, or having been used or acquired during a significant experience.[33]

Fletcher's definition implies that such value relies on the act of memory, whether of a relationship or event, of a pre-existing emotional attachment. While the term 'sentimental value' applies only to a narrow range of objects and emotional responses, the concepts of memory and relationship are central to the ways that objects and emotions interact.

This is particularly true for objects that are given as gifts, including religious donations.[34] Objects may be given as demonstrations of affection, as a way of producing or cementing friendship, familial or political relationships. Gifts can keep the giver present in the memory of the recipient, even when they are bodily absent, including, in the case of material legacies, after death.

Jo Turney showed how knitted items, made by a woman as gifts for her grandchildren, became repositories of memory:

> it wasn't just the knitting itself, it was the creation of that artefact that I thought was really important. It held lots of importance for [the grandma] and the family in general ... lots of memories would come out of it ... she'd tell me lots of stories about her mother and all her memories of her mother creating things and there'd be memories of her making things for her own children, and that's now been passed on to my children. So I really, really cherish all the little knitted garments she made.[35]

Like Ahmed, Gell also emphasised the way that objects can lead what he calls 'very transactional lives', as they move between their recipients, indexing different things for different audiences and under different circumstances.[36] This concept of changing emotional meaning underpins the concept of 'emotional value' proposed by Stephanie Downes, Sally Holloway and myself.[37] Emotional value expands the idea of sentimental value to include both negative and positive emotional relationships with objects, and critically allows for changes in those relationships over time and across cultures. It recognises that even if an object or space does not materially change, its

emotional value may alter significantly. As emotional objects function mne-monically and associatively, the emotional value of objects and places reflect changes in the recipients' relationship with the person or place they recall. As with Ahmed's 'affective value', emotional value might increase as a result of continued positive emotional interaction, but objects and places might equally lose emotional value, gradually or abruptly, as their cultural, geo-graphical or temporal circumstances change. In contemporary and earlier 'consumer societies', attachment to objects and places is more frequently aesthetic and driven by a desire to fashion identities or achieve status within emotional communities than reliant on memory or an association of mate-riality with relationships. The emotional value of consumer items often depends on both novelty and display, meaning that pleasure derived from them is transient and that such things can swiftly lose both economic and emotional value.[38]

## Emotional communities and materiality

Objects and places may have significantly different emotional values for dif-ferent groups of people who interact with them, and Barbara Rosenwein used documentary sources to demonstrate that different 'emotional communities' have their own 'emotional valuation and expression'.[39] Alexandra Walsham detailed the sharp change in the emotional value of relics during the emo-tional regime change of the Reformation, when, for Protestants, the bodies of saints, which had been revered and appealed to by Catholics as a source of hope and comfort, were emotionally devalued and derided.[40] The precious metal reliquaries, however, continued to be desired for their economic value, although this often led to their destruction.

The agency of particular material items and places can cause emotional communities and rituals to form around them. Indeed such things are often constructed with the purpose of creating or unifying such communities. Helen Hill examined the production of devotional space as an architectural response to relics and miracles at San Gennaro in Naples, arguing that this space can be seen as 'an effect of the working of materiality in imbricated economies'.[41]

However, objects and spaces can also work to delineate different emotional communities from one another, excluding one group in order to produce cohesion within another. While war memorials work as a focus for commu-nity mourning, they exclude those whose war-related deaths did not fit within the strict limitations of the memorial, for reasons such as timing, nationality or gender.[42] Places of worship stand as visible and tangible ways of defining particular religious and emotional communities within broader social struc-tures. Items of dress, particularly uniforms and badges, and objects such as banners denote belonging to particular ideological groups and therefore emotional communities. Badges or specific clothing can also be imposed upon excluded groups, to not only show difference, but to inculcate hatred or dis-dain, and shame in the person so marked. The emotional effects of such

objects differ markedly depending on whether the recipient is within or out-side the emotional communities they define. Similarly, the emotional value of such a marker will be vastly different depending on whether it is voluntarily chosen or imposed. While the Nazi swastika and the imposition of badges on Jews and other groups during the Third Reich are amongst the most obvious examples, the use of similar objects as marks of inclusion and exclusion has a long history.

## Powerful objects

Gell's idea of agency does not equate to a belief that objects, places or phenomena have intent or sentience, or that they possess supernatural power. Nonetheless, from within the cosmologies of the people who experienced them, supernatural belief frequently underpinned the emotional relationships that people had with the material world. In the context of medieval Chris-tianity, for example, the orthodox belief was that objects could be conduits for the power of God, through which he might allow them to work miracles, but in practice such objects, including relics, statues or pilgrimage were often used talismanically, as though they had inherent power.[43] Such powerful objects also functioned as indices, doing duty as persons, albeit personages, such as saints, who were themselves powerful. Religious rituals involving such things could serve the purpose of achieving emotional self-regulation. Durkheim observed that 'the feeling of comfort which the worshipper draws from the rite performed' allowed them to 'enter into the profane life with increased courage and ardour'.[44] Even when belief systems change, powerful objects can retain emotional value, demonstrated by the continuation of ritual prac-tices around them, albeit reframed to fit within new belief structures. The still common practice of throwing coins in fountains or wishing wells for 'good luck' can be traced to votive offerings to Roman gods, reframed to fit Christian and subsequently secular belief systems, and reflecting the coins' emotional rather than monetary value.[45]

## Importance of matter

Central to the understanding of emotions in a material world is the idea that, as Elina Gertsman put it, 'matter matters'.[46] The specific physical nature of objects, places and phenomena affects and effects the responses of people who encounter it emotionally and sensorially.[47] Tim Ingold has made a distinction between matter and materiality, noting that 'the ever-growing literature in anthropology and archaeology that deals explicitly with the subjects of *materiality* and *material culture* seems to have hardly anything to say about materials'. By materials, Ingold means 'the stuff things are made of'.[48] Such stuff necessarily affects the emotional uses to which they can be put – whether an object can be kissed, held in the hand, carried in procession, whether it has a fragrance or a sound, and how it might respond to such actions, perhaps by

being able to be moved, wearing away or warming to the touch. In some cases the 'stuff' of matter allows it to record and embody its own emotional history: the big toe on St Peter's statue in the Vatican has been worn away by the touch of thousands of pilgrims venerating it; the positioning of flowers, candles, stuffed toys and written messages in makeshift memorials on the sites of deaths are testament to public rituals of grief.[49]

The mutability of matter is also crucial to an understanding of its emotional value. Even without direct human interaction, metals tarnish, wood and wool are eaten by insects, the acidity of nineteenth-century paper causes it to become brittle and eventually disintegrate. Weeds and trees grow up through buildings, rivers change course, sometimes even the earth itself shifts. The emotional relationships that people have with the material world can be sharply affected by such changes, as was evidenced by the public emotional responses to the near destruction of the cathedral of Notre-Dame of Paris by fire in April 2019.[50]

## Objects through time – cultural, temporal, geographic and historical change

But materiality is only part of the story. The emotional value of an object or place may actually increase as it loses aesthetic and economic value. Stuart Brand observed that the most significant factor in determining how buildings are valued is their age.[51] Pernau argued for 'temporalization as the central category to link materiality with knowledge and practices', stating that 'spaces can be endowed with an emotional valence through practices and experiences over time'.[52] Chris Gosden and Yvonne Marshall recognised that objects have cultural biographies, that 'as people and objects gather time, movement and change, they are constantly transformed, and these transformations of person and object are tied up with each other'.[53] Such differences in cultural history mean that identical objects can vary enormously in their emotional value to particular individuals or communities. Since the Industrial Revolution, hundreds of thousands of ordinary items have been mass produced. The surfaces of some of these have been marked by their experiences over time. But of the ostensibly identical objects, the teacup that belonged to a prime minister or to one's grandmother is the one which holds emotional value, even though knowledge of such value might need to be gained from documentary, visual, oral or archaeological evidence.

Emotional value rarely translates well from one cultural context to another. Susan Broomhall detailed the failure of the objects offered as gifts by Dutch explorers to indigenous peoples in Australasia to produce either emotional value or the expected reciprocal friendship.[54] Museums around the world collected cultural objects in past centuries which were once and, in many cases, still are of enormous emotional value to their original owners, but which held and may still hold entirely different historical or aesthetic values for their curators and audiences.[55]

## Conclusion: challenges and potential

Since emotional objects can be 'anything whatsoever' they may also be found anywhere, including in museums, archives and private collections or being used in their original contexts, as in institutions or in families. It is often possible to visit churches or temples, or environments with emotional resonance, such as graveyards or the sites of battle. Yet not all objects or places function emotionally, and many may have emotional value at some point in their existence and not at others. Since emotional value is always relative to particular viewpoints, it is necessary to know the history of an object or place and the way it has been used and understood to be able to assess its emotional value over time. Such history may be found in documentary or visual sources, or it may be inscribed into the physical matter of the object or place itself.

It is not always easy to find evidence of the emotional value of places and things in historical contexts. Objects frequently become unmoored from their original settings. Quotidian items, or those with little economic value, may never be documented or depicted visually. Objects used for religious or supernatural purposes may be deliberately kept secret. Communities move away, change or suffer erasure; information about the places and spaces they valued is lost.

Conversely, historians of emotions may be faced with materiality that has not survived but which is known only from the traces it has left in the documentary and visual record, or even with objects and places which exist only in literary or artistic depiction, but which nonetheless possess imagined materiality with emotional resonance. In contrast to Ahmed's concept of emotions sticking to objects, the historian can find both emotions and materiality to be slippery concepts, difficult to keep both in mind at once. He or she must resist the temptation to prioritise one at the expense of the other.

However, by adopting an object-centred approach, using interdisciplinary tools, and paying attention to physical evidence such as marks of wear, placement, patterns of use, alongside documentary and visual sources, in order to interrogate materiality, it is possible to uncover past emotions, including those of people who are absent or under-represented in the documentary archive.[56] Such methods have the potential to provide an understanding of historical emotions as something that people *did* in a material world.

## Notes

1  For an extended overview of the development of the field of materiality and emotions, see Stephanie Downes, Sally Holloway and Sarah Randles, 'A Feeling for Things, Past and Present', in *Feeling Things: Objects and Emotions through History*, ed. Stephanie Downes, Sally Holloway and Sarah Randles (Oxford: Oxford University Press, 2018), 8–23.

2  Sara Ahmed, *The Cultural Politics of Emotion* (New York: Routledge, 2004), 6.

3  Oliver J.T. Harris and Tim Flohr Sørensen, 'Rethinking Emotion and Material Culture', *Archaeological Dialogues* 17, no. 2 (2010): 145–63 (149).

4  I use the term 'emotional object' here as shorthand to mean an object (or thing or phenomenon) with emotional value. Sally Holloway and Alice Dolan used 'emotional objects' in this way as the title for their 2013 conference 'Emotional Objects: Touching Emotions in Europe 1600–1900', Institute of Historical Research, London, 11–12 October 2013, and their introduction to their 2016 special issue of *Textile* (Alice and Sally Holloway Dolan, 'Emotional Textiles: An Introduction', *Textile* 14, no. 2 (2016): 152–9 (155–6). Downes, Holloway and I also used it in our introduction and first chapter of *Feeling Things*, 12–13, 16, 18. However, while convenient, it is also somewhat problematic, and it is necessary to point out that it does not imply a belief that inanimate objects are themselves capable of experiencing emotion. The alternative term 'emotive objects' has also been used in a similar way by Sekai Maswoswe (http://www.columbia.edu/~sf2220/Thing/web-content/Pages/sekai2.html, accessed 25 August 2019). However, this too is problematic because the use of the term 'emotives' is primarily associated in the field of the history of emotions with William Reddy's use of it to mean speech acts, and in the field of contemporary art emotive objects are considered as art objects which directly express or represent the maker's emotions.
5  Monique Scheer, 'Are Emotions a Kind of Practice (and Is That What Makes Them Have a History)? A Bourdieuian Approach to Understanding Emotion', *History and Theory* 51 (2012): 193–220 (193).
6  Margit Pernau, 'Space and Emotion: Building to Feel', *History Compass* 12, no. 7 (2014): 541–9 (541).
7  Sara Ahmed, *The Cultural Politics of Emotion* (New York: Routledge, 2004), 6.
8  Scheer, 'Are Emotions a Kind of Practice?'
9  Alfred Gell, *Art and Agency: An Anthropological Theory* (Oxford: Clarenden Press, 1998), 6.
10 Ibid., 6–7.
11 Ibid.
12 Jane Bennett, *Vibrant Matter: A Political Ecology of Things* (Durham: Duke University Press, 2010), 6.
13 Ibid., 24.
14 Ibid., 9.
15 'Convict Love Tokens', National Museum of Australia, http://love-tokens.nma.gov.au/, accessed 20 August 2019.
16 Toby R. Bennis, *Romantic Diasporas: French Émigrés, British Convicts and Jews* (Basingstoke: Palgrave Macmillan, 2009), 89.
17 Harris and Sørensen, 'Rethinking Emotion', 152.
18 See, for example, Sarah Randles, 'Carved in Stone: Engaging with the Past in Medieval Orkney', in *Historicising Heritage and Emotions: The Affective Histories of Blood, Stone and Land*, ed. Alicia Marchant (Abingdon: Routledge, 2019), 71–102, discussing the twelfth-century Norse experience of Neolithic burial mounds.
19 Kenneth J. McNamara, 'Shepherds' Crowns, Fairy Loaves and Thunderstones: The Mythology of Fossil Echinoids in England', in *Myth and Geology*, ed. L. Piccardi and W.B. Masse (London: Geological Society of London, 2007), 279–94.
20 Bennett, *Vibrant Matter*.
21 Grace Moore, '"Raising High its Thousand Forked Tongues": Campfires, Bushfires, and Portable Domesticity in Nineteenth-Century Australia', *19: Interdisciplinary Studies in the Long Nineteenth Century* 26 (2018), http://doi.org/10.16995/ntn.807.
22 Mikkel Bille and Tim Flohr Sørensen, 'In Visible Presence: The Role of Light in Shaping Religious Atmospheres', in *The Oxford Handbook of Light in Archaeology*, online September 2017, 10.1093/oxfordhb/9780198788218.013.13.
23 Cynthia Hahn, 'What Do Reliquaries Do for Relics?', *Numen* 57 (2010): 284–316 (310).

24 See, for example, the vast relic collections of Louis IX of France, and the Holy Roman Emperor Charles IV, as well as those of other wealthy medieval relic collectors. Holger A. Klein, 'Sacred Things and Holy Bodies: Collecting Relics from Late Antiquity to the Early Renaissance', in *Treasures of Heaven: Saints, Relics, and Devotions in Medieval Europe*, ed. Holger A. Klein Martina Bagnoli, C. Griffith Mann and James Robinson (London: British Museum Press, 2011), 55–67.

25 Alain de Botton, *The Architecture of Happiness* (Harmondsworth: Penguin, 2010), 9.

26 Pernau, 'Space and Emotion', 542.

27 Sally Holloway, *The Game of Love in Georgian England: Courtship, Emotions and Material Culture* (Oxford: Oxford University Press, 2019), 86–91.

28 Sara Ahmed, 'Affective Economies', *Social Text* 70, 22, no. 2 (2004): 117–139 (119–20).

29 Ibid., 119.

30 Ibid., 120.

31 Ibid., 129. Ahmed gives as an example the emotional resonance of the American flag in the time following the terrorist attacks of 11 September 2001.

32 Alicia Marchant, 'Romancing the Stone: (E)motion and the Affective History of the Stone of Scone', in *Feeling Things*, ed. Downes et al., 192–208.

33 Guy Fletcher, 'Sentimental Value', *The Journal of Value Inquiry* 43, no. 1 (2009): 55–65 (56).

34 Natalie Zemon Davies, *The Gift in Sixteenth-Century France* (Oxford: Oxford University Press, 2000), 12.

35 Jo Turney, '(S)mother's Love, or Baby Knitting', in *Love Objects: Emotion, Design and Material Culture*, ed. Anna Moran and Sorcha O'Brien (London: Bloomsbury, 2014), 23.

36 Gell, *Art and Agency*, 24.

37 Downes et al., 'A Feeling for Things', 13.

38 For a history of consumerism and some of its emotional context, see Frank Trentman, *Empire of Things: How We Became a World of Consumers, from the Fifteenth Century to the Twenty-first* (London: Allen Lane, 2016).

39 Barbara Rosenwein, *Emotional Communities in the Early Middle Ages* (Ithaca: Cornell University Press, 2006), 2.

40 Alexandra Walsham, 'Skeletons in the Cupboard: Relics after the English Reformation', *Past & Present* 206, no. 5 (2010): 121–43.

41 Helen Hill, 'Miraculous Effects and Anagogical Materialities: Rethinking the Relation between Architecture and Effect in Baroque Italy', in *Emotion, Ritual and Power in Europe, 1200–1920: Family, State and Church*, ed. Merridee L. Bailey and Katie Barclay (Basingstoke: Palgrave Macmillan, 2017), 193–220 (195).

42 Catherine Speck, 'Women's War Memorials and Citizenship', *Australian Feminist Studies* 11, no. 23 (1996): 129–45; Steven R. Welch, 'Commemorating 'Heroes of a Special Kind': Deserter Monuments in Germany', *Journal of Contemporary History* 47, no. 2 (2012): 370–401.

43 See Sarah Randles, 'Signs of Emotion: Pilgrimage Tokens from the Cathedral of Notre-Dame of Chartres', in *Feeling Things*, ed. Downes et al., 43–57.

44 Émile Durkheim, *The Elementary Forms of the Religious Life*, trans. Joseph Swain (London: George, Allen and Unwin, 1912). 382.

45 Mark A. Hall, 'Money Isn't Everything: The Cultural Life of Coins in the Medieval Burgh of Perth, Scotland', *Journal of Social Archaeology* 12, no. 1 (2012): 72–91 (73).

46 Elina Gertsman, 'Matter Matters', in *Feeling Things*, ed. Downes et al., 27–42.

47 Bernard L. Herman, *The Stolen House* (Charlottesville: University Press of Virginia, 1992).

48 Tim Ingold, 'Materials against Materiality', *Archaeological Dialogues* 14, no. 1 (2007): 1–16 (1).
49 See Jeffrey L. Durbin, 'The Material Culture of Makeshift Memorials', *Material Culture* 35, no. 2 (2003): 22–47.
50 'Our Lady of Paris', The Public Medievalist, https://www.publicmedievalist.com/our-lady-of-paris/, accessed 25 August 2019.
51 Stuart Brand, *How Buildings Learn: What Happens after They're Built* (New York: Viking, 1994), 10–11.
52 Pernau, 'Space and Emotion', 541–2.
53 Chris Gosden and Yvonne Marshall, 'The Cultural Biography of Objects', *World Archaeology* 31, no. 2 (1999): 169–78 (169).
54 Susan Broomhall, '"Quite Indifferent to These Things": The Role of Emotions and Conversion in the Dutch East India Company's Interactions with the South Lands', *Journal of Religious History* 39, no. 4 (2015): 524–44.
55 See, for example, the contrasting experiences of the museum presented by Christian E. Feest, 'The Collecting of American Indian Artifacts in Europe, 1493–1750', in *America in European Consciousness, 1493–1750*, ed. Karen Kupperman, (Williamsburg: University of North Carolina Press, 1995), 324–60; Divya P. Tolia-Kelly, 'Race and Affect at the Museum: The Museum as a *Theatre of Pain*', in *Heritage, Affect and Emotion: Politics, Practices and Infrastructures*, ed. Divya P. Tolia-Kelly, Emma Waterton and Steve Watson (London: Routledge, 2016), 33–46; Sandra H. Dudley, 'Encountering a Chinese Horse: Engaging with the Thingness of Things', in *Museum Objects: Experiencing the Properties of Things*, ed. Sandra H. Dudley (Abingdon: Routledge, 2012), 1–16 (1–3).
56 See Hilary Davidson, 'Holding the Sole: Shoes, Emotions, and the Supernatural', in *Feeling Things*, ed. Downes et al., 72–93; Sarah Randles, 'Material Magic: The Deliberate Concealment of Footwear and Clothing', *Parergon* 30, no. 2 (2013): 109–29.

# Part III

# Emerging themes in the history of emotions

# 14  Comparative emotions

*Joseph Ben Prestel*

How do historians dare to compare emotions? Are they not highly individual phenomena that are hardly comparable even between two different human beings? And even if we consider emotions to be more social than individual, doesn't a comparison flatten all historical, cultural and social differences between emotions in different settings? What kinds of sources would historians even use for such a comparison? Scholars in the social sciences and humanities have indeed been ambivalent about the possibility of comparing emotions. For a long time, two separate camps existed. There were those who prescribed to a universalist notion of 'basic emotions', which existed in every human being, a position often associated with the work of the psychologist Paul Ekman, and others who argued that the very concept of emotions is rooted in an epistemology that is specific to the West and should not easily be exported to other places where such a concept might not even exist, a position often associated with the work of anthropologists like Catherine Lutz and Lila Abu-Lughod.[1]

In this chapter, I will argue that the approach of emotional practices that scholars like Monique Scheer and Daniela Saxer have proposed not only avoids such hard positions, but also enables historians of emotions to compare sources from different historical contexts with each other.[2] To illustrate this argument, I will offer an example for such a comparison. The following pages will present sources from two different nineteenth-century cities: an article on personal advertisements (ads) seeking marriages that appeared in the Cairo-based periodical *al-Hilal* in 1892 and a text about these ads that was published in the year book of the Statistical Bureau of Berlin in 1874. This choice of sources is based on my research about debates on urban change in the German and the Egyptian capitals during the second half of the nineteenth century. The specificities of these two contexts matter and I will explore them in detail on the following pages. At the same time, the analysis of both texts also offers the opportunity to highlight similarities and to reflect on more general observations that can guide a comparative approach to sources in the history of emotions. Therefore, this chapter will begin with the question of how to find sources for a comparison before delving into an analysis of the two texts from Berlin and Cairo.

## Finding sources: on the search for corresponding traces

Historians of emotions have drawn on a variety of sources for their studies. From diaries and self-help literature to architecture and music, there are virtually no boundaries to the creativity in finding sources that tell us something about how emotions changed over time and how they affected the course of history. The aim of comparing emotions in history comes, however, with its own challenges and demands for sources. In discussions about historical comparisons, the issue of commensurability is a common theme.[3] Do not compare apples to oranges, a common advice about comparisons goes. In this context, historians of emotion have to answer the question whether emotions are commensurable or, put differently: how do they find objects of study that can be compared?

Some established approaches of thinking about emotions can complicate comparisons. If we consider emotions as objectifiable, universal human traits, it becomes hard to explain why we should compare them at all. From this perspective, emotions would appear more like automatic reactions that are not themselves shaped by social context. Historians could only compare the 'expression' of emotions, but would have to assume that 'underneath' them lie the same emotions. Variations between different geographical or historical settings would appear as a kind of surface phenomenon. Numerous authors have criticised this universalistic emotions paradigm. While anthropologists like Lila Abu-Lughod and Catherine Lutz have argued that such an understanding of emotions reflects contemporary Western norms rather than a universal truth, historians like Ruth Leys have highlighted that the definition of emotions as universal traits is not even shared among researchers working in experimental psychology or the neurosciences.[4]

A second approach considers emotions as subjective experiences. To study emotions, then, would mean for historians to only analyse the way contemporaries wrote or talked about them. This too, however, creates a number of problems for historical comparisons. If emotions are purely subjective, how can we compare them between two human beings, let alone two different social contexts? Moreover, comparisons necessitate an analytical language that is separate from the language of the sources or at least a *tertium comparationis* that defines what the objects being compared have in common. But if we are bound to what historical actors said or wrote about emotions in different languages, how can we know that they talked about comparable things? How can historians of the nineteenth century assume, for instance, that the English word *emotion*, the German word *Gefühl* and the Arabic word *ihsas* all shared similar qualities?[5]

The concept of emotional practices offers a way out of this problem and an entry point into comparisons in the history of emotions. According to Monique Scheer, who has detailed this approach in most detail, to think about emotions as a kind of practice means that we consider them as things that people 'do' in a concrete social context.[6] They are not simply 'there' in human beings, but are

shaped by social preconditions. Aspects like language, social hierarchies, or gender can all matter for emotions as practice. At the same time, thinking about emotions as practice also means to consider them as bodily activities, as reflected in phenomena like blushing, crying or shivering. While considering the materiality of the body is thus part of thinking about emotions as practice, this materiality can also, within limits, differ between different epochs, classes or geographical settings.[7] How do emotional practices differ from other kinds of practices? Building on Scheer, we can define them as activities that, in the eyes of contemporaries, connected the mind, the body and the social.[8]

Equipped with this understanding, historians can compare emotional practices in different settings. An approach that focuses on emotional practices provides them with both, a definition of their object of study as well as an understanding of potential differences between contexts that go beyond questions of emotional expressions in different cultures. This approach also serves to address the issue of comparing emotions in different languages. Considering emotions as a kind of practice provides historians with an analytical language outside of the language of their sources. It enables them to think about the commensurability of activities that contemporaries framed in terms of *Gefühl* or *ihsas* without simply assuming that these concepts are identical with the English concept of *emotion* today.

Looking for emotional practices in sources can often necessitate some detours. There is no single institution or archive that collects documents on activities that contemporaries saw a bridging mind, body and the social. Scholarly texts from the period under consideration can help in this regard. In late nineteenth-century Cairo and Berlin, for instance, advice literature, popular philosophical treatises and medical publications contained discussions of activities that fit the definition of emotional practices. In particular, changes in activities that contemporaries associated with love, such as nightlife, matchmaking services or courting ads in newspapers, were depicted as having an effect on and a connection to all three – mind, body and the social.[9]

Still, there is a variety of potential sources. Historians can analyse court records on nightlife, they can consider autobiographical writings and seek traces of practices that authors associated with love, or they can dig up literary portrayals of matchmaking. What is important for a comparison in this context is, once more, the commensurability of different sources. It is difficult, for instance, to compare an autobiographical text in one setting to a court record in another. These two types of sources will vary in their purpose, their intended audiences and the circumstances of their production, as well as the rules of their genre.

In Berlin and Cairo, we find love as a topic in published media that were a central component of urban change in both cities. These texts shared structural similarities, including the fact that they were penned for a literate, mostly middle-class audience. Ultimately, it is such similarities that pave the way for a comparison. The importance of structural similarities highlights a final, central element for choosing sources: time and synchronous historical change. Newspaper articles offer a corresponding set of sources for Berlin and

Cairo in the late nineteenth century because newspapers spread in both cities at this time. For earlier periods, other sources like court records or philosophical treatises might provide more promising paths to a comparison.

### Sources: two texts on seeking marriage through personal ads

In October 1892, a reader from the city of Tanta, located in the Nile Delta, sent a letter to the Cairo-based periodical *al-Hilal* (*The Crescent*). In his letter, the reader enquired about a recent ad in the newspaper *al-Ahram* (*The Pyramids*) that advertised 'requests for marriage'. As the editors of *al-Hilal* were 'famous men of knowledge', the reader sought their opinion on this issue from a 'moral' and a 'civil' standpoint. The editors began their response by pointing out that the ways of attaining marriage would be different in all nations due to the differences in 'their customs, morals, and times'. In Egypt and Syria, they added, it used to be the custom that parents and relatives chose the bride. The only way for young men to have knowledge of their brides before the wedding would have been through stories that their mothers or one of her friends shared with them about 'the darkness of [her] eyes' or other characteristics of her beauty. Yet, according to the editors, this custom was vanishing and a different, preferable practice was spreading that was common in Europe. Young men would increasingly go to the young woman's house themselves to inspect her conduct and morals. The editors returned to the reader's question by explaining that the search for a spouse through the exchange of letters and newspaper ads was a new custom in 'Europe and America'. 'In our countries', they continued, 'we have only heard about this once and we thought afterwards that it was merely done as a matter of buffoonery and joking around.'[10]

In their response, the editors left little doubt about their opinion on the matter. Seeking marriage through correspondence or personal ads in newspapers, they argued, turned marriage ultimately into a commercial contract, in which both parties just seek 'material gain'. Men, for instance, would only look at 'her finances, her outer appearance, her age, and her health'. In this, however, they ignored the most important aspect of the search for a bride, morals (*akhlaq*), which were presented as central to the happiness (*sa'ada*) of the married couple. The editors of *al-Hilal* expanded on this argument by painting a sombre picture of the emotional distress that a marriage through correspondence or newspaper ads would bring:

> And the misery of the couple if their characters differ and their morals clash! This is especially the case if their marriage was [arranged] by correspondence without arousing the attraction of love in them, when the lover disregards the errors of his beloved and the content eye ignores every little sin.[11]

Moreover, the editors stressed that such a way of finding a spouse was detrimental to women who were presented in these ads as if 'for sale in a bargain', a practice that did not protect the 'dignity of the families' and the 'honour of

the girls' (*karamat al-banat*). The text concluded that no scholar or philoso-
pher would have ever argued in favour of this way of meeting a spouse. For all
these reasons, *al-Hilal* responded to the reader in Tanta, seeking marriage
through correspondence or newspaper ads was not desirable.[12]

Eighteen years earlier, a text that was published in the German capital was
equally dedicated to the topic of people trying to find a spouse through news-
paper ads. In 1874, Friedrich Bartholomäi, a clerk in the Statistical Bureau of
the City of Berlin, wrote an article that zooms in on these ads for the Bureau's
yearbook.[13] Unlike the article in Cairo, the impetus behind this text was not a
letter from a reader, but rather the concept of a 'Folk Psychology' (*Völk-
erpsychochlogie*) of Berlin that the Statistical Bureau of the City at the time
subscribed to.[14] According to this concept, which had been developed by the
Bureau's director Hermann Schwabe, statisticians had to study phenomena that
promised to provide insight into the 'inner life' of Berliners. Bartholomäi fol-
lowed through on this proposition and studied 1,200 ads in Berlin newspapers, in
which inhabitants of the city sought marriages. For him, these ads served as 'a
rich material, which offers a deep insight into the ethical life, the customs, habits,
and characteristics of Berlin's population'.[15]

In the spirit of the scientific approach of Folk Psychology, Bartholomäi was
not quick to judge these ads in newspapers, which he saw as a result of the
growing city of Berlin in which older ways of finding a spouse became
increasingly difficult as people had to overcome longer distances and less
interactions between the sexes.[16] Despite such a functional explanation for the
fact that people sought marriages through newspaper ads, Bartholomäi also
stated that 'we would say that this approach (*Weg*) is businesslike and not
consistent with good manners and customs'.[17]

Bartholomäi was especially interested in the qualities that contemporaries
sought in their desired spouse or that they used to describe themselves. Accord-
ing to his analysis, men touted their 'cheerfulness and sociability' or a 'chivalric
heart' in these ads. Women advertised qualities like 'wealth of love and temper'
or 'cheerfulness and love of life'.[18] Bartholomäi noted that next to those ads
seeking marriage, there would also be 'courting ads', a genre that he vehemently
condemned, explaining: 'If you read ads like the following: "Did Otto Schulz
completely forget his Lene? She sends a friendly reminder about her … ["] an
uncomfortable feeling (*Mißbehagen*) creeps over you because they bear witness
to a deficient education of the heart'.[19] Bartholomäi saw this 'deficient educa-
tion' also reflected in the fact that many self-descriptions built on adjectives that
related to honour, while clearly for him the people who had submitted these ads
were not honourable. In his eyes, even worse was the idea that the presence of
such texts in newspapers caused a decay in the feeling of morality (*Sitte*) among
Berlin's younger population.[20] The ads would 'poison the hearts' of 'thousands
of immature children'.[21] Bartholomäi closed his text by emphasising that it had
been important for him to shed light on this phenomenon, 'even with the risk
that certain critics in the city parliament will consider [me] a useless preacher of
morals and a missionary'.[22]

## Analysis: the curious case of personal ads

Let us first consider critical differences between the two sources. Where did the two texts appear? The source from Cairo was penned as a newspaper article in a flagship publication of the Nahda, a movement of cultural revival that Arabic intellectuals subscribed to at the end of the nineteenth century.[23] *Al-Hilal* was edited by the famous intellectual Jurji Zaydan as a profit-oriented periodical that aimed at an educated Arabic readership across the world.[24] Bartholomäi's study, in contrast, appeared in the yearbook of the Statistical Bureau of the City of Berlin. Under the leadership of the Bureau's director Hermann Schwabe, this publication clearly sought to move beyond simply showcasing quantitative data.[25] Its readership could likely be found in the city government and a scholarly community.

While the audience of the two texts was therefore far from identical, the content of the two sources also differs in some respects. The article in *al-Hilal* discussed an activity that was barely practised in Cairo at the time. In their response, the editors of *al-Hilal* mentioned that they were only aware of one incident of a newspaper ad with the aim of finding a spouse and historical scholarship does not suggest otherwise. Friedrich Bartholomäi depicts an entirely different situation in Berlin, where he studied hundreds of these ads during the early 1870s. Not least, the two sources show a difference in the acceptance of these ads. In Berlin, we find more lenience towards them, whereas the source about Cairo reflects a pronounced rejection.

Despite these differences, however, the two sources speak to each other as documents for a history of emotions, more specifically a history of emotional practices. The texts from Cairo and Berlin reveal contentious debates about courting practices and discussions about the meaning of love during the second half of the nineteenth century. First, we can glimpse from both sources that courting ads in newspapers were a phenomenon that contemporaries in both cities regarded as a new practice that necessitated reflection. While Bartholomäi embarked on their investigation as part of his work for the Statistical Bureau, the editors of *al-Hilal* considered them in response to the query of a reader. Second, both sources reflect recent changes in the way contemporaries sought a spouse. In Berlin, Bartholomäi related the presence of newspaper ads to a reduced interaction between the sexes that urban dwellers faced in the growing city. In Cairo, the editors of *al-Hilal* pointed to a recent shift in finding a spouse, as men would increasingly go to the house of the bride themselves rather than having their parents or relatives chose a match for them. Third, and most importantly, discussions about how to find a spouse were embedded in debates about emotions.

In the two sources, we find that contemporaries addressed love as an element of finding a spouse. Whether it was the attraction of love that could lead the married couple to disregard the flaws of their partner that *al-Hilal* highlighted or the characteristics such as having a 'wealth of love' that Bartholomäi found in courting ads, the issue of love shines through in both texts. Yet, it is precisely the content

of this concept that was contested. Both sources warned against courting ads as a practice that turned marriage into a mere businesslike relationship. These ads would not only go against customs, but they could hardly instil happiness in the married couple, as *al-Hilal* put it, or even risked poisoning the hearts of young Berliners, as Bartholomäi warned. Not least, the role of other emotions emerges in both texts. The sources from Berlin and Cairo share a concern for questions of dignity, honour and shame. Historians have often pointed to these emotions as important elements of social control and the cases of Berlin and Cairo in the late nineteenth century speak to this observation.[26] The question that lurked behind both texts was therefore what kind of practices of love should be deemed acceptable. Rather than a conflict between emotion versus reason or emotional expression versus repression, both texts reflected a concern for an education of emotion, an 'education of the heart' as Bartholomäi put it.

## Contextualisation: comparable debates on urban change

We can substantiate these observations by consulting additional sources and research literature. Just a look at other articles in *al-Hilal* demonstrates that love was a contentious topic in late nineteenth-century Cairo. Readers asked in a letter, for instance, about the meaning of love or the editors stressed in another article that love formed a 'basis for civilization'.[27] We can also find contemporary books like Muhamad 'Umar's *The Present State of the Egyptians, or the Causes of their Retrogression* that discussed different aspects of love in detail.[28] The historian Hanan Kholoussy has depicted these debates in conjunction with the contemporary perception that fewer Egyptian men were getting married.[29] Adjacent to this marriage crisis, we can also glimpse a concern for changing emotions in the city. As the article from *al-Hilal* underscores, contemporaries debated the effects of new activities in the urban realm, such as transformed ways of courting.

In Berlin, too, arguments about love and particularly about courting ads can be found in a number of other sources. Police and court records show, for instance, that the city's authorities sought to curb a burgeoning market of courting ads in newspapers until the middle of the nineteenth century. By the 1870s, however, these ads were already a common and legally accepted phenomenon. They even provided the plot for a popular novel that traced a man's romantic adventures with courting ads under the title *A Victim of Modern Love or the Biggest Hero of Rendezvous in Berlin*.[30] Moreover, the historians Karen Hausen and Tyler Carrington have explored this history of courting ads through some of the legal debates around them as well as microhistories of love in Berlin.[31]

Additional sources and research literature do, however, only widen the scope of observations for a single setting. We now know that the sources on love in Berlin and Cairo were far from isolated in their respective location. It is through a comparison that we can relate findings from the two cities to each other. Considering the similarities between the sources together with the

wider context of their respective cities, a story emerges that shows parallels between debates on emotional practices in Berlin and Cairo. This story centres on three elements: historical change, control of emotions, and gender and class. The import of historical change for these debates comes clearly through in the fact that both sources address what they perceive as transformed activities. Newspaper ads serve these authors to highlight that courting practices have changed. At the same time, there is a wider dynamic of change in the two cities that underpinned this dynamic. Newspapers as a popular medium spread and multiplied their readership in both locales during the second half of the nineteenth century, while migration and new professions transformed the social composition of the two cities' populations.[32] Contemporaries in Berlin and Cairo argued about the effects of these changes on urban dwellers.

The two sources highlight that authors in the German and the Egyptian capitals shared a concern for the control of emotions in this context. Not only do they underscore that courting practices were a contentious topic in both cities, but these texts show that contemporaries like the editors of *al-Hilal* and Friedrich Bartholomäi feared a dynamic in which unprecedented practices led to unwanted transformations with new forms of love running counter to an older understanding of honour and shame. Moreover, these emotions were clearly embedded in a hierarchy of class and gender. Other sources and secondary literature illustrate that what male observers envisioned as an acceptable form of love was deeply entrenched in middle-class practices, in which a gendered form of honour served as a pivotal means of distinction from the lower and upper classes. Thus, the love life of female city dwellers represented a particular focus of men's concern about honour. The two sources, therefore, open a window on similarities in debates about urban change and emotions in the German and the Egyptian capitals. In both cities, these debates were part of a context of urban change, a concern for the control of emotions, and the reiteration of hierarchies of class and gender.

## Conclusion: why should we compare?

In this chapter, I suggested four steps for a comparison in the history of emotions: finding sources that can be compared (for example, newspapers, advice literature, popular philosophical treatises, medical publications or court records), a close reading of these sources, an analysis that pays attention to differences and similarities, and a contextualisation that draws on additional sources and research literature. While these steps are hardly innovative in historical research at large or comparative studies in particular, the history of emotions comes with its own challenges for comparisons. I have argued that considering emotions as practices offers a way out of some of these challenges.

We have, however, not looked at the most important question, yet: why should historians of emotion compare at all? There are manifold reasons why historians are interested in comparisons. Often, comparative studies serve to

test older hypotheses and to stimulate new questions for research. In the history of emotions too, comparisons can help to think about the units of analysis that scholars use. The cases of Berlin and Cairo illustrate this point. Historians frequently analyse the histories of Europe and the Middle East or Egypt and Germany in the nineteenth century as part of two separate stories. In histories of emotions, there are also a number of studies that zoom in on regional or national specificities. A comparative approach can put claims about such specificities to the test. By looking at the sources about love from Berlin and Cairo, we can appreciate similarities in emotional practices that would remain hidden if we stayed within the compartments of a German and an Egyptian history.

From here, new questions beckon: Why did these similarities emerge in the first place? When did they come about and what was their trajectory over the course of the nineteenth century? Can we observe similar emotional practices in other cities, such as Istanbul, Vienna or Calcutta? These are just some of the leads that the two sources discussed in this chapter offer. It is up to historians of emotions interested in comparisons to follow them.

## Notes

1  On these two positions and their import for a history of emotions, see Jan Plamper, *The History of Emotions: An Introduction* (Oxford: Oxford University Press, 2015), 109–62.
2  Monique Scheer, 'Are Emotions a Kind of Practice (And is That What Makes Them Have a History)? A Bourdieuian Approach to Understanding Emotion', *History & Theory* 51 (2012): 193–220; Daniela Saxer, 'Mit Gefühl Handeln: Ansätze der Emotionsgeschichte', *Traverse: Zeitschrift für Geschichte* 2 (2007): 15–29.
3  For a foundational text of comparative history, see Marc Bloch, 'Toward a Comparative History of European Societies', in *Enterprise and Secular Change: Readings in Economic History*, ed. Frederic C. Lane and Jelle C. Riemersma (Homewood: R.D. Irwin), 494–521.
4  See, for instance, Lila Abu-Lughod and Catherine Lutz, 'Introduction: Emotion, Discourse, and the Politics of Everyday Life', in *Language and the Politics of Emotion*, ed. Lila Abu-Lughod and Catherine Lutz (Cambridge: Cambridge University Press, 1990), 1–23; Ruth Leys, 'The Turn to Affect: A Critique', *Critical Inquiry* 37 (2011): 434–72.
5  The English word emotion alone went through a remarkable trajectory of historical change, as Thomas Dixon has shown: Thomas Dixon, *From Passions to Emotions: The Creation of a Secular Psychological Category* (Cambridge: Cambridge University Press, 2006).
6  Scheer, 'Are Emotions a Kind of Practice'.
7  Authors as diverse as Charles Tilly and Judith Butler have highlighted this point: Charles Tilly, *Durable Inequality* (Berkeley: University of California Press, 1998); Judith Butler, *Bodies that Matter: On the Discursive Limits of 'Sex'* (London: Routledge, 1993).
8  Scheer, 'Are Emotions a Kind of Practice'.
9  On debates about love in late nineteenth-century Berlin and Cairo, see also: Hanan Kholoussy, *For Better, for Worse: The Marriage Crisis That Made Modern Egypt* (Stanford: Stanford University Press, 2010); Tyler Carrington, *Love at Last Sight: Dating, Intimacy, and Risk in Turn-Of-The-Century Berlin* (New York: Oxford University Press, 2019).

10  'Al-Zawaj bi-l-Murasala', *al-Hilal* 1 (1892): 125–8.
11  Ibid., 127.
12  Ibid., 128.
13  Friedrich Bartholomäi, 'Volkspsychologische Spiegelbilder aus Berliner Annoncen', in *Berlin und seine Entwickelung*, ed. Hermann Schwabe (Berlin: Guttentag, 1874), 37–53.
14  On the history of Folk Psychology, see: Egbert Klautke, *The Mind of the Nation: Völkerpsychologie in Germany, 1851–1955* (New York: Berghahn, 2013).
15  Bartholomäi, 'Volkspsychologische Spiegelbilder aus Berliner Annoncen', 37.
16  In his text, Bartholomäi referred to a text by Hermann Schwabe that detailed these effects of the growing city on social interaction: Bartholomäi, 'Volkspsychologische Spiegelbilder aus Berliner Annoncen', 37; Hermann Schwabe, 'Betrachtungen über die Volksseele von Berlin', in *Berlin und seine Entwickelung* (Berlin: Guttentag, 1870), 126–51.
17  Bartholomäi, 'Volkspsychologische Spiegelbilder aus Berliner Annoncen', 37.
18  Ibid., 40.
19  Ibid., 44.
20  I have discussed the role of the concept of *Sitte* for a history of emotions elsewhere: Joseph Ben Prestel, *Emotional Cities: Debates on Urban Change in Berlin and Cairo, 1860–1910* (Oxford: Oxford University Press, 2017), 21–48.
21  Bartholomäi, 'Volkspsychologische Spiegelbilder aus Berliner Annoncen', 52.
22  Ibid.
23  On the Nahda, see, for instance, Max Weiss and Jens Hanssen, 'Language, Mind, Freedom, and Time: The Modern Arab Intellectual Tradition in Four Words', in *Arabic Thought Beyond the Liberal Age: Towards an Intellectual History of the Nahda*, ed. Jens Hanssen and Max Weiss (Cambridge: Cambridge University Press, 2017), 1–38.
24  On the profit-oriented character of a publication like *al-Hilal*, see: Elizabeth M. Holt, *Fictitious Capital: Silk, Cotton, and the Rise of the Arabic Novel* (New York: Fordham University Press, 2017), 105–18; Ami Ayalon, *The Arabic Print Revolution: Cultural Production and Mass Readership* (Cambridge: Cambridge University Press, 2016), 123–53; on the complex question of circulation and readership, see Hoda Yousef, *Composing Egypt: Reading, Writing, and the Emergence of the Modern Nation* (Stanford: Stanford University Press, 2016).
25  Anabella Weismann, 'Modell Metropolis: Über den 'soziologischen Blick' des Kommunalstatstikers Hermann Schwabe (1830–1874) auf die moderne Gesellschaft', in *Der soziologische Blick: Vergangene Positionen und gegenwärtige Perspektiven* (Leverkusen: Leske and Budrich, 2002), 63–85.
26  See, for instance: Ute Frevert, *Die Politik der Demütigung: Schauplätze von Macht und Ohmacht* (Frankfurt: S. Fischer, 2017); Liat Kozma, *Policing Egyptian Women: Sex, Law, and Medicine in Khedival Egypt* (Syracuse: Syracuse University Press, 2011), 79–116.
27  'Ma Huwa al-Hubb', *al-Hilal* 11 (1903): 347–8; 'Al-Hubb', *al-Hilal* 4 (1896): 258–60.
28  Muhammad 'Umar, *Hadir al-Misriyyin aw Sirr Ta'khkhurihim* (Cairo: Matba'at al-Muqtataf, 1902), 15–19, 42–4, 231–33.
29  Kholoussy, *For Better, for Worse.*
30  Prestel, *Emotional Cities*, 34–46.
31  Karin Hausen, 'Die Ehe in Angebot und Nachfrage: Heiratsanzeigen historisch durchmustert', in *Liebe und Widerstand: Ambivalenzen historischer Geschlechterbeziehungen*, ed. Ingrid Bauer, Christa Hämmerle and Gabriella Hauch (Cologne: Böhlau, 2005), 428–48; Carrington, *Love at Last Sight*, 126–43.
32  On Berlin, see, for instance, Peter Fritzsche, *Reading Berlin 1900* (Cambridge, MA: Harvard University Press, 1996); on Cairo, see, for instance, Ayalon, *The Arabic Print Revolution.*

# 15  Intersectional identities

*Katie Barclay and Sharon Crozier-De Rosa*

The recent phenomenon of the Women's Marches – those mobilised to protest against US President Donald Trump's inauguration – has brought the issue of 'intersectionality' to global attention.[1] Heated public debates have ensued about who has been included in and excluded from these extensively publicised, wide-reaching demonstrations. For example, organisers of the US marches responded to strident accusations that their protests were of relevance only to white middle-class women by stressing the importance of minority women and their different priorities. In doing so, they demonstrated the continuity of historic feminist debates about intersecting inequalities on the basis of gender, racialised positioning, religion and region. Those witnessing these highly emotional debates were reminded of earlier forms of protest: from African-American abolitionist and women's rights activist Sojourner Truth's 1851 speech 'Ain't I a Woman?', where the emancipated slave articulated her intersecting gendered and racialised oppressions, to early twentieth-century African-American suffragists' angry objections to being relegated to the back of the white-led suffrage processions. Intersectional oppressions produced emotionally volatile contexts, reminding us that intersectional identities combined to produce complex selves and emotions. This chapter explores how ideas about identity intersected with emotion, highlighting a range of ideas, beliefs and social practices across time and place, and how the historian might seek to explore such questions in their source material.

## Intersectionality and emotions

In the late 1980s, African-American legal scholar Kimberlé Crenshaw coined the term 'intersectionality'.[2] She was compelled to do so, she said, because she had observed that feminist and anti-racist advocacy had failed to recognise that racialised and gendered discrimination were in dynamic interaction. Certain strands of feminist and racial liberation movements had embraced identity-based politics, where aspects of the self were considered important explanatory markers of the human condition. They had taken the view that delineating difference did not need to become implicated in the politics of domination, where one person was better than another based on their

difference; identity could instead be 'the source of social empowerment and reconstruction'.[3] Identity-based politics were important sources of 'strength, community, and intellectual development' for members of marginalised groups. However, Crenshaw also noted that within identity politics 'difference' was a contentious and sometimes ambiguous concern. Far from failing to transcend difference, as some critics had accused, identity politics performed the opposite: it frequently conflated or ignored intragroup differences.[4] Through eliding difference, it minimised the dynamic interaction between multiple categories – dimensions of difference and their associated power differentials – including: gender identity, sexual orientation, ethnicity, racialised positioning, indigeneity, descent from colonisers or colonised, class, region, religion, linguistic background, ability and disability, age and so forth. Identity politics often failed to account for how different parts of identity 'intersected' to produce the self and personal experience.

Intersectionality is more than an intellectual theory; it is and was a 'reality'. As Crenshaw later explained it: for many people, '[i]ntersectionality was a lived experience before it was a term'.[5] For example, an individual did not simply exist as a 'woman' or a 'man', or other gendered identity. Rather, identities were positioned in the intersections of different categories, and these intersectional dynamics were subject to change, according to situation and across time. A person might be a black man, or a gay woman. They may also have a disability or be working class. All these components of identity worked together to produce unique personal experiences and to shape how people were treated. Ignoring their combination could cause problems. For example, in the 1970s, people in the USA could sue for discrimination on the grounds of race or gender, but not both together.[6] This caused issues for black women workers who found they were paid less than black men and white women. They wished to demonstrate that they were disadvantaged by the combination of race and gender, not one alone, but the law did not recognise a claim on this basis. An intersectional framework – one that has especially been emerging from feminist and critical race studies – has helped to bring previously invisible bodies and elided complex identities into view.

Scholarship on intersectional identities was initially underpinned by theories from Marxism and feminism, which looked to explain how political structures placed different groups into particular categories and with different degrees of power. However, as analysis of identity became more sophisticated – recognising that a person might be white and male but also working class, or black and female but middle class – models were needed that could help account for the significant diversity of experience produced when we acknowledge intersectionality. Here 'performance' theory has been quite influential, drawing on the work of sociologists like Ervin Goffman and gender theorist Judith Butler.[7] Performance theorists suggest that we consider humans as having a set of 'resources', from wealth and education to gender and class, which they combined to produce the self. People could use these sets of resources as forms of agency or to produce power. In different

contexts, some resources would be more influential than others and so the capacity of people to shape power relationships might vary depending on the situation. This was not to deny that some 'resources' held more influence than others in a wider range of situations – for example being white generally makes it easier in most contexts – but it enabled researchers to explain why people might have success in some situations but not others. An example might be where a minority's opinion holds more weight amongst his or her group than that of an outsider, or where enormous wealth compensated for a lack of education. For performance theorists, emotion can be another 'resource' that people use to more or less successfully shape identity or power relationships. The distressed middle-class woman in a nineteenth-century courtroom might gain greater sympathy from the jury or gallery than one who showed little emotion.[8]

While gender is only one intersectional lens, it is an important one, particularly in the realm of emotions scholarship. As the example of the Women's Marches demonstrates, differences between women have forced women – sometimes reluctantly and uncomfortably – to reflect critically on operations of power among women, the politics of identity and representations, and the dangers of eliding difference; to reflect on the operations of intersectional identity and oppression.[9] Yet, gender as a frame of analysis is also important because of the traditionally constructed dichotomy between masculinity and femininity, with masculinised qualities being valued above those deemed feminine. Feminist research has exposed a heteronormative power mechanism that reproduces a hierarchical binary gender order which devalues and delegitimises emotions as well as those who are often characterised as emotional. Recent feminist, queer and postcolonial scholarship has demonstrated how such devaluations and delegitimisations are tied to modern capitalist politics and to a hierarchical order based on race, gender and class.[10] Therefore, and as some of the chapters in this volume have elaborated, concepts such as reason, agency, control and objectivity have been characterised and privileged as masculine in the West, whereas those such as emotion, passivity, uncertainty and subjectivity have been stigmatised as feminine.[11] Subordinated subjects – women, yes, but also those who are sexually, racially, ethnically, culturally and economically marginalised – have often been attributed these feminised and denigrated qualities. Calling someone 'emotional' was an insult, and as such an insult that could be used to stigmatise and dominate particular groups.

This has major implications for the emotional standards to which these marginalised people are held. A crying woman might be viewed more sympathetically than a man as her emotion was viewed as 'natural'; a crying man might be condemned for his unmanly behaviour. Yet, acceptance of the idea that women were more naturally 'emotional' has produced negative consequences for women. It has been used to justify their exclusion from political and public realms. It is important to note that these standards – and reactions to them – do not remain static. Whether it is acceptable for men and women

to cry, and in what contexts, has varied enormously over time and place. Eighteenth-century European men were praised for their emotional sensitivity; tears a marker of manliness.[12] On the other hand, the working classes were castigated as 'hard', lacking in the appropriate emotion that could be used to reinforce 'civilised' judgement. Within this context, women from the working class could be seen as particularly 'unnatural' as their 'hardness' was contrasted with a middle-class ideal of the 'emotional woman'.[13]

Emotional standards change over time, in response to not only changing political, social and economic conditions, but also to challenges from those marginalised groups. African-American slaves, for example, used claims to their emotional sophistication – to their capacity to feel pain and suffering – as the basis of their demands to abolish slavery and to be recognised as fully human.[14] Nineteenth-century European women argued firstly that their emotions led to better judgements in some areas of social life, such as around families and households, and later rejected such claims of emotionality altogether to argue that they were similarly reasonable and rational as men.[15] Women fighting in different arenas today – for example, those advocating to be allowed to participate in frontline combat alongside men – still resort to arguing that 'feminine emotionalism' is not relevant and does not preclude them from assuming roles deemed more 'manly'.[16] Despite examples like the previous one, today emotions scholars tend to downplay gender differences, arguing that both reason and emotion combine when making decisions and that men and women do this similarly. If ideas about emotions and gender are not the same as personal experiences of emotion, that people believed such things shaped both personal behaviour and how they treated other people.

Applying ideas of intersectionality to understandings of emotion requires the historian to reflect on how ideas and experiences of emotion were shaped by different categories of identity and to be sensitive to how intersecting categories (say of race and gender) might shape both understandings and experiences of emotion in different ways. This can mean moving beyond just theories of emotion, say those written by philosophers or medical scientists, to examining how people's lived experiences shaped their personal experiences. An example here might be to recognise that the social conditions of slavery, where slaves were expected to present cheerful faces or suffer violent repercussions, might have shaped how they were allowed to express emotion, and that these constraints on emotional behaviour may leave a mark on the historical record.[17] The historian therefore may wish to read accounts of cheerful slaves written by their owners with a critical eye. Recently, ongoing representations of the cheerful slave have been challenged. For example, in 2016, a children's book (*A Birthday Cake for George Washington*) was taken out of circulation because of public outcry over its depiction of President George Washington's slaves as jovial workers.[18]

## Intersectional emotions and historical source material

### *Identifying categories of identity*

The first step in exploring intersectional emotions in source material is to recognise that the experience of emotion has rarely been considered identical across various identities. It may be that in some historical periods or places that some aspects of identity – gender, race, disability – were considered more important than others, and so were given more consideration when shaping power relationships between people. But it is rare for societies to genuinely hold all categories of people as equal. Therefore, one of the first jobs of the historian is to reflect on what aspects of identity were important in that particular society. If there is not an obvious starting point – perhaps because nothing has been written on this society by historians before – then starting with categories from our own society can be useful. Worst case, we might learn that ideas of gender or race or class held little purchase within the society we are studying – and that's quite interesting by itself.

Categories of identity intersect with emotion, because emotion plays a central role in producing power relationships. It does this in two ways. First, ideas about emotions can be used to reinforce hierarchies of power. That women were thought to be emotional was used by many classical thinkers to justify their subordination by men. Second, the experience of inequality produces certain forms of 'suffering', where people recognise their disadvantage through their embodied feelings. This can be manifested in multiple ways, from physical disadvantage that leads to pain, suffering or anxiety, to emotions associated with injustice, like anger or frustration, or to a sense that one cannot express one's desired emotions due to the emotional rules of society. In the latter case, a person might find an 'emotional refuge' to use William Reddy's term, where like-minded people could find a space to express their emotions freely with each other.[19] For example, slaves might have claimed evangelical Christianity as a space in which to express emotions not otherwise permitted, such as hope manifested through song and hand clapping.[20] Within hierarchical societies, some people might experience more 'emotional liberty', the freedom to express their emotion as desired, than others. Thus while expressing anger was considered unmanly in nineteenth-century Ireland, elite men who displayed anger were often give greater latitude than other social groups.[21] Identifying moments of emotional conflicts or sites of emotional refuge can offer an access point to the emotional power dynamics of a given society.

### *Setting emotional standards*

Having identified the category or categories of identity under study – say gender or class or even gender and class – then the historian sets out to read their historical source with attention to what they might tell us about this group. We may wish to begin with sources – like philosophical works or medical treatises – that

lay out emotional standards for a particular society. The chapter in this volume on prescriptive literature is a good starting point for identifying such sources. How do these texts apply their rules to different groups? Are men and women expected to perform emotion in the same way? Are there further differentiations, perhaps by class or race or some other category? If so, who is included in such discussions and who is ignored? What might we learn, for example, if a record makes no mention of black people or the disabled? We might attend to the audience for such material, exploring how the target reader might have shaped the material which was included.

Popular culture materials – novels, plays, television – can also be useful for depicting emotional norms for different identity groups. We can observe the range of emotions expressed by individuals, how they were depicted in emotional terms (did their face go red, or did they cry?), and how other characters responded to them. Responses can be important as they help us understand whether a character's emotional range was considered socially acceptable or deviant, giving access to the emotional standards of a society. As for all sources, understanding who produced such works and why can also help us understand how we should interpret the emotions produced in a text. Many nineteenth-century texts could be racist and these attitudes informed how black people were represented. One example we could offer of this is Charlotte Bronte's *Jane Eyre*. In this 1847 novel, Bronte 'others' the character of Bertha Mason, Mr Rochester's violently insane Creole wife. Dehumanised (described in animalistic terms) and presented as both childlike and emotionally unhinged, Bertha is an object of sympathy and fear. As the 'mad-woman in the attic' descended from racially dubious lineage, her emotional and psychological instability is gendered and racialised. Nineteenth-century audiences would have recognised in Bertha a level of decadence and untrustworthiness that they would not have expected from the more 'civilised' English characters, like Jane and Rochester. Illustrating that emotional norms and expectations change, it was not until nearly 200 years after her creation, with Jean Rhys's *Wide Sargasso Sea* novel (1966), that Bertha – renamed Antoinette Cosway – was granted the agency to represent herself as a victim of oppression, thereby contextualising her emotional 'instability'.[22]

### *Using emotional representations to elicit emotional responses*

Identifying the targeted audience of texts is pivotal for understanding how emotions and identity are intended to work in those texts – whether they are successful or not in this enterprise. This is true of works that have been produced in order to enlist public sympathy for or investment in a range of causes, from imperialism to abolitionism to religious missions. Therefore, while poems like Rudyard Kipling's 'The White Man's Burden' (1899) depicted the 'uncivilised' emotionally and morally incompetent colonised other to communicate a sense of pride in the imperial project while also eliciting sympathy for the white male imperialist from a general public that was well

disposed to Western imperialism,[23] other texts, like Harriet Beecher Stowe's 1852 novel *Uncle Tom's Cabin*, worked to induce feelings of sympathy for the humanised chattel slave, while still relying on seemingly benign stereotypes of the slave (including that of the long-suffering dutiful servant).[24] Understanding the motivations of the writer can also help us to discern anticipated emotional attitudes to the subject. Stowe, for example, said that she was compelled to write in the way she did because of a sense of Christian and maternal love, sorrow and compassion. This white female writer's emotional subjectivities inform her representation of the enslaved other.

Other works have represented others – colonised others, for instance – with the explicit intention of getting the public onside so that they will be inspired to not only emotionally, but also financially, support a cause. Mission work is one good example of this. Jane Haggis and Margaret Allen have used British Protestant missionary publications to examine how emotions were used to construct 'good' colonial subjects and imagined emotional communities of British and Indian women to appeal to the interested public 'at home', those most likely to offer practical, spiritual and financial support. Given their pervasiveness – for example, they were distributed widely by missionary societies at churches and Sunday Schools – these texts were regarded as effective vehicles for disseminating information about the good work being carried out by Christian missionaries. Often, as Haggis and Allen argue, these publications were predicated on juxtaposing the combination of cold loveless Indian family and ruthless unfeeling Indian men with 'the sweetness and light of an English home' to position the innocent and fearful Indian woman and child as in dire need of the missionary woman's civilised attentiveness to love, care and salvation. In this way, these sources can be used to furnish a conversion narrative that 'discursively construct(s) "emotional communities" of religion that work to imbricate Indian and British women into imperial structures of feeling that are raced, classed and gendered'.[25]

Similarly, historian Jane Lydon uses mission texts – in this case slides from magic lantern (image projector) shows – to lay bare the construction of the emotional relationship between the missionary or coloniser and the colonised other. Missionaries worked to create representations of colonised subjects – in Lydon's case, Australian Aboriginal people – to convince audiences – Australian colonists who were being appealed to contribute to the welfare and well-being of the country's indigenous population – that this group was worthy of their pity and compassion. Unfavourable public reactions to these shows – attacking and lampooning responses on the part of Australian settlers who were keen to protect their own interests in the face of threatening or unsettling settler–indigenous interactions as new frontiers were formed – can be looked at to reveal how emotional narratives worked to construct imperial relations and constitute colonial cultures.[26] Sources like these presentation slides can also be used to highlight the limitations of mission texts. We can use them to cast light on the emotional intentions of the author, but not necessarily the emotional reaction of the audience. Nor can they be used to

directly reveal the emotions of their subjects, although projects are under way that work to read sources like these against the grain to tentatively reconstruct a picture of what they reveal about indigenous people's feelings, about, for instance, kin, country and the arrival of strangers.[27]

### Emotions and self-representation

If representational sources offer access to emotional standards and the attitudes of different groups to others within a society, other types of sources might better offer insight into personal or individual experience. As noted in previous chapters, no source offers free access to the soul, but those produced by a particular group, rather than about them, offered the authors greater opportunity to exercise some agency in how they were represented. They might use such opportunities to challenge preconceptions about their emotional expression or repertoire, undermining stereotypes or making claims to power that are intertwined with ideas about emotion. This can open up opportunities to explore how different groups sought to express themselves in emotional terms. Audience here is again important. A group of slaves writing for a white audience to demand freedom might deploy emotional motifs familiar to their audience to persuade them to change their behaviour. As outlined in the chapter on protest emotions, former slaves' narratives expressed anger and rage, working to elicit a similar sense of outrage from a sympathetic abolitionist audience, in a way that was denied to them while in bondage where, for example, slave letters which were often read by owners could only accommodate muted emotions.[28] If this might not reflect how an individual African American expressed themselves in daily life (and it might!), such representations suggest their familiarity with such emotional norms and their ability to deploy them strategically.

One source that unambiguously declares that it represents the feelings of its author is Sojourner Truth's previously mentioned speech, 'Ain't I a Woman?', delivered at the Women's Rights Convention, Akron, Ohio, in 1851. In this much-cited text, Truth reveals her gendered and racialised positioning through pleas that have since elicited profuse emotional responses:

> That man over there says that women need to be helped into carriages, and lifted over ditches, and to have the best place everywhere. Nobody ever helps me into carriages, or over mud-puddles, or gives me any best place! And ain't I a woman? Look at me! Look at my arm! I have ploughed and planted, and gathered into barns, and no man could head me! And ain't I a woman? I could work as much and eat as much as a man – when I could get it – and bear the lash as well! And ain't I a woman? I have borne thirteen children, and seen most all sold off to slavery, and when I cried out with my mother's grief, none but Jesus heard me! And ain't I a woman?[29]

Truth's astute analysis of the inequitable treatment of black women, when placed alongside their white counterparts, was both a strategic challenge to a racist society and moving articulation of her suffering.

Sources that are targeted at members of the same group – such as love letters between a same-sex couple – might provide insight into how a group expresses themselves when they are alone and together. Gay subcultures in twentieth-century Britain provided men not only with an opportunity to meet other gay men, but a distinctive rhetoric that allowed them to express their feelings and to demonstrate their inclusion within the community.[30] Their love letters were turned against them during criminal prosecutions where their emotions were subject to scrutiny and ridicule. The emotions expressed within such subcultures were not necessarily more 'natural' for the individual than those they used in everyday life; indeed, opportunities to express such emotion might be relatively rare. However, they highlight how emotion was deployed and shaped personal experience in particular contexts and where opportunities for emotional liberty might be realised.

### Denying the imposition of emotional standards

In many of the sources that we have mentioned, readers can detect how dominant classes have prescribed emotional norms or standards for subjected peoples. We can also find texts where those subjected peoples have denied the relevancy of these emotional codes. For example, Irish nationalist feminist publications from the early twentieth century can be very usefully employed to trace how Irish women – who considered themselves doubly 'enslaved' through their gender and colonised status – rejected what they said were British imposed emotional norms.[31] These norms, which were disseminated around the United Kingdom of Great Britain and Ireland, directed that those on the Celtic peripheries were childlike, emotional and irrational, in contrast to the reasonable, disciplined Anglo-Saxon core. They also dictated that men and women belonged in separate spheres with different prescribed emotional norms: men in the public world of business, politics and war which necessitated courage, decisiveness and resilience; and women in the private world of intimacy, passivity and loving care. Irish women used the issue of political violence to argue that the emotional standards imposed on them by the British coloniser were inappropriately gendered and ethnicised; they were dismissive of an ethnic Celtic heritage of gender equality which declared that men and women could equally participate in the public sphere, even in theatres of war (whereas British standards declared the violent woman to be shameful).[32] Through examining these anti-colonial texts, we can see how women activists used awareness of their intersecting gendered, ethnicised and colonised positioning to rationalise their recourse to militancy, thereby denying British-centred understandings of the shame of the violent woman while also rebutting Anglo-Saxon tropes of the irrational Celt.

### Claiming emotional styles

Recognising that particular groups use emotion in specific ways can be interesting for what it tells us about group identity. Rather than seeking to conform to emotional standards produced by a dominant regime, many people have sought to use emotion and emotional expression as part of their identities. A number of twentieth-century feminists embraced their apparent 'emotionality' to argue that it offered a more ethical way to live. The capacity to feel empathy for the other, and the 'emotional intelligence' to read the needs of the other, could be both strategically useful and lead to a better, more peaceful society. Conversely, men, especially elite white men, were often criticised for their failures to exercise empathy, their social position coming to be marked by a deficiency of an ethical emotional range or nuance. Subcultures have often deployed particular emotional repertoires as part of their 'style', whether that is the distinctive way that twentieth-century African Americans deployed the idea of 'American cool' in their art and culture or the 'gloomy' presentation of goths in the 1990s.[33] Emotion here became a tool for expressing and honing identity, one that could reflect larger social trends or positioning but that was also shaped by the individual in the production of a particular type of self.

### Emotions, judgement and power

Once we have identified how different emotion rules apply to particular groups, and also how those groups deploy emotion themselves, the next step is to consider how these various expressions of emotion are valued and the implications for power relationships within a given society. Are certain forms of emotional expression considered good or worthy, indicative of virtue, while others are sinful or anti-social? Do they overlap with access to political power, such as when women were excluded from the vote due to their expected emotion? If so, what does that tell us about how power flows and operates in that society? Building on this, can we then look at how individuals or groups resisted such models of power, either by conforming their emotions to idealised norms despite their gender or race, or by producing new emotional communities in order to express themselves and to build resistance to the norm? To do this, we may wish to look at the circumstances in which our source material were produced. Mainstream advice texts that were widely circulated are indicative of larger or dominant norms, whereas letters or diaries captured by the police as part of criminal investigations might suggest to us that the emotion expressed was not acceptable. Many love letters between gay men that survive today do so as they became part of police evidence files during criminal prosecutions. Knowing that they were used as part of a criminal prosecution can help us interpret how that society valued such emotional expression and so the consequences for such feeling. Exploring how our sources were made and used helps us to build a picture of the positioning of the people who made them and used them.

*Silences and omissions*

One important practice when exploring intersectional identities is to look for gaps and silences. All-male parliamentary committees in the nineteenth century may tell us much about norms amongst elite men, but little about how women or minorities might experience emotion. Yet, if we are to write histories of people other than elite parliamentarians, we may have to approach our sources imaginatively and ask what is missing from such discussions, and how such silences shape the narrative being told. Histories of the 'self-made' man in the nineteenth-century Anglophone world, for example, often briefly acknowledge a wife or family 'behind the scenes' but place emphasis on the acts of the individual man.[34] We might want to ask how such achievements were made possible without the domestic and reproductive labour that enabled success. In an emotions context, we may consider how refusals to acknowledge certain forms of emotion – anger or pain – might be used to legitimise a parliamentary decision, or to dismiss the concerns of a particular social group. Denying that slaves were unhappy with the condition of slavery – and so the emphasis of 'cheerful slaves' in much nineteenth-century literature – could be used to justify continuing the practice. Reading between the lines is often a skilful task, requiring a good knowledge of the surrounding historical context, but can open up insight into social groups who are hidden behind those in power.

## Conclusion

A study of emotions requires historians to pay attention to whose emotions we are studying. Attending to large social groups has its uses in such studies, but can miss how emotional norms or standards are applied differently to different people, and that individual experiences shape our emotions and how, when and where we express them. The concept of 'intersectionality' draws attention to the ways that different aspects of identity frame our experience, providing historians with an analytical lens to apply to our source material. Exploring how gender, race, class, other dimensions of identity and their intersections interact with the experience, expression and valuation of emotion provides a more nuanced understanding of emotions' role for the individual and within society. It also allows us to explore how emotion could be deployed by individuals to shape wider power relationships. Attending to the relationship between intersectional identities and emotion in source material requires the historian to attend more carefully to whom emotional norms and standards are written for, who is excluded and how the excluded reshape or reframe emotions for their own purposes. This is typically done by a close reading of a wide range of source material, including acknowledging the gaps and silences than can appear in the record. If this can be a challenging exercise, its reward is a richer understanding of emotion as it was played out in everyday life. If the meanings attached to race, gender and other dimensions

of identity are culturally specific, this is a methodological approach that has relevance in a wide variety of global contexts. Imperial engagements in Africa, Asia and beyond have led to diverse communities with complex histories and power relationships; alternatives to the two-sex model for gender can be found in some Indian communities, as well as in the contemporary West. Class has less purchase in non-Western contexts, and yet social stratification remains marked across the world. Teasing out how emotions are experienced by individuals across the world's diverse cultures remains an exciting opportunity for historians of emotions.

## Notes

1  Discussed in greater detail in Chapter 16 'Emotions of Protest' by Sharon Crozier-De-Rosa in this volume. See also Sharon Crozier-De Rosa and Vera Mackie, *Remembering Women's Activism* (Oxford: Routledge, 2019).
2  Kimberlé Crenshaw, 'Demarginalizing the Intersection of Race and Sex: A Black Feminist Critique of Antidiscrimination Doctrine, Feminist Theory and Antiracist Politics', *The University of Chicago Legal Forum*, 140 (1989): 139–67; Kimberlé Crenshaw, 'Mapping the Margins: Intersectionality, Identity Politics, and Violence Against Women of Color', *Stanford Law Review* 43 (1991): 1241–99.
3  Crenshaw, 'Mapping the Margins', 1242.
4  Ibid.
5  Kimberlé Crenshaw, 'Why Intersectionality Can't Wait', *The Washington Post*, 24 September 2015, https://www.washingtonpost.com/news/in-theory/wp/2015/09/24/why-intersectionality-cant-wait/?utm_term=.2e52de6ca07d, accessed 21 October 2019.
6  Crenshaw, 'Demarginalizing.'
7  For a discussion of this methodology as applied to emotions scholarship see the introduction to Katie Barclay, *Men on Trial: Performing Emotion, Embodiment and Identity in Ireland, 1800–1845* (Manchester: Manchester University Press, 2019).
8  Ibid.
9  Spike Peterson, 'Thinking Through Intersectionality and War', *Race, Gender & Class* 14, no. 3–4 (2007): 10–27.
10  Brigitte Bargetz, 'The Distribution of Emotions: Affective Politics of Emancipation', *Hypatia* 30, no. 3 (2015): 580–96.
11  Peterson, 'Thinking Through Intersectionality and War', 3.
12  Thomas Dixon, *Weeping Britannia: A Portrait of a Nation in Tears* (Oxford: Oxford University Press, 2015).
13  Katie Barclay, 'Love and Friendship between Lower Order Scottish Men: Or What the History of Emotions Has Brought to Early Modern Gender History', in *Revisiting Gender in European History, 1400–1800*, ed. Elise Dermineur, Virginia Langum, and Åsa Karlsson Sjögren (London: Routledge, 2018), 121–44.
14  Lynn Festa, *Sentimental Figures of Empire in Eighteenth-Century Britain and France* (Baltimore: Johns Hopkins University Press, 2006).
15  Barclay, 'Love and Friendship'.
16  Leanne K. Simpson, 'Eight Myths about Women on the Military Frontline – and Why We Shouldn't Believe Them', *The Conversation*, 1 April 2016.
17  Saidiya Hartman, *Scenes of Subjection: Terror, Slavery, and Self-Making in Nineteenth-Century America* (Oxford: Oxford University Press, 1997).
18  Shamar Walters and Elisha Fieldstadt, 'Scholastic Pulls Children's Book Criticized for Depiction of Happy Slaves', *NBC News*, 19 January 2016, https://www.nbcnews.com/

news/us-news/scholastic-pulls-children-s-book-criticized-depiction-happy-sla
ves-n498986, accessed 3 November 2019.

19 William M. Reddy, *The Navigation of Feeling: A Framework for the History of Emotions* (Cambridge: Cambridge University Press, 2001).

20 Albert J. Raboteau, *Slave Religion: The 'Invisible Institution' in the Antebellum South* (New York: Oxford University Press, 2004).

21 Barclay, *Men on Trial*.

22 Carol Atherton, 'The Figure of Bertha Mason', *Discovering Literature: Romantics and Victorians*, British Library, https://www.bl.uk/romantics-and-victorians/arti cles/the-figure-of-bertha-mason, accessed 2 November 2019.

23 Patrick Brantlinger, 'Kipling's "The White Man's Burden" and Its Afterlives', *English Literature in Transition* 50, no. 2 (2007): 172–91.

24 Kevin Pelletier, '*Uncle Tom's Cabin* and Apocalyptic Sentimentalism', *Literature Interpretation Theory* 20 (2009): 266–87.

25 This article uses texts like those of the London Missionary Society, Church of Eng-land Zenana Missionary Society, the Mission Settlement for University Women and the Poona and India Village Mission, all of which were produced between the 1880s and 1900s. See Jane Haggis and Margaret Allen, 'Imperial Emotions: Affective Communities of Mission in British Protestant Women's Missionary Publications c1880–1920', *Journal of Social History* 41, no. 3 (2008): 691–716.

26 Jane Lydon, 'Charity Begins at Home? Philanthropy, Compassion, and Magic Lantern Slide Performances in Australasia, 1891–1892', *Early Popular Visual Culture* 15, no. 4 (2017): 479–99.

27 One example is Shino Konishi's project, 'Reconstructing Aboriginal Emotional Worlds', http://www.historyofemotions.org.au/about-the-centre/researchers/shino-konishi/, accessed 3 November 2019. On 'reading against the grain', see Nupur Chaudhuri, Sherry J. Katz and Mary Elizabeth Perry, 'Introduction', in *Contesting Archives: Finding Women in the Sources*, ed. Nupur Chaudhuri, Sherry J. Katz and Mary Elizabeth Perry (Urbana: University of Illinois Press, 2010), xv.

28 Thomas C. Buchanan, 'Class Sentiments: Putting the Emotion Back in Working-Class History', *Journal of Social History* 48, no. 1 (2014): 72–87.

29 Sojourner Truth, 'Ain't I a Woman?' Women's Rights National Historical Park, https://www.nps.gov/articles/sojourner-truth.htm, accessed 2 November 2019.

30 Jeffrey Meek, 'Risk! Pleasure! Affirmation! Navigating Queer Urban Spaces in Twen-tieth-Century Scotland', in *The Routledge Handbook of the History of Gender and Urban Experience*, ed. Deborah Simonton *et al* (London: Routledge, 2017), 385–96.

31 Crozier-De Rosa uses feminist periodicals like *Bean na hEireann*, translating as *Woman of Ireland*, (1908 to 1911) and the *Irish Citizen* (1912–20) to access Irish women's responses to British imposed emotional norms. See Sharon Crozier-De Rosa, *Shame and the Anti-Feminist Backlash: Britain, Ireland and Australia, 1890–1920* (New York: Routledge, 2018).

32 Crozier-De Rosa, *Shame and the Anti-Feminist* Backlash, chapter 'Shame of the Violent Woman'; Sharon Crozier-De Rosa, "Divided Sisterhood? Nationalist Feminism and Militancy in England and Ireland', *Contemporary British History* 32, no. 4 (2018): 448–69.

33 Peter Stearns, *American Cool: Constructing a Twentieth-Century Emotional Style* (New York: New York University Press, 1994); Christina Simmons, '"He Isn't Affec-tionate at All": African-American Wives in the 1940s and the Problem of "Cool"', in *Courtship, Marriage and Marriage Breakdown: Approaches from the History of Emotion*, ed. Katie Barclay, Jeffrey Meek and Andrea Thomson (London: Routledge, 2020), 144–59; Katie Barclay, *The History of Emotions: A Student Guide to Methods and Sources* (Basingstoke: Palgrave Macmillan, 2020).

34 Julie-Marie Strange, *Fatherhood and the British Working Class, 1865–1914* (Cam-bridge: Cambridge University Press, 2015).

# 16 Emotions of protest

## Sharon Crozier-De Rosa

In 2016, when Hillary Clinton was running against Donald Trump in the US presidential race, the US media – indeed, the global media – was saturated with the emotions of politics and political protest. Trump's rhetorical attacks on women and minorities and his 'Make America Great Again' slogan were aimed at restoring white working-class men's pride; negating their shame and relegitimising their place in American society.[1] Trump's deployment of emotive strategies sparked a passionate backlash headed by feminists, including Clinton, which sought to call him out for, among other things, his offensive and crude misogyny.[2]

Clinton herself did not escape being tainted by the emotions of political protest, even those of feminist protest. Rather, she was shamed in the media as every form of 'bad' feminist.[3] Commentators, from actors to activists, labelled her a bad pacifist feminist, bad intersectional feminist and a bad 'blame-the-woman' feminist.[4] In turn, these accusations spurred yet further emotional outbursts. An older generation of feminists smeared younger women who favoured more left-leaning Democrat Bernie Sanders over Clinton – the woman who could potentially be the first of her sex to occupy the highest position in US politics. For instance, 1970s feminist icon Gloria Steinem labelled them frivolous, boy-chasing girls. Former secretary of state Madeleine Albright also weighed in, telling Sanders-favouring women that they had 'a special place in hell' because they did not champion gender solidarity.[5]

Trump's eventual success spurred arguably the largest single-day protest in US history: an orchestrated set of Women's Marches that unified protesters from diverse political camps (including LGBTQ rights, environmental politics, immigration reform and other human rights branches). These marches were replicated globally (approximately five million people in 673 marches across 81 countries).[6] The emotional pitch was feverish, and this intense feeling was strategically deployed by intersecting political organisations.

What that 2016 political process – and many more before and after it – has demonstrated is that emotions are inescapably implicated in the realm of politics. The feminist in-fighting, the intra- and inter-party rivalries, the feminist/anti-feminist collisions and the mass coordinated protests – all revealing uncomfortably high levels of emotional investment in the 2016 presidential

outcome – demonstrate the multifarious uses and abuses of emotions in national and international politics. The tactics deployed by those on all sides of the political divide – the hurt that stemmed from the strategic use of vitriolic forms of shaming, as well as the sense of solidarity that derived from being a member of a group that rallied against such negative impositions – all of this confirmed that virtually no cause, no campaign and no campaigner was free of emotions, spontaneous or planned.

Yet, academics have been slow to centre their investigations on the often leading or at least highly influential role that emotions play in political machinations. Over the past two decades, sociologists have turned their attention to this phenomenon. Historians, however, have been hesitant to enter the fray. While sociologists can interview their subjects to determine their emotional motivations and strategies, historians recognise that their access to the emotions of protest tend to lie elsewhere than in the minds of live subjects. They must be creative in seeking out alternative sources. Some historians have addressed these challenges to produce a small, but growing, body of research.

This chapter will outline possible approaches for scholars wishing to enter this realm of historical enquiry. It will trace the place of emotions in the history of politics while also detailing the work undertaken by sociologists on the relationship between politics and emotions. What implications might this research have for the historiography of protest emotions? The essay will then offer examples of histories of the emotions of protest and explore some of the opportunities and challenges faced by researchers working in the area, including: the emotions of workers and workers' movements; campaigns that harness fear and those that centre on dignified or joyous defiance; feminist protest as a means of accessing the interface between protestors and opponents; and transient emotional sources and the growing volume of digitised sources.

## Writing emotions into histories of politics

German emotions historian, Ute Frevert points out that the relationship between politics and emotions is not a new subject. As far back as classical Athens, practitioners and theoreticians of politics have clearly understood that the two are deeply connected. Aristotle, she said, gave advice about how good orators could use rhetorical strategies to move their listeners – to make them feel certain emotions which would help speakers to achieve their political ends. This advice, Frevert states, was taken up by a number of influential leaders, from Pericles in ancient Greece to Abraham Lincoln during the American Civil War.[7]

However, despite the obvious presence of emotions in politics, sociologists Jeff Goodwin, James M. Jasper and Francesca Polletta argue that there has been some hesitation on the part of academic observers to admit to this presence. Instead, they have managed to 'ignore the swirl of passions all around

them in political life'.[8] In accounting for this relative absence, political scientist Carol Johnson cites the perceived gendered nature of emotions generally. Traditionally, emotion was associated with the feminised private sphere of home and family, while emotion's supposed antithesis, reason, was associated with the masculinised public world of business and politics.[9]

James Jasper agrees. He argues that this dualism – reason versus emotion – has two thousand years of Western philosophy behind it. As he explains it, politically, a traditional dualism existed between 'incompetent (emotional) masses and masterful (rational, calculating) elites'. In Plato's day, it was slaves who were deemed incapable of reason, driven only by 'appetites'. In the nineteenth century, Jasper traces this maligning of groups of people as irrational to the emerging working class. For centuries, he adds, women were considered far too emotional to make decisions, hence their exclusion from democratic processes, including voting. In the twentieth century, he concludes, the study of protest and that of voting went separate but parallel ways. Sociology absorbed the former and social sciences the latter. But the central debate in both fields was whether rationality or irrationality characterised 'normal' people's engagements with politics.[10]

Sociology may have absorbed the study of protest more generally, but by the mid-twentieth century history had turned to the study of the crowd. In 1985, in their ground-breaking text on 'emotionology', Carol Stearns and Peter Stearns noted that historians who had begun writing crowd history in the 1960s, like George Rudé and Charles Tilly, took the approach that rioters tended to carefully and logically formulate their goals and choose their targets.[11] Twenty years later and the historical study of protest remained dominated 'by the claim to rationality, to the extent that some authorities argue that emotions enters their subjects not at all'.[12] Doubtless, these proponents of the logical and rational crowd were retaliating against the pioneering study of crowd psychology – *The Crowd: A Study of the Popular Mind* written by Gustave Le Bon in 1895 – which characterised crowd motivations and actions as impulsive, unreasoning and primitive. Stearns' and Stearns' article extended this explanation. It was not simply that twentieth-century crowd historians were directing their energies towards refuting Le Bon's characterisations, but rather that they did not consider the emotional dynamics of protest movements as being relevant. Instead, 'Emotionology' argued, they deemed emotions to be 'an irrelevant by-product of protest, whose contours are firmly determined by organizational potential and rational crowd goals'.[13]

Whether new histories of protest from the 1960s onwards denied the relevance of emotions due to a deliberate strategy of combating earlier characterisations of the impulsive crowd that worked to delegitimise its grievances and goals or whether they simply overlooked the significant role played by emotions in political machinations, it remains that until very recently historians have omitted consideration of emotions from their protest histories. As I have said, the most detailed and extensive work carried out on the relationship between emotions, affect and protest has been in the field of sociology.[14] In the next section of this essay, I will explore what sociologists have

discovered about the role of emotions in politics and how this can be used by historians to deepen our understanding of the politics of emotions and the emotions of politics.

However, what must be kept in mind, and as emerging histories of emotional politics demonstrate, historians ask different questions of their sources, thereby producing studies not only of the emotional dimensions of past social movements but, more crucially for the discipline, of the changing dynamics of emotional politics over time. So, whereas a sociologist might analyse the role played by anger in the Women's Liberation Movement of the 1970s, a historian will work to contextualise the relationship between anger and gender over a longer run. By way of an example, a historian might ask if a 1910s suffragette's hammer is more evocative of unruly protest emotions than a 1970s feminist's militant actions because female anger was much more heavily frowned upon at the beginning of the century than at the end. What can consideration of this question tell us about the place of anger and the acceptability or otherwise of women's emotional outbursts over the twentieth century?

## Sociology and protest emotions

In attempting to establish an agenda for future enquiry into the relationship between protest and emotions, Jasper advised scholars to 'move beyond ancient but sterile debates over the rationality of voters and protesters (and politicians, although their rationality is rarely challenged in scholarly research)'.[15] Fellow sociologists Helena Flam and Debra King encouraged those interested in the study of political emotions to expand their emotional repertoire; to move beyond what they identified as 'the standard set' of protest emotions, shame, pride, anger and solidarity, and to instead embrace 'loyalty, joy, hope, fear, contempt, sadness, distrust, empathy, compassion, altruism, courage, gratitude and happiness'.[16] Through acknowledging the sheer range and diversity of the emotions implicated in protest politics, scholars could embark on a more complex journey towards understanding how proponents of social and political movements selected specific emotional formulae in order to cultivate their desired emotional milieus. They could examine individual groups' rationale for deploying love, loyalty and solidarity or anger, indignation and rage to achieve their political goals. Chief among these aims might be: using love and loyalty to motivate and sustain group membership; and/or, deploying anger and indignation to direct a movement's interface with its opponents or inculcate sympathy when engaging with the general public.[17]

Yet another sociologist, Deborah Gould, continues to argue that emotions scholars can go further than simply analysing protesters as 'rational actors' who seize political opportunities. They can instead see how activists – sometimes consciously but often less purposely – 'nourish and extend' a common sense of feeling that works to build a sense of the collective and that sustains social movements. The strong emotions that activists feel towards each other help sustain their relevant movements.[18] Jasper follows this approach up by questioning

the degree to which calculating and unthinking or spontaneous emotions can be separated anyway.[19] Surely, he argues, individual protesters' feelings and the emotions on display in protest movements – through, for example, campaign posters, banners, slogans and ephemera – are intertwined.

Whether approaching protest emotions as strategically deployed or as experienced and embodied feelings, historians can capitalise on two decades of sociological questions about and findings on the role of emotions in motivating, sustaining and even bringing about the decline of political movements. As stated, however, historians face a particular challenge when undertaking this task. They cannot be guaranteed a ready access to interviews with protesters on the subject of emotions and politics. Therefore, they have to seek and locate alternative sources that will allow access to those emotions – individual or collective – as they were historically felt or displayed.

## Histories and historical sources

When we think about the emotions of protest movements, strong images come to mind. Often these are of emotionally charged and confrontational or even violent episodes: protesters and police meeting head-on or furious crowds angrily demanding change. Yet, political protest showcases more than simply anger and rage, although these are often prominently on display.[20] Other images that may come to mind evoke more positive emotions: cheering crowds atop the crumbling Berlin Wall in November 1989; 1960s hippies adorned with signs promoting peace and love, not war and hate; or the hopeful sit-down protests of the mid-twentieth-century American Civil Rights Movement. In the remainder of the chapter, I will introduce a range of historical protest movements and explore some of the sources that will enable historians to access the diverse emotional dimensions of those campaigns.

Throughout modernity, people have protested over a multitude of issues. As nation-states have proliferated and democratic systems developed, they have demanded the right to be granted access to the privileges and responsibilities of citizenship, including voting. They have participated in movements that have brought about revolutionary overthrow. They have staged militant demonstrations in the name of civil liberties, labour protection, gender equality and redress for wartime sexual abuse and the disappearings of political regimes. In doing so, protesters have harnessed the power of negative emotions like anger and indignation, while others have performed silent vigils whose dignified and patient defiance aimed at eliciting a range of emotional responses from sympathy, even empathy, to anxiety and shame or perhaps anger and outrage.

Across all these movements, the vehicles for carrying and displaying emotions intersect. When attempting to reconstruct a history of political emotions, historians are faced with an ever-growing and diverse body of sources including: political periodicals, the popular press, songs, slogans, murals, placards and banners, campaign merchandise, as well as the bodies of protesters picketing,

barricading and marching, and, more recently, social media sites. Whereas access to some of these sources is restricted – for instance microfilms of protest literature in libraries or archives, campaign ephemera on display in exhibitions and museums, and murals on the walls of global cities – others are increasingly being digitised – newspapers available online (e.g. the National Library of Australia's 'TROVE' database, the US Library of Congress's digital directory 'Chronicling America' and the National Library of New Zealand's 'Papers Past'),[21] images, films, testimonies and reports from violent campaigns (e.g. CAIN: Conflict Archive on the Internet for the Northern Irish Troubles),[22] and photographs and ephemera from feminist movements (e.g. the University of Florida's Women's March on Washington Archive and Northeastern University's Art of the March repository – discussed further at the end of the chapter).[23]

## The emotions of working-class protest

Histories of the lower orders – the workers and the 'crowds' – offer us access to the emotions of the past. For example, labour and working-class movements harnessed a swathe of emotions to achieve their political ends; anger often being chief among these. Yet, as historian Thomas C. Buchanan points out, there is currently 'little in labor historiography that presents emotions as an important topic of study'.[24] This is changing. While historians like Peter Stearns analyse the reception of discrete emotions – for instance anger, which Stearns argues grew less acceptable in the face of a more lauded 'cool' emotional style which filtered down to affect all classes in a modernising USA[25] – others like Buchanan are now examining the emotional lives of workers, including workers' resistance, individual and organised.[26]

Accessing sources that display a group's collective emotions (for example members' frustration and indignation as written on banners or comedic and satirical representations of shame and shaming or the public sympathy embedded in newspaper accounts or eyewitness statements) is often straightforward. For example, researchers can readily retrieve 2010s Irish pro-abortion placards reading 'I am NOT a walking womb!' or 1910s anti-suffragist postcards depicting offensively ugly feminist women or newspaper articles (like the *Pittsburgh Post Dispatch*) that allow us to trace the waxing and waning of public sympathy and support for striking Carnegie Steel Company workers in the face of crowd violence and angry savagery during the Homestead Strike of July 1892 in Pennsylvania.[27]

Getting at source material that depicts the intimate emotions of individual workers and their resistance is a little more problematic, but not impossible. As Buchanan shows in his article on restoring emotions to working-class histories and Phillip Troutman demonstrates in his work on slave letters, in their correspondence American slaves voiced the grief and sorrow, as well as familial love, of those used to a life of separation and loss.[28] On the other hand, slave narratives – the testimonies of those who had managed to escape – more clearly expressed rage.

Therefore, whereas runaway narratives utilised anger 'to highlight the injustice of slavery to an audience supportive of domestic tranquillity', this was 'an emotion that had to be cloaked and muted in letters'; letters that were censored by slave owners.[29] Indeed, this mediation acts as a reminder to those using sources such as personal correspondence that they need to be keenly attuned to the fact that often the sentiments expressed in these texts were mediated through the middle classes. As such, these sources need to be read against the grain, as it were, if we are to get evidence of workers' actual emotional states.[30] This is a methodological challenge emotions historians – and others – face.

## From fear and shock to dignified or joyous defiance

A wide range of emotional states are present in protest movements. For example, fear plays a complex role in protest. Fear can paralyse. It can also be developed into outrage. Outrage can be harnessed to motivate protest. As Jasper argues, fear's complexity within the sphere of protest is due to the fact that it falls in between affective and reactive emotions. People can harbour an abstract fear, for example, a fear of war or of radiation. An unexpected event or reception of a new piece of information – for instance the beginning of a violent conflict or the building of a new nuclear reactor – can then trigger a moral shock. Shock, fear and anger can then be channelled into righteous indignation and political activity. Activists work hard to transform these sometimes 'inchoate anxieties and fears' into feelings of indignation and rage that are directed towards specific policies and decision makers.[31] This can be seen through, for example, the Campaign for Nuclear Disarmament or the Ban the Bomb protest movement from the 1950s to the 1980s. Fear that does not immobilise can be used by knowing activists in the attempt to produce change.

The role of fear does not stop here. The response of authorities – governments and police – to protest can elicit further emotional responses, including more fear or anger or outrage. Repressive and violent responses may effectively curtail protest. However, it may also radicalise it, sparking renewed protest. As Hélène Combes and Olivier Fillieule have argued, even within modern democracies where the tendency is towards pacific reactions to popular protest, marginalised groups – like ethnic, religious or low socio-economic groups – are particularly targeted by repressive measures and responses. This repressive approach can either be short term or longer term and can produce responses that are likewise short or long term. For example, police forces reacted forcefully, sometimes violently, to anti-globalisation demonstrations across the world from the late twentieth century into the early twenty-first century, further radicalising demonstrators. This link between repression and radicalisation has also taken on a more long-term relationship. For instance, during the Northern Irish Troubles, the fact that the police force was mostly made up of members of the dominant Protestant community fuelled not only fear but also further radicalising of the Catholic community – over a very long period of time.[32]

Fear and anger prevented, motivated and, in many cases, sustained political protest. Historians attempting to disentangle the multifarious roles played by fear in specific protest movements need to consider a range of sources. Broken windows and damaged property, demonstrators' angry slogans, placards and banners, images of riot police bearing down on crowds – all of these bear witness to the range of negative emotions fuelling and sustaining protest and conflict; as does graffiti and murals marking the walls of conflict zones – residential or commercial – a manifestation of political protest that will be mentioned again later in the chapter when discussing the digitisation of transient emotional sources.

Whereas many protest movements harness the power of negative or aggressive emotions, others have strategically deployed more positive emotions, including a patient display of dignified protest; those aimed at eliciting a complex assemblage of emotional responses from targets and spectators or onlookers alike, whether that response consist of more active affective reactions like outrage or more muted emotions like anxiety or frustration. Often, but not always, these protests have taken on a gendered dimension. For example, silent vigils staged by female bodies – protesting militarism, sexual violence and death – have attracted worldwide publicity.

The specifically gendered protests that I am referring to here include: the Women in Black (initially silent vigils protesting the continued occupation of territories by Israel and expanded to demonstrate against incidences of international militarism); the Plaza de Mayo demonstrations of the mothers and grandmothers of the 'disappeared' in Argentina (women carrying photographs of their missing children and grandchildren, drawing global attention to the more than 30,000 people who were kidnapped, tortured and executed by the military junta between 1977 and 1983); and the Wednesday demonstrations of the 'grandmothers' (since 1992, survivors of wartime sexual abuse at the hands of the Japanese military during the Second World War and their supporters hold placards in Japanese, Korean or English across from the Japanese Embassy in Seoul, Korea, demanding an apology from the Japanese government).[33]

As Vera Mackie and I argue in our book *Remembering Women's Activism*, the tactics and tools of the Seoul grandmothers' Wednesday protests are strategically employed in the attempt to elicit feelings of shame on the part of those who continue to deny redress to the elderly survivors. The use of elderly women's bodies patiently occupying stools across from the embassy – and the placement of the Peace Monument, a commemorative statue in the form of a young woman seated on a chair, facing the embassy, with an empty chair beside her – are also intended to generate public sympathy. The statue of the seated young woman represents the young Korean woman before her ordeal, while the shadow cast of an older woman – rendered via a mosaic 'shadow' on the ground behind the statue – depicts the old survivor who refuses to forget. The empty seat signifies those who are missing while also providing a place for visitors to sit, contemplate and have their photographs taken. By performing a dignified form of protest, the elderly survivors and their younger

supporters stage a demonstration that is worthy of the respectful position that these 'grandmothers' (*halmoni*) have attained in life. Models of this Peace Monument have been replicated internationally (for example, life size in a Glendale Park in California, as well as sold in miniature in museums like Seoul's War and Women's Human Rights Museum) indicating not only the global influence but also the emotional salience of the protest.[34] Taken together, the evocative immobile statue and the weekly ritualistic performance of protest by elderly survivors and their younger supporters cultivate an emotional milieu that draws on a range of anticipated responses: sympathy from a receptive global audience; and anger from those who deny the shame of this past.

Countless other political movements harnessed the affective potential of less unruly emotions. As mentioned, much-publicised branches of the global mid-twentieth-century anti-war campaign cultivated a peace-loving, conflict-averse strain of protest that emphasised love, compassion and understanding displayed through marches and sit-ins, as well as via songs, poetry, art and street theatre. Sources characterising some of these movements have since been collated and curated for museum-goers. For instance, the Wende Museum in California recently devoted an exhibition to the little-known Soviet hippie movement. Prominent Soviet hippies donated photographs, clothing and memorabilia that have worked to belie common perceptions about the emotionally restricted or stark experiences of life under the Soviet regime.[35]

More recent protests in places like Hong Kong have also placed trust in the sustaining power of positive emotional tactics. In recent years, the radical group People Power abandoned their previous disruptive approach to instead embrace a more festive form of joyous resistance. In their 2017 article, Vitrierat Ng and Kin-man Chan outline the details and successes, as well as the limitations, of this strategy.[36] In 2019, however, the limitations of this approach became increasingly apparent as demonstrations in Hong Kong erupted into violence. Still, commentators across the world continue to monitor protesters' stoic determination to show the 'spirit of struggle' in the face of China's coercive and authoritarian measures.[37] Television screens continue to relay images of the spirit of protest to audiences worldwide, conveying a clash of emotional cultures that reverberates globally.

## Feminism and interfacing with opponents

Modern feminist campaigns have also cultivated a range of emotions to bind members of their movement together and to confirm the exclusion of those who refuse to affirm group actions and goals, including those vehemently opposed to those goals, namely anti-feminists.

As I have written elsewhere, specific emotions characterise feminist/anti-feminist interactions.[38] As a highly gendered and social emotion, for example, shame performed this role in the early twentieth century. Feminists – those fighting for the vote – attempted to shame apathetic or resistant women into honouring their connection with their protesting sisters through joining the

campaign for the franchise. In turn, anti-feminists – those who cherished an ideal of a feminine community of womanhood untainted by association with the masculine world of politics – tried to shame their transgressive sisters into abandoning their ill-conceived quest which was jeopardising the cohesion of the community of womanhood, and to instead realign themselves with those advocating righteous models of femininity. Shame and its attendant virtues and values – disgrace, embarrassment, indignation, honour, courage and chivalry – were invoked, expressed, ridiculed and lauded as feminists and anti-feminists engaged in an emotional battle, with feminists emerging triumphant (in the battle, if not the war).

The early twentieth-century feminist and anti-feminist press proved invaluable for accessing this emotional interface. For instance, across the British Empire, feminist periodicals, like the *Irish Citizen* and the British *Votes for Women*, and conservative women's papers, including the British *Anti-Suffrage Review* and the Australian journal *Woman*, played host to a whole range of emotional expressions and tactics as editors and writers sought to convince readers to stay loyal to their cause. As a result of an intensive campaign to archive women's records – much of this happening in anticipation of the recent centenary commemorations of the granting of the female franchise – many of these periodicals have been digitised which now allows the feminist scholar ease of access.[39]

Feminist movements are also valuable for those wishing to trace change or continuity in emotional strategies and tactics over time because there is strong evidence that feminist practices connect era to era, as successive generations of women chase the seemingly elusive goal of gender equality. One very familiar and certainly topical example of this is the longevity of the Women's Marches. While their appearance in the 2010s mobilised feminist feeling globally, many commentators failed to recognise that this was more a reappearance than appearance. The suffragists of the early twentieth century – in Britain, America and beyond – had successfully harnessed the spectacle and political passion of the public parade. Historians have the opportunity of tracing the feminist emotional toolkit over the course of a century – as it was manifested through public pageantry, for example – to ascertain to what degree it reflects continuity or change.

## Transient emotional sources and digitisation

Technology now plays a significant role in writing histories of protest emotions, particularly feminist emotions. The digitisation of feminist sources offers emotions historians both unprecedented opportunities and challenges. Much of the passion and excitement of the 1910s American and British suffrage parades, as well as the anger and violence of onlookers, police and prison guards, has been captured by photographs and by ephemera on display (like the ladylike hammer that was used to destroy artworks and commercial properties and the force-feeding tubes that were forced on hunger-striking

suffrage prisoners and the notes of solidarity written on pieces of prison-issued toilet paper, all on display in places like the Museum of London and the Occoquan Workhouse complex in Virginia, USA). While visitors cannot touch these items, they can see them in their original state, if out of their original environment.

With the use of digital technology, however, much of what characterised the passion and excitement of the recent Women's Marches has been trans-formed – morphed from tangible 'things'[40] (knitted 'pussy' hats and home-made paper banners) into digitised images: either represented somewhat chaotically on individual campaigners' social media pages or collected, col-lated, photographed, and then neatly categorised and presented on online databases.[41] This latter example of digital transformation enhances global access, levelling the playing field as it were for historians who have not been able to travel to faraway locations. However, what remains to be seen is the degree to which the rendering of the material three-dimensional object as a non-tactile representation of the sentiments of protest communicates or impedes the communication of those protest emotions.

Of course, as germane as digitisation is to preserving and transforming fem-inist emotions, it is not only gendered protest movements that are affected by technology. A pertinent issue for historians of protest emotions more generally is the transient nature of so many of the sources which can be used to capture what are often impermanent emotions. Many of these form part of a particular cam-paign's emotional toolkit on a given day or over a given period. Projects such as the CAIN website (Conflict Archive on the Internet for the Northern Irish Troubles), for example, help to capture the transience of public expressions of protest. Political murals painted on the walls of private homes and commercial properties in Belfast and Derry turn public spaces into politicised places, serving as potent vehicles for ideals, ideologies, symbolism and propaganda (for example of the previously mentioned disenfranchised and radicalised Catholic commu-nity).[42] However, these murals are susceptible to change – they are amended, removed, replaced. They are impermanent reminders of the anger, outrage or hope that they initially embodied. By digitising them – archiving photographs of them in both their original and amended states – sites like CAIN can help his-torians to trace the contours of the shifting emotional politics of both the artists and their community. Digitising projects, then, play a crucial role in preserving more momentary evidence of political passions, at least those that do not vanish instantly, while documenting changing emotional contours – the stuff of histories of protest emotions.

## Conclusion

A wide array of often conflicting causes harnessed the power of discrete emo-tions, or sets of emotions, to bind groups, sustain movements, and interface with the public and opponents alike. Artefacts left by these movements allow us access to the emotions on display – and sometimes the emotions felt and

embodied – by protesters, from anger to joy, sadness to elation. Digitisation allows greater access to these artefacts – and therefore to protest emotions – which is particularly significant when so many of these sources are transient (for example murals on walls). But such a process of transformation also carries certain limitations. Whatever the limitations or the challenges, the politics of protest is a rich area of historical enquiry that warrants more attention.

## Notes

1 Chris Wallace, 'Shame as a Political Weapon: Donald Trump and the US Presidential Election', *The Conversation*, 1 December 2016, https://theconversation.com/shame-as-a-political-weapon-donald-trump-and-the-us-presidential-election-69029, accessed 9 September 2019.
2 Danielle Paquette, 'Public Slut-Shaming and Donald Trump's Attack on a Former Miss Universe's Alleged Sex History', *The Washington Post*, 30 September 2016, https://www.washingtonpost.com/news/wonk/wp/2016/09/30/public-slut-shaming-and-donald-trumps-attack-on-a-former-miss-universitys-alleged-sex-history/?noredirect=on, accessed 9 September 2019.
3 Sharon Crozier-De Rosa, 'What's Gender Solidarity Got to Do with It? Woman Shaming and Hillary Clinton', *The Conversation*, 8 November 2016, https://theconversation.com/whats-gender-solidarity-got-to-do-with-it-woman-shaming-and-hillary-clinton-68325, accessed 9 September 2019.
4 Douglas Ernst, 'Susan Sarandon: Hillary Clinton "more dangerous" than Trump', *The Washington Times*, 3 June 2016, https://www.washingtontimes.com/news/2016/jun/3/susan-sarandon-says-hillary-clinton-more-dangerous/, accessed 9 September 2019; and, Amanda Erickson, 'The Flawed Feminist Case against Hillary Clinton', *The Washington Post*, 28 July 2016, https://www.washingtonpost.com/news/book-party/wp/2016/07/28/the-flawed-feminist-case-against-hillary-clinton/, accessed 9 September 2019.
5 Kathleen Parker, 'What Steinem, Albright, and Clinton don't get about Millennial Women', *The Washington Post*, 9 February 2016, https://www.washingtonpost.com/opinions/what-steinem-albright-and-clinton-dont-get-about-millennial-women/2016/02/09/7d156d80-cf73-11e5-abc9-ea152f0b9561_story.html, accessed 9 September 2019.
6 Matt Broomfield, 'Women's March against Donald Trump is the Largest Day of Protests in US History, say Political Scientists', *The Independent*, 25 January 2017, https://www.independent.co.uk/news/world/americas/womens-march-anti-donald-trump-womens-rights-largest-protest-demonstration-us-history-political-a7541081.html, accessed 9 September 2019; and Sharon Crozier-De Rosa and Vera Mackie, *Remembering Women's Activism* (Oxford: Routledge, 2019), 7.
7 Ute Frevert, 'Emotional Politics', The Netherlands Scientific Council for Government Policy Annual Lecture presented in The Hague on 24 January 2019, file:///C:/Users/sharo/Downloads/ute-frevert-emotional-politics-wrr-lecture-2019%20(1).pdf, accessed 9 September 2019.
8 Jeff Goodwin, James M. Jasper and Francesca Polletta, 'Introduction: Why Emotions Matter', in *Passionate Politics: Emotions and Social Movements*, ed. Jeff Goodwin, James M. Jasper and Francesca Polletta (Chicago: University of Chicago Press, 2001), 1–24 (1–2).
9 Carol Johnson, 'From Obama to Abbott: Gender Identity and the Politics of Emotion', *Australian Feminist Studies* 28, no. 75 (2013): 14–29 (15).
10 James Jasper, *The Emotions of Protest* (University of Chicago Press: Chicago, 2018), 7.

11  George F.E. Rudé, *The Crowd in History: A Study of Popular Disturbances in France and England, 1730–1848* (New York: Wiley & Sons, 1964); and Charles Tilly, *From Mobilization to Revolution* (Reading, Massachusetts: Addison-Wesley, 1978).

12  Peter Stearns and Carol Stearns, 'Clarifying the History of Emotions and Emotional Standards', *American Historical Review* 90, no. 4 (1985): 813–36 (816).

13  Stearns and Stearns, 'Clarifying the History of Emotions', 816–17.

14  See also Joachim C. Häberlen and Russell A. Spinney, 'Introduction' (Emotions in Protest Movements in Europe Since 1917), *Contemporary European History* 23, no. 4 (2014): 489–503 (490).

15  Jasper, *The Emotions of Protest*, 2.

16  Helena Flam and Debra King, 'Introduction', in *Emotions and Social Movements*, ed. Helena Flam and Debra King (London: Routledge, 2005), 1–18 (2–3).

17  Flam and King, 'Introduction', 3.

18  Deborah B. Gould, 'Life During Wartime: Emotions and The Development of Act Up', *Mobilization: An International Quarterly* 7, no. 2 (2002): 177–200 (177). See also Deborah B. Gould, 'Concluding Thoughts' (Emotions in Protest Movements in Europe Since 1917), *Contemporary European History* 23, no. 4 (2014): 639–44.

19  Jasper, *The Emotions of Protest*, 2.

20  Häberlen and Spinney, 'Introduction'.

21  TROVE, National Library of Australia, https://trove.nla.gov.au/; Chronicling America, Library of Congress, https://chroniclingamerica.loc.gov/; and Papers Past, National Library of New Zealand, https://paperspast.natlib.govt.nz/newspapers, all accessed 14 September 2019.

22  CAIN: Conflict Archive on the Internet, https://cain.ulster.ac.uk/victims/about/index.html, accessed 14 September 2019.

23  Women's March on Washington Archive, University of Florida, https://ufdc.ufl.edu/womensmarch; and Art of the March, Northeastern University, http://artofthemarch.boston/page/about, both accessed 14 September 2019.

24  Thomas C. Buchanan, 'Class Sentiments: Putting the Emotion Back in Working-Class History', *Journal of Social History* 48, no. 1 (2014): 72–87 (73).

25  Peter Stearns, *American Cool: Constructing a Twentieth Century Emotional Style* (New York: NYU Press, 1994) and Carol Stearns and Peter Stearns, *Anger: The Struggle for Emotional Control in America's History* (Chicago: University of Chicago Press, 1986).

26  A good deal of this research is being carried out on workers' conditions and protest in Eastern Europe; for example: David Ost, *The Defeat of Solidarity: Anger and Politics in Post-Communist Europe* (Ithaca: Cornell University Press, 2005); and Laura A. Bray, Thomas E. Shriver and Alison E. Adams, 'Mobilizing Grievances in an Authoritarian Setting: Threat and Emotion in the 1953 Plzeň Uprising', *Sociological Perspectives* 62, no. 1 (2019): 77–95.

27  *Pittsburgh Post Dispatch* cited in Buchanan, 'Class Sentiments'.

28  Buchanan, 'Class Sentiments', 77; and Phillip Troutman, 'Correspondences in Black and White: Sentiment and the Slave Market Revolution,' in *New Studies in the History of American Slavery*, ed. Edward E. Baptist, and Stephanie M.H. Camp (Athens: University of Georgia Press, 2006), 211–42.

29  Buchanan cites John P. Parker, *His Promised Land: The Autobiography of John P. Parker, Former Slave and Conductor on the Underground Railroad*, ed. Stuart Seely Sprague (New York: Norton, 1996).

30  On 'reading against the grain', see Nupur Chaudhuri, Sherry J. Katz and Mary Elizabeth Perry, 'Introduction', in *Contesting Archives: Finding Women in the Sources*, ed. Nupur Chaudhuri, Sherry J. Katz and Mary Elizabeth Perry (Urbana: University of Illinois Press, 2010), xv.

31 James Jasper, 'The Emotions of Protest: Affective and Reactive Emotions in and around Movements', *Sociological Forum* 13, no. 3 (1998): 397–424.

32 Hélène Combes and Olivier Fillieule, 'Repression and Protest: Structural Models and Strategic Interactions', *Revue Française de Science Politique* 61, no. 2 (2011): 1–24.

33 All of these protests are discussed in Chapter 'Grandmothers' in Crozier-De Rosa and Mackie, *Remembering Women's Activism*, 161–199. For further reading, see Tova Benski, 'Breaching Events and the Emotional reactions of the Public: Women in Black in Israel', in *Emotions and Social Movements*, ed. Helena Flam and Debra King (London: Routledge, 2005), 57–78.

34 Crozier-De Rosa and Mackie, *Remembering Women's Activism*, 161–99.

35 For a survey of the anti-war movement in the US, see Simon Hall, *Rethinking the American Anti-War Movement* (New York: Routledge, 2012). There are too many texts on other region's anti-war movements to mention here. However, for Russia, for example, see Socialist Flower Power: Soviet Hippie Culture, Wende Museum 2018 Exhibition, https://www.wendemuseum.org/programs/socialist-flower-power-soviet-hippie-culture, accessed 15 September 2019.

36 Vitrierat Ng and Kin-man Chan, 'Emotion Politics: Joyous Resistance in Hong Kong', *The China Review* 17, no. 1 (2017): 83–115.

37 Rowan Callick, 'Hong Kong's Spirit of Struggle', *Inside Story*, 13 September 2019, https://insidestory.org.au/hong-kongs-spirit-of-struggle/, accessed 15 September 2019.

38 See Sharon Crozier-De Rosa, *Shame and the Anti-Feminist Backlash: Britain, Ireland and Australia, 1890–1920* (New York: Routledge, 2018).

39 Many of these periodicals have been very recently digitised (e.g. *Votes for Women* and the *Anti-Suffrage Review* which are now available via the London School of Economics Women's Rights Collection, https://digital.library.lse.ac.uk/collections/suffrage, accessed 15 September 2019).

40 Stephanie Downes, Sally Holloway and Sarah Randles, eds, *Feeling Things. Objects and Emotions Through History* (Oxford: Oxford University Press, 2018).

41 Women's March on Washington Archive, University of Florida, https://ufdc.ufl.edu/womensmarch; and Art of the March, Northeastern University: http://artofthemarch.boston/page/about, both accessed 14 September 2019.

42 Neil Jarman, 'Painting Landscapes: The Place of Murals in the Symbolic Construction of Urban Space', in *Symbols in Northern Ireland*, ed. Anthony Buckley (Institute of Irish Studies, Queen's University of Belfast: Belfast, 1998), 81–98.

# 17 Technology and feeling

*Susan J. Matt and Luke Fernandez*

In the fall of 1953, Annie Porter, a grief-stricken Utah widow, wrote in her diary that she had watched the World Series on television. 'I brot Dicks picture to be by me while I listened. We always used to listen – together!'[1] The tools of her daily life – a diary, a treasured photo, a glowing television – helped her express her loneliness and sorrow.

Roughly a decade later, in 1964, Marshall McLuhan famously declared 'the medium is the message', arguing that communication technologies were not empty vessels, separable from the ideas they carried, but were an intrinsic part of the messages they conveyed.[2] This insight is useful for scholars of the emotions. For whether they be radios, machine guns or tweets, devices of daily life not only communicate and shape messages, they also shape and convey feelings, and therefore offer a rich trove of sources on inner life.

This essay explores the importance of technology to the history of emotions. First, it defines technology and explains its relevance to the emotions. Then it offers examples of how tools have affected inner life, looking both at how technologies have reshaped people's feelings as well as how people have felt about their tools. Finally, it considers the sources that elucidate these relationships. Given the vast array of technologies humans have created, this essay focuses particularly, though not exclusively, on communication tools, and especially those of the modern era.

## Defining technology

While we may think we know what we mean when we talk about technology, the term's current meaning is of recent vintage. As Leo Marx noted, technology's modern definition, as 'the mechanic arts collectively', only became common after 1900. Before that, the word signified the study of such things – 'a branch of learning, or discourse, or treatise concerned with the mechanic arts'.[3] Therefore, if historians go looking for 'technology' in the past, they will not find it, or at least not as we mean it today. There are further complications in defining technology. A technology is not just a single object, but is part of larger systems of production. Of the auto, Marx wrote:

Its defining, indispensable material core was ... the internal combustion engine, plus – naturally – the rest of the automobile chassis. But surely the technology also includes the mechanised assembly lines, the factories, the skilled work-force, the automotive engineers, ... the corporate structures ..., and the networks of dealers and repair facilities.[4]

Then too, when a tool becomes integrated into daily life, people may forget it is a 'technology', and instead may regard it merely as a mundane object. Hats, window shades and nail clippers are tools that have become so commonplace that they are often invisible.[5] As literary scholar Walter Ong wrote, 'Today's ballpoint pens ... are high-technology products, but we seldom advert to the fact because the technology is concentrated in the factories that produce such things ... and is thereby obfuscated'.[6]

However, rather than taking such technologies for granted, and ignoring their effects on human feelings, historians should attend to the way cheap, disposable ballpoint pens democratised writing and changed how people expressed themselves. More fundamentally they should examine written language itself as a technology. Ong described the rise of writing as 'technologizing the word', arguing it 'restructure[d] thought', distanced writer from reader, separated past from present, and lifted words out of their lived context. While uncontroversial in most modern societies, at its inception written language provoked anxieties, for some, like Plato, feared it would profoundly alter speech, memory and debate.[7]

The recognition that tools like writing transform inner life and interpersonal relations is one we should carry with us as we examine the past. Historians too often pluck references to sadness or joy, ennui or homesickness, from letters, diaries, telegrams and TV shows, regarding them as unaffected by the form or vehicle through which they were conveyed. However, the message is indeed inseparable from the medium.

All technologies hold within them a history of aspirations and yearnings, for humans build them to extend their own powers and compensate for their deficiencies. Theologian Philip Hefner contends, 'We create technology in order to compensate for our finitude. Because technology can outlive us and be stronger than we are, more accurate, and faster, the very existence of our technology reminds us of our finitude and mortality'.[8] Tools, then, are essential sources for gauging what humans have wanted to be and to feel, what powers they have wanted to extend, what limitations they have encountered, and how they have imagined themselves and others.

## Tools and feelings

There is a small but growing literature on technology and emotion. Some scholars have examined how communication tools create new opportunities for feelings and their expression, as well as how they may reinforce or undermine existing emotional norms. Others have studied how people have

felt about their tools – gauging whether they provoked anger, joy or dread. Still others have considered how scientists used new devices to reconceptualise the notion of feeling itself.

The scholarship on communication technology is particularly rich. For instance, Katie Barclay, writing on 'technologies of love' in eighteenth-century Scotland, has described how love letters and wedding certificates 'become not just how we make love but part of its makeup'.[9] Similarly, when the US postal service expanded in the nineteenth century, Americans of all classes and races had increased opportunities to express themselves on paper. Historian Karen Lystra has shown how in the act of writing love letters, correspondents engaged in self-definition and disclosure. Such letters were fundamental to the rise of nineteenth-century individualism.[10] Recent work by Luke Fernandez and Susan Matt has likewise shown how the development of an affordable postal service and the resulting culture of correspondence gave Americans new permission to write about their feelings, overcoming longstanding prohibitions on self-absorption, self-promotion and vanity.[11]

Communication technologies do more than just create new emotional experiences for individuals. To borrow Barbara Rosenwein's terms, nineteenth-century letter writing also created 'emotional communities', offering correspondents space to share intimate thoughts and forge new emotional styles.[12] David Henkin documented how the postal service's expansion reconfigured notions of domesticity, transforming family life from a set of kin relations sustained by geographic proximity to a set of relations maintained through expressions of affection recorded on paper and sent through the mails.[13] Christian Miller and his cousin Benjamin Kenaga found just such community in correspondence. While they both had grown up in upstate New York, they had migrated to different parts of the Midwest. Reflecting upon the role letters played in their relationship, Christian observed in 1881, 'Dear Cousin ... although once we were allmost [sic] in dayly [sic] conversation with each other[,] ... by fate unavoidable ... [we] have been separated and therefore obliged to carry on our conversations by the medium of pen & ink'.[14] Pen and ink became the infrastructure of their relationship.

These communication tools have also inculcated particular modes of expression. While letters encourage extended acts of self-definition and disclosure, telegrams, postcards and tweets all require brevity and prompt informality. Historian John Kasson suggested the postcard's emergence in the late nineteenth century represented an alternative to Victorian gentility:

> postcards offered a way to celebrate one's outing as a step outside the everyday world. Messages like 'Margaret and I are down here having lots of fun', and 'Greetings to all from Coney Island', ... constituted a radical break with the older epistolary style in favor of a clipped new form of communication for an age of mass leisure.[15]

Sometimes not just the limited physical space of a message, but limits imposed by cost shaped expression. Initially, telegrams were the privilege of elites – or the costly necessity of those facing dire emergencies. To send a ten-word message across the Atlantic cost $50 in 1866; a message across the US cost between $5 and $6 – a sum roughly two or three times the daily wage of an industrial worker.[16] Consequently, Americans of modest means used telegrams mostly for emergencies and tragedies, sending terse, sorrowful messages. Similarly, mid-twentieth-century Americans made remarkably short long-distance calls because of their expense. These technological and economic limitations surely shaped emotional expression and family intimacy.

However, most people have not relied exclusively on one technology to communicate their feelings. Affluent Victorian families sent telegrams with time-sensitive news, and then sent longer letters with more space for intimacies. In 1864, Sarah Butler wrote to her husband, General Benjamin Butler, 'You have my letter ... which explains my telegram'.[17] Such sources remind us that different technologies each have particular 'affordances' (to borrow an awkward tech theory term), and that individuals use a mix of tools and techniques to articulate and communicate feeling.

Digital technologies also have been studied for their emotional implications. Social media has rewritten the rules for anger, and given individuals new opportunities to vent online, thus democratising a feeling once considered the exclusive prerogative of white men.[18] Likewise, the rise of smartphones may have reduced moments of transient boredom, but created a new malaise.[19] Peter Stearns argues social media has also created new opportunities for shaming.[20]

Other types of technology, while not explicitly designed for communication, nevertheless transmit feeling. John Kasson demonstrated how amusement parks legitimated and simultaneously industrialised pleasure in the late nineteenth century.[21] Gary Cross and Robert Proctor argue that during that same period the rise of commercialised, 'packaged', morsels of pleasure – from cigarettes to soft drinks, phonograph records to pornography – changed how members of industrialised societies sought and experienced enjoyment.[22] Another tool with a central role in emotional life is the car. Mimi Sheller described the 'emotional investments' people have in their cars. Autos connect individuals with 'family and friends', thereby creating 'emotional geographies'.[23]

Even small refinements to existing tools are worth studying, for their effects can be dramatic. Gerald Linderman demonstrated how rifling on muskets transformed the meaning of courage. At the start of the American Civil War, soldiers sought out opportunities for conspicuous displays of bravery. Generals encouraged their men to charge enemy lines, claiming such frontal attacks embodied courage. In contrast, dodging bullets, ducking behind trees, burrowing in the earth to avoid enemy fire were tactics of fearful cowards. Such evasive actions were also less necessary, given the inaccuracy of early American guns. Ulysses Grant noted that an enemy might shoot at you for hours 'without you finding it out'. However, once rifled guns were adopted,

the old advice about valour seemed unsuited to the new conditions of combat, for the effective range of these guns increased from 100 yards to 300 or 400 yards. With new arms, soldiers easily picked off their enemies. Consequently, men began to duck, hide behind trees, and dig trenches. During the first year of the war, a soldier recalled, 'the spade had been considered an ignoble weapon', but after the battle of Shiloh, soldiers considered it 'not in the least inconsistent with the highest development of personal courage'. As a result of rifled guns, courage was no longer defined by ostentatious heroics. Instead, to merit the label of valorous, one need merely survive.[24]

Considering more recent innovations in military technology, geographer Mei-Po Kwan has argued that geo-spatial technologies (GT), such as GIS systems, obfuscate feelings and bodies. Describing how these tools aid warfare by guiding drone strikes, she notes, 'a large number of bodies are affected by the application of GT (e.g. people profiled by geodemographic application and civilians who were annihilated as "collateral damage" by GPS-guided smart bombs that missed their targets)'. People 'are often treated merely as things, as dots on maps' and consequently empathy for opponents and civilians diminishes.[25]

In addition to tools which carry and embody hate, love, anger, and excitement, technologies have been used to measure and identify feelings (with questionable results). In the nineteenth century, early psychologists tried to provoke responses in laboratory subjects with electricity. Otniel Dror, Rob Boddice, Brent Malin and Jan Plamper have all discussed the invention of devices – from the polygraph to the 'Kissometer' – designed to detect and measure emotion.[26] Dror describes nineteenth-century psychologists' embrace of technology, writing 'they generated, purified, quantified, measured, manipulated, and ... recorded and preserved emotions in visual or numeric form'. Physiologist Claude Bernard used a newly invented 'cardiograph' to 'read in the human heart', believing this device could record emotional changes. Italian physiologist Angelo Mosso tried to induce particular emotions in animals, and also tracked how his own temperature corresponded to his feelings. Other scientists measured glucose levels in the Harvard football team's urine to explain their waning enthusiasm. These scientists hoped their cutting-edge technologies would make the invisible, interior self visible.[27] Contemporary psychologists still attempt this today as they fire up their fMRIs. While it is debatable as to whether these machines actually measure emotion, their invention and use nevertheless reveals much about how feelings have been reconceptualised over the last two centuries.[28]

These are but a few examples of the ways that the history of emotions is entangled with the history of technology. While most of the examples are drawn from the modern period, the underlying idea – that, at least in part, feelings depend upon the tools that transmit them – applies to all eras. The question, then, is where to find sources that elucidate these relationships?

## Sources

Fortunately, there are abundant bodies of evidence which reveal how technologies have shaped feelings. There is also plentiful evidence to help answer a related question – how individuals have felt about their tools. Both are worthy areas of study for historians of the emotions, and this section will suggest sources for both areas of enquiry. Evidence about tools' effects on feelings can be found in many of the sources historians traditionally examine for more conventional studies – but emotions scholars must examine them with a new eye. Newspapers, letters, diaries, telegrams, sermons, advertisements and etiquette guides offer glimpses of what particular devices meant, and how they affected individuals' inner lives. Additionally, the design and construction of the tools themselves reveal humans' changing aspirations and desires.

An obvious starting point for modern and early modern historians is the newspaper. Papers themselves have been tools for spreading emotional norms, publicising feeling, creating emotional – and sometimes 'imagined' – communities.[29] But in addition to the highly charged messages that papers carry and spread, they also frequently report on new devices and their anticipated effects. For instance, early press coverage of the telegraph suggested it would unite the sentiments of far-flung individuals. In 1846, a Philadelphia newspaper predicted the telegraph would 'make the whole land one being – a touch upon any part will – like the wires – vibrate over all'.[30]

Papers also offer hints about whether such expectations were realised and how technologies were assimilated into daily life. In 1893, New York's *Evening World* carried stories of the raw anger sparked by the telephone (and its infrastructure), describing 'a small-sized mob', which 'cut down a pole erected by the Delaware and Atlantic Telephone and Telegraph Company' in New Jersey.[31] Or one can learn of the joyful uses people eventually found for the telegram in the twentieth century. A Nebraska paper reported that due to falling telegram prices, 'Cupid is Using Telegrams', while a Richmond, Virginia paper reported that a couple had been 'Married by Wire'.[32]

Historians can also find evidence of technology's emotional effects from accounts of celebrations. For instance, reports on the completion of the Trans-Atlantic telegraph in 1858 detailed Americans' hopes for the cable. 'New-York yesterday went Cable-mad', reported the *New York Times*. A journalist noted, 'the enthusiasm that was generated knew no bounds; henpecked husbands and virago wives, whose lips had not met for years gave way to the excitement of the occasion, and saluted each other ... vigorously ... men meeting in the streets shook hands more heartily than usual'. New Yorkers were so excited that they set off cannons, tolled church bells, paraded through streets and launched fireworks which set City Hall afire.[33]

David Nye's work on the technological sublime likewise relied upon accounts of public festivities to uncover Americans' deep affection for grand technologies. On the fiftieth anniversary of the Golden Gate Bridge, a quarter of a million people turned out to walk across it. Nye writes,

San Francisco officials were unprepared for the massive turnout because they did not understand the American public's affection for spectacular technologies. Each day crowds visit the Kennedy Space Center, ascend St. Louis's Gateway Arch, and visit the observation decks of prominent skyscrapers. The public response to the birthday of the Golden Gate Bridge was matched by the excitement at the centenary of the Brooklyn Bridge or Statue of Liberty. For almost two centuries the American public has repeatedly paid homage to railways, bridges, skyscrapers, factories, dams, airplanes, and space vehicles. The sublime underlies this enthusiasm for technology. One of the most powerful human emotions, when experienced by large groups the sublime can weld society together.[34]

First-hand perspectives on new tools are also available in letters and diaries (which are again themselves technologies). Delia Locke, a California pioneer who kept a journal for half a century, recorded how the telegraph affected her moods. She wrote in September 1858: 'We have again received the Eastern mail. And the joyful tidings it brings sends a thrill of pleasure through every heart. The Atlantic Cable is laid – the mighty Telegraph enterprise has been successful! ... God be praised for all his rich gifts to rebellious man!'[35] However, her enthusiasm for the telegraph soon waned. In virtually every subsequent reference, she recorded that it brought news of deaths and disaster. For instance, in 1864, 'sad day – Aunt Hannah died about three o'clock this afternoon.... A telegram was sent to Mr. & Mrs. Read.'[36] Her diary records her changing experience of a new technology and also reflects how economics shaped her relationship to telegraphy, for like most Americans she used telegrams only in emergencies. The Confederate diarist Mary Boykin Chesnut expanded on this: 'A telegram reaches you, and you leave it on your lap. You are pale with fright. You handle it, or you dread to touch it, as you would a rattle-snake; worse, worse, a snake could only strike you. How many ... will this scrap of paper tell you have gone to their death?'[37]

Photographs can also be telling sources. The shifting ways people have arranged their facial expressions, related to others in a picture, and shared their images, reflect both changing expressive conventions and attitudes about the camera's purpose. Victorians often used photography to capture images of the dead, reflecting their awareness of the fleeting nature of life. By the twentieth century, however, funerary photography was declining and recording cheerful family occasions and vacation exploits came to be the new emotional purpose of the camera.[38]

Prescriptive literature records the rules that emerged in response to new tools. Etiquette books advised readers how to use communication devices to convey feeling. A 1906 manual lectured, 'Postal cards are not for social usage and type-writing is strictly for business'.[39] Emily Post, in 1922, offered model telegrams, such as a condolence telegram which read, 'Words are so empty! If only I knew how to fill them with love and send them to you.'[40]

Sermons and moralistic writing reveal anxieties about particular tools' emotional and moral effects. For instance, when photography was first invented, German writers worried it would spur 'a mass epidemic of vanity', and considered it a tool for the 'Devil's artistry'.[41] Similarly, some observers warned against the automobile, fearing it enabled sexual and romantic freedom, and labelling it a 'house of prostitution on wheels'.[42]

Advertisements are also promising prescriptive sources, for they try to frame emotional responses to the devices they tout. Adverts for phonographs, phones and radios instructed consumers to reach for the phonograph, the radio knob or the phone book in empty moments. The phone 'banishes loneliness', promised Nebraska Bell in 1912. The National Phonograph company in 1906, claimed, 'You can't be lonesome if you own an Edison'.[43] During the 1920s, adverts depicted autos as commodities that might provoke envy or assuage it (if one purchased the car in question).[44] Airline advertising tried to allay consumers' fears of flying, coaching them to regard their anxieties as symptomatic of feminine weakness or an 'underdeveloped psyche'.[45]

Legislation and crime records reveal social norms about the proper and deviant uses of particular machines. Early motorists, for instance, encountered hostile legislators and neighbours alike, and faced laws which required extremely slow speeds and gave right of way to horses.[46] Sometimes, residents threw stones and tin cans at reckless drivers.[47] Other opponents of the car left 'nails and wire in the wheel track'.[48]

Oral histories can convey how technologies were used – often in ways far different from how similar tools are used today. While twenty-first-century TV viewing is frequently a solitary pursuit, or done just with one's family, initially it was a more communal, less isolating experience. Chicagoan Pat Amino recalled it was her sister who first had a television: 'So, every Friday, Saturday and Sunday, we would rush over there to look at this little TV. It must have been nine inches ... About twenty of us are gathered around this little television, watching Lawrence Welk ... It was fun.'[49]

While such sources provide information about how people used and felt about their technologies, the architecture of the devices themselves should be analysed to understand their creators' assumptions about human feelings. Neil Postman has suggested that every tool contains a philosophy, 'which is given expression in how the technology makes people use their minds, in what it makes us do with our bodies, in how it codifies the world, in which of our senses it amplifies, in which of our emotional and intellectual tendencies it disregards'.[50] For instance, the construction of the party line telephone assumed a level of communal feeling and intimacy many would find foreign today. Neighbours eavesdropped on each other's calls and also used the system to bring the community together. Iowa resident H.E. Wilkinson, born in 1892, remembered the party line relieved the boredom of farm life. When a peddler came to town and lodged with a local family, his hosts persuaded him to play his 'jew's harp' for the neighbourhood over the phone. To summon the audience, they used the 'general ring', and all the families picked up. Entire

households gathered around the receiver to listen in. Wilkinson recalled, 'we thought the music was wonderful, we who were so hungry for diversion of any kind, ... we applauded loudly and happily into the transmitter. It was entertainment, and it was coming mysteriously over that slender thread of wire strung on poles along our fence lines.'[51] Early phone system architecture assumed a level of neighbourly intimacy and its design encouraged such feelings.

Today's software code likewise carries expectations about feeling. Emoticons – the typographic portrayal of emotional expression like :-) – and emoji – the pictured faces designed to relay feeling states – are based on the idea of universal, basic emotions.[52] While that theory is flawed, these symbols nevertheless shape emotional expression online; as such, they are useful sources both to discern online correspondents' feelings, as well as important evidence of the (contested) assumptions about psychology pervading Silicon Valley.[53]

New devices likewise promise to measure emotion, though they may end up standardising rather than gauging it. Tara Brigham describes 'affective computing' which aims to 'identify, interpret, process, and even respond to a human's emotional state'.[54] Such aspirations pervade the digital world. Barbara Rosenwein notes that video-game designers embed within their games particular emotional models which constrain the range of feelings and decisions players are able to express and enact. Other programmers are monitoring gamers' expressions to gauge their feelings. Some designers in fact describe their software development process as 'emotioneering'. [55]

While twenty-first-century designers are explicit about their efforts to shape emotions through their tools, this is not a new trend. When studied together, the history of emotions and the history of technology reveal that our tools have long been both an expression of our feelings, and an abiding influence on them. Inner experience has never been divorced from the outer, material, technological world; instead inner and out, feeling and tool, shape and reshape each other. We would do well to explore them together.

## Notes

1 Annie Maude Porter Dee Diary, 1 October 1953, Thomas D. Dee and Annie Taylor Dee Family History Collection, Stewart Library Special Collections, Weber State University, Ogden, UT.
2 Marshall McLuhan, *Understanding Media: The Extensions of Man* (New York: McGraw Hill, 1964), 7.
3 Leo Marx, 'Technology: The Emergence of a Hazardous Concept', *Technology and Culture* 51 (2010): 561–77.
4 Marx, 'Technology', 574.
5 Neil Postman, 'Five Things We Need to Know about Technological Change', Denver, Colorado, 28 March 1998, https://web.cs.ucdavis.edu/~rogaway/classes/188/materials/postman.pdf, accessed 30 August 2019.
6 Walter J. Ong, 'Writing is a Technology that Restructures Thought', in *The Written Word: Literacy in Transition, Wolfson College Lectures 1985*, ed. Gerd Bauman (Oxford: Clarendon Press, 1985), 30.
7 Ong, 'Writing', 23–50.

8 Philip Hefner, 'Technology and Human Becoming', *Zygon* 37 (2002): 655–66 (658–9).
9 Katie Barclay, 'Doing the Paperwork: The Emotional World of Wedding Certificates', *Cultural and Social History* (online first 14 March 2019): 2, https://doi.org/10.1080/14780038.2019.1589156, accessed 2 September 2019.
10 Karen Lystra, *Searching the Heart: Women, Men, and Love in Nineteenth-Century America* (New York: Oxford University Press, 1989), 27.
11 Luke Fernandez and Susan J. Matt, *Bored, Lonely, Angry, Stupid: Changing Feelings about Technology, from the Telegraph to Twitter* (Cambridge, MA: Harvard University Press, 2019), 21–33.
12 Barbara H. Rosenwein, 'Worrying about Emotions in History', *The American Historical Review* 107: 3 (2002): 821–45.
13 David M. Henkin, *The Postal Age: The Emergence of Modern Communications in Nineteenth-Century America* (Chicago: University of Chicago Press, 2006), 146.
14 Christian Miller to Benjamin Kenaga, 18 April 1881, Series 1, Box 3, folder 83, Christian Miller correspondence, 1874–82, Kenaga Family Papers, Beinecke Library, Yale University, New Haven, CT.
15 John F. Kasson, *Amusing the Million: Coney Island at the Turn of the Century* (New York: Hill & Wang, 1978), 40–1.
16 Anton A. Huurdeman, *The Worldwide History of Telecommunications* (Hoboken: John Wiley & Sons, 2003), 135n; Robert Luther Thompson, *Wiring a Continent: The History of the Telegraph Industry in the United States, 1832–1866* (Princeton,: Princeton University Press, 1947), 369; 'Measuring Worth', https://www.measuringworth.com/calculators/uscompare/, accessed 11 November 2019; Tomas Nonnenmacher, 'History of the U.S. Telegraph Industry', http://eh.net/encyclopedia/history-of-the-u-s-telegraph-industry/, accessed 3 July 2016; Clarence D. Long, *Wages and Earnings in the United States, 1860–1890* (Princeton: Princeton University Press, 1960), 14.
17 Sarah Hildreth Butler to Benjamin Franklin Butler, 29 May 1864, in *Private and Official Correspondence of Gen. Benjamin F. Butler, During the Period of the Civil War*, vol. 4 (Norwood, MA: Plimpton Press, 1917), 281.
18 Carol Zisowitz Stearns and Peter N. Stearns, *Anger: The Struggle for Emotional Control in America's History* (Chicago: University of Chicago Press, 1986); Fernandez and Matt, *Bored, Lonely, Angry, Stupid*, 294–355.
19 Fernandez and Matt, *Bored, Lonely, Angry, Stupid*, 141–87.
20 Peter N. Stearns, *Shame: A Brief History* (Urbana: University of Illinois Press, 2017).
21 Kasson, *Amusing the Million*.
22 Gary S. Cross and Robert N. Proctor, *Packaged Pleasures; How Technology and Marketing Revolutionized Desire* (Chicago: University of Chicago Press, 2014).
23 Mimi Sheller, 'Automotive Emotions: Feeling the Car', *Theory, Culture & Society* 21, no. 4/5 (2004): 221–42 (222, 229, 236).
24 Gerald Linderman, *Embattled Courage: The Experience of Combat in the American Civil War* (New York: Free Press, 1987), 135, 143, 134–55.
25 Mei-Po Kwan, 'Affecting Geospatial Technologies: Toward a Feminist Politics of Emotion', *The Professional Geographer* 59, no. 1 (2007): 22–34 (23–4).
26 Rob Boddice, 'Medical and Scientific Understandings', in *A Cultural History of the Emotions in the Age of Romanticism, Revolution, and Empire*, ed. Susan J. Matt (London: Bloomsbury, 2019), 17–32; Jan Plamper, *The History of Emotions: An Introduction* (Oxford: Oxford University Press, 2015); Otniel Dror, 'The Scientific Image of Emotion: Experience and Technologies of Inscription', *Configurations* 7, no. 3 (1999): 355–401; Brent Malin, *Feeling Mediated: A History of Media Technology and Emotion in America* (New York: New York University Press, 2014).
27 Dror, 'The Scientific Image', 357, 358, 361, 398, 391.

28  William M. Reddy, 'Humanists and the Experimental Study of Emotion', in *Science and Emotions after 1945: A Transatlantic Perspective*, ed. Frank Biess and Daniel M. Gross (Chicago: University of Chicago Press, 2014), 41–66; Plamper, *The History of the Emotions*, 180, 184–5; Thomas Dixon, *From Passions to Emotions: The Creation of a Secular Psychological Category* (Cambridge: Cambridge University Press 2006).

29  Fernandez and Matt, *Bored, Lonely, Angry, Stupid*, 294–355; David Paul Nord, 'Newspapers and American Nationhood, 1776–1826', *Proceedings of the American Antiquarian Society* 100, no. 2 (1991): 391–405; Benedict Anderson, *Imagined Communities: Reflections on the Origin and Spread of Nationalism*, rev. ed. (London: Verso, 1991).

30  Quoted in Daniel J. Czitrom, *Media and the American Mind: From Morse to McLuhan* (Chapel Hill: University of North Carolina Press, 1982), 12.

31  *The Evening World* [New York] 20 May 1893, Sporting Extra, 2; Fernandez and Matt, *Bored, Lonely, Angry, Stupid*, 96.

32  'Love Always Finds a Way', *The Norfolk Weekly News Journal* 25 March 1910; 'Married by Wire', *The Bee*, 4 May 1905

33  'The Ocean Telegraph', *New York Times*, 18 August 1858, 1.

34  David E. Nye, *American Technological Sublime* (Cambridge: MIT Press, 1994), xiii.

35  Delia Locke, 18 September 1858, in Delia Locke Diary, 1858–1861, Locke-Hammond Family Papers, MSS 110, Holt-Atherton Special Collections, University of the Pacific, http://www.pacific.edu/University-Libraries/Find/Holt-Atherton-Special-Collections/Delia-Locke-Diaries.html, accessed 15 April 2013.

36  Delia Locke, 23 May 1864, in Delia Locke Diary, 1862–1869.

37  Mary Boykin Chesnut, 9 June 1862, in *A Diary from Dixie, as Written by Mary Boykin Chesnut*, ed. Isabella D. Martin and Myrta Lockett Avary (New York: D. Appleton and Company, 1906), 177; Fernandez and Matt, *Bored, Lonely, Angry, Stupid*, 259.

38  Fernandez and Matt, *Bored, Lonely, Angry, Stupid*, 21–46; Christina Kotchemidova, 'Why We Say "Cheese": Producing the Smile in Snapshot Photography', *Critical Studies in Media Communication* 22 (2005): 2–25 (2); Nancy Martha West, *Kodak and the Lens of Nostalgia* (Charlottesville: University Press of Virginia, 2000).

39  Ellin Craven Learned, *The Etiquette of New York To-Day* (New York: Frederick A. Stokes Company, 1906), 193.

40  Emily Post, *Etiquette in Society, in Business, in Politics and at Home* (New York: Funk & Wagnalls, 1922), 485.

41  *Der Leipziger Anzeiger* (1839), quoted in Richard Rudisill, *Mirror Image: The Influence of the Daguerreotype on American Society* (Albuquerque: University of New Mexico Press, 1971), 50.

42  Frederick Lewis Allen, *Only Yesterday: An Informal History of the 1920s* (New York: Harper & Row, 1957), 83; Robert Staughton Lynd and Helen Merell Lynd, *Middletown: A Study in American Culture* (San Diego: Harcourt Brace, 1957), 258.

43  *The Alliance Herald* 25 April 1912; *Evening Star* 8 April 1906, 15; Fernandez and Matt, *Bored, Lonely, Angry, Stupid*, 103.

44  Susan J. Matt, *Keeping Up with the Joneses: Envy in American Consumer Society, 1890–1930* (Philadelphia: University of Pennsylvania Press, 2003), 50, 94.

45  Richard K. Popp, 'Commercial Pacification: Airline Advertising, Fear of Flight, and the Shaping of Popular Emotion', *Journal of Consumer Culture* 16, no. 1 (2016): 61–79 (63, 62).

46  Dorothy V. Walters, 'Devil-Wagon Days', *The Wisconsin Magazine of History* 30, no. 1 (1946): 69–77 (70).

47  'New York Pedestrians Confront Reckless Drivers, 1902', in *Major Problems in American Urban and Suburban History: Documents and Essays, Second Edition*,

ed. Howard P. Chudacoff and Peter C. Baldwin (Boston: Houghton Mifflin Company, 2005), 266–67.

48 Walters, 'Devil-Wagon Days', 70.

49 Interview with Pat Aiko (Suzuki) Amino by Mary Doi, 30 March 1998, *Regenerations Oral History Project: Rebuilding Japanese American Families, Communities, and Civil Rights in the Resettlement Era, Chicago Region*, vol. 1, 43, http://texts.cdlib.org/view?docId=ft7n39p0cn&doc.view=entire_text, accessed 2 September 2019.

50 Postman, 'Five Things'.

51 H.E. Wilkinson, *Memories of an Iowa Farm Boy* (Ames: Iowa State University Press, [1952] 1994), 90–1; Fernandez and Matt, *Bored, Lonely, Angry, Stupid*, 159–60.

52 'Don't Know the Difference between Emoji and Emoticons? Let Me Explain', *Guardian*, 6 February 2015, https://www.theguardian.com/technology/2015/feb/06/difference-between-emoji-and-emoticons-explained, accessed 20 August 2019.

53 Rich Firth-Godbehere, 'Silicon Valley Thinks Everyone Feels the Same Six Emotions', *Quartz* 17 September 2018, https://howwegettonext.com/silicon-valley-thinks-everyone-feels-the-same-six-emotions-38354a0ef3d7, accessed 23 June 2019; Luke Fernandez and Susan Matt, 'AI Doesn't Know How You Feel', BLARB, Los Angeles Review of Books Blog, 4 November 2019, http://blog.lareviewofbooks.org/essays/ai-doesnt-know-feel/, accessed 11 November 2019.

54 Tara J. Brigham, 'Merging Technology and Emotions: Introduction to Affective Computing', *Medical Reference Services Quarterly* 36, no. 4 (2017): 400.

55 Barbara H. Rosenwein and Riccardo Cristiani, *What Is the History of the Emotions?* (Cambridge: Polity, 2018), 112–20.

# 18 Emotions and the body

## Mark Neuendorf

Over the past four decades, the body has emerged as an object of focused historical enquiry. Amidst wider scholarly challenges to universalist assumptions about gender, sexuality and race, historians have come to view the body as a site of contested meanings, constituted through discourse. Bodies have 'been lived differently, brought into being within widely dissimilar material cultures, subjected to various technologies and means of control, and incorporated into different rhythms of production and consumption, pleasure and pain'.[1] Continued research into the histories of bodies from outside the modern West has served to 'denaturalize the Western body' as the focal point of scholarly research.[2]

'Body studies' offers an obvious entry into the field of the 'history of emotions', whose practitioners share similar ambitions to upend simplistic assumptions about the biological bases of feeling and behaviour. While human biology may remain relatively stable, the articulation, expression and experience of feeling is informed by culture, in all its manifestations; as such, comparisons of bodies over time can illustrate 'how factors such as social rank, gender, place and religion affected people's experiences of emotion'.[3] The adaptation by historians of emotion of a 'biocultural' model of experience – that is, the assumption that feeling is 'the dynamic product' of physiological processes and 'culturally bound expression' – allows for such a 'historicization of the human'.[4] By paying careful attention to the 'layers of historical-cultural scripts' shaping representations of emotions, historians of the body can re-examine 'archival material with an eye to the literal', with a view to reconstructing past actors' context-specific perceptions of their feeling bodies.[5]

Issues relating to the intersection of emotions and the body have been examined by scholars in disparate fields across the humanities and social sciences, from a range of methodological perspectives: material culture, affect studies, performativity, sensory history. A particularly influential model for drawing together these varied research strands has been Monique Scheer's framework for the study of 'emotional practices'.[6] Drawing upon Bourdieuian practice theory, Scheer explains bodies as being shaped by regulatory social scripts and feeling rules, which cultivate 'habits of feeling'. Through socialisation, these competencies become ingrained into a disposition, known as the

*habitus*, which situates people in the environment and social body. Key to this process are 'emotional practices': 'complexes of speech acts and bodily perceptions and arousals' enacted through rituals and social interactions, which allow people to achieve valued emotions, be it through the mobilisation, regulation, navigation or communication of feelings.[7] It is through such practices that the material 'reality' of emotions is constituted; the 'flesh' of any historical actor or community is the sum total of words, objects, rituals and metaphors that construct or represent affective life.[8] Attention to emotional practices, and their changing significance, thus provides insights into the experience of embodiment, otherwise inaccessible to historians.

This approach also broadens the search for instances of historical emotions: any source that offers a snapshot of bodies from the past, and particularly those that sustain 'traces of observable action', such as movements, gestures or facial expressions, can provide some insight into the feeling rules and rituals that constitute bodily habits.[9] This chapter provides a survey, by no means exhaustive, of some of the sources available to historians of the body, while also discussing some of the key approaches and methodological concerns that have interested scholars in this growing field and how these can contribute to the study of emotional practices. Reflecting scholarship in the field of 'history of emotions' more generally, there is a focus here on the modern West; however, some suggestions have been made concerning directions for further study. The first section considers questions relating to the reading and interpretation of sources, which is followed by thematic sections, discussing the performance of emotion and the feeling body.

## Reading bodies in historical sources

References to affected or moved bodies abound in the historical record and reflect the ideals and beliefs that ordered people's understanding of emotion and embodiment. Emotion terms have thus been recognised as a window to the 'prevailing emotional norms' of a community.[10] Practice theory provides a tool for further recovering the experience of embodiment from historical sources; its 'analytical perspective ... [allows] for a critique of past theories of emotion, especially their strategies of naturalization and interiorization' – that is how ideas about emotion come to be experienced in the body.[11] A focus on the practices that past actors have used to shape their emotions allows historians to re-create the processes by which bodily habits are cultivated. Evidence for emotional practices can be gleaned from any artefacts or objects that either depict bodies or were implicated in bodily practices.[12]

Such an approach provides an entry point from which to study embodiment in ancient societies, for which visual representations of emotion have often survived with little contextual information. Archaeologists, to date, have been more comfortable identifying '[s]ocial emotional values' than the 'subjective emotional experience' of people from the past, owing to the nature of the material available to them.[13] Such approaches have, certainly, revealed the

nuances of emotional life in classical or prehistoric societies, illustrating, for instance, distinctions in emotional norms between people of different status, as Stephen Houston has shown, in an important study of Classic Maya iconography (c. 250–750 CE).[14] A focus on embodiment and practice has the potential to further refine such claims. As Rosemary Joyce suggests, similar icons were also likely used as 'models ... for the embodied gestures of living people': that is, as objects from which bodily practices were learnt.[15]

Richer histories of embodiment are possible for literate societies, for which survive both visual depictions of emotional ideals and written descriptions of bodies' purported experiences. Commonly, feelings are scripted in corporeal metaphor, reflecting the sort of 'merging of body and mind' characteristic of the habitus's 'knowing body'.[16] These terms often 'reflect what people think or thought is/was happening in and outside their body', and so attention to the contexts in which they were formulated can bring to light histories of experience.[17] In medieval Icelandic sagas, for instance, verbs such as '*springa*, to burst, and *bregða*, to move' are indicative of a prevailing conception of emotion as movement, and likely shaped these emotions for readers.[18] Early modern European descriptions of a heart 'bursting' with joy reflect contemporary understandings of the emotional body; in an era where the heart was believed to direct passions, such verbs denoted a vessel figuratively filled to the brim with roiling blood and spirits.[19] The use of such metaphors and terms undoubtedly shaped the habitus too, reflecting and informing the bodily practices enacted by actors in different contexts.[20]

Attention to such terms and representations in the historical record is useful, as it is through emotion that individuals 'come into being'.[21] The process of identifying and representing feelings, in language or art, helps us to '"figure out" what we feel', however imprecise the representations are.[22] Since 'emotion talk' – writing about or vocalising feelings – is 'always bound up in a bodily practice', the ways that people emote offer a frame through which to reveal the body's role in producing or cultivating identities.[23] Personal diaries, for instance, provide examples of past actors examining and reporting on their emotions, and through this systematic emotion talk conditioning their bodies to particular ways of knowing and feeling. Some of the most expressive emotional communities in the modern West have been associated with such texts, for example Calvinists and Protestant non-conformists, who kept spiritual diaries as a method of discovering and validating their faith and humility. Their diary entries regularly explored intense feelings, and the association with the Divine; for women in particular, Alison Searle notes, descriptions of pain in such writings were a way of representing the 'embodied life of faith'.[24]

In scripting their feelings, actors are still always constrained by culture and their social position: assumptions relating to class, gender, family, nationality, sexuality and race all inform the navigation of feeling. Emotional norms may encourage particular forms of embodiment, or inhibit them, which has implications for the interpretation of sources. Karen Harvey, for instance, has shown how, in the early modern period, the gendering of the 'body–emotion connection' made it 'difficult to disentangle a woman's description of physical

and emotional anguish because women in particular linked their experience of emotions (their own and other people's) to direct effects on their bodies'. This in turn guided Harvey's interpretation of moments of corporeal pain reported by Mary Toft, an eighteenth-century woman investigated for faking monstrous births; when read alongside Toft's anxieties about family, health and the body, conspicuous moments of 'physical suffering' are shown to have passed for generalised expressions of 'emotional distress'.[25] We can expect to find manifold different configurations of the 'body–emotion connection' reflected in the sources, depending on the unique circumstances of their creation. An attention to moments of bodily experience, considered alongside the broader cultural scripts informing the expression of emotion, can enable historians to reveal the processes by which identities were discovered and explored.

The terms and emblems used to represent bodily experience can differ between communities – even within the same society. In many cases these differences reflect divergent ideas about social or biological difference. Emotion terms also evolve over time, with some words becoming obsolete; as Barbara Duden has shown, *geblüt*, the 'key word by which women designated the lived flesh' in early eighteenth-century Germany, has fallen out of medical use since the decline of humoural pathology.[26] Changing emotional lexicons, or the disuse of key descriptors of bodily experience in the sources, hint at wider changes in communities' feeling rules and emotional practices, and so are key areas for the study of historical bodies.

Emotion terms have varied origins. Often, bodily metaphors filter down from academic discourses to shape popular understandings of emotion, and so attention to more outwardly 'scholarly' works (e.g. philosophical and theological treatises, and physicians' case notes) can inform the interpretation of lay reflections on somatic conditions, as reported in, for example, letters, diaries, medical correspondence and other autobiographical material. Folk traditions and mythology have also historically informed the representation of feelings, as have religious and spiritual texts, which often provide ready exemplars for emotional expression. Literature, including popular culture sources, provide a space for the development of, and experimentation with 'emotives'; that is, personal emotional descriptions that have 'an exploratory and a self-altering effect'.[27] Descriptions of emotions in creative works function to evoke the same in readers, inviting them to 'simulate' the feelings of characters by '[recalling] their own past sensory experiences'.[28] Emotives in popular texts generally conform to dominant emotional styles, however emotions scripted from outside, or in opposition to, the dominant emotional regime, also shape different or subversive bodies, as histories of countercultures attest; for example, the 'alternative emotional practices' of left-wing activists in 1970s West Germany, detailed in specialist journals and newspapers, promoted intense, convivial, or at time disruptive emotions, which were intended to counteract the fear and alienation said to be imposed by capitalist society.[29] Whichever way emotions are recorded, caution is always required in the reading, to discern the interests, perspectives and prejudices of the person that recorded them.

Images provide a useful complement to the historical study of bodies in literate societies, revealing norms of display and gesture, and also hinting at the practices used to cultivate emotions. In all cases though, an informed reading is needed, which takes into account contemporary valuations of emotion. Whether, for instance, a stand-alone depiction of weeping – one of the foremost communicative acts represented in the Western canon – is to be interpreted as grief, love, joy, or religious zeal, depends largely on the situatedness of the figure; it is only with a recognition of prevailing cultural scripts, including knowledge of identities (e.g. gender, race, status) that the specific composition of the body can be understood. For those modern societies where abundant written and material sources survive, evidence of framing strategies can illustrate the methods that past actors undertook to guide the appropriate interpretation of bodies. In the medieval and early modern periods, significant icons and frescoes – including images of Christ's Passion – were often staged in settings that guided bodily practices. Early modern prints were usually accompanied by verse directions, explaining to the viewer how to interpret the feelings displayed by the figures presented within. Newspaper editors and film and television producers have proved adept at editing images to deliver desired impressions; headlines, captions and commentary assist in this delivery. This contextual information can provide insights into an image's meanings and interpretations (though caution must to be taken not to infer viewers' individual responses without documentary evidence).

While ideas about emotion and physiology inform modes of representation, the materiality of sources, and associated processes of production, have also, historically, influenced the definition of emotions. The introduction of photographic reproduction, for instance, offered unprecedented opportunities to analyse and record emoting bodies in clinical settings. However, as Beatriz Pichel has shown, the vagaries of the inscription process raised questions about the utility of the medium.[30] What elements of a figure best represented an emotion? Could a single image, devoid of movement, adequately capture the complexities of an emotion? Scientists' experiments with different techniques and technologies – as recorded in scientific writings – ultimately shaped the terminology used to describe emotional display (e.g. 'expression', to describe a scientific still-frame of a face), while also fanning debates over the physiology of feeling. Such moments of tension in the sources, which invariably emerged at times of cultural or technological change, provide particularly interesting subjects for the study of emotional practices.

## Performing emotions

Theories of performativity, derived from the work of Erving Goffman and Judith Butler, explain identities as being cultivated through repeated communicative acts, shaped by social norms. It is in this tradition that Scheer's concept of emotional practices has typically been conceived: an actor's emotions and dispositions are cultivated and learned through repeated interactions with

the environment. Understanding the 'situatedness' of historical bodies – their habits, and the practices that cultivate them – is a key concern of historians of emotions; this is best achieved by 'get[ting] a look at bodies and artifacts of the past'.[31] Prescriptive sources, which outline the limits of acceptable behaviours and expressions, are probably the most accessible sources for the history of bodily practices. Iconography, portraiture, conduct manuals, didactic and educational works, and sources of popular culture, have all, historically, provided models for the appropriate expression of emotion. When read alongside contemporary sources that offer 'traces of observable action' – letters, diaries, hagiographies, news reports, travelogues, illustrations, candid photographs and film, to name a few – the processes by which bodily practices are rehearsed and habituated, and identities communicated through feeling, can be revealed and recreated.

The predominance of prescriptive texts on emotional expression can be a useful signifier of a rigid or complex emotional regime. Take for instance the so-called 'age of sensibility', a period of effusive emotional display in the eighteenth century. As consciously 'enlightened' people across the Atlantic world came to prize politeness and sentimental emotion as markers of gentility and virtue, outward displays of feeling came to substitute for honour and sincerity. This led to a preoccupation with dramaturgy in 'polite' society, with new feeling rules, derived largely from contemporary acting manuals and physiognomic tracts, instrumental in shaping new standards of expression and oratory, across the bar and pulpit.[32] Actors perfected accentuated sentimental emotions for the stage, which were in turn scrutinised by onlookers, and then reconstructed in prints, letters, news columns and theatrical criticism. Novels, too, provided explicit direction on the performance of emotion, with feeling bodies rendered visible through a ubiquitous 'verbal pictorialism'.[33] Painting manuals, which detailed the precise rendering of sentimental emotion, were widely distributed, encouraging artists to capture an eloquent expression of feeling. Together, these texts and performances naturalised a distinctive style of expression and display, moulding new standards of address and comportment. This much is evident from contemporary letters and memoirs, which illustrate heightened concerns about bodily control, and fixate on the physiognomy of others; editorials and periodical essays that agonised over the potential affectation of feeling similarly highlight the strains and anxieties imposed by this rigid emotional regime.

Taken together, such arrays of sources thus document the situatedness of bodies in a particular context, and rich documentary evidence survives to pursue similar studies in other contexts. Taking a wide view of a period's cultural artefacts and extant ephemera – e.g. treatises, novels, memoirs, newspapers, works of art, photographs and film, legal statutes, pictorial advertisements, toys, medical textbooks, websites – a community's feeling rules and emotional practices can be readily identified and recreated. Historians have fruitfully developed case studies for the management of bodies in the modern West. Peter Stearns and Carol Z. Stearns, in a series of works,

pioneered research into the emotional codes of the modern United States, ranging from specific emotions to more general emotional styles (e.g. 'American cool').[34] In an important study documenting the importance of cheerfulness to the evolution of individualism and consumer culture in the United States, Christina Kotchemidova has highlighted the multifarious sources by which the new bodily ideal was delivered; conduct literature, workplace managerial strategies, self-help guides and visual media were all deployed to assist people with smiling, and *feeling* happy.[35] An examination of a broad subsection of sources from any society could similarly highlight the practices it mobilises to shape bodies and identities.

The situatedness of bodies is necessarily dependent on the environment. Spatial variables, including buildings, objects, audiences and institutional display rules, operate to sanction or restrain expressions in different arenas. Katie Barclay has usefully employed the term 'performative space' to describe the interplay of bodies with a physical location and associated feeling rules.[36] The study of such spaces is made possible through examination of a broad cross-section of sources relating to a building or environment, and the traces of action performed within.

The most prominent performative spaces are those invested with powerful institutional or corporate ideologies, and which exert sustained surveillance of bodies. The courtroom is Barclay's paradigmatic example. As the spaces in which the rights and privileges of property and nation are secured, Western legal institutions impose norms and practices to promote adherence to these ideologies. Participants are expected to acquiesce to the norms of the court – ideally, to submit to the law's 'majesty'. Bodies are central to this process. In the Western legal tradition, emotions have come to be scrutinised as markers of interiority, with 'ideas about guilt and innocence … often closely connected to how the body on trial [is] read and interpreted'.[37] For defendants, 'feelings of guilt or expressions of atonement' have the potential to affect verdicts handed down to them.[38] As such, the courtroom has developed into an arena for the communication of emotion, through the interplay of bodies and institutional environment. Instrumental to this process was the opening up of legal spaces to observers, and particularly journalists, who ensured that the social interactions that constituted the 'courtroom drama' were scrutinised, and circulated widely through newspapers and other media.[39] Though these were by no means unmediated accounts, reporters' preoccupations with particular emblems and bodies provided 'insights into wider cultural beliefs about how power is produced' in the courtroom, and indeed played a central role in the construction of its actors' public identities.[40]

Given the wide variety of sources available to the historian – depositions, court records, news reports, images and film – the courtroom provides a particularly rich site for the study of performative space. For instance, as Laura Kounine has shown, in a study of trial documents produced during early modern witchcraft prosecutions, a prevailing 'embodied view of subjectivity', in which 'physicality and comportment' informed assumptions about motive

and conscience, meant that culturally significant corporeal expressions could stand as evidence in trials.[41] In the eighteenth and nineteenth centuries, participants in criminal trials – including judges and lawyers – were scrutinised by reporters and other onlookers, who searched for visible cues of their inner states (e.g. a judge's tears during sentencing that illustrated the law's overriding humanity; appropriate displays of masculinity that conferred good 'character' on male suspects). The gradual integration of visual media into legal proceedings – illustrators in the crowd, photographers parked outside judicial buildings, videographers even entering some courtrooms – has created even greater scrutiny of the spectacle of legal emotions. Such images are grist for the study of emotions in the performative space. Legal cartoons, with their exaggerated depictions of the gestures and expressions of judges, lawyers and defendants, implicitly remark on the figures' credibility or dissimulation, or indeed mock the court's claims to judicial objectivity.[42] Photographs of proceedings are no less significant. When, for instance, the Italian anarchist Luigi Lucheni – under arrest for assassinating Empress Elisabeth of Austria – was photographed grinning while being led by officers of the state, the smile became a focus of the investigation itself, a symbol from which reporters, magistrates and psychologists debated the suspect's motives and character.[43] Attention to such spectacles in the sources provides evidence 'of the emotive body driving historical action', and can also, potentially, bring to light the agency of marginalised actors.[44]

Different spaces and rituals can also channel collective emotions, uniting individuals into social bodies through the performance of emotion. This can occur in situations and spaces with loosely defined emotional norms, and which allow for the combination of (potentially disorganised) crowds. The importance of public streets or civic squares as 'performative' spaces has been highlighted by historians, who identify emotions through a comparison of written sources with visual depictions of crowded bodies in urban settings (e.g. in taverns or the high street).[45] The combination of emotional bodies into crowds is perhaps most prominent in arenas with specified boundaries. Some of our best sources of 'crowd behaviour' exist for organised meetings of strangers for entertainment or instruction. Written sources dealing with premodern theatrical performance and oratory regularly reference the emotional responses of audiences, with viewers' accounts often also detailing the appraisal of emotion in others, and the author's efforts to replicate these displays. Working from testimony recorded in social surveys, oral histories and newspapers, James Jones has demonstrated the communal experience reported by mid-twentieth-century British working-class cinemagoers. Some patrons evidently sought privacy in the darkened rooms; however, testimonials also made clear that for others, '[r]eading, interpreting and appropriating the emotional experiences of others became a significant part of [their] own emotional responses'.[46]

Attention to performativity can similarly help us interpret the interests and motives of crowds in more outwardly political demonstrations. Historians of 'the crowd' have dismissed explanations of popular mobilisations as irrational,

instead stressing the organisation of even disruptive mass movements, like riots. There is no universal experience or expression of collective 'anger': crowd violence, like individual emotions, are unique to their historical context. Examining evidence from nineteenth-century newspapers and sermons, Margrit Pernau has linked the increasing fervour of religious demonstrations in colonial South Asia to shifts in emotional norms, which positioned visceral emotion as an admirable marker of zeal. Thus, for example, the Muslims of Kanpur, after facing spiritual disparagement by British colonisers, responded to the partial demolition of a mosque with highly emotive processions, and clashes with the colonial police: acts which were intended to embody politically relevant emotions, specifically the zeal of martyrs at the storied Battle of Karbala.[47] A careful reading of sources relating to seemingly 'violent' outbursts in other contexts can similarly help to reveal the underlying logic of crowd behaviour.

The contours of any performative space can be reconstructed, provided evidence remains of 'observable action', and spectators' responses to it. An examination of hagiographies, chronicles and monuments could potentially provide insights into the practices of medieval religious communities. A cross-section of memoirs, superintendents' diaries, rule books, medical case notes, police reports, photographs and contemporary novels can be used to reconstruct the emotional repertoires produced by formal and informal institutions (schools, hospitals, churches, prisons, neighbourhoods, sporting clubs). Film, images, ephemera and oral history interviews can be used to re-create the experiences of people in modern arenas; Benno Gammerl, for instance, has combined photographs and oral history testimony to uncover the spatial settings and feeling rules that shaped the performative spaces of diverse gay men's venues in West Germany.[48]

Visual sources are integral to the study of bodies and performance in the age of photographic reproduction, though attention needs to be paid to the camera as an agent of the performative space. Bodies are often staged for purportedly 'candid' shots or 'objective documentary photos',[49] and so the historian of emotional practices must take care to consider the cultural ideals and editorial priorities framing the production of images, as well as the rehearsed or even habituated responses of observers to a camera lens. The presence of a recording device at everyday events – dinner parties, celebrations, weddings, funerals – may prompt adherence to specific display rules. Documentary evidence can bring these tensions to light. For instance, during the Victorian era, as photographic portraits became more common, trade journals agonised over whether, and in what ways, the presence of photographers and their machines influenced the expressions of sitters.[50] Such sources hint at prevailing anxieties over technology, and its relation to the body and emotion. They also, perhaps, provide fleeting evidence of the evolution of the habitus – reflections on bodies learning to *respond to* the camera.

## Feeling bodies

Bodies are moved or affected – often in relation to other bodies and the environment. It is through feeling bodies that social formations come into being, and ideologies inculcated. To date, much of the research into the history of feelings has drawn from methodological approaches developed in cultural studies. A prominent, though contested, method for reclaiming experience from sources has been to read for the production and circulation of 'affect', broadly defined as 'the embodied, sensate aspect of mental and emotional activity'. Theorists of affect have conceived it as an intensity that precedes, or in some way is independent of, language or cognition.[51] From this basic premise, it has been argued that certain arrangements of spaces and objects create affective 'atmospheres' which impress upon bodies, with various social and political implications.

Recent work has critiqued the notion of autonomous affective responses;[52] seemingly involuntary bodily responses are more productively thought of as habits, 'executed by a knowing body' according to acquired cultural scripts.[53] As Scheer notes, communities enact emotional practices to create meaningful feelings and aesthetic experiences.[54] It is often with recourse to other objects that such embodiments are enacted; works of art, broadly defined, help evoke 'sensual resonances' which in turn communicate emotions, and thus contribute 'to the formation of identity and self-expression'.[55]

The same can be said for any aesthetic or sensory engagements that are enacted for ritual or political purposes. In Europe's Middle Ages, for instance, 'mystic assemblages' – networks for the circulation of spiritually significant texts and objects – were constructed in certain religious communities to rehearse and cultivate specific affects, as a means of creating bonds and intensifying devotional practices. As Christine Libby notes, such networks are identifiable by 'moments of affective excess and/or dissonance … in the textual record': in this instance, hagiographies and mystic texts that document moments of spiritual ecstasy.[56] Similar moments can be identified in other written and visual sources, which can be productively read as technologies for the mobilisation of bodily practices. Despite the apparent inexpressibility of affect, as it is defined by some scholars in this field (i.e. as 'intensities' or 'resonances'), habituated feelings are often represented as bodily movements, carefully scripted according to the dictates of the prevailing emotional regime. Such instances of feeling provide insights to past actors' efforts to emote. In the 'culture of sensibility', sentimental spectacles in textual or visual works provoked rapturous commentary from cultivated spectators, who described with relish the exquisite feelings these scenes supposedly excited in them: warm, sensuous or 'voluptuous' feelings. Similar arrays of desired or proscribed 'affects' are commonly mobilised in textual sources in most emotional regimes, and their insertion can hint at efforts to attain or cultivate particular habits or dispositions.

Bodies and faces, or their representations, have traditionally been viewed as powerful 'catalyst[s] for feeling'.[57] The processes by which such representations are invested with meanings has thus been a focus of much research in the fields of affect studies, and the history of emotions. As Leila Dawney notes, '[p]olitical formations, such as nationalism or militarism, are experienced as feeling: they are lived, known and felt through and between bodies'.[58] To the historian, the encounter of publics with 'material-affective entities' – representations (usually of bodies) that enact distinctive cultural scripts – marks a point at which ideologies are embodied, and political regimes substantiated.[59] In the modern period, in which feelings of sympathy have become associated with corporeal sensation,[60] the spectacle of the body in pain assumed unprecedented significance to Western publics, for its presumed capacity to induce such feelings in observers. Visceral depictions of abject or wounded bodies were increasingly found to 'create a sense of property in the objects of compassion', implicating spectators in the plight of unfortunates, and so creating a moral imperative to act against perceived injustices.[61] Abject bodies became sources of authority which, in social reformers' words, 'spoke for themselves'; graphic depictions, in both word and image, thus became the stock-in-trade of any number of social reformist and public health texts: medical case notes and textbooks, hygienist treatises, abolitionist tracts, autopsies and parliamentary inquiries.

By the age of photographic reproduction, the political import of broken bodies needed little explanation; images of the sombre figure of infant refugee Alan Kurdi, drowned and washed ashore on a beach in Turkey in 2015, were widely distributed in the assumption that their affective force would implicate Western viewers in the figures' suffering. Such is the nature of these depictions, and associated affects, that they were (and continue to be) mobilised in support of both 'progressive' and 'reactionary' causes. Depictions of the dirty or degraded bodies of the working poor in nineteenth-century medical journals or parliamentary debates served the interests of medical imperialism or industrial capitalism. Written descriptions or images of war dead, or wounded ex-service-people have been circulated in service of nationalism's affective politics from at least the nineteenth century; as Dawney points out, selective staging of disabled service-people by military charities in the twenty-first century – with images often circulated in carefully edited television specials – utilises the affective force of wounded bodies to '[tie] the bodies of publics' to the wider cause that the soldiers represent.[62]

Feeling bodies are integral to the production of social bodies. An assumption in affect studies is 'that we are not self-contained in terms of our energies'; affect, however defined, has been shown to be readily transmitted between individual bodies and environments.[63] Scheer points out that the presence of others, or expressive crowds, 'can cause us to do an emotion', and this sort of response is often habitual.[64] Collective emotions, however seemingly irrational, can reflect communities' learned bodily habits. In examining early modern accounts of crowd paranoia over the presence of the

undead in eastern Europe, Stephen Gordon interprets collective displays of fear as part of an attempt to 'restore cohesion' in a traumatised group, emotions that were likely mimetically performed by people habituated into the same emotional repertoire.[65]

In some cases, elaborate ritual is employed to unite bodies through feeling. Evidence of communal emotional practices can be determined by examining both ethnographic writings and artefacts or archaeological findings. John Laurence Creese, for instance, has shown that alliances amongst Northern Iroquois societies were negotiated through elaborate 'emotion work', focused around 'persistent attentions' on the body and objects (e.g. communal celebrations, personal grooming, adornment, sharing of goods and pipes).[66] Religious groups have, historically, sought to strengthen cohesiveness or assert their authority through ritual processions. Early modern religious processions, for example, used rehearsed chants, sermons and other devotional activities to create 'a visual and aural spectacle' that was 'intended to unite communities through physical participation in an emotional ritual'.[67] The significance of such events is testified by surviving documentary evidence and devotional objects dating back to Europe's classical era.

The figurative or physical effects of collective emotions can be read in historical sources from the use of physiological or corporeal terms. Observers across the long eighteenth century conceptualised crowd behaviour using the language of sympathy and emotional contagion developed in contemporary medical and philosophical works. Just as it was assumed that the nervous system communicated disorder sympathetically between the body's organs, so too did writers conceive of sympathy transmitting potentially 'disruptive energies' between individual bodies; in the words of the eighteenth-century physician Robert Whytt, sympathy between persons communicated 'various motions and morbid symptoms … from one to another, without any corporeal contact or infection'.[68] Influenced by popular mesmerism, nineteenth-century writers in Europe and the United States described charismatic orators as affecting crowds through 'animal magnetism'.[69] The trope of electrical currents running through excitable crowds is a commonplace of reporting on popular entertainments and political mobilisation in the modern sensation cultures. The use of such terms in historical sources point to the assumed embodied feeling produced by a crowd, as well as contemporaries' efforts to understand, interpret and communicate affect.

As with other depictions of bodies, it is possible that the emotional values of crowds and outsiders differ, creating obstacles to communication, and leading sometimes to disharmony. Whether communal fellow-feeling is praised in a source as a vehicle for humanitarian cohesion, or denounced as a harbinger of insurrection depends largely on the author's identity, and the direct political and intellectual context. Ruling-class opponents to popular movements have, historically, viewed crowds with trepidation, with social and racial prejudices tending to obscure or erase the political will of mass movements – and indeed the individuality of those bodies making up the movement.

This is reflected in the tropes and terms used to describe crowds. Popular protests can be typecast using generic descriptions of monstrosity or ill-discipline (e.g. the unruly or impressionable 'mob'); concerned with the social unrest in France around the 1840s, Charlotte Brontë, for instance, described the people as suffering 'spasms, cramps and frenzy-fits'.[70] Consideration is needed when reading highly partisan sources about crowds, with the emotional communities of both participants and observers taken into account.[71] Where possible, a range of texts and images, produced by people from different perspectives, should be consulted, to allow for a critical evaluation of the atmosphere of the crowd.

## Conclusion

Scholars, working from a range of methodological perspectives, have made significant inroads into the recovery of the history of experience. Emotions come into being through practices, and a careful reading of historical sources – be they textual, visual or tactile – allows historians to document the processes by which the learning body habituates particular dispositions. The impact of space and the environment on bodily practices can be revealed through the consultation of sources that convey 'traces of observable action'. Various affective objects – often visual or textual representations of bodies – are involved in the articulation of feeling. When examined together, combinations of such sources provide a useful basis for examining the feeling self, and its place in the world.

## Notes

1 Catherine Gallagher and Thomas Laqueur, 'Introduction', in *The Making of the Modern Body*, ed. Catherine Gallagher and Thomas Laqueur (Berkeley: University of California Press, 1987), vii.
2 Frances E. Mascia-Lees and Patricia Sharpe, 'Introduction: Soft-Tissue Modification and the Horror Within', in *Tattoo, Torture, Mutilation, and Adornment: The Denaturalization of the Body in Culture and Text*, ed. Frances E. Mascia-Lees and Patricia Sharpe (Albany: State University of New York Press, 1992), 1–9 (2).
3 Karen Harvey, 'The Body', in *Early Modern Emotions: An Introduction*, ed. Susan Broomhall (London: Routledge, 2017), 165–8 (165).
4 Rob Boddice, *A History of Feelings* (London: Reaktion Books, 2019), 9, 11.
5 Ibid., 11; Rob Boddice, 'The History of Emotions: Past, Present, Future', *Revista de Estudios Sociales* 62 (2017): 10–15 (14).
6 Monique Scheer, 'Are Emotions a Kind of Practice (And Is That What Makes Them Have a History)? A Bourdieuian Approach to Understanding Emotion', *History and Theory* 51 (2012): 193–220.
7 Pascal Eitler, Bettina Hitzer and Monique Scheer, 'Feeling and Faith – Religious Emotions in German History', *German History* 32, no. 3 (2014): 343–52 (345).
8 Barbara Duden, 'Heterosomatics: Remarks of a Historian of Women's Bodies (à propos the History of the Greek Orders of Columns by Joseph Rykwert)', *RES: Anthropology and Aesthetics* 47 (2005): 247–50 (247).
9 Scheer, 'Emotions', 218.
10 Barbara Rosenwein, *Emotional Communities in the Early Middle Ages* (Ithaca: Cornell University Press, 2006), 29.
11 Scheer, 'Emotions', 217.

12  Ibid., 217–18.
13  Sarah Tarlow, 'Emotion in Archaeology', *Current Anthropology* 41, no. 5 (2000): 713–46 (728).
14  Stephen D. Houston, 'Decorous Bodies and Disordered Passions: Representations of Emotion among the Classic Maya', *World Archaeology* 33, no. 2 (2001): 206–19 (215).
15  Rosemary A. Joyce, 'Archaeology of the Body', *Annual Review of Anthropology* 34 (2005): 139–58 (145).
16  Scheer, 'Emotions', 218.
17  Inger Leemans, 'Comment: Embodied Emotions from a Dutch Historical Perspective', *Emotion Review* 8, no. 3 (2016): 278–80 (280); Scheer, 'Emotions', 218.
18  Kirsi Kanerva, 'Porous Bodies, Porous Minds: Emotions and the Supernatural in the *Íslendingasögur* (ca. 1200–1400)' (PhD thesis, University of Turku, 2015), 97.
19  Michael Stolberg, 'Emotions and the Body in Early Modern Medicine', *Emotion Review* 11, no. 2 (2019): 113–22 (113–15).
20  Scheer, 'Emotions', 218.
21  Joanna Bourke, 'Fear and Anxiety: Writing about Emotion in Modern History', *History Workshop Journal* 55 (2003): 111–33 (123).
22  Rob Boddice, 'Introduction: Hurt Feelings?', in *Pain and Emotion in Modern History*, ed. Rob Boddice (London: Palgrave Macmillan, 2014), 1–15 (1).
23  Scheer, 'Emotions', 212.
24  Alison Searle, '"A Kind of Agonie in my Thoughts": Writing Puritan and Nonconformist Women's Pain in 17th-Century England', *Medical Humanities* 44 (2018): 125–36.
25  Karen Harvey, 'What Mary Toft Felt: Women's Voices, Pain, Power and the Body', *History Workshop Journal* 80 (2015): 33–51 (43).
26  Duden, 'Heterosomatics', 248.
27  William Reddy, *The Navigation of Feeling: A Framework for the History of Emotions* (Cambridge: Cambridge University Press, 2001), 128.
28  Laura Otis, *Banned Emotions: How Metaphors Can Shape What People Feel* (Oxford: Oxford University Press, 2019), 4.
29  Joachim C. Häberlen and Jake P. Smith, 'Struggling for Feelings: The Politics of Emotions in the Radical New Left in West Germany, *c.*1968–84', *Contemporary European History* 23, no. 4 (2014): 615–37 (623–5).
30  Beatriz Pichel, 'From Facial Expressions to Bodily Gestures: Passions, Photography and Movement in French 19th-century Sciences', *History of the Human Sciences* 29, no. 1 (2016): 27–48.
31  Scheer, 'Emotions', 217
32  Paul Goring, *The Rhetoric of Sensibility in Eighteenth-Century Culture* (Cambridge: Cambridge University Press, 2005), 5–6.
33  Janet Todd, *Sensibility: An Introduction* (London: Methuen, 1986), 5.
34  See, e.g., Carol Z. Stearns and Peter N. Stearns, *Anger: The Struggle for Emotional Control in America's History* (London: University of Chicago Press, 1986); Peter N. Stearns, *American Cool: Constructing a Twentieth-Century Emotional Style* (New York: New York University Press, 1994).
35  Christina Kotchemidova, 'From Good Cheer to "Drive-By Smiling": A Social History of Cheerfulness', *Journal of Social History* 39, no. 1 (2005): 5–37.
36  Katie Barclay, *Men on Trial: Performing Emotion, Embodiment and Identity in Ireland, 1800–45* (Manchester: Manchester University Press, 2019). See also Margrit Pernau, 'Feeling Communities: Introduction', *The Indian Economic and Social History Review* 54, no. 1 (2017): 1–20 (15).
37  Laura Kounine, 'Emotions, Mind, and Body on Trial: A Cross-Cultural Perspective', *Journal of Social History* 51, no. 2 (2017): 219–30 (222).

38 Daphne Rozenblatt, 'Introduction: Criminal Law and Emotions in Modern Europe', *Zitiervorschlag: Rechtsgeschichte – Legal History* 25 (2017): 242–50 (242).
39 Barclay, *Men on Trial*, 11.
40 Ibid., 13.
41 Laura Kounine, *Imagining the Witch: Emotions, Gender, and Selfhood in Early Modern Germany* (Oxford: Oxford University Press, 2018), 54–5; Isabelle Laskaris, 'Agency and Emotion of Young Female Accusers in the Salem Witchcraft Trials', *Cultural and Social History* (online first 2019), https://doi.org/10.1080/14780038.2019.1585316.
42 Rozenblatt, 'Introduction', 247.
43 Daphne Rozenblatt, 'The Assassin's Smile: Facial Expression as Political Expression', *History of Emotions – Insights into Research*, October 2016, https://doi.org/10.14280/08241.48.
44 Laskaris, 'Agency and Emotion'.
45 For a useful survey see Una McIlvenna, 'Emotions in Public: Crowds, Mobs and Communities', in *The Routledge History of Emotions in Europe 1100–1700*, ed. Andrew Lynch and Susan Broomhall (Abingdon: Routledge, 2020), 216–32.
46 James Jones, '"These Intimate Little Places": Cinema-Going and Public Emotion in Bolton, 1930–1954', *Cultural and Social History* (online first 2019), https://doi.org/10.1080/14780038.2019.1609801.
47 Margrit Pernau, 'Anger, Hurt and Enthusiasm: Mobilising for Violence, 1870–1920', in *Emotions, Mobilisations and South Asian Politics*, ed. Amélie Blom and Stéphanie Tawa Lama-Rewal (London: Routledge, 2020), 95–112.
48 Benno Gammerl, 'Curtains Up! Shifting Emotional Styles in Gay Men's Venues since the 1950s', *SQS: Suomen Queer-tutkimuksen Seuran Lehti*, 10, no. 1 (2016): 57–64.
49 Rozenblatt, 'Assassin's Smile'.
50 Pichel, 'From Facial Expressions', 34.
51 Stephanie Trigg, 'Affect Theory', in *Early Modern Emotions: An Introduction*, ed. Susan Broomhall (London: Routledge, 2016), 10–13 (11).
52 See, e.g., Ruth Leys, 'The Turn to Affect: A Critique', *Critical Inquiry* 37, no. 3 (2011): 434–72.
53 Scheer, 'Emotions', 199–202.
54 Ibid., 212.
55 Erin Sullivan and Marie Louise Herzfeld-Schild, 'Introduction: Emotion, History and the Arts', *Cultural History* 7, no. 2 (2018): 117–28 (122–3).
56 Christine Libby, 'The Object of His Heart: Subjectivity and Affect in Mystic Texts', *Literature Compass* 13, no. 6 (2016): 362–71 (369).
57 Stephanie Downes and Stephanie Trigg, 'Facing Up to the History of Emotions', *Postmedieval: A Journal of Medieval Cultural Studies* 8 (2017): 3–11 (4).
58 Leila Dawney, 'Affective War: Wounded Bodies as Political Technologies', *Body & Society* 25, no. 3 (2019): 49–72 (55).
59 Ibid., 52.
60 See, e.g., Tara MacDonald, 'Bodily Sympathy, Affect, and Victorian Sensation Fiction', in *Affect Theory and Literary Critical Practice: A Feel for the Text*, ed. Stephen Ahern (Cham: Palgrave Macmillan, 2019), 121–37 (122).
61 Thomas Laqueur, 'Bodies, Details, and the Humanitarian Narrative', in *The New Cultural History*, ed. Lynn Hunt (Berkeley: University of California Press, 1989), 176–204 (176–7).
62 Dawney, 'Affective War', 51.
63 Teresa Brennan, *The Transmission of Affect* (Ithaca: Cornell University Press, 2004), 6.
64 Scheer, 'Emotions', 209.

65 Stephen Gordon, 'Emotional Practice and Bodily Performance in Early Modern Vampire Literature', *Preternature: Critical and Historical Studies on the Preternatural* 6, no. 1 (2017): 93–124 (98).
66 John Laurence Creese, 'Emotion Work and the Archaeology of Consensus: the Northern Iroquoian Case', *World Archaeology* 48, no. 1 (2016): 14–34.
67 McIlvenna, 'Emotions in Public', 225.
68 Mary Fairclough, *The Romantic Crowd: Sympathy, Controversy and Print Culture* (Cambridge: Cambridge University Press, 2013), 22, 39.
69 See, e.g., Alison Winter, *Mesmerized: Powers of Mind in Victorian Britain* (Chicago: University of Chicago Press, 1998).
70 Quoted in Winter, *Mesmerized,* 332.
71 Barbara H. Rosenwein, 'Problems and Methods in the History of Emotions', *Passions in Context* 1, no. 1 (2010): 1–32 (12–13).

# 19 Epilogue

*Peter N. Stearns*

History is an empirical discipline, which means that, ultimately, historical research depends heavily on the kinds of sources available for any given topic. Historians may integrate their empiricism with theory or place their evidence within larger generalisations; they may explore issues like causation beyond the strict limits of available evidence. But ultimately they need data, and their work can be evaluated in terms of the data they have uncovered and on how well they use it.

Historical sources are always a bit tricky, regardless of the specific topic. They are sometimes hard to find and no small amount of imagination goes into discovery. They often require careful interpretation because every source is produced for a particular reason and context that shapes its meaning; the content of a source can rarely be read at face value. Even when a variety of sources are assembled, there are often some aspects of the topic that are not fully covered, requiring some additional, careful interpretation. Historical sources also must often be teased to reveal experiences well beyond what their creators intended to convey.

As the chapters in this book suggest, the history of emotion poses some particularly acute source problems. What kinds of sources can possibly allow judgements about the nature of emotional life in the past? After all, it's sometimes hard to figure out emotional life in the present, when the individuals involved can be directly questioned. Most emotions historians are careful to admit their challenges, and acknowledge the gaps in evidence that sometimes cannot be entirely closed. One crucial issue (aside from opportunities in material culture and art) frequently involves the challenge of language. Historians have to work hard to understand what emotion words which are familiar in the present meant in the past and, equally important, to interpret cases where new words are introduced or old ones drop away.

But the chapters in this volume also suggest, correctly, that emotions historians, despite being a fairly new breed, have been very imaginative in uncovering a wide range of evidence. Many have begun their work with some of the more obvious opportunities, like prescriptive literature, or the musings of philosophers like Aristotle or Confucius, or some of the more readily available artistic portraits. But the field by now has gone well beyond these initial forays (which, however, remain vital and useful), to deal with court records, letters, diaries and social media, and so on.

These steadily expanding empirical opportunities have allowed emotions historians to connect their work to a wide array of additional topics, like social protest or technological change. They are beginning to allow analysis of the emotional experience of social groups, like workers or immigrants, that once seemed impossibly elusive compared with the more abundant evidence available on the middle and upper classes.

Additional discovery is also beginning to expand the field beyond its initial focus primarily on the experience of Western societies (in Europe, but also 'settler' societies like Australia or the United States). Much remains to be done, and some societies offer a somewhat different array of sources from those more familiar in the Western past. But, as one of the previous chapters suggests, careful work on sources is beginning to allow some comparative analysis; another desirable next step in the field.

One point is abundantly clear, as the preceding essays collectively suggest: the history of emotions depends heavily on a capacity to combine different kinds of sources, in making judgements about past emotional experience and about significant changes in this experience over time. On many topics it may seem sensible first to explore sources that suggest what kinds of emotional standards are being 'officially' recommended in a society, through prescriptive materials, religious treatises and so on. But to get beyond the level of recommendations, it is vital to look for other evidence, and this is where legal records, or artefacts or diaries come into the picture. Diversity of sources is important for many fields of history, but it stands tall in the emotions field.

Another vital aspect of emotions history, emphasised particularly in some of these introductory essays, involves the need and opportunity for interdisciplinary interactions, even as historians of emotions go about their work in uncovering and analysing historical sources. In some cases, collaboration with linguists proves vital, and there are good examples of this in the analyses of changing word use. Interaction with scholars who deal with literature, or art, or material culture has produced important insights, and sometimes applies directly to the ways relevant sources are discovered and analysed. But emotions historians also need to work actively with sociologists, psychologists and even neuroscientists, taking advantage of their findings but also seeking to contribute a vital historical dimension – including an explanation of the sources of evidence available and how they can be handled. Here, too, there is abundant opportunity for the future.

As essays in this collection attest, historical methodologies in the field of emotions history have developed. Approaches have been designed to help interpret source material with greater sophistication and nuance. Yet, practical and ethical issues continue to be uncovered. We continue to confront and deal with concerns about whose voices, and whose emotions, to highlight. We understand that the researcher–subject relationship too is important and so we work on recognising not only how emotions helped to create the source but on how we are shaped by our emotional engagement with the past. Finally, the future is where these essays aim, even as they discuss the kinds of

sources that have been brought into play thus far in the history of emotion. There is so much still to accomplish. Some emotions or emotion-related experiences have not been explored very well – one historian has cited the challenge of doing a history of joy, for example. Certain social groupings need more attention. The regional dimension, in moving beyond the Western experience, offers obvious invitation. Even for Western Europe, some time periods (including, in some cases, more recent periods) have received less attention than others.

So this collection invites scholars and students not only to think about how sources have been deployed thus far, but to consider next steps. The history of emotion offers abundant opportunities for student research, to help deal with some of the many topics that warrant further attention. Many of the sources discussed in the preceding essays are directly available for student use, though obviously opportunities vary depending on the topics involved. Student work has already proved revealing in dealing with challenging subjects like the history of gratitude or the history of patience, where emotional components are central. Individual or group projects or, often, active student–faculty collaborations will continue to advance the field. Whatever the format, students can use research opportunities to advance their own skills (useful in many careers, including but not confined to the historical profession), and they can really contribute directly to the field as a whole.

The history of emotions remains an exciting venture. It has already depended on the skills, imagination and diligence of many scholars at various levels of training. It will move forward as additional researchers lend their talents, pondering what kinds of sources (established or more novel) and what kinds of empirically based analysis will generate answers to key questions about the emotional experience of the past and its evolution into the emotional experience of our own time.

# Index

Printed in Great Britain
by Amazon